HAGOP KEVORKIAN SERIES ON NEAR EASTERN ART
AND CIVILIZATION

30

The publication of this work has been aided by
a grant from the Hagop Kevorkian Fund.

CALLIGRAPHY
and
ISLAMIC CULTURE

Annemarie Schimmel

New York University Press
Washington Square, New York

Library of Congress Cataloging in Publication Data

Schimmel, Annemarie.
 Calligraphy and Islamic culture.

 (Hagop Kevorkian series on Near Eastern art and
civilization)
 Bibliography: p.
 Includes indexes.
 1. Calligraphy, Islamic. 2. Alphabet—Religious
aspects—Islam. 3. Civilization, Islamic. I. Title.
II. Series.
NK3636.5.A2S34 1983 745.6′19927 83-8115
ISBN 0-8147-7830-5
ISBN 0-8147-7896-8 (pbk.)

First published in paperback in 1990.

c 10 9 8 7 6 5 4 3 2
p 10 9 8 7 6 5 4 3 2 1

Manufactured in the United States of America

New York University Press books are printed on acid-free paper, and
their binding materials are chosen for strength and durability.

In memoriam

Ernst Kühnel
Richard Ettinghausen

The divine in the didactic is the meaning of calligraphy. Islam, we might say, marries with the cursive flow of the Arabic hand and the authority of that ever-running script, with its endless occasions of artistic freedom within the rigorous constraints of its curving shapes and lines and parallels, occupies Islamic art hardly less thoroughly than the scripture determines its religion. The believer must be reader, not spectator: he will not be educated by imagery, only by the text. It is the pen, celebrated in the Qur'an, which merits the perpetual pride of hand and eye.

Kenneth Cragg
"The Art of Theology"

Contents

Color plates follow p. 33
Black-and-white plates follow p. 76

Foreword

When I was asked, in 1979, to deliver the Kevorkian Lectures in 1981–82, the suggested theme was calligraphy. I very gladly accepted the topic, imagining that I would speak, in the four lectures, about the various styles of calligraphy and about the development of the Arabic script in its different forms from the early Kufi to modern calligraphic painting. I discovered, however, that in spite of the numerous recent publications on Islamic calligraphy, most of which excel by the quality of their pictures, little had been written about the position of the calligrapher or his training. There was also a certain lack of information about the religious significance of calligraphy in Muslim culture, a topic closely related to my interest in the study of Sufism. Furthermore, the indulgence of Arabic and Persianate poets in wordplays and puns based on the terminology of calligraphy had always been loathed rather than appreciated, let alone enjoyed, by Western scholars and seemed to deserve special treatment.

Several informative Persian and even more Turkish works concerning the biographies of calligraphers, to which some Arabic his-

torical material was added, proved a mine not only of information but also of joy and, at times, amusement; Sufi texts unfolded ever new aspects of letter mysticism and cabalistic wordplays; and out of the thousands of examples of the use of calligraphic imagery in the poetry in all Islamic languages that I had collected over many years, I selected a handful that seemed to cover the major topics of this inexhaustible field. Thus, the lectures took the form in which they are now offered to the public after they were delivered, in late February and early March 1982, at New York University, accompanied by a great number of color slides. The transcription follows the generally accepted rules; in case of Turkish words, we usually follow the modern Turkish usage. Dates are given in the Christian era, unless a certain page or document bears a *hijra* date; this is then given as well.

I have to thank many friends for their help and encouragement. First of all, my thanks are due to the inviting institution, the Kevorkian Foundation and New York University, who did everything to make my visits to New York enjoyable. I am particularly grateful to Professor R. Bayly Winder, Chairman of the Hagop Kevorkian Center for Middle Eastern Studies, and to Professor Peter Chelkowski and his wife Goga, in whose hospitable home I stayed during my visits. The Metropolitan Museum of Art, New York, and the Fogg Art Museum, Harvard University, were most generous in providing me with photographs and facilitated my search for new material. Stuart Cary Welch shared his knowledge with me in numerous enlivened discussions about artistic problems. Wolfhart Heinrichs, Harvard University, patiently answered some questions concerning classical Arabic poetry, and Wheeler M. Thackston, Jr., Harvard University, was kind enough to read, as he had done before, my manuscript and made valuable suggestions. My research assistant, Ali S. Asani, never tired of locating relevant material in the libraries and checking references.

Carol Cross in the Department of Near Eastern Languages and Cultures, Harvard University, carefully typed the text of the manuscript and thus relieved me of a heavy burden.

This book is dedicated to the two masters and friends who did much to kindle and keep alive my love of Islamic calligraphy: Ernst

Kühnel, with whom I was fortunate enough to study Islamic art in Berlin, and Richard Ettinghausen, who more than twenty years ago expressed the hope that I would one day write a book on aspects of Islamic calligraphy, and whose living presence we sorely missed during the lectures.

Cambridge/Bonn
May 29, 1982 Annemarie Schimmel

The Arabic Alphabet

	Transcription	Numerical value	Alone form	Initial form	Medial form	Final form
alif	' / â	1	ا	ا	ـا	ـا
bā'	b	2	ب	بـ	ـبـ	ـب
tā'	t	400	ت	تـ	ـتـ	ـت
thā'	th	500	ث	ثـ	ـثـ	ـث
jīm	j	3	ج	جـ	ـجـ	ـج
ḥā'	ḥ	8	ح	حـ	ـحـ	ـح
khā'	kh	600	خ	خـ	ـخـ	ـخ
dāl	d	4	د	د	ـد	ـد
dhāl	dh	700	ذ	ذ	ـذ	ـذ

	Transcription	Numerical value	Alone form	Initial form	Medial form	Final form
rā'	r	200	ر	ر	ـر	ـر
zā'	z	7	ز	ز	ـز	ـز
sīn	s	60	س	سـ	ـسـ	ـس
shīn	sh	300	ش	شـ	ـشـ	ـش
ṣād	ṣ	90	ص	صـ	ـصـ	ـص
ḍād	ḍ	800	ض	ضـ	ـضـ	ـض
ṭā'	ṭ	9	ط	ط	ـطـ	ـط
ẓā'	ẓ	1000	ظ	ظ	ـظـ	ـظ
ᶜayn	'	70	ع	عـ	ـعـ	ـع
ghayn	gh	900	غ	غـ	ـغـ	ـغ
fā'	f	80	ف	فـ	ـفـ	ـف
qāf	q	100	ق	قـ	ـقـ	ـق
kāf	k	20	ك	كـ	ـكـ	ـك
lām	l	30	ل	لـ	ـلـ	ـل
mīm	m	40	م	مـ	ـمـ	ـم
nūn	n	50	ن	نـ	ـنـ	ـن
hā'	h	5	ه	هـ	ـهـ	ـه
wāw	w	6	و	و	ـو	ـو
yā'	y	10	ى	يـ	ـيـ	ـى
lām-alif	lâ		لا	لا	ـلا	ـلا

Styles of Calligraphy

Come, O pen of composition and write letters
In the name of the Writer of the Well-preserved Tablet and the Pen![1]

Thus begins a sixteenth-century treatise on calligraphy, and the expression is representative of the numerous formulas by which Islamic poets and calligraphers began their epistles on writing. The art of writing has played, and still plays, a very special role in the entire Islamic culture, for by the Arabic letters—heritage of all Islamic societies—the Divine Word could be preserved; and Muslims were well aware that writing is a special quality of the human race, "and by it man is distinguished from the other animals." It is, as Ibrahim ash-Shaybani stated, "the language of the hand, the idiom of the mind, the ambassador of intellect, and the trustee of thought, the weapon of knowledge and the companion of brethren in the time of separation."[2]

The field of Islamic calligraphy is almost inexhaustible, given the

various types of Arabic script and the extension of Islamic culture. It is therefore not surprising that a comparatively copious literature about various aspects of Arabic calligraphy has been produced not only in Muslim lands but also in the West, since Arabic letters were known in Europe during the Middle Ages and were often used for decorative purposes. The fine Kufic inscription on the coronation gown of the German emperor shows the west's admiration for Arabic writing as do paintings like the famed "Madonna with the *shahāda*"[3] (profession of faith). These letters were understood as exotic decorative devices, however, and only in the late fifteenth century was the Arabic alphabet first made accessible to German readers in its entirety. It is found in the travelogue of a German nobleman, Breydenbach, who performed a pilgrimage to the Holy Land and offered his impressions of the journey to his compatriots in woodcuts, among which is also found an awkwardly shaped Arabic alphabet. Somewhat later presses for Arabic printing were founded, first in Italy, then in Holland; but there was no general interest in the letters used by the alleged archenemy of the Christian world.[4] As late as in the eighteenth century, with the unbiased interest in Oriental subjects growing, some studies were devoted to the early development of the Arabic script; as Adolf Grohmann has shown in his indispensable work on Arabic Paleography, J. G. C. Adler was the first to study the Kufic inscriptions on early coins.[5] But one should not forget that even Goethe, in his *West-Östlicher Divan* (1819), played with the names of various styles, such as *naskh* and *taʿlīq,* claiming that, whatever style the beloved uses, it does not matter as long as he expresses his love. Grohmann's survey has been updated and enlarged by Janine Sourdel-Thomine in her articles on *kitāb* and *khaṭṭ* in the new *Encyclopedia of Islam*.

It was natural that the type of Arabic that first attracted the orientalists was the angular script as found on the coronation gown and on early coins, which was generally called Kufi. For a long time it was used in Western scholarship to distinguish merely between two major types of script—the so-called Kufi and the cursive hand, the latter type then subdivided into the western, Maghribi character and the style used in the Persian world, *taʿlīq* or *nastaʿlīq*. Even A. J. Arberry, in his handlist of the Korans in the Chester Beatty Library,

2

uses only these terms without entering into a more detailed definition of the cursive hands.

A debt of gratitude is owed to Nabia Abbott, who did the first independent study of the so-called Koranic scripts, published in 1939.[6] The incoherent statements found in Arabic and Persian sources concerning the earliest forms of Arabic writing are difficult to disentangle. They speak often of *ma°qilī,* which was invented, according to legend, by the prophet Idris and had no curved lines whatsoever.[7] Then, out of this inherited script °Ali ibn Abi Talib allegedly developed the so-called Kufi, with a division of ¹⁄₆ curved and ⁵⁄₆ straight lines—a tradition that may reflect the transition from earlier Semitic alphabets to the elaborate Kufic style of the first centuries of the Hegira. It is remarkable that a scholar like Abu Hayyan at-Tauhidi in the early eleventh century still mentions twelve basic forms of Kufi, many of them named after the places where they were first used.[8] We certainly can recognize the *mā'il* script that, slanting to the right rather unbeautifully, is found on some fragments of vertical format (in contrast to the horizontal formats of Kufi Korans).[9] Nabia Abbott regards many pieces that show a slight slant toward the left and a low, small curve at the beginning of the *alif* as Meccan, but we still do not know how Medinan or Basrian styles may have looked. It seems, however, that Kufa was indeed one of the important centers for the art of writing, and the political connection of °Ali ibn Abi Talib with this city accentuates the generally maintained claim that °Ali was the first master of calligraphy. Later generations ascribe to him the invention of the "two-horned *alif,*" which may be the shape found in early inscriptions and called "split arrowhead *alif.*" As in Sufism, the spiritual pedigree of the

"Horned" *alif*

calligraphers invariably leads back to °Ali, and in the late fifteenth century, Sultan-°Ali Mashhadi, the famous master of *nasta°līq,* claimed that "the renown of my writing is due to the name of °Ali."[10]

3

Franz Rosenthal correctly states that "the earliest Arabic documents of writing exhibit, to say the least, a most ungainly type of script."[11] One of the true miracles of Islam is how this script developed in a comparatively brief span of time into a well-proportioned, highly refined calligraphy of superb beauty. As used for early Korans, Kufi *is* the liturgic script par excellence,[12] as Martin Lings has shown with great clarity. However, it is more than doubtful whether any of the fragments preserved in the museums date back to the time of the first caliphs, as is claimed by their proud owners. As early as in the ninth century the great mosque in Damascus boasted of possessing a copy of ᶜOthman's Koran, and so did the mosque in Cordova; this latter copy was so heavy that it had to be carried by two men.[13] The *terminus ante quem* for a fragment or a copy of the Koran can be established only when the piece has a *waqf* note, showing the date of its accession in a certain library. The earliest datable fragments go back to the first quarter of the eighth century; but it is possible that the recently discovered Korans in Sanaa, which are at present being inventoried and analyzed by a German team, may offer a further clue to the early development of writing. Less problematic, of course, is the date of coins and of architectural Kufi.

The very impressive, sometimes truly festive character of the oldest Korans—which were written in *muṣḥaf,* that is, book form, as distinguished from the papyrus scrolls with profane texts[14]—may suggest that at least some of them were written *tabarrukan,* or for the sake of blessing, rather than for reading purposes. They may have also served for the *ḥuffāẓ* and *qurrā',* who had committed to memory the Holy Book but wanted a written support. Diacritical marks and signs for vowels were added in the days of ᶜAbdul-Malik (685) in order to avoid misreadings of the sacred text;[15] colored ink was used for this purpose, and thus the poets would compare such manuscripts to a colorful garden.

The number of known Kufi Korans and fragments is remarkably great and increases almost daily, but no two of them seem to be completely identical in style. The majority, with the exception of the *mā'il* fragments, are written on vellum in horizontal format. Often only three to five lines of black or brown letters fill the page, and the letters on the hairy side of the parchment are usually faded; as the poet says:

4

After being full of glory the places became desolate desert,
Like lines of writing when books are worn out.[16]

Sometimes golden ornamentation is used for sura headings or to separate the *āyas;* in some cases groups of five *āyas* are separated by a minute *h,* a letter whose numerical value is 5. Generally the *alif* begins with a crescent-shaped curve at the lower right, the *n* goes

Kufic *alif*

straight down without any curve, and *r* and *w* are flat and curled in themselves. *Dāl, kāf,* and *ṭā'* can be extended to a great length according to the space at the writer's disposal, and one can understand why Persian poets of the twelfth and thirteenth centuries spoke of someone's heart or intellect as being "as narrow as a Kufic *kāf.*" The

Kufic *kāf*

distance between the single letters is almost equal—grammatical considerations are not taken into account—which also holds true for the separation of words from line to line.

The measurements of the early Korans vary as widely as those of later times. A tradition ordered God's Word to be written in large letters, and most Korans seem to comply with this injunction; but there are also miniature copies. A fragment on fine vellum, 7 by 4

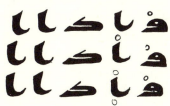

Beginning of the first three lines of Sura 81, *wa idhā a,* from an early Koran, showing the equal distance between the letters. After Moritz, *Arabic Palaeography*

5

cm, with fourteen lines on the page, written in brownish ink, is as meticulously calligraphed as large manuscripts. Whether such a pocket Koran was meant for a traveling scholar, an officer in the caliphal army, or a merchant is unknown.[17]

Some Koran copies were written on colored paper. A famous example is the one whose greatest part is preserved in Tunis, fragments of which are found in Western museums. It is written in golden letters on dark blue vellum, and one may assume that cross-relations with Byzantium may have inspired the artist, since the use of purple and other colored paper for official Byzantine documents is attested. (A good example is the purple letter sent by Constantine VII Porphyrogenetos to ᶜAbdur-Rahman of Cordova in 949.) Another possible source of influence may be Manichean art. Mani appears constantly in Persian poetical imagery as the painter par excellence, and precious, lavishly decorated Manichean writing from Central Asia may have influenced the use of colored and gilded paper in some sectarian or mystical writings; that seems to be the case in the correspondence of Hallaj, which aroused the suspicion of the Baghdadi authorities.[18]

As we can barely date any of the early Korans and only very few names of calligraphers are known,[19] the problem of their provenance is equally puzzling. If all the Korans now preserved in Tunis were written in Ifriqiyya, a flourishing school of calligraphy must have existed there during the first centuries of the Hegira. Somewhat later this "school" produced also one of the most unusual Korans hitherto known, the so-called *Muṣḥaf al-ḥāḍina,* which was ordered by the nurse of the Zirid prince al-Muᶜizz ibn Badis in 1019–20. It is in a vertical format, with five lines on pages measuring 45 by 31 cm. The letters with "teeth" are slanting toward the left; the rounded ones look like buds, resembling the eastern varieties of Kufi much more than the Maghribi style that began to emerge about the same time.[20] Given the mobility of Islamic artists, the possibility cannot be excluded that a calligrapher from Iran may have spent a more or less extended period of his life in Tunisia; but this is highly speculative. Interestingly, Ibn Badis himself composed a book on "pens, ink, and script."[21]

Eastern Kufi seems to have developed out of an apparently innate

6

tendency of the Persians to use a slightly slanting script. The first known example of eastern Kufi is dated 972. Eastern Kufic Korans belong to a period when the art of the book had developed considerably, mainly because of the introduction of paper in 751, and are frequently written on paper instead of vellum; the vertical format used for profane works was adopted also. Diagonal lines became predominant; the high endings of *ṭ* and *k,* utterly flat in early Kufi, assume elegant long strokes toward the right; and triangular forms become a distinctive feature of both the letters in general and the ending curves, which are sometimes filled with minute triangles. Eric

dāl in plaited decorative Kufi, from the border of a Koran, fifteenth century

Schroeder suggested that this might have been the *badīᶜ* script mentioned in Arabic historical works, but this is not the case.[22] Eastern Kufi found its most perfect expression in a style called—without obvious reason—Karmathian Kufi, represented by a Koran, scattered pages of which are found all over the world. The numerous examples allow a stylistic analysis that may help to answer the question whether the Kufic calligrapher carefully planned and outlined each of his pages or whether he was able to visualize the completed page and write it without previous modeling.[23] In this Koran the combination of very slender letters with a colored arabesque background is fascinating; it is echoed in the tombstone of Masᶜud III in Ghazni.

Eastern Kufi developed into a smaller variant used in numerous Korans written in eastern Iran and Afghanistan, of which the present owners usually claim that they are at least from the time of caliph ᶜOthman. This style, in ever more delicate form, continued to be used for such decorative purposes as chapter headings after Korans were no longer written in this hand. It still occupies a place in contemporary book decoration.

rabbuka "your Lord", late decorative Kufi, from the border of a fifteenth century Koran

Western Kufi probably developed a character of its own about the same time as its eastern cousin; its characters are very pronounced long, round endings of the *n,* and so on, which foreshadowed the wide endings of the later Maghribi script.

min, from a North African Koran, tenth century, with the *nūn* developing into the Maghribi form

Kufic Korans and the few profane manuscripts in this style always remained legible; but, when the script was used on material other than vellum or paper, new forms had to be developed. Coins and seals offer some beautiful and finely incised shapes of letters that had to be fitted into a small round space, so that the shapes of these letters had to undergo some changes. Particularly difficult to disentangle are inscriptions on woven material, the so-called *ṭirāz* work, which was either woven into linen or silk with different threads of varying colors or, more rarely, embroidered on the fabric. The *ṭirāz* inscription would mention the name of the ruler or of a vizier who had ordered the piece of cloth from one of the official looms, and it might also contain some good wishes for them, blessings over the Prophet, or the like. Ernst Kühnel, to whom we owe the most important studies of *ṭirāz,* rightly describes the group, most examples of which are preserved (the Fatimid *ṭirāz*), as an art form "in which calligrapher and weaver sometimes seem to compete to make the deciphering of the decorative borders as difficult as possible."[24] Whoever has tried to read the Yemeni fabrics in the Boston Museum of Fine Arts will agree with him![25] Similar difficulties may also be encountered in ceramics, although the material itself offered

8

fewer problems for calligraphers, who usually devised harmonious formulas of blessings or popular adages to fill the borders of bowls and plates. Good ceramic Kufi often has a fine incised line around the letters to distinguish them properly.[26] The difficulties for the reader begin with the numerous inscriptions that are not the works of a master calligrapher but seem to be hastily jotted on the glaze and may often consist of no more than remnants of pious wishes.

Easiest to follow is the development of Kufi on stone, beginning from the simple inscription on the Nilometer in Rauda/Cairo. The discovery of a comparatively large number of tombstones in Egypt that date from the eighth to the tenth century enables the scholar to trace the development of the decoration: the extension of letters (*mashq*) that was then filled with secondary devices called *musannam* and looking, as the name indicates, like camels' humps, or with floriated and foliated *ḥilliyas* that were used to fill the space between, beneath, and above the letters.[27] The *horror vacui*, which is considered a formative principle in so much of Islamic decoration, seems to have contributed to the invention of these forms that, in the course of time, developed into the innumerable varieties of floriated and foliated Kufi, to which the plaited Kufi was very soon added. The letters *lām* and *alif*, which form the article in Arabic and that are repeated time and again in the profession of faith as well as in the word *Allāh*, induced the artists to plait their stems in ingenious ways. And it should be kept in mind that the central concept of Islam— the word *Allāh*—offered infinite possibilities to artists, who would fill the space between its two *l*'s with knots, flowers, stars, and other designs, which, if put in their proper context, serve the art historian to date Kufic inscriptions.[28] The tendency to embellish the name of

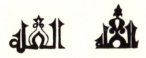

Allāh with decorative developments between the two *lām*. Egypt, tombstones, eighth century. After Bassem Zaki

God was not restricted to one area: the stucco band with the word *Allāh* from Sar-i Pul in Afghanistan, dated 1164,[29] and a window

9

screen consisting of the same word and built in Zaragossa, Spain, at about the same time show that these decorative tendencies were universal.[30]

The plaiting, often combined with foliation, attained its greatest perfection in the thirteenth century,[31] when the Seljuks in Anatolia found some superb solutions for this calligraphic device (as in Sivas and Konya), while the inscription at Iltutmish's tomb in Delhi, which is slightly earlier, proves that as far east as the recently conquered Indian cities plaiting had assumed an important role, undoubtedly introduced from Afghanistan with its superb Ghaznavid and Ghorid inscriptions. Finally, the mathematical regularity of plaits and knots

lām-alif in plaited Kufi

rather than the letters themselves determined the calligraphic presentation. The last great example of this art is the profession of faith in its Shia form in Oljaitu's *miḥrāb* in the Friday Mosque in Isfahan, dated 1307, which appears to the untutored eye merely as a network of arabesques.

This inscription has an almost magical character; indeed, one may understand it as a kind of amulet; for such inscriptions as this, illegible as they might appear, conveyed *baraka* to the onlooker. One is even inclined to say that, the more incomprehensible the text seemed, the more it radiated this quality of sacredness, as Richard Ettinghausen has duly stressed.[32] Seen from a different angle, the regularly posited knots and foliation are comparable to the *radīf* (the constantly repeated rhyme word of a Persian poem), because the artistic vision out of which both emerged—the poem with its monorhyme and the regularly ornamentalized Kufi—is the same.

Kufic writing is usually thought to be connected with Arabic texts, whether the Koran, or sacred sayings, at times historical inscriptions. However, the complicated *ductus* was used even for Persian

10

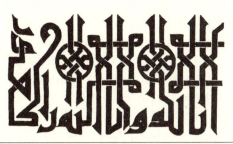

"Verily we belong to God, and to Him we return" (Sura 2/151), in plaited Kufi, Shifa'iye Medrese, Sivas, Turkey, 1278

works, and there exists a long poetical inscription of Mas^cud III (1099–1115) in Ghazni that contains a heroic epic with which he had his palace decorated. Other inscriptions in Kufic Persian are found in Bukhara, Uzgend, Delhi, and Nakhchewan.[33]

The development of Kufic epigraphy was largely due to the material used. While stucco inscriptions could assume an almost tapestry like quality, working with bricks required a different technique out of which angular forms developed, leading to the *shaṭranjī* (rectangular) Kufi. Minarets in Central Asia and Afghanistan (Minara-i Jam) show some of the earliest examples of this style; and the names of the Prophet and the righteous caliphs in the "Turkish triangles" in the Karatay Medrese in Konya (1251) are among the earliest examples of rectangular Kufi in tilework and contrast in this same building with a most intricate Kufic inscription that fills the drum of the dome; the latter led to highly refined stellar forms. *Shaṭranjī* Kufi became a favorite with artists in Iran and Turan. The Timurid masters in Samarqand and Herat and the Safavid architects in Isfahan and elsewhere invented delightful ornaments consisting of the

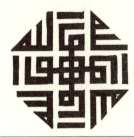

Huwa Allāh, fourfold, in quadrangular Kufi "He is God"

11

names of God, His Prophet, and the First Imam ^cAli,[34] or of pious
formulas, which were inserted in colorful tiles in the overall pattern
of vaults, entrances, and domes. This rectangular Kufi was at times
used for book decoration and has lately inspired some modern Mus-
lim artists to develop new forms of art.

The conviction of the first students of Islamic calligraphy (also
held by some Islamic historians) that the cursive hands developed
out of the Kufi has long been discarded. We now know that there
was always a cursive hand in which people jotted down various texts,
business transactions, and so forth on leather and palm leaves but
mostly on papyrus. Grohmann, studying the numerous papyri avail-
able, has shown how this nonliturgical style of writing developed in
the first centuries of Islam.[35]

The cursive hand began to be shaped more elegantly with the
arabization of the *dīwān* under the Omayyad caliph ^cAbdul-Malik in
697, when particular scripts for the chancellery were required.
The first name to be mentioned is that of Khalid ibn Abi'l-Hayyaj,
who wrote poems, informative news, and also Korans during the
rules of al-Walid and ^cOmar II, that is, in the first two decades of
the eighth century. We do not know, however, whether the Korans
were written in Kufi or in cursive hand on papyrus, a style of which
a fragment has been preserved.

The development of the cursive hand and its use by both the *war-*
rāq (the copyist) and the *muḥarrir* (who was in charge of the clean
copying of manuscripts in the chancelleries) resulted in a whole lit-
erature on the duties of a *kātib* (secretary) in which the rules for the
construction of letters, the cutting of the pen, the preparation of
both types of ink, *midād* and *ḥibr,* and the whole vocabulary con-
nected with these occupations were discussed at length. This litera-
ture also provided the *kātib* with all necessary grammatical, histori-
cal, geographical, and ethical information.[36] Qalqashandi's *Ṣubḥ al-*
a^cshā, the fourteen-volume manual for the Mamluk chancellery in
Egypt, is a good summary of earlier works and presents a very lucid
introduction to the art of writing in its third volume.[37]

The earliest chancellery scripts must have been very heavy; their
prototype was *ṭūmār,* described by Nabia Abbott as an angular Kufic
style but understood later as a powerful script written with a broad
pen, often in loops and connections of letters not permitted in other

styles, and without dots; it was then mainly used for the ruler's signature. The pious caliph ᶜOmar II regarded the large measurements of *thaqīl ṭūmār* documents used by his predecessor as a sheer waste of money and urged his secretaries to use a smaller hand for documents. Heavy *ṭūmār* and so-called *shāmī* (Syrian) script were discarded by the ᶜAbbasids, who instead used a pen called *niṣf* (half) for their own outgoing documents; smaller styles were prescribed for correspondence between officials, such as *thuluth* (one third). The rule was that a person with lower rank used smaller letters when writing to his superior.[38]

The most frequently used script for documents was *tauqīᶜ*. Invented by Yusuf, the brother of Ibrahim as-Sijzi, it remained the preeminent chancellery script and could be used in different sizes according to the rank of the addressee and the importance of the document. Each style had a small (*khafī*) and a large (*jalī*) variant. Ishaq ibn Hammad, secretary to the ᶜAbbasid caliph al-Mahdi (775–85), is mentioned as the first to have founded a real "school" of calligraphy; the names of fifteen of his disciples are mentioned. Slightly later Ahmad ibn Abi Khalid al-Ahwal, "the Squint-eyed," worked for al-Ma'mun. Qalqashandi, following the earlier sources, ascribes to him the invention of a variety of styles, among them *khaṭṭ al-muᶜāmarāt* (for correspondence between amirs), *khaṭṭ al-qiṣaṣ* (for small pieces of paper), and *ghubār al-ḥilya* ("for secrets and for pigeon post"). But we do not know what these styles looked like. It is attested that a document written by al-Ahwal—a letter from Ma'mun to the Byzantine emperor—was exhibited in Constantinople for its unusual beauty.[39] As Ma'mun's rule gave rise to numerous ventures in the field of science, philosophy, and theology, it was apparently also a crucial period for the development of calligraphy. The caliph's vizier, al-Fadl ibn Sahl Dhu'r-Riyasatain, is credited with shaping, at the caliph's behest, the *riyāsī* script that seems to be a more compact form of *niṣf* with a large space between the lines. This script was accepted for Ma'mun's bureau.[40]

Documents could be written on paper of various colors, according to the exigencies of protocol.[41] A story that provides an idea of how these medieval forerunners of the long Ottoman and Persian *firmāns* may have looked is told about the Sahib Ibn ᶜAbbad, vizier, calligrapher, and famed littérateur. In 996, he produced, for the inves-

قلم توقيع

(ضعف در رضف جع تعلات زفتا تسا بدين جعلا ميرشند)

لا وفاء للملوك ولا مروّة لكذوب

قال بعض طلوك الفرس لا ملك الا

بالرّجال ولا رجال الا بالمال ولا مال الا

بالعدل والسّياسه والحمدلله

١٣٢٤

كتبه العبد عبدالعزيز

Model of the *tauqī^c* style, written in 1324h/1906, with the ligatures between the final letters of words and the initial *alif* of the following letter

titure of the *qāḍī al-quḍāt* (chief judge), a document of seven hundred lines, each of them written on one sheet of Samarqandi paper; the whole scroll was rolled up and put in a sheath of ivory, which looked like a thick column. This wonderful document was presented—al-

most one century later—to Nizamulmulk, along with a Koran that contained an interlinear translation in red and an explanation of difficult expressions in blue; those verses which could be applied to practical purposes were marked in gold.[42]

The use of colored inks was likewise common in the chancelleries. The letter that Timur sent in 1399 to Sultan Faraj of Egypt was seventy cubits long and had been calligraphed in golden letters by his master scribe, Badruddin Muhammad Tabrizi, to whom also seven Korans on thick Khanbaliq paper are ascribed[43]—three of them in *thuluth* and four in *naskh,* with the *basmala* in Kufi and the *sha'n an-nuzūl* (the explanation of when and where the revelation came) in *riqā*[c] and *rīhānī* style.

One special feature of the chancellery scripts seems to be that they contain many more ligatures than do the copyists' styles. A protocol script of the caliph al-Muqtadir (r. 908–32) shows the *lām* and the *alif* joining together, and in the later *musalsal* that was used in official writing virtually all letters are closely connected with one another. Ibn Khaldun's remarks about the almost "secret" style of chancellery writers shows that this development continued through the centuries.[44] When Hafiz in the fourteenth century complains that his beloved did not send him a letter made from the chainlike letters to catch the fluttering bird of his heart, he cleverly alludes to a document in *musalsal* script.[45]

A smaller script, *ijāza,* was derived from *tauqī*[c] and was commonly used in Ottoman documents; it preserves the large loops between the final letters and the *alif* of the definite article of the following word, which is also found in the Turkish *dīvānī* style, where the loops assume the shape of pointed ovals.

How well known the chancellery styles were in the Middle Ages is attested by a line of the twelfth-century poet Khaqani, who claims:

I have bound the eye of greed and broken the teeth of avarice,
like a *mīm* in the style of the calligrapher, like a *sīn* in *dīvānī* script.[46]

The letter *mīm* as used by calligraphers is "blind," that is, it has no opening in the center, while the three teeth of the *sīn* are straightened out in chancellery style into a single line.

15

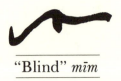

"Blind" *mīm* *sīn* "without teeth"

In the case of Ottoman *dīvānī* the flow of the lines follows the imperial *ṭughrā*, the decorative shape developed out of the handsign of the emperor, which was already fairly well developed in the days of Mehmet the Conqueror.[47] Hence the lines show a rising tendency toward the left. A *jalī* form of *dīvānī* was sometimes used by Ottoman calligraphers for decorative pages.

Line in *dīvānī* script

The development of calligraphy inside and outside chancellery use was facilitated by the introduction of paper, for papyrus with its raw surface did not allow artistic writing. The first book on paper about which we know anything was written by 870, but there may have been earlier examples. Scribes and calligraphers occupied an important place in Islamic society, and more than one story in the *Arabian Nights* tells of the importance of writing and of beautiful writing with "erect *alif*, swelling *ḥā'*, and well-rounded *wāw*."[48] The use of diacritical marks and, in many cases, of vowel signs became more common, even though some sophisticated persons might object to the use of these signs in private correspondence because it would mean that the addressee was not intelligent enough to decipher the message.[49] But at the same time there was an awareness of the danger of misreading important words, and the general feeling was well expressed by the ᶜAbbasid vizier ᶜAli ibn ᶜIsa (d. 946) that "writing provided with diacritical points is like an artistically designed cloth."[50] Somewhat later, an Andalusian poet compared a drummer's stick in a musical performance to "a reed pen in the

16

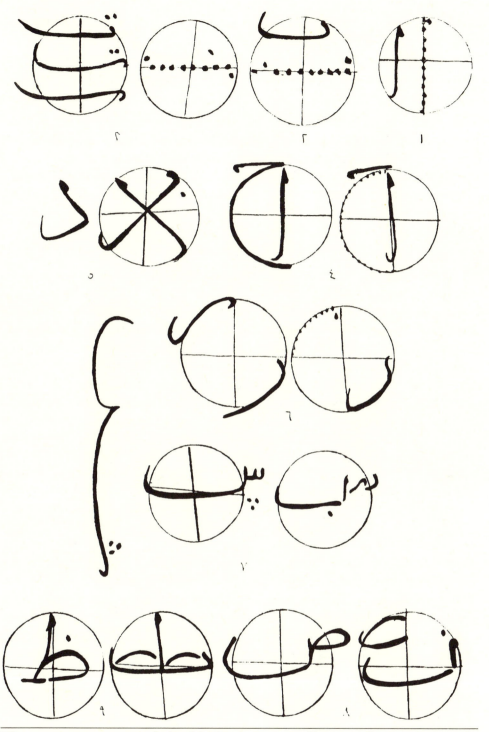

The measurements of Arabic letters according to Ibn ar-Rawandi, *Rāḥat aṣ-ṣudūr*

hand of a littérateur who constantly marks dots when writing poetry."[51]

Praise of beautiful script is common in the sources of the ninth and tenth centuries. When Isma῾il al-Katib saw a fine handwriting, he exclaimed:

> If it were a plant, it would be a rose;
> if it were metal, it would be pure gold;
> if it were something to taste, it would be sweet;
> and if it were wine, it would be very pure.[52]

One may here also think of the story of the first *qalandar* in the *Arabian Nights* in which the monkey wins the king's heart by his elegant calligraphy in various styles and by his skillful poetical allusions to writing.[53]

But on the whole, the development of truly beautiful, well-measured script is connected with the name of Ibn Muqla, a native of Shiraz who served several times as vizier until he finally died in prison or was killed in 940. Before that, his enemies had cut off his right hand, the harshest punishment to be meted out to the undisputed master of calligraphy. His main contribution to the development of the cursive hand was to relate the proportions of the letters to that of the *alif*.[54] The measurements were taken by rhomboid points produced by the pen so that an *alif* would be, according to the style, 5, 7, or 9 points high, a *bā'* 1 point high and 5 points long, and so on. This geometry of the letters, which was perfected by explaining the relations among the parts of letters in circles and semicircles, has remained binding for calligraphers to our day, and the perfection of a script is judged according to the relation of the

Examples of measuring letters by using of rhomboid dots

18

letters to each other, not simply to their shape. Every lover of calligraphy would probably agree with Abu Hayyan at-Tauhidi's statement: "Ibn Muqla is a prophet in the field of handwriting; it was poured upon his hand, even as it was revealed to the bees to make their honey cells hexagonal."[55] Thus, his name has become proverbial in Islamic lore and is mentioned not only by calligraphers but by poets as well, almost all of whom continue to play on a pun the Sahib Ibn ᶜAbbad had invented shortly after the calligrapher-vizier's death:

> The writing of the vizier Ibn Muqla
> is a garden for the heart and the eyeball (*muqla*).[56]

Or:

> The script of Ibn Muqla!—He whose eyeball (*muqla*) regarded it
> carefully,
> Would wish that all his limbs were eyeballs![57]

Even in our century the Egyptian poet laureate Shauqi compared the pillars of the Alhambra to "*alifs* written by Ibn Muqla."[58]

The vizier, who continued to write skillfully even after his hand had been amputated, taught his art to several followers, among them his daughter, with whom ᶜAli ibn Hilal, known as Ibn al-Bawwab, studied the art.[59] He added some more elegance to the strict rules of Ibn Muqla, and the Koran that he wrote in the year 1000 (now in the Chester Beatty Library) is a remarkable piece of writing, particularly the long swinging curves at the final round letters. One wonders if some of the hundred Korans in the library of the Buwayhid vizier Ardashir ibn Sabur, which were written by the best calligraphers, came from his pen, as one also wonders how great the ratio between Kufi and cursive Korans in this famous library might have been. (The vizier owned, besides the Korans, more than ten thousand manuscripts, most of them autographs.)[60]

When Ibn al-Bawwab, who was noted for his immensely long beard,[61] "completed the letters of annihilation and traveled toward the practicing-house of eternity"[62] in 1032, no less than ash-Sharif al-Murtada wrote a threnody on him. During his lifetime he was

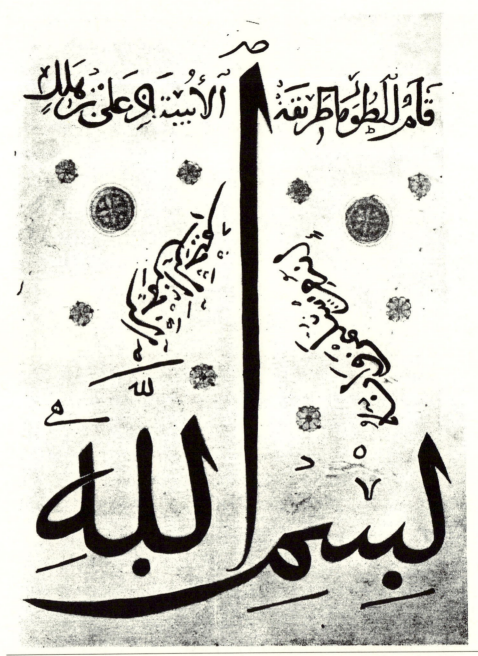

Bismillāh in the handwriting of Ibn al-Bawwab in *ṭūmār* script. From
Ünver-Athari, *Ibn al-Bawwāb*

famous in the Islamic world, for his younger contemporary, Abu' l-
ᶜAla al-Maᶜarri, describes an evening in the verse:

The crescent (*hilāl*) appeared like a *nūn,* which has been written
 beautifully
With golden ink by the calligrapher Ibn Hilal [i.e., Ibn al-
 Bawwab],[63]

nūn in cursive script

and the highest praise one might bestow upon a book "like an or-
nated garden," in which content and form were equally attractive,
was that:

> Its lines were written by the hand of Ibn Hilal
> from the mouth of Ibn Hilal,[64]

that is, Ibn Hilal as-Sabi, the famous stylist of the tenth century. A
few decades later, Sana'i in eastern Iran could describe outwardly
delightful but inwardly disgusting people as resembling

> the nonsensical talk of Musaylima the Liar
> in the script of Ibn Muqla and Bawwab.[65]

The school of Ibn al-Bawwab was continued in Baghdad. Among
the masters of his style was a woman, Shuhda al-Katiba, from whom
the chain of transmission goes to the last of the great medieval cal-
ligraphers, Yaqut al-Mustaᶜsimi (d. 1298), a eunuch who had been
in the service of the last ᶜAbbasid caliph, whom he outlived by forty
years. To be sure, there were flourishing schools of calligraphy be-
fore him, as Ibn ar-Rawandi's remarks about the masters of his na-
tive Kashan prove for the time around 1200—remarks supported
by the superb quality of some early calligraphies;[66] but to Yaqut a
new way of trimming the pen is attributed—a slight slant that makes
the thicker and thinner strokes more distinguishable and renders
the script more elegant. In later times, no greater praise could be
bestowed upon a calligrapher than to say that he was able to sell his

21

own writings for a piece of Yaqut. Among his doubtlessly numerous disciples six are singled out, each of whom is credited with the development of a particular style. From that time onward the *sitta* styles remain exclusively in use for copyists' and "calligraphers'" purposes. They are (1) *naskh* (connected with ᶜAbdallah as-Sayrafi), (2) *muhaqqaq* (connected with ᶜAbdallah Arghun), (3) *thuluth* (connected with Ahmad Tayyib Shah), (4) *tauqīᶜ* (connected with Mubarakshah Qutb), (5) *rīhānī* (connected with Mubarakshah Suyufi), and (6) *riqāᶜ* (connected with Ahmad as-Suhrawardi).[67]

With the introduction of these six basic styles, the multiplicity of previous styles falls into oblivion, for it is amazing and somewhat disquieting that Ibn an-Nadim's *Fihrist*, composed in the time between Ibn Muqla and Ibn al-Bawwab, enumerates no less than twenty-four different cursive hands, among which some that were to become very prominent later are not mentioned.[68] It is consoling that a writer who is almost contemporary with Ibn an-Nadim, Ibn Wahb al-Katib, complains that even the scribes are no longer aware of all the different styles of the good old days.[69]

Among the *aqlām as-sitta* the most impressive one is *thuluth*, which belongs to the *aqlām murattaba*, the rounded, plump style, and is also

alif and wāw in a "round" style, such as *thuluth*

described as *muqawwar* (hollowed) or *layyin* (soft). It is written with a broad pen; the *alif* begins with a light stroke at the right upper angle and can have a slight curve at its lower left. Even in the Middle Ages it was compared to a man looking at his feet. *Thuluth* was mainly used in epigraphy, less frequently in calligraphy except for the sura headings of Korans. Some fine Korans in *thuluth* belong to Mamluk Egypt; written in golden ink, the eyes of their letters are sometimes filled with dark lapis lazuli.[70] It seems that an art form that later became a favorite with calligraphers was invented under Timur. Sayyid ᶜAbdul Qadir ibn ᶜAbdul Wahhab wrote a Koran for him in which the first, the central, and the last lines are in *thuluth*, the rest in *naskh*.[71] This combination of two styles was then continued in Mamluk and Ottoman times, especially for decorative album

22

pages. *Thuluth* in its *jalī* form was predominantly used for the enormous inscriptions with names of God and the Prophet or other religious formulas as they adorn Turkish mosques and have been aptly described by Franz Rosenthal as "religious emotion frozen by art."[72]

The other large script used in the Middle Ages is *muḥaqqaq,* (meaning the "accurate, well-organized, ideal" script); according to Tauhidi, the first condition for writing is *taḥqīq* (attempting accuracy).[73] Like *rīḥānī*, which is its smaller relative, *muḥaqqaq* has flat endings terminating in sharp points.[74] It is therefore called a dry (*yābis*) script, in which the difference between the vertical letters and the lower ones is very marked, *alif* being 9 points high (in *thuluth* only 7). *Alif* has a small stroke at its upper right but under no circumstances swings out at the lower left; thus, the contrasts between

alif and *wāw* in a "dry" script, such as *muḥaqqaq*

the letters become more marked. *Muḥaqqaq* was always a copyists', not a chancellery, script; and like the most common copyists' script, the *naskh*, it is distinguished by the *lā al-warrāqiyya*, that is, a way of writing *lām* and *alif* as a single, triangular letter.

lā al-warrāqiyya, the *lām-alif* as used by the copyists

Modern handbooks of calligraphy in Turkey claim that both *muḥaqqaq* and *rīḥānī* are merely flat variants of *thuluth,* and the style has formerly rarely been observed by Western scholars, even though allusions to it are abundant in poetry.

The true copyists' script is the small *naskh,* written with a fine pen and with a straight *alif* without an initial stroke. Among the chancellery styles its counterpart is *riqᶜa,* meant for small pieces of paper and notes but not for significant documents. In both styles the *alif* measures only 5 points. Even though *riqᶜa* was never a classical script, the last biographer of Turkish calligraphers, Ibnül Emin Inal, devotes a whole chapter to the masters of this style who, as is to be

expected, were mainly high government officials.[75] Out of *riq^ca, qĭrma,* the "broken script," developed; that was a kind of shorthand used in the government for tax purposes and for other purposes that were not supposed to become commonly known.[76]

Naskh as an artistic form developed according to local taste. In Iran it is rounded and very upright, with the letters extremely neatly drawn, thus clearly contrasting with the normal slanting style of writing in Iran. The last great master of *naskh* in Iran was Mirza Ahmad Nayrizi in the early eighteenth century who wrote with a very obliquely cut pen and whose Korans were highly prized.[77] From Iran the round *naskh* reached India, where it is even stiffer, the round endings of the letters being small and perfectly circular so that a page may look very calm and sedate. However, the letters are often too closely crammed together, and someone used to Turkish *naskh* would find a Koran printed in Pakistani style difficult to appreciate.

The Turks developed a *naskh* in which the fine, graceful letters seem to walk swiftly toward the left. This style, whose foundation was laid by Shaykh Hamdullah around 1500 and that was perfected by his successor, Hafiz Osman, after seven generations, has become a model of beauty. That is why the Turkish saying claims, *Kuran Mekke'ye indi, Mĭsĭr'da okundu, Istanbul'da yazĭldĭ* ("The Koran was revealed in Mecca, was recited [properly] in Egypt, and was written in Istanbul").

Derived from *naskh* is *ghubār,* the dust script, written with a minute pen. Originally meant for pigeon post, it was later used for decorative purposes such as filling single letters with a whole text or making up figures of human beings, animals, or flowers from pious formulas. One can also write the *basmala* or the profession of faith in *ghubār* on a grain of rice.[78] The first *ghubār* Koran of which we know was written for Timur by ^cOmar al-Aqta^c, a calligrapher who did not belong to the Yaqutian chain of transmission. The ruler, however, was not happy with a Koran that could be fitted under a signet ring. He rebuked the calligrapher, who then wrote another copy of the Holy Book, each page of which measured a cubit in length. Timur, finally impressed, handsomely rewarded the artist.[79]

The story may or may not be authentic, but it certainly shows the predilection of late-fourteenth and fifteenth-century connoisseurs for

24

Korans of enormous sizes—suffice it to mention a Mamluk copy of 117 by 98 cm and the Koran written by Timur's grandson Baysunghur, which measures 101 by 177 cm. To write Korans, or at least their first and last pages, in gold was not unusual, as copies from all parts of the Muslim world, from Morocco to India, prove. But non-religious texts could also be lavishly decorated, particularly poetry composed by kings, be it al-Muctamid's verse in the ninth century in Baghdad[80] or the poetical works of the Deccani rulers Muhammad-Quli Qutbshah and Ibrahim cAdilshah around 1600.[81]

But the cursive hand did not remain restricted to chancellery or copyist purposes. Shortly after the year 1000 one finds its first examples in architectural inscriptions, and in a comparatively short time it replaced Kufi, or coexisted with it for a while until Kufi became so highly involved that it had to be replaced by a more readable script. A typical example is the area of the Quwwat ul-Islam mosque and the Qutb Minar in Delhi (1236), where both styles are used to a high degree of perfection. Two decades later, Konya is another striking example, where the sophisticated Kufi of the Karatay Medrese and the elegant *thuluth* surrounding the gate of the neighboring Ince Minareli Medrese are almost contemporary (1251 and 1258, respectively). Such inscriptions show that *thuluth* had indeed reached a high degree of refinement even before it was given its final touch by Yaqut, and it is not astonishing that two generations later some of Yaqut's disciples excelled both in Koranic calligraphy and in the layout of huge architectural inscriptions. They used to write the texts for the stonecutters or tilemakers; it is told of one master that he "wrote *Sūrat al-Kahf* . . . and the stonecutters reproduced it in relief . . . simply with baked bricks."[82]

Thuluth remained the ideal style for epigraphy and was used on virtually every material and everywhere. Muslim artisans seem to have covered every conceivable object with writing, often with verses or rhyming sentences. The *Kitāb al-muwashshā*, which offers a lively picture of the life of the elegant upper class in Baghdad in the ninth and tenth centuries,[83] quotes verses that were artistically written on pillows and curtains, goblets and flasks, garments and headgear, belts and kerchiefs, golden and silver vessels, as well as on porcelain. Handsome slave girls had verses written in henna on their cheeks and foreheads, as did writers with the reedpens that they used or

sent as gifts to friends. *Miḥrābs* (prayer-niches) in wood and marble show every possible combination of script, and wood inlaid with mother-of-pearl or ivory inscriptions has been found from India to Spain. Glazed tiles with inscriptions scribbled around their borders not only offer difficult specimens of the early "hanging" style but sometimes preserve interesting pieces from Arabic or Persian literature, both poetry and prose; inscriptions inlaid in copper or brass may offer either historical information or contain literary pieces in which the vessel is imagined speaking about its destination. Many of them have a religious content (thus the Bidri ware from the Deccan with strongly Shiite invocations), and mosque lamps in Syrian glass supply us with the names of their donors or allude to the Prophet who is sent as *sirājun munīr* (a shining light; Sura 33/40), or else to the light-verse of the Koran (Sura 24/35). The use of inscriptions on glass and ceramics was so widespread that mock Arabic words are found on some porcelain pieces produced in China for export to Near Eastern countries. Many signs on vessels no longer yield any meaning, for more and more the craftsman imitated traditional models without understanding the letters, which therefore often consist simply of remnants of repeated blessing formulas. Quite early in history the Arabs seem to have used rugs with inscriptions or letters on them; otherwise, the long deliberation put forth by the fourteenth-century theologian as-Subki as to whether or not one was allowed to tread upon such a rug would be meaningless.[84]

Cursive epigraphy reached its apex in the inscriptions on mosques and minarets. The use of tiles enabled the artists to produce highly intricate, radiant inscriptions of flawless beauty; here, Timurids and Safavids found unsurpassable solutions. India, on the other hand, can boast of some of the finest inscriptions carved out of marble or laid in black into white marble, as in the Taj Mahal, where calligraphers and architects skilfully produced the illusion that all letters are absolutely equal in size, despite the changing perspective.[85] One must also not forget the powerful stone inscriptions with a highly decorative organization of the verticals in rhythmical parallelism, as found in fifteenth-century Bengal or early seventeenth-century Bijapur,[86] an area whose contributions to the development of the art of Arabic epigraphy is usually overlooked because art historians tend to focus on the examples of Ottoman Turkish architecture that have

long since become the perfect embodiment of cursive epigraphy at its best.

Naskh and *thuluth* seem to embody the genius of the Arabic script most perfectly, whereas the development of Arabic writing in the Western part of the Muslim world, the Maghrib, is less attractive to many. Even Ibn Khaldun, a Tunisian himself, did not approve of the writing of his compatriots who had not participated in the reform of the cursive hand by Ibn Muqla and his successors and who lived in an area that, as he implies, was not really culturally advanced enough to equal Cairo with its numerous facilities where a refined art like calligraphy would be sought and hence taught.[87] We know, however, that there were also quite a number of scholars and writers in the Maghrib who practiced calligraphy according to the rules of the Baghdadian masters, which they apparently learned while traveling to the East.[88] Inscriptions in the Alhambra as well as on Spanish silks prove that for epigraphic purposes the traditional *thuluth* was generally used.

The punctuation of Maghribi differs from that in the East in that the *f* has its dot beneath it and the *q* has only one dot. The common North African hand was apparently refined in Spain; the so-called Andalusian script, with its dense succession of letters, impresses the reader by its high degree of straightness.

It seems that in the Maghrib vellum remained in use for copies of the Koran longer than in the East, and some Maghribi Korans written in gold on fine vellum have a beauty of their own, even though they do not conform to the canon. Maghribi appears to the spectator less logical than *naskh,* for the very wide opening of the initial *ʿayn* and the enormous endings of the letters, which are by no means perfectly circular, look too irregular. Some later manuscripts have buttonlike upper endings of the verticals, and the pages often assume a spiderweblike character. The decoration in its strong colors, however, is often strikingly attractive; the use of colored inks for the vowel signs adds to the picturesque quality of the page. Examples from the works of the Moroccan master al-Qandusi from the early nineteenth century, as shown in Khatibi and Sijelmasi's book, reveal the artistic possibilities of this style.[89]

Maghribi was exported to western Africa, but both in Bornu and in Kano (northern Nigeria) the letters are much heavier than in the

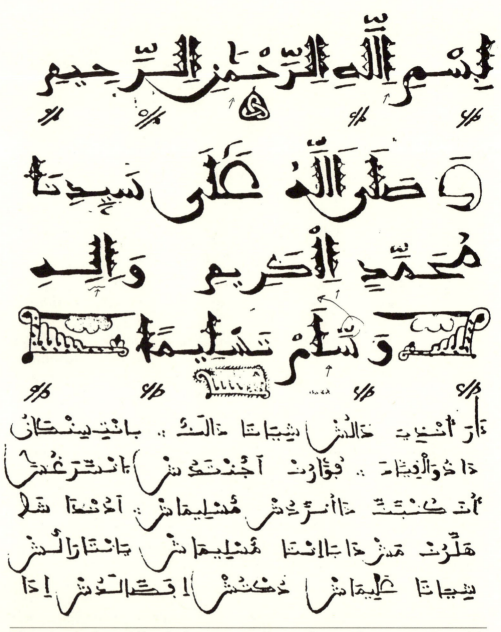

First page of an Aljamiado manuscript, a sixteenth-century Spanish text in Arabic letters in Maghribi style. Only the initial *basmala* and the blessings upon the Prophet are in Arabic. Courtesy Dr. Luce Lopéz-Baralt, Puerto Rico

28

Maghrib proper: in Bornu they rather resemble oblique Kufic letters, whereas in Kano they are very stiff. Besides, the normative *naskh* style became more common in West Africa as soon as printed religious books were imported from Egypt and other Middle Eastern countries.[90]

Most lovers of Islamic calligraphy would bestow the highest praise on the "hanging" style as developed in the Persianate world. A certain trend toward extending the letters to the lower left can be found in early Persian manuscripts and on ceramics from the twelfth and thirteenth centuries. This is a natural development, because the frequently occurring verbal endings *-t, -i, -st* require a movement of the pen from the upper right toward a long, swinging left ending. The so-called *ta'līq* was used, according to Qadi Ahmad, exclusively for chancellery purposes.[91] That remained so even after Mir-'Ali of Tabriz, called *qudwat al-kuttāb* ("the exemplary calligrapher"),[92] had regulated the hanging style by shaping and measuring the letters according to the rules developed for the Arabic cursive style. Legends tell that a dream of flying geese, interpreted for him by Hazrat 'Ali, inspired him to perfect the style so that he can be called, not the inventor, but the first calligrapher of *nasta'līq*. The masters of

The "bird-like" shapes of some letters in *nasta'līq*

this style still teach their disciples to form certain letters like a bird's wing or beak. Under the Timurid prince Baysunghur Mirza (d. 1433) the hanging style became the true vehicle for Persian texts, and it is said that all his forty court calligraphers were Mir-'Ali Tabrizi's disciples. Mir-'Ali's son, 'Abdullah Shakarin-Qalam, perfected his father's work, and his style remained so predominant that attempts by some other calligraphers, namely Maulana 'Abdur-Rahman Khwarizmi and his two sons, to develop a style of their own is harshly criticized by some Oriental sources.[93]

Nasta'līq, the "bride of the Islamic styles of writing,"[94] is certainly

29

an ideal vehicle for poetical texts, and the combination of fine poetry written in elegant *nastaʿlīq* and decorated with artistic borders is doubtlessly one of the greatest achievements of Muslim artists. Toward the end of the fifteenth century, pages with pious sayings or with pithy quatrains were as popular as were small oblong *safīnas,* anthologies in which poems were written in minute elegant *nastaʿlīq.* The greatest masters of this style are connected with eastern Iran. Sultan-ʿAli Mashhadi (d. 924/1519), the *Sulṭān al-Khaṭṭāṭīn,* (King of Calligraphers) produced during a lifetime of some eighty years an enormous number of books, many of which are extant, but he was surpassed in elegance by Mir-ʿAli Haravi, examples of whose hand are found in most libraries and museums. It is said that Mir-ʿAli was asked about the difference between Sultan-ʿAli's and his own writing and answered, "I have brought it to perfection, but his writing has a special flavor."[95] The two masters are in a certain way comparable to Ibn Muqla and Ibn al-Bawwab;[96] but to some poets Ibn al-Bawwab compared to them appeared "like a doorkeeper with his stick in his hand."[97]

After the dispersion of the Timurid rule in Herat, different schools of *nastaʿlīq* developed in Safavid Iran, where the outstanding master is Mir-ʿImad, whose pedigree goes back to Mir-ʿAli.[98] Before Mir-ʿImad, the name of Mahmud Nishapuri outshines calligraphers of the first half of the sixteenth century in Iran. He was the favorite of Shah Tahmasp, for whom he wrote a Koran in *nastaʿlīq* in 1538; it is one of the very few specimens of a whole Koran in the hanging style, which is not aesthetically well suited to Arabic. An Indian poet says in the seventeenth century:

> The condition of love is not elegant beauty,
> just like a Koran in *nastaʿlīq.*[99]

This means that what matters is the content more than the form. Another fragment of a Koran in *nastaʿlīq* was written for Shah Tahmasp by the librarian of Bahram Mirza, the calligrapher, painter, and historian Dost-Muhammad.[100]

From Iran the hanging style was adapted in those countries where Persian culture prevailed, namely in India, where many masters of this style migrated in the latter days of Shah Tahmasp and during

the heyday of the Moghul Empire and in Ottoman Turkey. Turkish *ta ͨlīq* tends to a slightly wider opening of the final semicircles of the rounded letters, whereas Indian *ta ͨlīq*, like Indian *naskh*, often has rather tightly closed, perfectly circular endings.

Out of *ta ͨlīq* developed *shikasta*, the "broken script," which was apparently in the beginning mainly used in the chancelleries and was molded into a more elegant form by Shafi ͨa of Herat (d. 1676), whose writing looked "like the tresses of a bride."[101] ͨAbdul-Majid of Taliqan (d. 1185/1773) brought it to perfection.[102] It seems more than an accident that this style developed at exactly the same time when the word *shikast* (broken) became one of the key words of Persian poetry in India. Pages with *shikasta*, their lines thrown, as it were, over the page without apparent order, are often reminiscent of modern graphics rather than of legible script, and thus the aesthetic result of the most sacred, hieratic script, the early Koranic Kufi, and that of the extreme profane, poetical script are quite similar: one admires them without trying to decipher them. The poets then would claim that they wrote their letters in *khaṭṭ-i shikasta* in order to express their broken hearts' hopeless state;[103] and one wonders whether Bedil, the most famous representative of the involved Indian style in poetry, had in mind a page of *shikasta*, with its lines crossing each other, when he exclaimed:

The back and the face of the plate of your understanding are Islam and infidelity:
Out of nearsightedness have you made the lines of the Koran into a cross![104]

There are some peculiar developments of the Arabic script in the eastern part of the Islamic world. Among them is the so-called Bihari style, which was used in India mainly in the fifteenth century. The rules of Ibn Muqla were either unknown to, or neglected by, its calligraphers; in fact, its slowly thickening lower endings and the flat *ṣād* are reminiscent of Maghribi, and, as in that style, the decoration in colorful inks can render a good Bihari manuscript quite beautiful.[105] Again, in the Central Asian areas, influences of Mongolian and Chinese writing are palpable; and certain Korans, in which the long endings are strangely stacked, would deserve more

31

intense study. It seems that some of these texts were written with a brush instead of with a reedpen; but more research has to be done in this field.

Out of the basic styles of Arabic writing a great number of derivatives developed and are still in use. The long verticals that are so predominant in Arabic especially invited the calligraphers to invent fascinating calligraphic fences on album pages, a technique that probably grew out of the headings of princely documents and that were apparently particularly common in India.[106] Playful inventions were not lacking either: while the use of animated letters on metal

Zoomorphic letters: *sīn* and *yā'*, from a bronze pen-case. After Herzfeld

vessels in the eleventh and twelfth centuries is well attested, the Herati master Majnun is also credited with inventing a script of human and animal figures of which, unfortunately, no trace has yet come to light.[107] Mirror script, used first for seal cutting, developed into a special art; some of the greatest Turkish calligraphers have elaborated highly sophisticated mirrored inscriptions for mosques and mausoleums.[108]

The *khaṭṭ-i nākhun*, in which the script is engraved with the fingernail into the backside of the paper, was invented, or made popular, in the sixteenth century by Nizamuddin Bukhari, whose talent was praised in a poem by the Safavid prince Bahram Mirza; it is still known to one or two artists in Pakistan.[109]

It goes without saying that in the long history of Islamic calligraphy various attempts have been made to introduce new shapes— "sharpening the teeth of the *sīn*"; adding little flourishes to the letters; and creating styles poetically called "bride's tresses," "peacock script," "flame script," "crescent script," and so on—but none of these had a major bearing on the development of calligraphy proper, and historians mention such innovations with great disapproval. Thus, even the calligraphic paintings of the Pakistani artist Sadiqain, interesting as they may look as an attempt to write the Koran in a picto-

32

rial style, are frowned upon by professional calligraphers, since his letters do not follow the classical rules.

For the lover of calligraphy, however, it is fascinating to observe that throughout the Islamic world a new interest in calligraphy as such as well as in calligraphic painting has occurred recently—a trend that stretches from Morocco to Pakistan, with leading representatives also in Egypt and Iraq.[110] This new interest in calligraphy, from whatever angle it be, shows that the Muslims are very much aware that the Arabic letters—the "letters of the Koran"—are their most precious heirloom, and everyone will probably agree with Qadi Ahmad who, well aware of the fact that most of his compatriots were illiterate, wrote: "If someone, whether he can read or not, sees good writing, he likes to enjoy the sight of it."[111]

Kufic *kāf* from a Koran, Iran, ca. twelfth century. While other known pages of this Koran are written in normal Eastern Kufi, the *Sūrat al-ikhlāṣ* (Sura 112), which contains the profession of God's absolute Unity, is written in highly complicated Kufi reminiscent of stucco decorations, and so is the name of the Prophet Muhammad

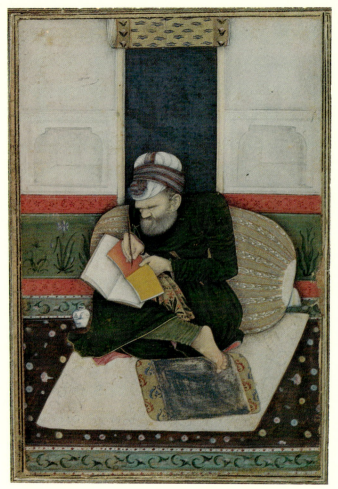

A Scribe. Moghul, India, ca. 1625.

Anonymous Private Collection, courtesy of
the Fogg Art Museum, Harvard University.

10 by 7.1

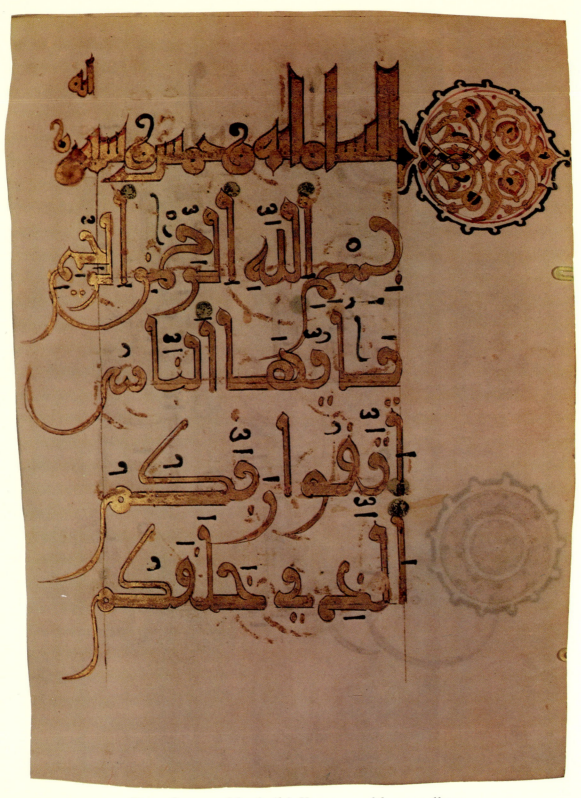

Page from a Maghribi Koran, gold on vellum.

Courtesy John Rylands Library, Manchester. Ms. Arabic 691, fol. 87 b

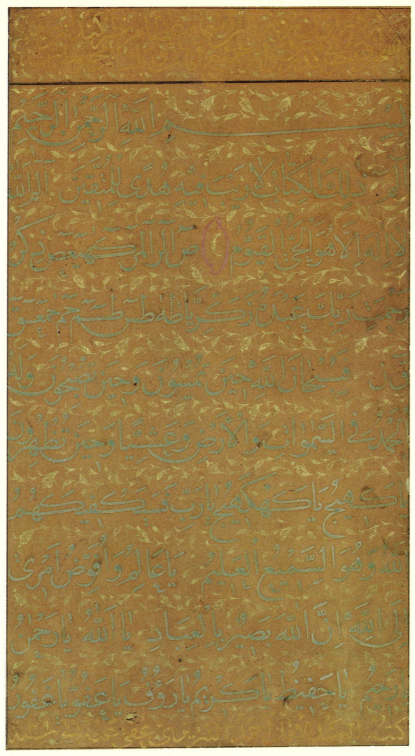

Arabic prayers, written in *naskh* by Ahmad an-Nayrizi,
colors and gold on parchment, dated 1137/1724.

The Metropolitan Museum of Art, Rogers Fund, 1962

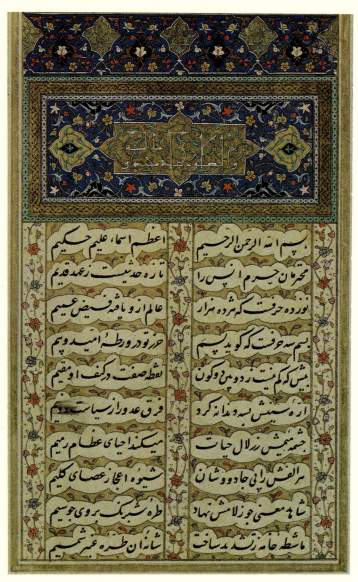

Beginning of Jami's poem on the secrets of the
letters of the *basmala* in *nastaʿlīq*, chapter
heading in late decorative Kufi.
Ca. 1500, probably Herat.

The Metropolitan Museum of Art,
Purchase, 1952.
Joseph Pulitzer Bequest

Calligraphers, Dervishes, and Kings

When you want the goal of your striving to flourish, turn not away from the teacher. Teach your son writing, and teach it to your family and your relatives . . . , for writing brings to you the best of luck and raises to the throne him who is not [otherwise] qualified: it is a craft, blessed among the crafts, and by it the lowly are able to rise.[1]

Thus states Ibn ar-Rawandi in the late twelfth century, and three hundred years before him the prototype of learned secretaries, Ibn al-Muqaffa͑, had formulated the maxim: "The script, *khaṭṭ,* is adornment for the prince, perfection for the wealthy, and wealth for the poor."[2]

Indeed, the art of writing is an essential part of the entire culture of the Muslim world. It was of course of enormous importance for preserving the text of the Holy Book. The sentences of the Prophet

or, in later times, the sayings of some of the saints could fill the house of the owner of a fine piece of religious calligraphy with *baraka*. Handwriting was also considered as legal proof for the identification of individuals, as the jurists maintained;[3] and, as in the West, much could be learned about the education and cultural background of a person merely by looking at his handwriting. That is still so even in remote areas such as West Africa.[4] Popular stories also, not only the *Arabian Nights,* show the high appreciation of calligraphy even among the illiterate: the famous Turkish master Hafiz Osman had once forgotten his purse and, returning from Istanbul to Üsküdar, paid the ferryman with an artistically written *wāw*.[5]

Even though a Muslim of the middle or upper class would receive a general education in the basics of decent writing, it took much more to be rightly called a *khaṭṭāṭ* (calligrapher). A look at the careers, family backgrounds, and even some of the idiosyncrasies of calligraphers reveals some interesting facets of Muslim culture. Certainly there were many of whom one could say that "by walking in the valley of calligraphy he became noted and famed,"[6] a formula applicable to ministers and poets, theologians and members of the nobility, for all of whom good handwriting, or at least enough knowledge to appreciate calligraphy, was as much part and parcel of their education as was a knowledge of the Koran and the art of versification. However, in order to be called a *khaṭṭāṭ*, long study with a master was required until one graduated by receiving the *ijāza* (permission), which gave the calligrapher the right to sign his products with his own name (or, in some cases, with a nickname given by the master) by writing *katabahu fulān* (written by so-and-so).[7]

The rules that had to be obeyed in this process resemble in the main those by which the medieval Muslim studied poetry and music, or was introduced into Sufism. As in Sufism, a *silsila*, a spiritual chain, was absolutely necessary to connect the discipline through generations of masters with the founder or with the most famed writer of his particular style. In the field of *naskh* and its derivatives for the earlier period, that would be Yaqut; in Turkey, Shaykh Hamdullah of Amasia and Hafiz Osman for the last three centuries. In the *nastaᶜlīq* tradition the *silsila* would go back to Mir-ᶜAli of Tabriz,

36

Sultan-ᶜAli of Mashhad (ca. 1442–1519) and Mir-ᶜAli al-Katib (d. 1556), in later times to Mir-ᶜImad (killed 1615). The imitation of models written by these masters was an important part of instruction: thus, one finds pages with the inscription *Mīr-ᶜAlī al-kātib naqalahu fulān* (transferred by so-and-so).[8]

For the earlier centuries we are faced with a lack of reliable data because the biographers—especially those more remote in time—tended to bring the masters in as close a sequence as possible, or to connect them with other important historical personalities. This is particularly evident in the case of Yaqut, who is credited with having received a handsome reward from the king of Delhi, Muhammad Tughluq (d. 1351), for a copy of Avicenna's *Shifā'*, and who is said to have been admired by the Sufi master ᶜAbdul-Qadir Gilani (d. 1166). This would give him a life span of some two hundred years.[9]

The future calligrapher needed certain psychological characteristics: he should be "of sweet character and of an unassuming disposition," as one of the earliest handbooks says.[10] Since writing was in many cases the writing of sacred words, the calligrapher "should not be unclean for a single hour,"[11] as Sultan-ᶜAli admonished the adept in his rhymed epistle *Ṣirāṭ as-suṭūr* (or *Ṣirāṭ al-khaṭṭ*), which was once copied by the leading master of *nastaᶜlīq*, Mir-ᶜImad.[12] I have met calligraphers or girls who embroidered the golden texts on tombcloths, who performed *ghusl,* the major ritual ablution, every morning before going to work. And if they did not go that far, they at least had to renew their *wuḍū'* time and again. For "purity of writing is purity of the soul,"[13] and this is reflected in external purity as well; to write the Koran in a worthy style was always the highest goal for a calligrapher, and it can be touched or recited only in the state of ritual purity (Sura 56/79).

The person interested in calligraphy had to find a master to instruct him, individually or in a small group, letter by letter.[14] It was by such constant rehearsing of single letters that the script in the eastern part of the Muslim world assumed such beauty, while in the Maghrib the scribes immediately began to write whole words and therefore never came close to the elegance of the eastern styles, as Ibn Khaldun (himself a Tunisian) deplored.[15] The pupil then had to spend all day practicing, as Mir-ᶜAli says:

Forty years of my life were spent in calligraphy;
The tip of calligraphy's tresses did not easily come in my hand.
If one sits leisurely for a moment without practicing,
Calligraphy goes from his hand like the color of henna.[16]

It is said that Hafiz Osman used even the moments of rest during the long and arduous pilgrimage to fill sheets of paper with his *mashq* (practice),[17] faithful to the advice, "Either trim your pen or write something!"[18] When the Persian master known as Rashida had to go into hiding after his uncle Mir-ᶜImad had been assassinated, he ran out of paper. Finally he went to another calligrapher and complained that he was forgetting the rules of writing.[19] One therefore understands an eighteenth-century calligrapher from Lahore who sadly stated:

> Like a narcissus I appeared from Not-Being,
> the reed of the pen in my waistband. . . .
> Due to sleeplessness the marrow of my soul
> dried up in my bones like the stem of the reed.[20]

Under the master's guidance the pupil learned how to sit properly, usually squatting, but also sitting on his heels; the paper should rest on his left hand or on the knee[21] so that it is slightly flexible, because the round endings can be written more easily in this way than if the paper is put on a hard desk or low table, as had to be done for large pieces. Then he learned the measurements of the letters by the dots and circles introduced by Ibn Muqla and had to practice *irsāl,* that is, the swinging of the long ends, while the letters that are called in Persian *dāmandār* (with a train), which means the round endings of *n, s, y,* and so on[22] should look "as if they were woven on the same loom," since they must be absolutely equal in size.[23] (The comparison of calligraphy to something woven or embroidered occurs frequently in early Arabic texts.)[24]

"At daytimes one should practice the small hand, *khafī,* in the evening the large one, *jalī,*" says Sultan-ᶜAli of Mashhad,[25] who also enumerates the requirements for calligraphers as being "ink as black as the author's fortune [or, rather, "misfortune," *bakht-i siyāh*], a pen

38

which is as restless as the eyes that shed tears, and a spirit as elegant as the *khaṭṭ,* 'down/script' of a beautiful friend."

Sultan-ᶜAli's younger compatriot, Mir-ᶜAli, puts it less poetically but more practically: the calligrapher needs five things—a fine temperament, understanding of calligraphy, a good hand, endurance of pain, and the necessary utensils:

And if any of these five is missing,
 then it will be of no use even if you strive for a hundred years.[26]

As can be gathered from such remarks, a sound knowledge of writing implements was required. The pen was of course the most important utensil for the calligrapher, the instrument that as an early Arab writer says, "introduces the daughters of the brain into the bridal chambers of books."[27] The classical handbooks devote long chapters to the art of clipping and trimming the reedpen.[28] The pens of highest quality came from Wasit and Shiraz, later also from Amul and Egypt.[29] Pens—"cypresses in the garden of knowledge"[30]—were often used as presents for viziers and scribes, accompanied by verses that, according to the elegant Baghdadian style, might describe the beauty of the scribe who was to use them[31] or might contain unusual comparisons to praise the miraculous thing, "whose weight is light, and whose importance is heavy, and whose use is immense."[32]

Such pens belonged to the items treasured even in the palaces of the kings: the Fatimid caliph al-Mustansir had boxes filled with all kinds of pens, among them some that had been used by Ibn Muqla and Ibn al-Bawwab.[33] And a pen found at a noted calligrapher's tomb might induce a young man to turn to the art of writing.[34]

In rare cases, the calligrapher might use a very fine steel pen or a quill, but these are exceptions that the biographers note down carefully.[35] In early manuscripts from India and—as far as one can see—from Central Asia, the calligraphy was executed with a brush.[36]

Since the style of writing depends largely on the angle at which the pen is cut and the ratio between the two sides of the *shaqq,* the incision made in the middle of the pen's end, every master had his special way of trimming his pen.[37] The penknife was often beauti-

39

fully ornamented, especially in Ottoman Turkey, and was cherished by the masters, although it is, as a tenth-century poet claims, "angry with the pen and hurts it."[38] The cutting was done on a small plate of ivory or tortoise shell or similar hard, polishable material, which was at the most 10 cm long and 3 cm broad.[39]

Once the pen was properly trimmed, the calligrapher had to turn to the preparation of the ink, and many masters have left recipes for ink that does not fade. Methods differ considerably. In Istanbul some calligraphers would carefully collect the lampblack that covered the oil lamps in the Süleymaniye mosque and settled in certain corners of its walls; thus, not only was the raw material for their ink of good quality, but it also carried the *baraka* of the mosque with it.[40] After mixing the soot with the other ingredients, the ink was put, in small quantities, into the *dawāt,* the inkwell, an item that has inspired Arabic, Persian, and Turkish poets for about a thousand years.[41] Precious inkstands, often inlaid with gold or silver, square or round, of metal or precious wood (later also of porcelain), were used as gifts.[42] Thus, Ibn ar-Rumi in the late ninth century says in a verse about a *dawāt* made of ebony with gold inlay that he presented to someone:

> We send you the mother of wishes
> and of gifts: a negro woman of noble descent,
> who has decorated herself with yellow, for the negro
> likes to wear yellow dresses.[43]

And seven centuries later, a Turkish writer inscribed on a box with three inkwells that contained various colors that they represented "my heart's blood, the smoke of my heart, and my black fortune."[44]

The calligrapher would sometimes hang the inkwell over his left arm so that it was "swinging like earrings at the neck."[45] In later times combined pencases and inkwells, made of metal and often decorated with verses such as the ones just quoted, came into more common use. The inkwell was certainly as important in the field of calligraphy "as a king on his throne";[46] and it could be described as "the navel of the Khotanese musk deer,"[47] not only because its contents were black as musk, but also because it was recommended, from the days of al-Ahwal in the early ninth century, to put some

40

perfume into the *līqa* (i.e., the piece of cotton or raw silk that is placed in the inkwell to prevent the ink from flowing too abundantly). Alluding to the *līqa,* a seventeenth-century poet could say:

In the ears of those with dark hearts there is a piece of cotton
 [consisting] of words,
as if they had put a *līqa* in the inkstand.[48]

In this connection, a very strange story is told about Ibn al-Luᶜaybiya, one of the leading masters in the late twelfth century, who was unequaled in his art in Egypt. He was writing a copy of the Koran for Sultan Saladin on a cold, cloudy day and, so he tells:

> Before me there was a brazier with fire in it; the *līqa* in the inkstand had become hard, and I had no water close at hand so that I could have put it into it. But there was a flask of wine before me, and I poured some of it into the inkwell. Then I wrote with it one page of the Koran copy and warmed it on the brazier so that it might dry up. And a spark sprang up and burned the written script completely without leaving anything of the paper. I was frightened, got up and washed the inkwell and the pens, put new ink into it, and asked God for forgiveness.[49]

As a sidelight on the importance of the *dawāt*, one may mention that already in early Persian poetry the connection between *dawāt* and *dawlat* (fortune) was made, a connection that is achieved by adding a minute stroke to the *alif* of *dawāt,* which changes it into a *lām*.[50]

"The inkstand is one-third of the writing, the pen, one-third, and the hand, one-third," says a tenth-century handbook for secretaries.[51] But after preparing the pens and the ink, the paper too had to be specially treated. Paper manufacturing was introduced into the Arab world after 751, and paper was one of the main reasons for the development of ornamental cursive handwriting. In early days, paper from Samarqand and Syria was considered to be outstanding,[52] but later one finds a large variety of places with papermills, some of which were in India (Daulatabadi, Adilshahi, and Nizamshahi paper are mentioned in the fifteenth century).[53] China

provided silk paper, which was used in Timur's days for both documents and Korans.[54] But all papers, whatever their quality, were made from rags. Khaqani, in the mid-twelfth century, skillfully alludes to the two most exquisite ingredients for royal chancelleries when he claims, in a panegyric poem, for the "Shah of the two Iraqs" for his document (*tauqī*):

the morning is Syrian [*shāmī,* which also means "evening"] paper,
 and the meteor an Egyptian pen.[55]

After selecting the right quality of paper, the calligrapher had to cover it carefully with *āhar,* a mixture of rice powder, starch, quince kernels, along with egg white and other ingredients; this mixture was then pressed until it was incorporated into the paper, to which it gave a smooth, shiny surface on which the pen could glide easily.[56] Thus, when Kalim sings about a sharp sword:

When the paper receives a letter from the description of the
 sword, paper and *āhar* fall apart![57]

he certainly reaches the height of hyperbole.

The next step was to burnish the paper with a piece of stone, preferably an agate, to remove all unevenness from it; and finally, the calligrapher put the *masṭar* between two sheets of paper. The *masṭar* consists of fine silken threads fixed on a frame of cardboard and serves as a ruler. Two pages at a time can be marked with delicate lines.[58]

In case the calligrapher wanted to create a special arrangement of words in so-called *ṭughrā* shape, he would draw a model that was then fixed on the paper with fine needles, thus producing sequences of dots through which coal dust was usually rubbed for fine outlines, along which the figure could then be executed. The same process was used for large architectural inscriptions, some models of which were preserved for a long time.[59]

After this preliminary work, the calligrapher might begin to write a sacred sentence or a beautiful poem. But until he reached this point, he had to fill page after page or wooden slate after slate with *mashq* (practice), which had to be washed off again and again. (Oriental ink is soluble in water). Only the exercise sheets of the great

masters were later kept as works of art in themselves. The washing off of the books provided the poets with a number of metaphors, as Fani of Kashmir says about the "book of life":

The child "tear" saw so many manuscripts and washed them off, and yet, due to its confusion, it did not become acquainted with the book.[60]

To grade a pupil's progress in the art, the pupil might receive first the degree of *sawwadahu* (he sketched it) and somewhat later be

Masṭar, ruler of cardboard with silken threads. The Metropolitan Museum of Art, gift of H. P. Kraus, 1973

permitted to sign with *mashaqahu* (he practiced it)—at least, that was the custom in Turkey.[61]

Even the most accomplished calligrapher would sometimes delete pages from his writings in case the calligraphy was not absolutely flawless; such pages (called *mukhraj*, "taken out") were again collected by the master's admirers and sometimes made into an album, as in the case of Hafiz Osman.

While practicing, the calligrapher was not supposed to lift anything heavy in order to protect his hands.[62] One is therefore surprised to find that a master like Shaykh Hamdullah (d. 1519) was an excellent sportsman: not only was he a good swimmer who sometimes swam the Bosporus, carrying his writing implements between his teeth, but he excelled in archery.[63] Perhaps his absolute concentration on the target was a spiritual exercise, strengthening both his eye and his mind, for this truly mystical concentration is at the heart of calligraphy, as of every true art. Typical of this attitude is the story of the calligrapher in Tabriz who did not even notice the terrible earthquake in the city because he, sitting in a little basement, was so engrossed in producing a flawless *wāw*.[64]

After finishing the calligraphy of a document, but not of a book or poem, the scribe was supposed to put some sand on it, which was considered auspicious.[65]

As in all traditional Islamic sciences, the disciple could finally receive his *ijāza*,[66] that is, "he attained the highest rank by the permission to sign with *katabahu*" (he wrote it).[67] My own teacher in *nastaʿlīq*

Signature—*katabahu*—of Ibn Hilal Ibn al-Bawwab, 408/1017–8. After Ünver-Athari, *Ibn al-Bawwāb*

said, "By imitating a piece by Mir-ʿImad, I received my *icazetname* to write my name and to teach."[68] It was also possible to receive an *ijāza tabarrukan* (for the sake of blessing) from a master whom one

44

venerated but with whom one had not studied, after having gained a formal *ijāza* from a first master.[69] The Sufi practice of receiving the patched frock from one's own master, the *shaykh at-tarbiya,* and then sometimes adding to it the *khirqa-i tabarruk* from another master immediately comes to mind.

The *ijāza* could have a caveat or put some stipulations on the recipient, as in a document of 1198/1775 where the teacher writes:

> Under the condition that he not divide a single word to write it on two lines, and that he always write the formula "God bless him and give him peace" after mentioning the noble name of the Prophet, and that he not place himself haughtily above his colleagues, I give him permission to write the *kataba.*[70]

It seems that the *kataba* for a calligrapher could be restricted to certain kinds of writing (e.g., decorative pages, *ḥilyas*, or books), but it could also be valid for every kind of calligraphy in the special style that the newly graduated calligrapher would write. Thus, tombstones are signed as early as in eighth-century Egypt and also much later in Istanbul or Thatta; the *kataba* gives important information about the artists who sketched and executed them.[71]

Since the *ijāza* was rarely granted, the friends of the graduating calligrapher sometimes composed poetical chronograms for this festive day and praised his skill in drawing an *alif* "which resembles the beloved's cypress-like stature, with which all other letters are in love,"[72] and so forth.

If a master was very satisfied with his disciple's work, he would put his own *kataba* on it now and then. As generous as Mir-ᶜAli seems to have been with his *kataba* (which may explain the enormous number of pieces bearing his signature), he was quite disappointed when his disciple Mahmud Shihabi Siyawushani imitated his writing so well that, without his permission, he even signed his writings with the master's name; he retorted to Mir-ᶜAli's line:

> Whatever he writes, good or bad, he ascribes to me,

with the remark, "I sign in his name only the bad ones!"—which is rightly called by his modern-day biographer, Mehdi Bayani, an "utmost breach of etiquette."[73]

45

The relation between master and disciple was, in a certain sense, similar to the close, loving relationship between a Sufi *pīr* (spiritual guide) and his *murīd* (disciple) (as was indeed the case with Mir-ʿImad and his favorite, Mirza Abu Turab).[74] Thus, speaking against the master or annoying him could cause heavenly punishment; when a disciple of Shaykh Hamdullah claimed to write better than his teacher, this disciple soon happened to cut two of his fingers with a penknife, and the wound did not heal for a whole year,[75] while Mir-ʿAli's anger about a preposterous disciple resulted in the unlucky man's becoming blind shortly thereafter.[76]

As in other arts and crafts, the future calligrapher usually began his training early. Mir-ʿImad began at the age of eight; others at nine or so; and some particularly gifted calligraphers received their *ijāza* at the age of thirteen, seventeen, or eighteen. The normal age range, however, seems to have been in the twenties. That the discipline was hard is evident from Mustaqimzade's frequent allusions to "studying under the master's rod,"[77] as in the Turkish verse that compares calligraphy to *demir leblebi* (iron chickpeas), "but in the master's mouth the iron turns into wax."[78] Again, as in other arts and crafts, particularly music, calligraphy was connected with certain families. Even in early centuries the scribes of the *dīwān* apparently inherited both their skills and their offices through generations, as was the case, for instance, of the Ibn Wahb family.[79] In Ibn Muqla's case, too, his father and brother were noted calligraphers. A look at the biographies suffices to prove that families of calligraphers remained prominent for generations, and not rarely a particularly gifted disciple was married to the master's daughter to continue the family profession. This was true in Turkey and Iran as well as in Sind, and was probably so in other countries also.

This family lineage also accounts for the fact that one finds a considerable number of women in the calligraphic tradition. In the Prophet's time there were women skilled in writing, including one of Muhammad's wives, and later slave-girl scribes sometimes achieved important positions despite reservations voiced by the orthodox.[80] The poets of medieval Baghdad enjoyed describing the charming girl scribe whose ink looked like her hair, whose complexion was as white and soft as her paper, whose eyelashes resembled pens.[81] But the role of the women calligraphers was more important than such

46

little verses would lead us to believe. One of the leading calligraphers in the Middle Ages, who formed a link between Ibn al-Bawwab and Yaqut, was Zaynab Shuhda al-katiba (d. 574/1178). Mir-ᶜImad's daughter Gauharshad was a noted calligrapher; and if emperors are celebrated as good masters of the craft, princesses did not lag behind. Foremost are the names of Shah Ismaᶜil's daughter[82] and Aurangzeb's gifted daughter, Zebunnisa, who not only practiced three styles of calligraphy but was a patroness of poets, scholars, and calligraphers.[83] The Lady Malika Jahan, whose copy of the Koran in unusually bold, colorful letters is preserved in the Chester Beatty Library, may be the accomplished wife of Sultan Ibrahim II ᶜAdilshah of Bijapur (r. 1580–1626), although an attribution of this Koran to a later period seems more likely.[84] In the eighteenth and nineteenth centuries a number of Turkish women are known to have written so well that their writings still adorn mosques and *tekkes* in Istanbul. One of them received her *ijāza* before reaching puberty in 1169/1756 and produced a model book of calligraphy at the age of twelve. Her *ijāza* by the well-known master Mehmet Rasim Efendi is an interesting piece of Arabic literature.[85] The biographies of some of the women calligraphers reveal once more the close relationship between calligraphy and religion. One of these women, separated from her rich, illiterate husband, devoted herself to writing *ḥilyas*, descriptions of the Prophet, and considered the nine *ḥilyas* she had produced as a substitute for children, hoping that they would intercede for her on Doomsday.[86] Another young widow joined a Sufi order and excelled in copying Korans.[87]

Here again an important aspect of the calligraphic tradition becomes evident: many masters—apparently almost every famous calligrapher in Ottoman Turkey—were in one way or the other connected with a Sufi order. Even in earlier Persian sources one can read that this or that master led a dervishlike life or walked around in a felt gown like a Sufi. Yaqut's famous disciple, Yahya as-Sufi, bore his surname with full right,[88] as did Pir ᶜAli as-Sufi. Nearly a century before as this latter master, the great theoretician of the school of Ibn ᶜArabi, ᶜAbdul-Karim al-Jili (d. ca. 1408), was praised for his most elegant handwriting.[89] One also has to remember that more than one pioneer in the field of calligraphy was guided by a dream appearance of Hazrat ᶜAli (thus Mir-ᶜAli of Tabriz) or of

Khidr (Sultan-ʿAli of Mashhad, Shaykh Hamdullah)[90] who indicated to them the direction in which to develop their style.

In Turkey the development of calligraphy is particularly connected with the Mevlevi order, which played such an important role in the growth of music and poetry in the Ottoman Empire.[91] However, one finds members of almost all the other orders, including the Naqshbandiyya, some of whose members excelled as calligraphers in Timurid Herat as well as in Ottoman Turkey.[92] Mustaqimzade, himself a devout Naqshbandi, of course highlights the contributions of his order to the development of calligraphy. The Shaʿbaniyya, Qadiriyya, Sunbuliyya, Khalvatiyya, and Jalvatiyya are all represented in the biographies;[93] and, whether the calligrapher was a full member of, or only loosely affiliated with the order, as is so often the case with Muslim fraternities, his inspiration certainly came from these religious centers. Sufi tendencies manifested themselves in the large number of fine invocations of Sufi saints, usually in *ṭughrā* shape, and in calligraphic pictures with religious content. The painter-calligraphers of the Bektashi order must be especially mentioned in this connection. The last great master of *thuluth* and *naskh* in Turkey, ʿAziz Rifaʿi from Trabzon (1872–1934), became a follower of the well-known spiritual leader Kenan Rifaʿi in 1907; after World War I he was invited to Egypt by King Fuad, for whom he wrote a Koran in six months. Staying in Egypt during the heyday of Kemal Atatürk's reforms, he became the true reviver of the modern Egyptian school of classical calligraphy.[94]

Just as the Sufi tradition seems to be an almost integral part of the life of calligraphers, many of them were also poets.[95] The greatest masters indulged in rhyming exercises to teach their disciples some secrets of the craft, as it became popular from Ibn al-Bawwab's time onward.[96] The most famous examples in the Persian tradition are the instructive verses by Sultan-ʿAli,[97] Mir-ʿAli,[98] and their compatriot and contemporary, Majnun of Herat.[99] To be sure, what they produced was not great poetry but practical verse. Sometimes their lines reflect a state of disappointment or unhappiness. When a Persian calligrapher of the late seventeenth century describes how, "Out of love for the script he wanted to take to his bosom the young bride of 'Hope' . . ." and finally discovered

48

that in this field of deprivation
nobody can open the knot of fortune with the strength of [his]
 craft,[100]

he takes up an idea that had been commonplace with writers from early times onward. Thus complained the Arabic poet ᶜAbdullah ibn Sarah (d. 515/1121):

> As for writing books, it is the most troublesome profession;
> Its leaves and fruits are deprivation.
> He who practices it is comparable to the owner of a needle
> Which clothes others while its own body remains naked.[101]

ᶜAli Efendi, author of the *Manāqib-i hünarvarān,* quotes an Arabic verse that was apparently popular enough to be engraved on at least one inkwell: [102]

> Don't think that writing had made me happy,
> and there was no generosity of the hand of Hatim at-Ta'i.
> I need only one thing,
> namely the shifting of the dot from the *kh* to the *ṭ*.[103]

That means that, instead of *khaṭṭ* (script), he needs *ḥaẓẓ* (fortune). This pun was used six hundred years before him by Kushajim, scribe and poet at the Hamdanid court in Aleppo, who says about himself that he

produced lines of a delightful handwriting on the paper, like a
 striped garment,
but *khaṭṭ* has no use so long as it is not dotted wrongly [namely,
 transformed into *ḥaẓẓ*][104]

And more than one good calligrapher must have felt like the sixteenth-century Ottoman master Ishaq Qaramanli, who one day carried with him a highly decorated Koran written by Yaqut's disciple Arghun, which a customer estimated to be worth 6,000 *aqcha;* but when he saw that the same person bought a strong donkey for 10,000 *aqcha,* he gave up calligraphy and went into retirement.[105]

Many calligraphic pages bear the inscription *li-kātibihi* ([text] by its calligrapher). Some of them would boast of their unusual talents, such as the not very modest Mir-ᶜImad who addressed himself with a multiple pun:

When from your pen a *dāl* is drawn,
it is better than the two tresses and the stature of the beloved.[106]

He alludes with *d* and *l* to the tresses, with *alif* to the stature. More outré than this perfectly classical verse is the claim of a Turkish calligrapher who announced in verse that he, bearing the six pens (i.e., styles) in his hand like a rod, would not fear even a seven-headed dragon![107]

Other masters were the subject of admiring verses in which their unsurpassable art was praised, and someone like ᶜAbdur Rashid Daylami ("Rashida"), who for a long time served at Shahjahan's court, would elegantly calligraph such verses written in his honor and then return the pages to the authors.[108]

From a cursory glance through the biographies it would seem that the development of a calligraphic career was rather uniform: growing up in an intellectual environment, the young people studied—often with relatives—and then either tried to gain their livelihood as independent or court calligraphers or joined some practical profession. In Ottoman Turkey after about 1500 talented young men from all parts of the country would flock to Istanbul—where the art flourished under the benevolent patronage of the sultans—to receive their training in calligraphy. Many would later be employed as teachers in the imperial schools or in *madrasas* (theological schools), or they would work in the chancellery of the sultan or some vizier or in religious administration or financial offices (of which a fine representation is found in the rare first edition of Mouradgea d'Ohsson's work).[109] Probably what was remarked about one of the outstanding calligraphers at the turn of our century who earned his money by writing imperial documents could be said of many of them:

If there had not been the trouble of gaining his livelihood and he could rather have lived [exclusively] for his calligraphy, he certainly could have written in those forty years [of service in

the bureau] hundreds of copies of the noble Koran and other pieces of work.[110]

In Ottoman Turkey, many good calligraphers reached the highest echelons of the religious establishment—or, perhaps vice versa: many leading orthodox theologians were outstanding calligraphers, an impression that is verified by comparisons with medieval Arabic records. Many masters served as Shaykh ul-Islam or, even more frequently, Qadi^caskar of Rumeli, Anadolu, or Istanbul.[111] The most outstanding example is Mustafa Raqim (1787–1825), whose powerful inscriptions are known to every visitor to Istanbul and some of whose calligraphic pictures have been reproduced dozens of times.[112]

The less fortunate had to write Korans and other works on order and were apparently regarded as somewhat inferior by their colleagues; as is written about a poor Turkish calligrapher in the eighteenth century: "He belongs to those who spend their days in the fodder-place of the world like near-sighted goats and make calligraphy their sustenance."[113]

Only a minority of calligraphers could hope to serve in a princely or royal library. These lucky few enjoyed the highest prestige[114] and could even joke with their patrons, as the often repeated story of Sultan-^cAli and Husayn Bayqara shows. Sultan-^cAli, who had decorated the whole Murad garden in Herat with his calligraphy[115] (besides the almost innumerable manuscripts of Persian poetry that he produced), was addressed by Husayn Bayqara, who said, "I want you to prepare my tombstone!" Sultan-^cAli replied, "But that needs some time, Your Majesty." Husayn Bayqara laughingly retorted, "I really don't intend to die that fast!"[116]

Calligraphers of this caliber were given, according to the local customs, high-sounding titles such as *qudwat al-kuttāb* (Model of scribes); *qiblat al-kuttāb* (point of orientation for scribes); or, particularly in Iran and India, *Jawāhir raqam* (Jewel letters), *Zarrīn qalam* (Golden pen), *^cAmbarīn qalam* (Amber pen), and so on.[117] But these calligraphers, being close to the rulers, also suffered with them and underwent hardships when their patrons were killed, the kingdom was conquered, or the patronage ceased for some other reason. A typical example is the leading master of *nasta^clīq*, Mir-^cAli,[118] who was active in Herat at the time of Husayn Bayqara, stayed there when

51

Shaybani Khan and his Uzbeks entered the city,[119] and witnessed how the Uzbek Khan was impudent enough to correct Sultan-ʿAli's handwriting and Bihzad's painting. He survived the Safavid conquest of Herat in 919/1515 and apparently did well under the art-loving governor Sam Mirza; but when Herat was finally lost to the Uzbeks in 935/1530, ʿUbayd Khan took Mir-ʿAli, like other artists, with him to Bukhara, where he produced some of his finest work. He was accompanied by his disciple, Sayyid Ahmad Mashhadi, who served for some time in the library of the Shaybanid ruler ʿAbdul ʿAziz before returning to his native town after Mir-ʿAli's death in 1556,[120] while the master calligrapher's children emigrated to India.[121] Other calligraphers from the Timurid court at Herat went with the Safavids to Tabriz and Qazvin and served there to develop a new era of nastaʿlīq calligraphy. Still others followed the example of the numerous poets who migrated to India in search of employment; and Qandahar, where Humayun stayed for some time before reconquering India, became a second Herat. The Indian tradition of developed nastaʿlīq really begins at that time at Qandahar.

Not every calligrapher was born and reared in an educated middle- or upper-class milieu, though this was the normal pattern. Sultan-ʿAli Mashhadi has told the pitiful beginnings of his career in his poem[122]—the orphaned child who had practiced without a teacher, was guided by some saintly personality, and finally emerged as the leading and certainly most prolific writer of nastaʿlīq, which he wrote in the style of Azhari of Herat.[123]

Now and then one finds condescending remarks about a master "whose father was a saddler, but . . . ,"[124] and one of the greatest masters in fifteenth-century Iran is known as ʿAbdallah-i Haravi Tabbakh, or Āshpaz, "the Cook." It is told that he became interested in calligraphy when he brought a trayful of soup from his father's little shop to Maulana Jaʿfar the calligrapher, who was surrounded by elegant young disciples.[125] Thanks to his hard work he soon surpassed his noble classmates and became an outstanding master, not only in Maulana Jaʿfar's style of nastaʿlīq, but also in naskh, in which he wrote forty-five Koran copies. "In the fire of longing, the kettle of his desire began to boil and, heated by his master's instruction, became aflame with fame, and through his education he became a 'cooked' perfect human being whose specialty is to spread out the tablecloth of mastership and to distribute lavishly various kinds of

delicacies."[126] "The Cook," thus poetically praised, married his master's daughter and became his true successor; he also went to India for some time, presumably to Bidar.[127]

An example from more recent times is that of Rif⁽ᶜ⁾at Efendi (1857–1942), an orphan from Istanbul who was so fascinated by the beauty of Arabic letters he saw on tombstones that he collected the dust of charcoal to prepare an inklike matter, which he kept in clam shells, and used the stems of nettles as a pen to copy inscriptions from tombstones. He was discovered by a calligrapher who properly trained him, so that he became a highly respected master of the craft.[128] At the same time, the leading calligrapher in Istanbul was Filibeli Bakkal ᶜArif (d. 1909) who, as his surname indicates, kept a grocery shop besides instructing people in calligraphy.[129] We are again reminded of the Sufi tradition a thousand years ago when the Sufi master, who often was a craftsman or artisan, would instruct his select disciples in his little shop, introducing them to the mysteries of Divine Love and Beauty, as the calligrapher made them express these mysteries in well-measured writing.

But there are still more amazing facts than the development of a poor orphan into a master calligrapher. Some of the oustanding calligraphers suffered from defects that scarcely seem compatible with the art of writing. Of course, one does not mind if a calligrapher is mute[130] (as the proverb has it, "writing is the tongue of the hand") or, like the great Mir-ᶜAli, hard of hearing;[131] but the first well-known calligrapher in the ᶜAbbasid Empire is known as *al-Aḥwal,* "the Squint-eyed." The art of *nastaᶜlīq* in Turkey was perfected by a crippled, left-handed master, Esᶜad Yesari, surnamed ᶜImad-i Rum (d. 1798). *Nastaᶜlīq* had become popular in Turkey thanks to the work of Dervish ᶜAbdi Mashhadi (d. 1647),[132] a disciple of Mir-ᶜImad, and was then refined in the eighteenth century by this Esᶜad, who was born with his right side completely paralyzed and his left side affected by a palsy that lasted for a long time. Still, his urge to write was so great that he began to practice as a mere child and became the founder of Turkish *nastaᶜlīq* to whom all *silsilas* go back. Disciples flocked to his house, where the best penmakers, paper manufacturers, and merchants of pens and penknives also used to gather. Sultan Mustafa III, impressed by this unusual calligrapher, called him to the court.[133]

While some calligraphers might write alternately with their left or

right hand, more or less for fun,[134] others had to find solutions for more difficult problems.[135] Ibn Muqla, the founding father of *naskh* calligraphy, was not the only one who wrote excellently even after his right hand had been cut off. ʿOmar al-Aqtaʿ, which attribute means "with amputated hand," is famous among the calligraphers of Timur's time and was apparently able to write in every style. At the same time, Sultan Faraj in Egypt punished a calligrapher who had practiced letter magic by cutting off his tongue and the upper phalanges of his right hand, but after the ruler's death he continued writing skillfully with his left hand.[136] During the Talpur period in Sind one Muhammad ʿAlam ibn Muhammad Panah Tattavi wrote several works even after one of the previous rulers, the Kalhora, had cut off both his hands. Among them is a fine Koran of high quality (written ca. 1800) that is signed: "Written by the *maqtūʿ al-yadayn* Muhammad ʿAlam," to which he added a Persian verse:

> I have written this noble book with amputated hands
> so that people with insight should praise me.[137]

As long as royal patronage continued, calligraphy in all its branches flourished. Various forms were developed to please the eyes of art-loving princes, among which one has to mention the art of *waṣṣālī*, the preparation of a special cardboard by pasting and pressing layers of paper together. These *waṣlī* became the ideal vehicle for album pages and were eagerly collected.[138] It seems that the art of preparing such pages goes back to Baysunghur Mirza's court, and ʿAli Efendi's verse that he "produced rainbows on the sky of the page"[139] could be applied to more than one artist. Yet, the same author complains bitterly about those who cut to pieces pages with verses,

> and place at the border of each page unconnected verses like a commentary, that means, they divide every poetical piece into four and separate every hemistich from its relatives and paste it wherever they want.[140]

This Turkish quotation from the late sixteenth century applies also to many of the Moghul album pages in which a miniature or the

54

central piece of calligraphy have no relation whatsoever to the surrounding lines, and purely aesthetic considerations seem to have played a role in producing a lovely page.

The courts—again, first the Timurid court in Herat—sometimes had a *qāṭiᶜ* who cut out extremely fine letters to be pasted on the pages.[141] The *Dīvān* of Husayn Bayqara as cut out by ᶜAbdallah, son of Mir-ᶜAli, is probably the best-known example of this art, since some pages from it had been *enlevé par des misérables sots* (as Huart translates the Turkish author Habib's *juhalā-i khudhalā*)[142] from the Aya Sofya manuscript and found their way into Western collections. (The occurrence in Habib's book, published in 1306/1887, shows that the theft must have taken place at a very early time.)

The art of *découpé* work was perfected after 1500;[143] some of Mir-ᶜAli's verses have been cut out exactly according to the author's handwriting by Sangi ᶜAli Badakhshi in Bukhara in 943/1537, among them the calligrapher's charming remark:

My head became a *w,* my foot a *d,* and my heart an *n,*
until the writing of me, sick of heart, became so well shaped (*mauzūn*)

with the famous line

Writing, *khaṭṭ,* became the chain on the foot of this demented person.[144]

In Turkey, where the tradition continued, Fakhri of Bursa is mentioned as the best master of this art.[145]

Some calligraphers in royal service were occupied with preparing seals, cutting precious stones, and drawing the inscriptions of coins. Others were charged with writing the royal *ṭughrā* in ever more refined forms. One usually forgets that the poet Tughra'i, whose *Lāmīyat al-ᶜajam* is one of the most famous medieval Arabic poems, was a calligrapher and vizier at the Seljukid court and acquired his surname from the skill with which he drew the *ṭughrā.*[146]

We are comparatively well informed about the masters at Akbar's court who were experts in cutting *riqāᶜ* and *nastaᶜlīq* on seals;[147] these had developed a special technique of mirror script, and were called

chapnivīs (left writer).[148] Some of them became so fluent in this technique that they could write entire stories in *khaṭṭ-i maᶜkūs* (inverted script).[149] The highest office in this branch of the royal bureaus was, at least in Turkey, the *sersikkeken* (First Seal Cutter), whose assistant apparently did much of the artistic work.[150] Some engraver-calligraphers worked not only on the comparatively soft agate but on hard stones as well. Maulana Ibrahim at Akbar's court engraved the words *laᶜl-i jalālī* upon all pieces of ruby in the treasury, and much later the Turkish master Vahdeti produced a long inscription on an enormous piece of emerald in the Ottoman treasury.[151] In later days, when not only artistically designed coins but also bank notes came into use, some of the best Ottoman calligraphers were engaged in drawing the models of Turkish and Egyptian bank notes and postage stamps.[152]

The enthusiasm for beautiful calligraphy led very early to forgeries and, to say the least, wrong attributions. One of the oldest recorded tales of a forgery is told about Ibn al-Bawwab who, at the behest of the Buwayhid prince Baha'uddaula, set out to write the missing *juz'* of a Koran written by Ibn Muqla; carefully preparing the same kind of paper, he succeeded so well that the delighted prince decided to claim that the entire Koran copy was the work of Ibn Muqla.[153] Similarly, it is told that ᶜArif Bayazid Purani, a member of the leading intellectual family of Herat, was such a good calligrapher that one day he imitated a page written by Sultan-ᶜAli after preparing the same kind of *waṣlī* and the same ornamentation. The piece was shown to Mir ᶜAli Shir Nava'i, who was visiting the Puranis and was highly surprised to see "his" page in their house. His librarian was summoned and brought the original page. Sultan-ᶜAli, who was present, became so angry that he took both pages and threw them in the basin around which the guests were sitting. But, perceiving Mir ᶜAli Shir's anger, he quickly took them out, and it was finally decided that the page that had not been damaged by water should be the master's original.[154]

Looking at the enormous amount of material at hand, one may ask what and how fast a master calligrapher wrote. The *warrāq,* the copyist in ancient times, seems to have led a rather miserable life, for he had to produce large quantities of well-written pages to gain his livelihood. One of the early scribes could copy up to 100 pages in twenty-four hours,[155] but even a good calligrapher could reach a

56

high speed. The story of Muhammad Simi Nishapuri, one of Bay-sunghur's calligraphers, has often been told. He composed and wrote 3,000 lines of poetry in twenty-four hours and neither slept nor ate until he had finished them in spite of all the noise surrounding him. But this Simi was a rather eccentric figure in his time, noted both for his enormous appetite and for his strong *baraka,* which helped all children who learned writing from him to obtain a good position in life.[156] We know that another calligrapher, Maulana Ma'ruf at the court of Iskandar Mirza, was paid to write 500 verses a day; and when he once had neglected his duty for two days, he made up for it by writing 1,500 verses in one day, while a disciple was entrusted with trimming his pens.[157] Of Molla Shu'uri, one of the calligraphers in Timurid Herat, the amount of 300 verses—apparently for one day—is mentioned with approval, and this seems to have been more than average.[158]

It is told that Yaqut wrote 1,001 copies of the Koran, producing two *juz'* a day, which amounts to two Korans a month. This legend probably serves to explain the numerous copies of Korans more or less legitimately attributed to Yaqut.[159] Ibn al-Bawwab wrote 64 copies of the Holy Book, of which at least one is preserved.[160] The earliest information about the amount of writing done by a calligrapher goes back to the generation after Yaqut, a few earlier data notwithstanding. Yaqut's disciple Nasrullah Qandahari is credited with 25 copies, some of which are still extant; another disciple, Hajji Muhammad Bandduz, completed the Holy Book probably sixteen times, while Pir Muhammad as-Sufi al-Bukhari, who spent most of his life in Samarqand, copied the Koran 44 times. One copy by him, dated 1444, is known;[161] moreover, he wrote 849 *mushaf,* which, as is understood from twelfth-century sources, does not necessarily mean a full copy but rather a quarter (*rub'*) or another fragment of the Koran, which was then bound separately.[162] This explains the sometimes amazingly great number of "copies of the Koran" produced by some scribes, even though for later Ottoman times astonishing quantities of complete Korans are attested for individuals.

The attitude of the calligraphers to the art of writing a Koran varied. 'Ali al-Qari, the well-known theologian and author of many religious works in the Naqshbandi tradition (d. 1605), used to write one superb Koran every year, sell it, and then live on the proceeds for the next year;[163] while one of his compatriots some decades later

produced 400 copies of the Koran in his lifetime, making an average of 10 per annum.[164] Some calligraphers may have written, like Molla Khusrau Yazdi (d. 1480), two pages every day for the sake of blessing. Others may have followed the example of Sayyid Mehmed Kaiserili around 1700, who made it a point to write all 30 *juz'* of the Koran every month so that he turned out 12 copies of the Holy Book every year—but his biographer does not particularly dwell upon the elegance of his writing.[165] One of the last great Turkish calligraphers presented the 304th of his 306 copies to the last Ottoman sultan, Reshad, and "he had collected all the wood pieces of the pens with which he had written the Koran and ordered that the water for his funeral washing should be heated with this wood,"[166] a custom that was known as early as the twelfth century among pious calligraphers.[167]

Besides writing the Koran, the masters of the *naskh-thuluth* tradition had a number of other favorite works they liked to reproduce. It may therefore be interesting to look at the work of one of the major calligraphers of nineteenth-century Turkey, Vasfi Efendi (d. 1247/1831),[168] because his inventory reflects the predilection of most Turkish writers in the succession of Shaykh Hamdullah and Hafiz Osman: 20 copies of the Koran, 3 *Shifā'* (i.e., Qadi ʿIyad's work about the qualities of the Prophet, which was immensely popular in medieval Islam, and had acquired a certain sanctity of its own),[169] and 150 *Dalā'il* and *Anʿām* (i.e., Jazuli's collection *Dalā'il al-khayrāt*, which contains blessings for the Prophet and has been used by millions of pious souls to express their love for the Prophet). The predilection for Sura 6, *al-Anʿām*, seems peculiar to the Turkish tradition[170] and is apparently inspired by a model written by Shaykh Hamdullah. In addition, Vasfi Efendi wrote 1,150 prayer books and the commentary on the *Pandnāma;* he also copied the *Forty ḥadīth*, probably in the redaction of Jami; single prayers from the tradition; and *hatm cüz'leri*, the last of the 30 parts of the Koran. Besides all that, he several times imitated the *ḥilya* as standardized by Hafiz Osman, in which the lofty qualities of the Prophet are written in *naskh* with the line *raḥmatan lilʿālamīn* in prominent *thuluth* in the center and the names of the four righteous caliphs in the corners,[171] and he wrote another 200 *ḥilyas* in different styles. Vasfi further composed more than 2,300 album pages and 3,000 fragments—certainly a remarkable achievement! Copies of Bukhari's *Ṣaḥīḥ* and

other, later collections of *ḥadīth* such as the *Mashāriq al-anwār* and *Mishkāt al-maṣābīḥ* were likewise favorites with pious masters. One eighteenth-century calligrapher is credited with 70 copies of the Bukhari, the *Shifā'*, Baydawi's commentary on the Koran, "and other voluminous works."[172] A special sanctity surrounded Busiri's *Qaṣīdat al-Burda,* which was copied, alone or in one of the numerous *takhmīs* (quintuplet) versions, by a great number of masters, particularly in Mamluk Egypt. Busiri himself was a well-known calligrapher of the thirteenth century who trained some disciples.[173]

Turkish calligraphers excelled particularly in album pages in which the lines of *naskh* and *thuluth* were harmoniously blended to convey—mainly—quotations from the Prophetic tradition. Many of them, like their predecessors in Iraq and Iran, were also engaged in composing inscriptions for mosques and other religious buildings and ornamenting mosques with enormous calligraphic plates in *jalī* script. The way in which Ottoman calligraphers overcame the enormous difficulties encountered in composing and then executing the Koranic inscriptions around the apexes of Ottoman mosques still looks like a miracle to the modern admirer.

Among the calligraphers of *nastaʿlīq,* the preferences are of course completely different, for to write the Koran in *nastaʿlīq* was, as we saw, very unusual. Pious Arabic sentences, invocations of ʿAli, and short prayers are found on *nastaʿlīq* pages as well, but the major achievement of the calligraphers was to copy classical Persian literature, particularly poetry;[174] and it is here that a unique blending of text and calligraphy was achieved. It goes without saying that the favorites of Persian readers, Saʿdi and Hafiz, top the lists of the available material; Nizami's *Khamsa* or parts of it are also well represented, but even more prominent in later times is Jami's poetry, the most romantic of his epics, *Yūsuf ū Zulaykhā* being copied over again. Another favorite was Maulana Rumi's *Mathnawī,* about which a calligrapher wrote, at the beginning of a complicated chronogram:

. . . the *kitāb-i Mathnawī-i maulavī-i maʿnavī,*
which has given prominence to both *ḥaqīqa* (Divine Truth) and
 sharīʿa (religious law),
is the best medicine for the pain of the wounded,
and there is no other remedy for the soul of ailing lovers.[175]

This means that by copying the *Mathnawī* the calligrapher felt that he was receiving spiritual medicine for his heart's pain.

Next in frequency to this work, at least during the late fifteenth and the early sixteenth centuries, stands a book that nowadays is not even available in a good edition, the *Dīvān* of Shahi Sabzavari, who himself was one of the calligraphers, musicians, and poets of Baysunghur Mirza's court.[176] Sometimes the calligraphers would copy historical texts but preferred to turn to ᶜAli's "Forty sayings" in Jami's versification or to the *Munājāt* of ᶜAbdallah-i Ansari, a lovely prayer book of the eleventh century. The great *dīvāns* of Khaqani and Anvari are surprisingly rarely represented in M. Bayani's useful list.[177]

Some manuscripts are remarkable not only for their beauty but also for the little insights into a calligrapher's mind that the colophon may allow. We certainly appreciate the master who wrote at the end of Shabistari's *Gulshan-i rāz:*

> Praise be to God that the commentary of the *Gulshan-i rāz*
> became clear in this shape through my pen!
> With geometrical art each verse of its text
> was written altogether on one line,
> and it did not happen that one of its hemistichs
> became confused with another line.[178]

Sultan-ᶜAli of Mashhad—from whose pen probably more *nastaᶜlīq* manuscripts emerged than from that of any other calligrapher because he continued writing almost to the end of his very long life—boasted in his verses added to a copy of the *Dīvān-i Ḥāfiz* (written in 896/1492) that in spite of his being sixty-three years old his musk-colored pen was still young so that by the grace of God he did not spoil a single page,[179] and even manuscripts that he copied ten years later are of flawless beauty. Likewise Shaykh Hamdullah, when more than eighty years old, was able to copy a perfectly flawless Koran, "with my head shaking and my hair falling out in the days of old age."[180] And we feel for the successor of a calligrapher who had intended to copy Jami's *Subḥat al-abrār* ("The Rosary of the Pious") who died during this work and was lamented by his friend with the lines:

60

He wanted at some point that with famous script
he should ornate a book by Jami.
He did what was allotted to him of this work—
He chose the Rosary, which is very choice.
The days cut off the thread of his life,
and the thread of the Rosary was not completed by him.[181]

Some calligraphers who had been copying all kinds of texts for the sake of earning money turned to writing pious texts in the later years of their lives[182] or retired to a quiet place where they could pursue their art without the disturbances of courtly or urban life. Qum was "a haven of disappointed artists"[183] in the sixteenth century, and many Shia artists spent their last years in Mashhad.

Knowing the difficult circumstances under which many of the calligraphers and scribes worked, one wonders if their eyes did not fail them over the course of the years. It seems that at least from the sixteenth century onward it was unusual to write small calligraphy without eyeglasses.[184] The first concrete remark pertaining to the use of spectacles is connected with Shah-Mahmud Nishapuri in the mid-sixteenth century, who wrote inscriptions and decorative pages wearing glasses.[185] The word *ᶜaynak* (spectacles) begins to appear in Indo-Persian poetry at about the same time. A miniature in Istanbul that shows Yaqut with spectacles is of course an anachronism.[186] Later poets, then, sometimes claimed that the sky itself had put on spectacles consisting of sun and moon to admire someone's beautiful handwriting or an exquisite album.[187]

Plaited Kufic *lām-alif*, from a stucco inscription

Love of calligraphy being so typical of Islamic culture, it would be surprising if the rulers themselves had not turned to this noble art.

61

Indeed, many of them were not only connoisseurs of calligraphy but masters of this art, among them the Ayyubid al-Malik al-ᶜAdil (d. 569/1174)[188] and the accomplished prince of Hama, Abū'l-Fida' (d. 1331).[189] One understands why Mamluk historiographers sometimes sadly state that this or that sultan's handsign looked ungainly as a crow's foot![190] Yet at the same time some of the finest, and certainly largest, Korans were written for these very sultans, and the epigraphy on buildings constructed during their reigns, as on metalwork and glass, belongs to the finest examples of Islamic art.

It is told that Muᶜawiya, the founder of the Omayyad house, was a good writer himself and that the Prophet gave him some instructions as to how to write the *basmala*—instructions that reflect later ideals of scribes; for example, "Put a *līqa* in your inkwell, sharpen the pen, and put the *b* upright and separate the *s* and make the *m* blind, and write the word *Allāh* beautifully, and extend the *ar-Raḥmān* and make the *ar-Raḥīm* fine."[191] Another Omayyad ruler, Marwan, learned writing—as tradition has it—together with his cousin, the caliph ᶜOthman ibn ᶜAffan (d. 36/656);[192] the role of ᶜAli ibn Abi Talib as the first member of the calligraphers' spiritual pedigree has been mentioned earlier.

The practical interest of rulers in calligraphy became visible toward the end of the tenth century. ᶜAdudaddaula the Buwayhid is known as a good calligrapher who learned the art from Ibn Muqla's brother.[193] Slightly later the ruler of Gilan, Qabus ibn Wushmgir (d. 1013), wrote such a good hand in *naskh* that a source claims that, when the eye of the Sahib Ibn ᶜAbbad, himself a noted master of calligraphy, fell on his writing, he asked in his usual rhymed style, *A-hādhā khaṭṭu Qābūs am janāḥu ṭā'ūs* ("Is this the script of Qabus or a peacock's wing?")[194] The comparison of beautiful handwriting with a peacock's wing remains common in the later Persian tradition.[195]

A century later, the ᶜAbbasid caliphs al-Mustazhir (d. 512/1118) and even more al-Mustarshid (d. 529/1135) were known as masters of the "Bawwabian style" in calligraphy,[196] while the last ruler of the ᶜAbbasid house, al-Mustaᶜsim (d. 656/1258), studied writing with his slave, the famous Yaqut.[197]

Even though the Zirid prince al-Muᶜizz ibn Badis (d. 453/1061) wrote a treatise on calligraphy, and the Nasrid ruler of Granada, Muhammad II (d. 701/1302), is mentioned as a good calligrapher,

the interest seems to center in the Persianate area. Two of the early Ghaznavid rulers, Masᶜud ibn Mahmud (d. 432/1041) and his son Ibrahim (d. 491/1098), are mentioned for their good hand; Masᶜud reportedly studied calligraphy with Ibn al-Bawwab.[198] Both—thus Mustaqimzade—used to write Korans, which they then gave away to the poor and needy. Ibn ar-Rawandi extensively speaks of the thirty *juz'* of a magnificent Koran that the last Seljukid ruler, Tughrul, wrote after studying calligraphy with an uncle of Ibn ar-Rawandi and had it beautifully illuminated and gilded, spending large amounts of money on it and then distributing it.[199] In the following centuries, rulers in Iran, India, and Ottoman Turkey not only patronized calligraphers but sometimes competed with them. Thus, Shah Shujaᶜ the Muzaffarid, often mentioned in Hafiz's verse, is praised as having written well in the style of Yaqut.[200]

Both Ahmad ibn Uwais Jala'ir of Baghdad[201] and Yaᶜqub, the ruler of the Aqqoyunlu Turcomans, were known for their good hand; the latter tried to attract to his court the most famous calligrapher of his age, Sultan-ᶜAli of Mashhad.[202] However, a particular love of calligraphy seems to be a hallmark of the house of Timur in all its branches. Timur himself was interested in calligraphy as in other arts and crafts, and his grandson Ibrahim Mirza ibn Shahrukh was instructed in calligraphy by the noted author Sharafuddin of Yazd.[203] His handwriting was so perfect that, as Daulatshah claims, his pages could be sold as works of Yaqut.[204] Ibrahim Mirza excelled in *jalī* writing; not only were many of the now destroyed inscriptions in Shiraz written by him, but some Korans are still extant to give witness to his art—one in golden letters in *rīḥānī* script (measuring 65 by 45 cm) is preserved in Shiraz,[205] and another one (completed on 4 Ramadan 830/29 June 1427) is in the Metropolitan Museum.[206]

Even greater is the fame of Baysunghur Mirza, whose library in Herat was the veritable center of the art of the book. He had forty calligraphers in his service (which number may be taken as simply denoting a very great number) and "each of them was the miracle of his time and the rarity of the age," and "they left such rare and unusual works that until the hem of resurrection they will not be wiped out by the hand of the events of time and not trodden down by the turning over of ages."[207] The prince himself also "unfurled the flag of the pen in the battlefield of the calligraphers."[208] One of

63

his Korans in *muḥaqqaq* is preserved in Mashhad; another one, of the enormous size of 177 by 101 cm, is in the Gulistan Museum,[209] and some superb pages found their way into the Metropolitan Museum. Among those who surrounded him, and who were allegedly all disciples of Mir-ᶜAli Tabrizi, were artists who excelled in many other fields besides calligraphy, such as Shahi Sabzavari, whose poetry was a favorite of the Timurid age; the poet Katibi Turshizi, a disciple of Maulana Simi in calligraphy; and Yahya Sibak who, under the pen name Fattahi, wrote the influential novel *Dastūr al-ᶜush-shāq.*[210]

The Timurid interest in calligraphy once more becomes evident at the court of Husayn Bayqara of Herat who, although not a great calligrapher himself, gathered the leading masters of his day around him. His son Badiᶜuzzaman Mirza, who went first to Tabriz and, after the Ottoman conquest of that city, to Istanbul (where he died from the plague in 1517), wrote an extremely good hand in *nastaᶜlīq.*[211] But the major figures in Herat were, of course, Sultan-ᶜAli of Mashhad and his younger colleague Mir-ᶜAli al-Katib, who were patronized not only by the sultan but also by his powerful vizier, Mir ᶜAli Shir Nava'i.[212]

The calligraphic tradition continued in the Timurid house in India; but the Safavids also contributed to the development of the script. Shah Ismaᶜil I was not only a fine poet in Turki but wrote a good hand,[213] and the story has often been told of how he tried to hide the painter Bihzad and the calligrapher Mahmud Nishapuri during the preparation for the battle of Chaldiran in 1514 lest the Ottomans find and kidnap his most prized artists—a story that, however, can be dismissed, since both artists joined the Safavid court about a decade later.[214] Under Shah Ismaᶜil's descendants the interest in fine arts reached two peaks—in the early days of Shah Tahmasp and during the rule of Shah ᶜAbbas the Great. Shah Tahmasp himself (d. 976/1576), a skillful painter in his youthful days, wrote *thuluth, naskh,* and *nastaᶜliq.*[215] A copy that he made of one of the best-sellers of those days, ᶜArifi's mystical *mathnavī Gūy-o Chaugān,* is now in Leningrad, where it was brought along with many other pieces from the shrine of Ardabil to which it had been bequeathed and that was occupied by the Russians during the war of 1828. Among the masterpieces of calligraphy written for Tahmasp is a

64

Khamsa of Nizami in the hand of Nizamuddin Zarrinqalam in *ghubār* (dust) script—not to mention the famous *Houghton Shahname*, in which not only the illustrations but also the high quality of the writing is worthy of attention.[216]

Tahmasp's brother Bahram Mirza (d. 956/1549 at the age of thirty-three) likewise excelled in poetry, particularly in the art of *mu ᶜammā* (riddle), music, and calligraphy. In his superb library the noted calligrapher, painter, and *découpé* master Dost-Muhammad served for some time as librarian and collected for his master a *muraqqa ᶜ*, in the foreword of which he writes:

My pen which showed the letter of your praise in writing
And which was a flag in the horizons of your laud—
Like the pen I'll be all tongue in your praise,
Like the reedpen, I have my head constantly on the script of your order.[217]

A Koran copy written by Bahram Mirza in *muḥaqqaq* is preserved in Istanbul.

The tragic fate of Bahram's son Ibrahim Mirza, who was executed in 1577 in the bloom of his youth, has always moved historians of art, for this prince seemed to combine all talents that were typical of noblemen, from calligraphy to archery to poetry. He also kept a flourishing library and was a disciple of Malik Daylami in calligraphy, but he is known more than anything else as a collector of specimens of Mir-ᶜAli's calligraphy. As his biographer says, "I have never seen anyone so much searching for and wanting writings of Mir-ᶜAli, and being enchanted and thrilled by them,"[218] so that, according to Qadi Ahmad's judgment, about half of what Mir-ᶜAli had written was found in Ibrahim's collection, including the *muraqqa ᶜ* that he had prepared "to provide for his last days and a journey to the Hijaz, together with some samples, manuscripts, and books."[219]

Shah ᶜAbbas, who sometimes practiced calligraphy, was fond enough of good writing to hold the candlestick for his favorite, ᶜAli-Riza of Tabriz, who excelled predominantly in *thuluth* and who composed many of the inscriptions in the public buildings in Isfahan.[220] The strained relations between ᶜAli-Riza and the unquestioned mas-

ter of *nastaʿlīq* in the early seventeenth century, Mir-ʿImad, are known, as is the tension between this somewhat haughty calligrapher and the ruler. Mir-ʿImad's assassination in 1615 was probably a result of jealousy and perhaps overstressed competition, coupled with some unwise remarks by Mir-ʿImad, even though Mustaqimzade claims that Mir-ʿImad was murdered by the order of the "erring, sinister looking Shah" because he was not only a Sunnite but a staunch member of the Naqshbandiyya and a correspondent of Ahmad Sirhindi![221]

In later times, Shah ʿAbbas II was praised by flattering courtiers for his delicate handwriting,[222] and the interest in calligraphy continued in the Qajar dynasty as well. Both Fath-ʿAli Shah and Muhammad Shah Qajar are mentioned among the *nastaʿlīq* writers who produced some decent pages,[223] and even Nasiruddin Shah was almost as interested in calligraphy as in specimens of human beauty.

Calligraphy was practiced in Muslim India from early times, and certainly after the Ghaznavid conquest of northwestern India. It is reported that Iltutmish's grandson, the "angel-like Nasiruddin" (r. 1246–66), left the reins of the government to his general Balban and spent most of his time copying the Koran; from the money acquired by the sale of the copies he would live without burdening the public treasury.

In the fourteenth and fifteenth centuries, calligraphers from Iran came to India, and merchants exported specimens of calligraphy of one or the other Persian master to India and probably to Turkey also. These then served as models for the indigenous calligraphers.[224]

The love of artistic writing shown by the earlier Timurids, either by patronage or by their own work, was inherited by Babur, who was well acquainted with the artistic trends at the court of his cousin Husayn Bayqara. It seems that Mir-ʿAli had particularly friendly relations with the young prince, for he composed some short poems in his praise.[225] Babur invented a style of his own, the *khaṭṭ-i bāburī*, and sent a copy of a Koran in this hand to Mecca. No example of this style has survived, for only Mir-ʿAbdul-Hayy from Mashhad (d. 980/1572 in Delhi) had mastered this unusual hand to perfection (some unpleasant colleagues would claim that it was the only thing

he ever mastered).[226] Babur's main calligrapher in the six styles was
Mir Shaykh-i Awwal-i Kirmani.[227]

When Humayun stayed in Iran, he was lucky to find some fine
calligraphers who, particularly after Shah Tahmasp's "sincere re-
pentance," were happy to accompany him to India. His son Akbar
then was able to attract numerous masters to his court, even though
he was the only Moghul emperor to remain illiterate. Abu'l-Fazl's
list in the *A'in-i Akbarī* gives the names of eighteen masters who
worked at the court, among whom he also mentioned Shah-Mah-
mud of Nishapur,[228] who may have indeed spent some years away
from Iran, as did Dost-Muhammad. Bada'uni states that *nastaᶜlīq*
was "improved much" by Mir Munshi Ashraf Khan, a Husayni *sayyid*
from Mashhad who excelled in various styles,[229] "and all the *firmāns*
which are written in Hindustan are almost exclusively in his noble
hand."[230] Mir Dauri, the *Kātib al-mulk* from Herat, belonged also to
the masters who are singled out by Bada'uni and worked on the
calligraphy of the *Ḥamza-nāma;*[231] and there were a considerable
number of masters "who wrote the seven styles well."[232] A treatise
on calligraphy was dedicated to Akbar.[233] Among the native Indian
masters, Mir Maᶜsum Nami deserves special attention because he
was not only a good historian of his native province, Sind, but was
also a noted physician and a decent poet; in his quality as master
calligrapher in *nastaᶜlīq* he adorned Agra Fort, the Buland Darwaza
in Fathpur Sikri, Fort Mandu, and other imperial monuments with
metrical inscriptions that he himself composed, particularly with
chronograms. He also served as an ambassador to Iran where he
was presented to Shah ᶜAbbas.[234]

Competing with Akbar as a maecenas of fine arts was his gener-
alissimo Khankhanan ᶜAbdur-Rahim, and the fact that the superin-
tendent of his library, Molla Muhammad Amin of Kashan,[235] a dis-
ciple of Shah-Muhammad of Mashhad, received a monthly salary of
4,000 rupees[236] shows how much the Khankhanan appreciated cal-
ligraphy. Since he even kept in touch with the masters living in far-
away cities like Kashan and Qazvin and commissioned them to write
some works for him, many artists from Iran came first to him in the
hope of employment.[237] One of these was ᶜAbdur-Rahim ᶜAmbarin-
Qalam from Herat, who then joined Jahangir's court; he is the sub-

ject of an exquisite miniature at the end of a copy of Nizami's *Khamsa,* which he calligraphed for the emperor.[238]

Jahangir was particularly fond of good *nastaʿlīq* and wrote a large, though not artistic hand that is well known from the remarks he hastily jotted down in the manuscripts that were entered into his library, such as a *Dīvān* of Hafiz in the hand of Sultan-ʿAli.[239] He also eagerly collected pages by Mir-ʿAli, as can be seen in the albums assembled by him and his son Shahjahan. When the news of Mir-ʿImad's assassination reached him, he exclaimed, "If Shah ʿAbbas had given him to me I would have paid his weight in pearls!"[240] But even though he could not save him, he at least gave shelter to some of Mir-ʿImad's relatives, among whom Aqa ʿAbdur-Rashid Daylami, called Rashida, is particularly important. He was Mir-ʿImad's nephew and disciple (almost all the assassinated master's relatives excelled in calligraphy).[241] Rashida was made the instructor of Dara-Shikoh and, because of infirmity, finally gave up his work after serving at the court for twenty-three years;[242] he spent his last years as supervisor of buildings in Agra. It is told that his death anniversary in this city was celebrated every year by a meeting of calligraphers.[243]

Shahjahan, like his father, was instructed in calligraphy, but his large, sweeping hand "cannot be called calligraphy," as Mehdi Bayani correctly states.[244] The best calligrapher among the Moghuls was Dara-Shikoh, and many fragments show his versatility.[245] A Koran written by him for the mausoleum of his patron saint, ʿAbdul-Qadir Gilani, is still preserved in that shrine in Baghdad.[246] Dara's Hindu secretary, Chandar-Bhan Brahman, was, like his master, a disciple of Rashida,[247] while Dara's son, Sulayman-Shikoh,[248] was instructed by a noted calligrapher from Agra, Mu'min Akbarabadi Mushkin-Raqam (d. 1091/1680 at the age of ninety).[249] Dara's younger brother and successful rival, Aurangzeb, was also instructed in calligraphy by a leading master, Sayyid-ʿAli Tabrizi al-Husayni Jawahir-Raqam (d. 1094/1682), who, like Rashida, belonged to the *silsila* of Mir-ʿImad.[250] Aurangzeb was a powerful calligrapher, as can be witnessed from the copies of the Koran that are preserved in various museums.[251] The third brother, Shah-Shujaʿ, copied some pages "after the writing of Maulana Mir-ʿAli,"[252] which shows that admiration for the great master of Herat and Bukhara continued in the house of Timur. A few decades later, Muhammad Shah Rangela (d.

1748) tried his hand in *nasta°līq* calligraphy[253] and, as the poetical talent was inherited by most of Babur's descendants, the interest in calligraphy too continued to the very end of the Moghul dynasty. The last emperor, Bahadur Shah Zafar (d. 1862), mastered various styles and even instructed disciples in calligraphy (as he had also some disciples in Sufism). He is best known for charming little calligraphic pictures of faces, flowers, and other items in *ṭughrā* style.[254]

In the Deccan, the calligraphic tradition goes back to Bahmanid days. The large *thuluth* inscriptions inside Ahmad Shah Wali's (d. 1435) tomb in Bidar are written by Shukrullah Qazvini,[255] and the inscriptions at the Ni°matullahi shrine in Bidar, which are almost contemporary with Ahmad Shah's mausoleum, are probably the most outstanding examples of elegant *thuluth* carved out of stone found all over India in this early period. One wonders if these inscriptions were drawn by one of Shah Ni°matullah's disciples, the famous calligrapher Ashrafuddin Mazandarani, who wrote some verses of the poet Adhari in *jalī thuluth* for Ahmad Shah's palace, "and the Telugu masters, who are miracle workers in imitation, carved it in a huge stone and placed it over the gate."[256] The inscriptions at the Ni°matullahi shrine would conform to this description.

The influx of calligraphers—either visiting or settling there—continued during the later Bahmanid time. °Abdallah-i Tabbakh of Herat was one of those who went to India and, as the chronicles state, composed an ode in honor of the prime minister, some of whose verses are quoted by Habib.[257] Although the place in "India" is not specified, the only prime minister of that period who was worthy of an ode was Mahmud Gawan of Bidar (assassinated 1481), the most important maecenas of scholarship and art in the Bahmanid kingdom. His relations with Herat are well known, and in his correspondence with one of the Iranian masters of historiography and calligraphy, Sharafuddin Yazdi, he used plentifully the imagery from the sphere of writing.[258] It is said that the superb *muḥaqqaq* inscription of his madrasa in Bidar, parts of which are still visible in radiant tilework, was composed by °Ali as-Sufi who, at some point, worked also in Istanbul to adorn some of Mehmet the Conqueror's buildings.[259]

Another Persian calligrapher called, like the most famous master of his time and therefore sometimes confused with him, Mir-°Ali al-

Katib-i Mashhadi, died in Gujarat in 1528;[260] he may have been an instructor of Sultan Muzaffar the Benevolent, the art-loving, pious son of Mahmud Begra who is known as a calligrapher and musician.

The inscriptions on the sarcophagi of the Qutbshahi kings in Golconda prove that calligraphy was as highly developed in the Deccan as it was in the Moghul Empire. Lutfullah al-Husayni of Tabriz (d. 1633) decorated many monuments in the city of Hyderabad, built in 1600 by Sultan Muhammad-Quli Qutbshah.

It seems that calligraphy flourished particularly at the ᶜAdilshahi court of Bijapur, where even the first ruler, Yusuf, is credited with a good hand in nastaᶜlīq. IbrahimᶜAdilshah II, the most charming personality among the Bijapuri rulers, wrote some calligraphic pages. A copy of his book, *Kitāb-i nauras*, was written by the court calligrapher ᶜIsmatullah. Several other copies were entered into the royal library in 1613 when the accomplished disciple of Muᶜizzuddin of Kashan, Muhammad Baqir, served as head librarian, but even more famous was the copy produced by Mir Khalilullah Shah. This master, a disciple of Sayyid-Ahmad of Mashhad,[261] left the Safavid Empire and traveled through various cities until he reached India. IbrahimᶜAdilshah was so delighted with his copy of the *Kitāb-i nauras* that he gave him the title *Pādishāh-i qalam* ("Emperor of the Pen"), made him sit on his throne, and "bade his courtiers to accompany him to his residence." The calligrapher then composed a chronogram for this occasion, playing with his surname *shāh* (which, like Mir, indicates his status as a *sayyid*), *Shāh gardīd pādishāh-i qalam* ("The Shah/king became the emperor of the pen").[262] Ibrahim's court poet Zuhuri, to whom we owe such colorful poetical descriptions of the Deccan, was very fond of Khalilullah, but others criticized him because he used the razor too often for amendments—something a good calligrapher should never do. (Khalilullah is reported to have remarked, "I write with the pen knife!")[263] Pages written by him were very expensive, and one of his admirers had to give a good Arab horse to the owner of such a page to obtain it.[264] Many of Khalilullah's calligraphies were later housed in the library of Asafuddaula in Lucknow—which was, alas, destroyed in 1856 after it had fallen on bad days decades before—as becomes clear from the report of the then cataloguer, the Austrian orientalist Aloys Sprenger. Khalilullah, who is also called Amir Khalil Qalandar or Butshi-

70

kan, returned to Iran at the invitation of Shah ᶜAbbas, but he preferred life in India and died in Hyderabad in 1626. On the whole, Ibrahim ᶜAdilshah seems to have preferred the *naskh* style of calligraphy in which most copies of the *Kitāb-i nauras* are written. The calligraphic panels that cover large areas of the Ibrahim Rauza, the king's mausoleum, in Bijapur are of highest artistic quality.

Many of the calligraphers who visited India or settled there had to pass through Sind, for the Lower Indus Valley served as a kind of *relais* for artists during the mid-sixteenth century. The two Turkish dynasties that ruled in Sind after the fall of the indigenous Samma dynasty in 1520, namely the Arghuns and Tarkhans, had descended from Herat; thus, calligraphers and poets who fled the war-stricken city found many old friends and relatives in the capital, Thatta. Barely any manuscripts have survived from that time; yet the inscriptions on tombstones in Makli Hill prove the presence of excellent masters of *thuluth* and, less prominently, of *nastaᶜlīq* in Sind; and even the last dynasty of Sind, the Talpurs (1786–1843), though themselves not active in literature or fine arts, were able to attract a number of good calligraphers from Iran and northern India.[265]

Perhaps the most outstanding royal tradition of calligraphy is found in the Ottoman house, where almost every other ruler is known as a calligrapher. Murad II's interest in calligraphy is mentioned by the sources;[266] Mehmet the Conqueror studied calligraphy with a master from Samsun;[267] and Ekrem Hakkı Ayverdi has given a detailed account of the high standard of calligraphy on various media during Fatih's time.[268] The real royal tradition, however, seems to begin with Mehmet's son Bayezid II who, during his governorship in Amasya, had the good fortune of becoming the disciple of the founder of the Turkish school of *naskh* and *thuluth*, Shaykh Hamdullah (1436–1519), who continued the line of Yaqut's disciple, Ahmad Suhrawardi. Amasya was apparently a fertile soil for calligraphy; at least it is claimed that Yaqut was born in that city. As for his spiritual descendant, Shaykh Hamdullah, his whole family was famed for good writing.[269] He himself was, as legend has it, inspired by Khidr to develop a new elegant style of *naskh* and *thuluth*. Prince Qorqut also studied with him in Amasya; then the shaykh proceeded to Istanbul where his former pupil Bayezid had ascended the throne in 1481 after much internecine struggle. He was highly

71

honored by the sultan, who did not mind placing the cushions in the right position for him or holding his inkstand. The master was also granted a decent income from two villages in the Szigetvar area. It is a strange coincidence that his life span is almost exactly the same as that of Sultan-ʿAli of Mashhad, who occupied a very similar position both in the spiritual genealogy of calligraphers and in the official hierarchy of a Turkish court.

Shaykh Hamdullah wrote forty-seven copies of the Koran and many thousands of prayers as well as other texts,[270] and from him the *silsila* goes through his son-in-law Shukrullah through six generations until it reached Hafiz Osman in the second half of the seventeenth century. Since Shaykh Hamdullah's grandson was squinteyed, he had to write bent very closely over the paper and did not attain the same perfection as his father and grandfather; therefore, the line continued through nonrelatives.[271]

In the late fourteenth century Ibn Khaldun had praised Cairo as the center of civilization and hence of good calligraphy; the same could be said even more justifiably about Istanbul from 1500 onward.[272] Sultan Süleyman the Magnificent's good hand in both *thuluth* and *taʿlīq* was highly praised by Turkish writers,[273] and he was lucky enough to be surrounded by a number of excellent calligraphers who decorated his buildings with their inscriptions. The most outstanding personality among them was Ahmad Qarahisari, whose artistic genealogy went through Pir Yahya as-Sufi[274] to ʿAbdallah as-Sayrafi to Yaqut. His large inscriptions in roundels in the Süleymaniya mosque are as well known to every visitor to Istanbul, as are his very unusual and daring specimens of the *basmala,* in which he reached the absolute perfection of the large *tauqīʿ* hand and that lately have frequently been printed in both the East and the West because of their unique dynamism (after Habib had published it first in his book *Khaṭṭ ū khaṭṭāṭān* in 1306/1887). One understands why some admirer thus described his *basmala* in a Persian verse:

> The stature of this *basmala* in the garden of calligraphy
> Became a cypress and produced seed from dots.
> These letters became the victorious army;
> Each *alif* is finally a flag![275]

72

Qarahisari, according to the biographers a petit, very elegantly attired person, must have been possessed by a special power, and his art is as unique as is his contemporary Miᶜmar Sinan's architecture. Famous is the Koran that he wrote for the sultan; and in his album pages he combined, as it became more and more popular, *naskh* and *thuluth* in a harmonious blending.[276] It is not surprising that he did not form a school but had only a few very special students, among them his former slave and then adopted son, Hasan Chelebi Charkas.[277] In 963/1556, when he was close to ninety, "the dots of his script became transformed into moles on the cheeks of the houris of Paradise."[278]

A generation later, Murad III appears as the ruler who best combined love of fine arts and mystically tinged verse. His *jalī thuluth* was so outstanding that two of his writings adorn the Aya Sofya mosque.[279] It was for him that ᶜAli Efendi translated Qutbuddin Yazdi's *Risāla-i quṭbiyya* as *Manāqib-i hünarvarān*.[280] This ᶜAli Efendi from Gallipoli was an employee in the *dīvāns* of several grandees and a prolific writer of pretty mediocre prose, history, and poetry as well; he apparently devoted every spare moment of his busy life in the various corners of the Ottoman Empire to calligraphy, which he had learned from Shaykh Hamdullah's grandson, Shukrullah-zade Pir Mehmet Dede. For his translation of Qutbuddin's work he secured the help of the noted calligrapher ᶜAbdullah Qirimi;[281] but it is his additions to the text, casting interesting sidelights on the history of Turkish calligraphy and on the life of a rather frustrated calligrapher, that are of special value even though his work has to be used with caution. Another artist who was aware of Murad III's love of calligraphy dedicated a book of calligraphic models (now in Vienna) to him.[282] During Murad's reign a "strange man" (*tuhaf admi*) reached Istanbul—the Persian ambassador Elchi Ibrahim Khan (990/1582) who "had attained a white beard due to the love of [black] writing and who exaggerated in his album pages the flaking of gold and ornamentation for, since his handwriting was not very distinguished, it was to hide his mistakes that he spent gold lavishly."[283]

Somewhat later, Sultan Murad IV (1623–40) is praised as a fine calligrapher even by one of the leading masters of *nastaᶜlīq*, Nargis-izade; and Sayyid Ibrahim Efendi Nefeszade dedicated his *Gulzār-i*

savāb, an important work on calligraphy often transcribed by later calligraphers, to him.[284]

Slightly later the Turkish calligraphic tradition reached its apex with Hafiz Osman (c. 1642–98), a member of the Sunbuliyya order centered in the *tekke* of Kocamustafa Pasha.[285] The Koran as written by him is still the ideal for every art-loving, pious Turk, who would certainly agree with the chronogram marking his death:

> To serve the word of God day and night,
> The Almighty had granted him *yad-i ṭūlā* [special power].[286]

Yahya Kemal, the last classical Turkish poet, has praised Hafiz Osman in his poem "Kocamustafa Paşa", calling him "the prophet of penmanship", whose luminous being illuminates the darkness of the cemetery where "creepers, inscriptions, stones, and trees are blended together." It was Hafiz Osman who instructed the royal brothers Mustafa II and Ahmad III even after he suffered a stroke. As Bayezid II had attended to Shaykh Hamdullah's needs, thus Mustafa II did not mind holding the inkstand for his teacher, and it is told that he once remarked: "Never will there be another Hafiz Osman!" Whereupon the calligrapher replied: "Your Majesty, as long as there are kings that hold the inkstand for their teacher there will be many more Hafiz Osmans!" He thus pointed to the importance of patronage as well as to the rules of proper behavior which even a king has to observe vis-à-vis his teacher.[287] The instruction was apparently very successful, as shown by the large *basmala* the sultan wrote in one stroke of the pen; it now adorns the Aya Sofya.[288] It is said that he always asked Hafiz Osman to write a sentence first and then copied it.[289] Mustafa's brother and successor Ahmad III practiced first with Hafiz Osman and, after the master's death in 1698, with his favorite disciple, Yedikuleli ᶜAbdallah, who wrote a beautiful copy of the Koran for him.[290] Sultan Ahmad himself, who had also studied *taᶜlīq,* wrote both Koran copies and album pages. One day in 1136/1725 he assembled all the masters of calligraphy to show them the album of his own calligraphy; the two leading poets of the age, Vehbi and Nedim, immediately extemporized chronograms, and several calligraphers followed suit with their chronograms and verses, for "Mercury, the scribe star, himself came down to look at this al-

74

bum and found the lofty lines . . . worthy to be hung from the highest sky."[291] Sultan Ahmad III wrote a fine mirrored *basmala*[292] and apparently made it a point to send at least one piece of *jalī* calligraphy to each major mosque in Istanbul.[293] Remarkable is the inscription for his mother's tomb in Üsküdar, which consists of the Prophetic tradition: "Paradise lies under the feet of mothers."

Even though Sultan Mehmed, son of Ahmad, is credited with having copied a number of Korans,[294] there is little evidence of outstanding artistic activity among the rulers of the eighteenth century.

Invocation of the Prophet Muhammad, written by the Ottoman Sultan Mahmud II about 1838

But with Mahmud II (d. 1839), otherwise noted for his political reforms, a master of the craft once more occupied the Ottoman throne. He received his *ijāza* from Mehmet Vasfi for a fine *ḥilya*, but the influence of Mustafa Raqim, the master of large decorative writing, is also visible in his writing. He is credited with "one of the finest tablets in *jalī thuluth* ever written" in Turkey.[295] Finally, the sources mention Sultan ʿAbdul Majid, who died in 1861 at the age of forty and, despite a rather lascivious private life, now and then found time to write beautiful calligraphies, some of which are found in mosques of Istanbul. He was granted the *ijāza* for *thuluth* by ʿIzzet Efendi.[296] And it is no accident that the useful little book by Habib, *Khaṭṭ ū Khaṭṭāṭān*, was dedicated to Sultan ʿAbdul Hamid in 1305/1887.

Kings and dervishes were equally fond of calligraphy, an art that enabled them to adorn the Word of God most beautifully and that inspired them to create an artistic equilibrium between the content

75

of a Persian or Turkish verse and its delicate calligraphic line, a line in which the music of the verse and the music of the line are harmoniously blended. When Ibn al-Bawwab, the master calligrapher of the late tenth and early eleventh centuries, died, a poet wrote a dirge on him:

The scribes must have had a premonition that they would lose you, and that this day would be spent in weeping.
That is why the inkwell was filled with black, as if it
were mourning you, and the pens were split.[297]

But while all of calligraphy, for one moment, seemed to mourn its great master, the calligraphers did not remain in this state. For as hard as the path to perfection was and even though few had reached the heights that Ibn al-Bawwab, Yaqut, Sultan-ᶜAli, or Hafiz Osman had attained, yet every calligrapher must have felt—as a consolation in the days of repeating the same letter thousands of times—what a seventeenth-century writer in Sind expressed in a short line:

Everyone who lives through the Water of Life of the pen, will not die, but remain alive as long as life exists.[298]

lām-alif in plaited decorative Kufi, from the border of a Koran, fifteenth century

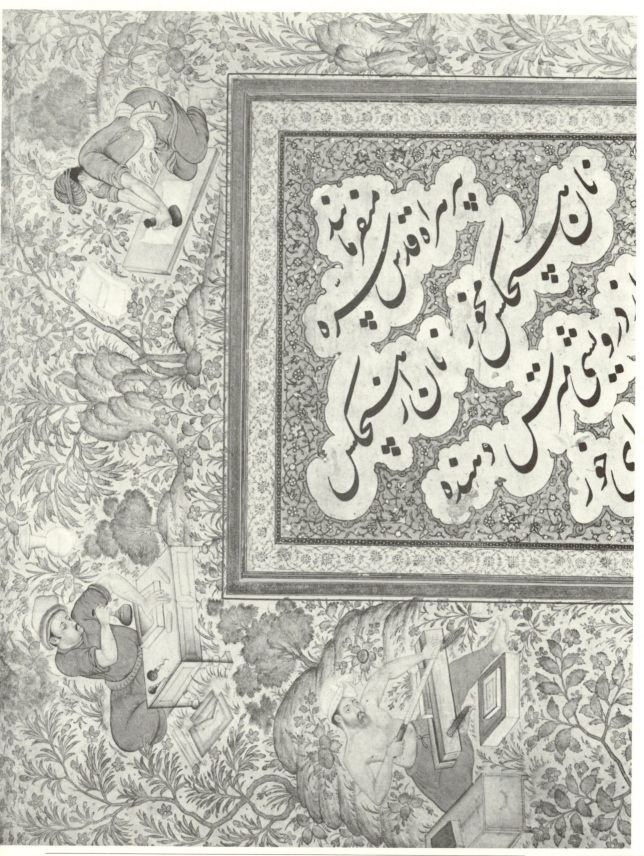

Polisher of paper and Scribe, from the border of the Jahangir Album, India, ca. 1615. Courtesy of the Freer Gallery of Art, Smithsonian Institution, Washington, D. C.

Page from a Koran (Sura 24, verses 32–36), written on vellum in *mā'il* script. By permission of the British Library, MS. Or. 2165, f. 67 b., eighth century

The profession of faith in its Shiite form, in extremely plaited Kufi. Around it Koranic inscriptions in *thuluth*. Isfahan, Masjid-i Jami[c], Mihrab of Oljaitu, 1307

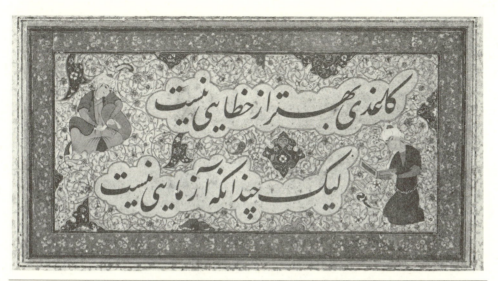

Page from an album in *nastaᶜlīq*, written by Mir ᶜAli during his stay in Bukhara, ca. 1535–40. Courtesy of the Fogg Art Museum, Harvard University, Cambridge, Mass.

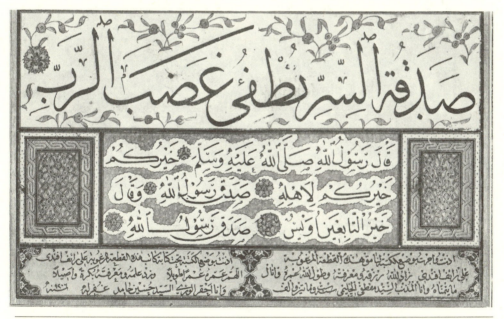

Diploma (*ijāza*) for a Turkish calligrapher, ᶜAli Ra'if Efendi, by two master calligraphers, dated 1206/1796. Reproduced from the Collections of the Library of Congress, Washington, D. C.

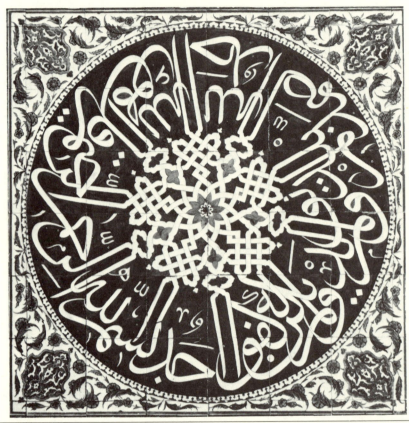

Sura 112 written in circular form, fayence. Mehmet Sokollu Mosque,
Istanbul, seventeenth century. Photo Eduard Widmer, Zurich

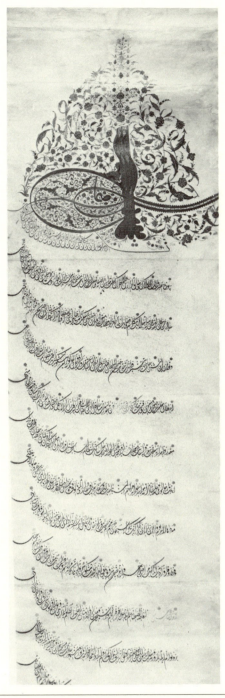

Firman of the Ottoman Sultan Mehmet III, dated 1599. 373 cm by 55,5 cm. Tughra, text in *dūvānī* script. Staatliche Museen Preussischer Kulturbesitz, Museum für Islamische Kunst, Berlin

Parviz Tanavoli, *Heech and Chair III*, Iran, 1973

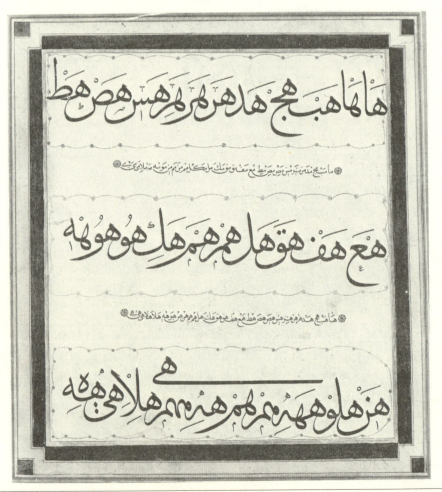

Various forms of *hā'* in *naskh* calligraphy on an exercise sheet. Courtesy of the Fogg Art Museum, Harvard University, Cambridge, Mass.

Anthropomorphic and zoomorphic letters from a canteen in metal, Syria, mid-thirteenth century, Mosul school. Courtesy of the Freer Gallery of Art, Smithsonian Institution, Washington, D. C.

Peacock whose tail is made of *dīvānī* calligraphy, containing blessings for an Ottoman ruler. Turkey, ca. 1700. From the "Bellini-Album." The Metropolitan Museum of Art, Louis V. Bell Fund, 1967

Page from an anthology of poetry in *nasta'līq* script. The script is cut out and pasted on the paper. Iran or Turkey, 16. century. The Metropolitan Museum of Art, Gift of Mrs. Lacey W. Drexel, 1889

Calligraphy
and Mysticism

"By '*Nūn* and the Pen' and by the honor of the illiterate Prophet
but for whom the Pen would not have been created!"[1]

More than any other religion, Islam stresses the importance of the
Book and is in fact the first religion in which the distinction between
the *ahl al-kitāb* and those without a written revelation was clearly
stated to form part of its legal system.

Yet, the bearer of this message, Muhammad the Prophet, is called
in the Koran *ummī*, which came to be interpreted as "unlettered" or
"one who needs no learning," because for the preservation of the
true essence of the Divine message, for the "inlibration" of God (as
Harry Wolfson calls it), the Prophet's mind had to be absolutely pure,
just as Mary had to be a virgin to become the vessel of incarnation.
For this reason the mystics loved to dwell on the illiteracy of the
Prophet; and as proud as they were of the revealed Book, they also
realized that letters might be a veil between themselves and the im-

mediate experience of the Divine, for which the mind and the heart have to be like a blank page. Muhammad is therefore praised in ever changing images:

The orphan, who recites the Koran without lesson,
drew the line of abolition [naskh, or "a line of naskh calligraphy"]
 over the ancient pages,[2]

for the message which he brought abrogated all previous revelations.

However, this message itself, the Koran, abounds in allusions to writing. At the very beginning of the revelation, in Sura 96, God appears as He "who taught man by the pen," and the first words of Sura 68 read: "Nūn, and by the Pen!" This sentence has inspired poets and mystics throughout the centuries and is alluded to in many verses, all the more as the last three verses of this sura are recited against the evil eye.

Everything, the Koran holds, has been written from all eternity on the lauh al-mahfūz, the Well-preserved Tablet, by means of the preexistent Pen. Such formulations led of necessity to discussions about predestination and free will, and they color the religious history of early Islam. "The Pen has already dried up," says a tradition that was quoted in defense of the idea that whatever had been decreed in preeternity cannot be changed. Maulana Rumi, who felt that such an interpretation would be dangerous for man's development and hamper him on his way to higher levels of spiritual progress, interpreted the saying differently. The fact that the Pen has dried up does not mean that everything is preordained but rather that there is written once and for all that good actions will be recompensed while sins will be punished; this is the unchangeable rule according to which man should act.[3] There is also another tradition: when the Pen was about to write down the punishment for the disobedient Muslims who were going to hell, a terrible voice came, shouting, "Behave, O Pen!" and from fear the Pen was split—which is why every pen has to be split in order to write.[4]

Since, according to general belief, all man's actions are written on the Tablet, in Islamic languages fate is generally termed maktūb, "written," or "written on the forehead"—sarnivisht or alïn yazïsï, in

Persian and Turkish, respectively. The lines engraved on man's face could then be interpreted as telling of his fate, as constituting, as it were, the title page of his destiny, which could be deciphered by those with insight. The warrior-poet Khushhal Khan Khatak says in a fine Pashto quatrain that "the true men of God in this world read from the tablet of the forehead the script of the heart."[5]

Poets have often complained that the "writers of pre-eternity" have written the fate of lovers in black[6] or considered the image of the beloved they carry in their minds as drawn by the pen of destiny on the tablet of their heart.[7] Over and over have suffering lovers cried out like Sassui in Shah ʿAbdul Latif's Sindhi verse:

Had I known that the disaster of separation would befall me,
I would have washed off the writing of destiny in the very begin-
 ning![8]

But mystically inclined writers would rather agree with Ruzbihan Baqli, who saw the Pen of the decision (*fatwā*) of pain take the ink of loving friendship from the inkwell of ecstatic experience to write letters of love on the heart of the lovers.[9]

For a rebel poet like Ghalib the "writing on the forehead" is the mark left by the prostration before his idol.[10] (In Islam the dark mark on the forehead caused by frequent prostrations is regarded as a sign of special piety; see Sura 48/29.) And how should man not act improperly, *munharif* (lit., "slanted"), when the Pen that wrote his fate was cut in a crooked way?[11]

The Pen, which was able to write everything on the Tablet, is, according to a Prophetic tradition, the first thing that God created.[12] For the Sufi theoreticians and some philosophers it was therefore at times regarded as the symbol of the First Intellect or, rather, the First Intellect itself. Ibn ʿArabi, combining this idea with the beginning of Sura 68, *Nūn wa'l-qalam,* speaks of an angel called *an-Nūnī* who is "the personification of the First Intellect in its passive aspect as the container of all knowledge."[13] That corresponds to the common interpretation of *nūn* as the primordial inkwell, to which its shape indeed can be compared.[14] The fifteenth-century Shia thinker Ibn Abi Jumhur, who closely follows Ibn ʿArabi's system, considers the Divine Throne, the Pen, the Universal Intellect, and the pri-

mum mobile as one and the same,[15] whereas much earlier the Ikhwan as-Safa had interpreted *ʿaql* (Intellect) as God's "book written by His Hand" and developed a whole mythology of the heavenly Book and the Pen.[16] It is, therefore, not surprising that calligraphers would regard their own profession as highly sacred, since it reflects, in some way, the actions of the Primordial Pen, as a Persian writer says:

> The world found name and fame from the Pen;
> If the Pen were not there, there would not be the world.
> Anyone who did not get a share from the Pen—
> Don't think that he is noble in the eyes of the intelligent.[17]

Besides speaking of the mystery of Pen and Tablet, the Koran places man's whole life under the sign of writing. Did not God make the angels act as scribes? There is no moment that the *kirām kātibīn*, the noble scribe-angels (Sura 83/11), do not sit on man's shoulders to note down all his actions and thoughts, and on Doomsday finally his book will be presented, more or less filled with black letters.[18] For this reason the calligrapher Ibn al-Bawwab instructs the adept in his rhymed epistle to write only good words:

> For all the acts of man will meet him tomorrow,
> When he meets his outspread book![19]

But since most ink is soluble in water, Persianate poets who were afraid lest their songs about wine and love might have blackened the book of their actions too much found the solution—tears of repentance will wash off the pages. Rarely would a rebel poet claim that he was no longer afraid of the Day of Judgment because

> I have blackened the page so much that it cannot be read![20]

an allusion to the *mashq* in which letter over letter, line upon line, fills the page and makes it finally illegible. (Rumi too speaks of writing one text on top of another.)[21]

It was the letters of the Koran that became the true sign of the victory of Islam wherever the Muslims went, and when they were

80

adopted by peoples with non-Semitic languages they endowed these idioms with some of the *baraka* that Arabic and its letters bear, owing to their role as vessels for the revelation. It therefore became incumbent upon the pious to write the Divine Word as beautifully as possible and, as an often quoted *hadīth* promises, "He who writes the *basmala* beautifully obtains innumerable blessings" or "will enter Paradise."[22] Indeed, a famous calligrapher appeared after his death to a friend in a dream to tell him that his sins were forgiven because he had written the *basmala* so well.[23]

The Arabic script of the Koran is therefore the most precious treasure for the Muslim. As a modern Turkish author writes, "Even though foreign artists could build mosques, yet they could not write a copy of the Koran. Calligraphers have been regarded as destined for Paradise for writing the Koran, while painters who wrote 'the script of the infidels,' that is painting, were considered food for Hell."[24] Although the Prophet himself had employed some non-Muslims as teachers of writing, certain orthodox Muslims regarded it as—to say the least—abhorrent to show reverence to a non-Muslim teacher of calligraphy, as our best Ottoman source states.[25] The same attitude is expressed in Mustaqimzade's remark that neither the Koran nor a *hadīth* should be written on European (*firangī*) paper.[26]

Since the Arabic letters are the badge of identity for the Muslim peoples, a break with this tradition is completely different from an exchange of Roman letters, in the West, for another alphabet. The example of Turkey, where the Arabic script was given up in 1928, is well known, and it may be that one facet of the numerous tensions that eventually led to the breakup of Pakistan was that fact that Bengali, contrary to the West Pakistani languages that use the Arabic alphabet, is written in a Sanskrit-based alphabet (although some orthodox circles tried to introduce the "letters of the Koran" for this language too).

The all-embracing character of the Arabic letters contributed greatly to the feeling of unity among Muslims. Allusions to the Arabic alphabet were understood by everyone who was able to read, and the idea of an early Sufi that "there is no letter which does not worship God in a language"[27] furnished mystics and poets with almost unlimited possibilities for interpreting the letters and discovering ever new meanings in them, which in turn were expressed by

artistic means. Did not the Koran itself state: "And if all the trees on earth became pens, and all the oceans ink, the words of thy Lord would not be exhausted" (Sura 31/28)?

Owing to the sacred character of Arabic letters, anything written in them has to be treated carefully. As in the Christian and Jewish traditions, one finds Muslim, and particularly Sufi, stories about people who picked up each scrap of paper with Arabic letters because the name of God or a sacred word might be written on it, the *baraka* of which should not be destroyed.[28] Perhaps even some of the early Kufic Korans were, as Martin Lings thinks, meant to be contemplated like icons to partake of their *baraka* rather than to be read.[29] (The example of a Turkish *ḥāfiẓ* who refused to learn Arabic grammar because "the Koran is not Arabic," but rather a sacred object in itself, immediately comes to mind.)[30] The reverence for the written word, in which the illiterate villager participates as much as the scholar or the calligrapher, permeates Muslim life and becomes visible in the minute inscriptions on seals and bezels as well as in the enormous Koranic inscriptions that were arranged between the minarets of Ottoman mosques in Ramadan where they would be illuminated to make the Divine Word shine in the darkness.[31]

Since calligraphy thus was regarded as a sacred art, connections between calligraphers and Sufis were natural. In both traditions, the *silsila* goes back to ʿAli, the first calligrapher in the Kufic style. A nineteenth-century Turkish verse extends the relations between the Koran and the four righteous caliphs even more:

> Siddiq Abu Bakr read the sent-down book;
> ʿOmar stitched its binding and cover;
> ʿOthman wrote it in the right sequence and kept it;
> ʿAli gilded and decorated its pages.[32]

Contrary to this outspokenly Sunni statement, Shia artists would rather maintain that the fourth and eighth imams had been calligraphers.[33]

The sacred character of calligraphy becomes evident in popular traditions and legends, which are very Sufi in character. Thus, the pious Mustaqimzade teaches that in order to acquire good handwriting one should first recite a *fātiḥa* (Sura 1) for the soul of Shaykh

Hamdullah, the greatest Turkish calligrapher, then look at his writings, and then begin one's exercise. Even more powerful is the following method:

> Cut a fresh pen for *thuluth* and *naskh,* wrap them in paper, take two fingers deep dust out from Shaykh Hamdullah's tomb, recite the blessing over the Prophet and the glorification; then bury them in a Friday night [at the masters tomb]. After one week take them out, and whenever you begin to practice, write the first line with them, then the rest with other pens.[34]

To dream of meaningful letters that then would be explained according to their literal, mystical, and numerical value by the mystical guide was apparently quite common among calligraphers, as is shown by the story of a Turkish calligrapher who saw himself practicing with the great master Rasim. The dream-lesson ended with the letters *alif, sīn,* and *ḥā* and was interpreted in complicated ways to mean that on the sixty-ninth day he would become the calligraphy teacher of the sultan—which, of course, came true.[35]

All life was permeated with love of Arabic letters. The beginning of learning for a traditional Muslim child is the *bismillāh* ceremony in which the boy (at age four years, four months, and four days) is taught the formula *Bismillāhi'r-raḥmāni'r-raḥīm* "In the name of God the Compassionate the Merciful," which was sometimes written with a sweet liquid on a slate which the child had to lick off. His entering into the world of the Holy Book was then duly celebrated.[36] For the eighteen letters of the *basmala* contain, among other things, an allusion to the eighteen thousand worlds, and the *bā'* of *bism* points to the *bahā'Allāh* (God's splendor), its *sīn* to *sanā' Allāh* (God's sublimity), and its *mīm* to *mamlakat Allāh* (God's kingdom).[37]

If the child was artistically minded, he would not only learn the suras required for his daily prayers but also copy at least parts of the Koran in order to acquire merit—as the Buddhist monks would copy thousands of pages of the Pali canon;[38] as the writer of the Torah would give all his religious emotion to the production of immaculate letters on the scroll; or as Christian monks would devote their time to producing beautiful copies of the psalms or the missal; and as painters, in a more correct parallel to the calligraphers of the

Koran, would never tire of interpreting the mystery of the incarnation in pictures.

Therefore, people would sometimes write a copy of the Holy Book in order to expiate their sins. Thus, Bada'uni tried by this means to obtain forgiveness for his participation in the translation of Hindu epics as ordered by Akbar, and a medieval Arab poet who "had an inclination to write satires" eventually repented and spent the rest of his life copying Korans.[39]

The letters of the Koran, even when detached, carry a sanctity of their own. Often letters or holy phrases are duplicated, mirrored, and used as ornamentation. In many families one finds vessels with Koranic quotations that were filled with water to be used in case of illness,[40] or one would wash off the ink from scraps of Koranic verses or prayers and have the ailing person drink the water. In Shiite environments such as Iran and parts of India one often finds that these vessels also contain the invocation to ᶜAli (nādi ᶜAliyan maẓhar al-ᶜajā'ib), "Call ᶜAli, the locus of manifestation of wonderful things" which was considered very powerful. The Koranic quotation used for apotropaic purposes is usually the throne verse (Sura 2/256), but the line Naṣrun min Allāh wa fathun qarīb "Help from God and near victory" (Sura 61/13) is often found as well. Even seemingly meaningless, unconnected letters can convey some blessing, provided they have been written with the proper intention by a skilled amulet maker; and inscriptions on metalwork, which often consist of mere fragments of blessing formulas, may still bear the baraka of the full prayer.[41]

One finds whole dresses or coats covered with Koranic verses, or even with the complete text of the Koran, worn by soldiers.[42] This was common in India where an eighteenth-century poet alludes to this custom:

Like that gown in which the sura of the Koran is woven,
the fabric of beauty is venerable due to the khaṭṭ ["script/down"].[43]

Weapons bear Koranic inscriptions that sometimes allude to the owner's name (as in the case of Sulayman the Magnificent, an allusion to Solomon's power mentioned in Sura 27).[44] Pilgrims' banners were embroidered with sacred texts as were tomb covers, in which

بِسْمِ اللهِ الرَّحْمَنِ الرَّحِيمِ وَصَلَّى اللهُ عَلَى سَيِّدِنَا مُحَمَّدٍ وَعَلَى الِهِ وَصَحْبِهِ أَجْمَعِينَ

‹ لَهُمْ أَسْمَاءُ أَصْحَابِ الْكَهْفِ ›

وَالأَسْمَاءُ لَهُمْ كَوَامِلُ كَثِيرَةٌ مِنْهَا الأَسْمَاءُ هَمِّ إِذَا كُتِبَتْ وَجُعِلَ عَلَى بَابٍ دَارٍ لَمْ يَحْتَرِقْ

أَوْ عَلَى مَتَاعٍ لَمْ يُسْرَقْ أَوْ عَلَى مَرْكَبٍ لَمْ يَغْرَقْ وَعَنِ ابْنِ عَبَّاسٍ رَضِيَ اللهُ عَنْهُمَا أَنَّ أَسْمَاءَ

أَصْحَابِ الْكَهْفِ تَصْلُحُ لِلطَّلَبِ وَالْهَرَبِ وَإِطْفَاءِ الْحَرِيقِ وَتُكْتَبُ فِي فِرْقَةٍ وَيُرْمَى بِهَا

وَسَطَ النَّارِ تُطْفَأُ وَلِلْبُكَاءِ الطِّفْلِ تُوضَعُ تَحْتَ رَأْسِهِ فِي الْمَهْدِ وَلِلْحَرْثِ تُكْتَبُ عَلَى

الْفَرْطَاسِ وَتُرْفَعُ عَلَى خَشَبٍ مَنْصُوبٍ فِي وَسَطِ الزَّرْعِ وَلِلتِّجَارِ وَلِلْعَمَلِ الْمَثْلَثِ

وَلِلضَّيَاعِ وَالْغِنَى وَالْجَاهِ ه

وَقَالَ أَبُو سَعِيدٍ مُحَمَّدٌ الْمُفْتِي
الْإِمَامُ رَحِمَهُ اللهُ تَعَالَى
إِنِّي رَأَيْتُ أَصْحَابَ
الْكَهْفِ وَالْمَقَامِ
فَقُلْ لَهُمْ مَنْ تُكْتَبُ
أَسْمَاؤُهُمُ الشَّرِيفَةُ
تَيَمُّنًا وَتَبَرُّكًا
فِي عَمَلِهِ مَوْرُودٍ وَلَمْ
يَجِدْ تَأْثِيرَهَا وَأَرَوْنِي
بِأَرْكَبُوا الأَسْمَاءَ عَلَى
شَكْلِ الدَّائِرَةِ وَالْقِطْمِيرِ فِي
وَسَطِهَا وَقَدْ جَعَلَ آيَةَ الْكُرْسِيِّ
عَلَى ظَهْرِ الدَّائِرَةِ طَلَبًا لِلْبَرَكَةِ وَالْحِفْظِ ه

وَهَذِهِ السَّبْعُ الْمُنْجِيَاتُ الَّتِي تُنَجِّي إِنْ شَاءَ اللهُ مِنْ أَهْوَالِ الْإِنْسَارِ وَمِمَّا لَهَا مَعَهُ لَوْ رُزِمَ السَّمَاءَ الْعِبَادَ مَتْرٍ جَبَّارٍ حَدَّ

تَرْفَعُهُ اللهُ وَلَا إِلَهَ إِلَّا هُوَ بِرَكَنِهِمَا وَهُوَ بِسْمِ اللهِ الرَّحْمَنِ الرَّحِيمِ قُلْ لَنْ يُصِيبَنَا إِلَّا مَا كَتَبَ اللهُ لَنَا هُوَ مَوْلَانَا

وَعَلَى اللهِ فَلْيَتَوَكَّلِ الْمُؤْمِنُونَ وَإِنْ يَمْسَسْكَ اللهُ بِضُرٍّ فَلَا كَاشِفَ لَهُ إِلَّا هُوَ وَإِنْ يُرِدْكَ بِخَيْرٍ فَلَا رَآدَّ

لِفَضْلِهِ يُصِيبُ بِهِ مَنْ يَشَاءُ مِنْ عِبَادِهِ وَهُوَ الْغَفُورُ الرَّحِيمُ وَمَا مِنْ دَآبَّةٍ فِي الأَرْضِ إِلَّا عَلَى اللهِ رِزْقُهَا

وَيَعْلَمُ مُسْتَقَرَّهَا وَمُسْتَوْدَعَهَا كُلٌّ فِي كِتَابٍ مُبِينٍ إِنِّي تَوَكَّلْتُ عَلَى اللهِ رَبِّي وَرَبِّكُمْ مَا مِنْ دَآبَّةٍ إِلَّا

هُوَ آخِذٌ بِنَاصِيَتِهَا إِنَّ رَبِّي عَلَى صِرَاطٍ مُسْتَقِيمٍ وَكَأَيِّنْ مِنْ دَآبَّةٍ لَا تَحْمِلُ رِزْقَهَا اللهُ يَرْزُقُهَا

وَإِيَّاكُمْ وَهُوَ السَّمِيعُ الْعَلِيمُ مَا يَفْتَحِ اللهُ لِلنَّاسِ مِنْ رَحْمَةٍ فَلَا مُمْسِكَ لَهَا وَمَا يُمْسِكْ فَلَا مُرْسِلَ

لَهُ مِنْ بَعْدِهِ وَهُوَ الْعَزِيزُ الْحَكِيمُ وَلَئِنْ سَأَلْتَهُمْ مَنْ خَلَقَ السَّمَوَاتِ وَالأَرْضَ لَيَقُولُنَّ اللهُ قُلْ أَفَرَأَيْتُمْ مَا تَدْعُونَ

مِنْ دُونِ اللهِ إِنْ أَرَادَنِيَ اللهُ بِضُرٍّ هَلْ هُنَّ كَاشِفَاتُ ضُرِّهِ أَوْ أَرَادَنِي بِرَحْمَةٍ هَلْ هُنَّ مُمْسِكَاتُ رَحْمَتِهِ قُلْ حَسْبِيَ اللهُ عَلَيْهِ يَتَوَكَّلُ الْمُتَوَكِّلُونَ

Talisman in West African Maghribi from Nigeria with the names of the Seven Sleepers and Qitmir

sometimes the Prophet was invoked and blessed—an indication of the owner's hope for the Prophet's intercession on Doomsday.[45] That inscriptions in religious buildings often contain a unity of intent is well attested: the Koranic sayings in the Dome of the Rock in rejection of the Trinity[46] are as meaningful as the constantly repeated motto of the Nasrid kings in the Alhambra, *Wa lā ghāliba illā Allāh* ("And there is no victor save God"). Inscriptions in mausoleums speaking of heavenly bliss belong to this category.

Besides the Koran, the traditions of the Prophet were also considered to be full of *baraka,* and therefore the classical collections of *ḥadīth* as well as Busiri's *Burda*—the superb Arabic ode in honor of the Prophet—were copied time and again, sometimes with interlinear translations or paraphrases. Not only would the calligrapher acquire merit by writing this poem, but he would also be protected against fire and illness, according to popular belief.[47] And while the *Burda* was one of the favorite models of calligraphy in Mamluk Egypt, Turkish calligraphers never tired of writing the *ḥilya-i sherīf,* the qualities of the Prophet, in the form standardized in the seventeenth century.[48]

The use of the names of God; of the Prophet; or, in Shiite environments, of ᶜAli, in rectangular Kufi, adds to the sanctity of religious buildings; and the words of the *shahāda* or the names of *al-ᶜashara al-mubashshara* (the ten to whom paradise was promised)[49] in squared Kufi convey blessing to the onlooker, as do the circular plaques, common in Turkey, with the names of the Seven Sleepers.[50]

And should not the final verses of Sura 68, the formula against the evil eye, be particularly effective when written in the shape of an arrow?[51]

Another form of expressing one's trust in the sanctity of certain books is to take prognostication from them.[52] Consulting not only the Koran by opening it at random but also the *Dīvān* of Hafiz and Rumi's *Mathnawī* is still very popular in the eastern Islamic world, and I know families in India and Pakistan who would never choose a name for their newborn child without having recourse to the Koran or to Hafiz.

All these different aspects of sacred writing explain why the mystics, and following them the poets, have developed a special vocabulary tinged with allusions to the Koran and the art of writing. One

86

of the most famous examples is the first line of Ghalib's Urdu *Dīvān* in which he cries out:

> The picture—of the daring of whose writing does it complain?
> From paper is the shirt of every figure!

That means that every human being is a letter written by the Primordial Pen, either beautifully or crooked, which stands on fine parchment or on brittle or coarse paper, and is put in relation to other letters, which it may or may not like. This idea was common with medieval writers, but Ghalib ingeniously combined it with the paper shirt, which was the dress of complainants at court during the Middle Ages.[53] Since a letter becomes visible only when written on some material, preferably paper, it is, so to speak, wearing a paper shirt and appears thus as a complainant against the Eternal Writer and His Pen. Seven hundred years before Ghalib, his compatriot in Delhi, Amir Khusrau, had expressed the same idea but had resigned himself to the will of the Eternal Calligrapher-Painter, with whom letter or picture cannot quarrel.[54]

In a different interpretation, man himself becomes the pen, for the *ḥadīth* says: "Man's heart is between two of God's fingers, and He turns it as He pleases."[55] Therefore, Rumi sings of the Divine Calligrapher who writes with the heart of the lover, now a *z*, now an *r*, and cuts the pen of the heart in different ways to write either *riqāᶜ* or *naskh* or any other style—and the heart-pen says only, *"Taslīm* [I gladly accept]—you know who I am."[56] Rumi loved this imagery and repeats it several times in the *Dīvān*.

> My heart is like the pen in your hand—
> from you comes my joy and my despair![57]

or:

> We are the pen in that master's hand;
> we ourselves do not know where we are going.[58]

And as the pen, according to an old saying, "sheds tears and at the same time smiles most beautifully,"[59] man should do the same while moved by the hand of God. Since the pen has to be nicely trimmed,

87

the mystic, longing for suffering and death in the path of the Beloved, exclaims:

> When you say, "I shall cut off your head!"
> I shall run on my head out of joy like the pen![60]

ᶜAttar, who wrote this verse, describes the true lover, whose duty it is,

> like the pen, with cut-off tongue,
> to turn his head on the tablet of annihilation.[61]

Rumi goes even further and says, with a clever allusion to Sura 68:

> When you are like a *nūn* in genuflexion, and like a pen in prostration,
> Then you will be joined, like *Nūn wa'l-qalam*, with "and what they write,"[62]

that is, with the Divine Order.

The imagery of writing served the Sufis well to describe the act of creation. Famous is Rumi's delightful story in the *Mathnawī* in which he describes the little ant who walked on a beautifully written manuscript—probably a fine illuminated copy of the Koran—and exclaimed full of amazement:

> What wonderful pictures this reed has made,
> like sweet basil and a garden of lilies and roses![63]

But the little ant has to learn that it was not the pen that had created these lovely forms but rather the hand and again not the hand but the mind, and so forth, until it reached the first cause of all action, that is God. The story is found, in less poetical but still very impressive words, in Ghazzali's *Iḥyā' ᶜulūm ad-dīn* in the chapter on *tawakkul* (trust in God),[64] which probably inspired Rumi's verse.

The mystery of creation is explained differently, though again in the imagery of writing, by the Persian Shiite mystic Haydar-i Amuli (d. 1385):

Letters written with ink do not really exist qua letters, for the letters are but various forms to which meanings have been assigned through convention. What really and concretely exists is nothing but the ink. The existence of the letters is in truth no other than the existence of the ink, which is the sole, unique reality that unfolds itself in many forms of self-modification. One has to cultivate, first of all, the eye to see the selfsame reality of ink in all letters, and then to see the letters as so many intrinsic modifications of the ink.[65]

The idea certainly goes back to Ibn ᶜArabi, who expressed the view:

> We were lofty letters not yet pronounced,
> latent in the highest peaks of the hills.
> I was you in Him, and we were you and you were He
> and the whole is He in Him—ask those who have attained.

A seventeenth-century Javanese commentator on these verses, which were apparently widely discussed among the Sufis, explains the relations between the various aspects of being by stating that the *ahadiyya* is like a blank sheet of paper, the *waḥdat* (which can be equated with the *ḥaqīqa muḥammadiyya*) like a mark on the paper. The *wāḥidiyya,* then, is symbolized

> by an *alif* or any other letter formed from the mark. Each letter is an expression and fulfillment [of the potentialities] of the mark; it is not it from the standpoint of determination, nor other than it from the standpoint of being. This mark, which does not exist apart from the blank sheet, represents *waḥdat,* for all letters, however manifold, are combined within it; and it is displayed in each of them according to its receptivity.[66]

The mark, or dot, is certainly to be understood as pertaining to that point by which the letters are measured; thus, the image gains additional depth by truly translating the technique of calligraphy into a symbol of eternity.

ᶜAbdur-Ra'uf of Singket, who wrote these lines, gives still another

illustration of the secret of unity and multiplicity, which is close to Haydar-i Amuli's formulation:

Another illustration may be taken from the twenty-eight letters of the alphabet. When they are hidden in ink they are ink; when they are on the point of the pen, they are the point of the pen; but when they are written upon a tablet they are different both from the ink and the pen.[67]

Long before him, Rumi had expressed the secret of unity and diversity, which is solved in loving union, by the verse:

When I write a letter to my friend,
paper and pen and inkwell is He![68]

The letters are the expression of something of a higher order. The thinkers and literati generally mused on the relations between the written word and its hidden meaning, whereas the mystics' experience of the letters of the Arabic alphabet was that they had a very special quality. Some writers even assumed that the spiritual counterparts, the "angels" of the letters, might appear to the pious calligrapher, who then might visualize the *alif* with its initial flourish as "an angel with a beard."[69] Louis Massignon has drawn the attention of scholars to the threefold value system of the Semitic alphabets, among which Arabic is the most perfect. The letters can be seen as phonetic signs; they have a semantic value; and they also have an arithmetic value.[70]

In the first instance, it was the detached letters at the beginning of twenty-nine suras that inspired Muslim thinkers to construct a complicated system of relations and combinations. Rumi calls these letters "signs of divine activity, resembling the rod of Moses which contains in itself mysterious qualities."[71] Did not these mysterious letters, which appear singly, or in groups of two, three, four, or five, add up to 14 in number, that is, exactly half of the letters of the alphabet? And these letters were thought to correspond to the 28 lunar mansions. The unconnected Koranic letters were considered as *nūrāniyya* (luminous), because they express those mansions which

are visible above the horizon of Yemen, while the others correspond to the mansions beneath the horizon.[72]

Among the unconnected letters, the *a-l-m* at the beginning of Sura 2 and Suras 29–32 particularly inspired the mystics. Did it mean *Allāh-laṭīf* (subtle, kind)—*majīd* (glorious)? Or did it mean Allah and Muhammad, connected by Gabriel, who appears here as *l*? Or does it point to the three modes of prayer—the *alif* being the upright position, the *lām* the genuflexion, and the *mīm* the prostration? Or— so profane poets would ask—was it not an allusion to the stature, the curls, and the mouth of the beloved that, in turn, caused them *alam* (pain)? A sectarian interpretation might deduct from the numerical value of the three letters 1, 30, and 40, totaling 71, an allusion to the 71 sects that will perish, while the Shia is the 72nd, the group that is saved.[73] In the *ṭāhā* of Sura 20 the interpreters saw an address to the Prophet, meaning *ṭāhir* (pure) and *hādī* (guiding) and, since the numerical value of these letters is 9 plus 5 equals 14, they could easily find here an allusion to the full moon on the 14th night, to which the Prophet was often compared and that he even surpasses in radiance.[74] *Ṭāhā* was seen as expressing Muhammad's aspect as *nāṭiq,* teaching people the mystery of primordial purity; *yāsīn* (at the beginning of Sura 36) showed him as the Prophet who preaches the Holy War; both letter groups are therefore used as proper names as substitutes for Muhammad.[75]

The isolated letters were used to predict historical events, such as the duration of the ꜥAbbasid caliphate, and it is a strange coincidence that the letters *ṭāsīn,* in the old numerical system, give the sum 309, which is not only the number of the years the Seven Sleepers spent in the cave but also the date of the execution of al-Hallaj, the title of whose most provocative book, the *Kitāb aṭ-ṭawāsīn,* was taken from these very letters.

The mystics and the early Shia thinkers, including the Ikhwan as-Safa, pondered the fact that nowhere are more than five letters found at the beginning of the suras;[76] and the two pentads, *ḥ-m-*ꜥ*-ṣ-q* and *k-h-y-*ꜥ*-ṣ,* offered them much room for interpretation. Was not Islam founded on 5? There are five daily prayers, five types of alms, five pillars of faith, but also the *Panjtan* (i.e., the five members of the Prophet's family), five legislating prophets, five planets, and so on.[77]

Out of such speculations the art of *jafr* developed very early;[78] its invention is usually attributed to Jaᶜfar as-Sadiq, the sixth imam, and, just as the mysteries of the unconnected letters were to be veiled from the uninitiated, the art of *jafr* was to be handed down only through the descendants of Fatima. One could use *jafr* for prognostication. It was probably first connected with apocalyptic speculations about the return of the hidden imam and similar events,[79] but then it grew into an art of its own in which one could mix letters and their numerical value to produce one name instead of another name that one wanted to hide (an art that, on the profane plane, was very popular in the riddles on names which are known at least since early ᶜAbbasid days). Words of equal numerical value could be regarded as near identical. My Turkish friends used to explain the frequent use of tulips in Turkish decorative art by the fact that tulip, *lāle,* has the same numerical value as *Allāh* and as *hilāl,* the crescent and symbol of Islam, namely 66. In *jafr* one could combine the letters composing a Divine Name "with those of the name of the object desired" or substitute the letters of a word by a manipulation in which the first and the last, the second and the second to last letters were interchanged, and so on. In order to guarantee success for certain prayers, each Divine Name had to be repeated according to the numerical value of its letters, that is, *Allāh* 66 times, *quddūs* 199 times.

These cabalistic techniques were much more prominent in Sufi practice than is usually realized: Does not the numerical value of the complete profession of faith, 619, exactly add up to that of *khattāt* (calligrapher) and its second half, *Muḥammad rasūl Allāh* = 454, adds up to the word *al-kātib* (the scribe)?[80] In the 1950s in Turkey many upper-middle-class people still used the Koran as written by Hafiz Osman and often printed in facsimile for speculation, not realizing that the number of letters and words on the pages in this Koran is certainly not identical with that of other, let alone of the first Kufi, copies of the Holy Book. In the sect of the Nurcus, the *jafr* still plays a certain role.

Along with these techniques goes the *ḥisāb al-jummal* (gematria), in which the letters are combined with elements, stars, and the like. Each of the four elements corresponds to seven letters in the sequence of *abjad* so that the first, fifth, ninth (etcetera) letters would

92

be related to fire; the group beginning with *bā'* to air; the group beginning with *jīm* to water; and the final group, beginning with *dāl*, to earth. The letters could thus be used in magic and in astrological predictions and may have influenced letter imagery in general.[81]

How common it was among the mystically minded Muslims of the ninth and tenth centuries to have recourse to mystical interpretation of individual letters may be understood from Avicenna's philosophical alphabet by which he, partly deviating from the accepted Shia-Ismaili interpretation, showed his own philosophical views. In an Ismaili alphabet discovered by Henry Corbin the sequence of the first ten letters is as follows:

alif: al-amr, the Divine Order
bā: al-ᶜaql, Intellect
jīm: an-nafs, Soul
dāl: aṭ-ṭabīᶜa, Nature
hā: hayūlā, Material Substance
wāw: al-jism, the body
zā: al-aflāk, the spheres
ḥā: aṭ-ṭabā'iᶜ al-arbaᶜa, the four humors
yā: al-mawālīd, the nativities[82]

It thus gives a descending sequence leading from God to the lowest earthly manifestations, which is a logical outgrowth of Ismaili doctrine. Ibn Sina, on the contrary, begins his alphabet with *alif* as *al-bāri'* (The Creator in Himself) and follows the traditional sequence unto *dāl;* a second tetrad from *he* to *ḥā* contains the same concepts in relation to others, and the higher letters are explained in terms of their numerical value (2 times 5, or by adding up the numerical values of other letters). Thus, *qāf,* with the value of 100, would consist of *sīn,* 90, and *yā,* 10, and means "the gathering of everything on the creatorial plane". Ibn Sina interprets the unconnected letters of the Koran in much the same way: *Nūn wa'l-qalam* means, then, "an oath by the world of existentialization and that of creation," which is "everything."[83]

Massignon has accused Ibn Sina of having invented an artificial system against the traditional one, but tendencies to develop such new interpretations of the Arabic alphabet have remained common

to our day. And the mystical interpretation of each and every letter is a special feature of Islamic literature. There is even an interpretation of the alphabet in the Indian Sanskrit-based sequence developed in a branch of the Chishti-Sabiri order (see Appendix A).[84]

It is particularly the *alif,* with the numerical value 1, that has never ceased to intrigue the mystics. Standing tall and unconnected at the beginning of the definite article as at the beginning of the word *Allāh,* it is the Divine letter par excellence, as Hallaj said:

> The Koran contains the knowledge of everything. Now the science of the Koran is in its initial letters; the science of the initial letters is in the *lām-alif,* the science of the *lām-alif* is in the *alif,* and that of the *alif* is in the point.[85]

In Hallaj's system the point or dot is the primordial dot, which we have already encountered as the basis of creation, but it is also the dot in the calligraphic system of Ibn Muqla, which was developed during Hallaj's lifetime.

Since *alif* is the letter of Unity and Unicity, the true *faqīr* who has annihilated himself in perfect poverty and love can be compared to it:

> Known for lack of silver and famous for lack of bread,
> like a Kufic *alif* in nudity and nakedness.[86]

Thus says Sana'i, and two centuries later Yunus Emre in Anatolia compares the *erenler,* the men of God, to *alif*s: they are, like this letter, *āyāt-i bayyināt* (signs of clear proof).[87] *Alif* points to God who "is the *ālif,* the one who has connected (*allafa*) all things and yet is isolated from all things," as Sahl at-Tustari stated in the late ninth century.[88] Some decades earlier, Muhasibi had invented a fine myth to explain the high position of *alif:* "When God created the letters he ordered them to obey. All letters were in the shape of *alif,* but only the *alif* kept its form according to the image in which it was created."[89] ᶜAttar took up this idea in his *Ushturnāma:*

> This *alif* was first one in the origin;
> Then it produced the numbers of connection.

94

When it becomes crooked it is counted as a *dāl*,
When it puts another bent upon itself,
Then it becomes a *rā*, o ignorant one!
When the *alif* is bent like a reed,
Then its both ends become crooked, and it is a *bā;*
When *alif* becomes a horseshoe, it is a *nūn.* . . .[90]

That means that, just as everything came from God, who created Adam "in His likeness," so the letters emerge from the *alif*, which corresponds to man, created in God's likeness; but it is also true in general calligraphic terminology because of the similarity of the *alif* to a standing person and its role as the invariable point of relation for all other letters.

For Rumi, the *alif* was honored by being the first letter of the alphabet because of its unity and sincerity, and the lover who emulates it by becoming endowed with Divine attributes will be the first in line as well.[91]

But one should also not forget that in the formula *bismillāh* the *alif* of *ism* disappears in writing between the *bā* and the *sīn*, and therefore Sana'i expressed the secret of complete annihilation by comparing the mystic to "the *alif* of *bism.*" [92] Two centuries later, the Kubrawi leader Isfara'ini saw the "hidden *alif*" of the *bism* pointing to the *alif* of *Islām,* "which is hidden in the hearts of the faithful who have attained unity." [93] Sana'i knew well:

> With the *alif* there come *bā* and *tā—*
> regard *b* and *t* as idols *(but)*, and *alif* as Allah.[94]

Therefore, the *alif* was the only letter that was absolutely necessary to know, for as Yunus Emre says:

> The meaning of the four books is contained in one *alif.*[95]

That is a simple statement to which most popular Sufi poets would agree, but it was interpreted in the Hurufi tradition as meaning man, who in his stature resembles the *alif* and contains the entire meaning of the revealed books in him.[96] The poets never ceased using the *alif* for the slender figure of the beloved, and when Hafiz says in one of his most famous verses

95

There is on the tablet of my heart nothing but the *alif* of my
 beloved's stature—
What shall I do? My teacher gave me no other letter to
 memorize![97]

one can interpret the line on the worldly level as pertaining to a
human beloved and, on the religious level, the *alif* as the cipher for
Allah. Many poets, particularly in the popular tradition where book-
ish learning was despised, have therefore sung of the *alif*, the only
letter the mollas had taught them, which is enough for this life and
the next.[98] Why should they bother to read thousands of books or
"blacken the book of their actions" by reading and writing letters
that, as Qadi Qadan says, "suddenly appear like crocodiles"?[99] The
alif is the letter of Divine Wisdom and

> From Love even the crooked *dāl* becomes an *alif*,

as Rumi triumphantly sings.[100] When one adds to this plain state-
ment the idea that *alif* is a fiery letter and *dāl* an earthy one, the
image of transformation through Love becomes even more perti-
nent.

It should also not be forgotten that in the *ishtiqāq kabīr*[101] of later
Shia circles the very name of *alif* with its numerical value 111 (1–
80–30) was understood as representing the triad Allah (*alif:* 1), Mu-
hammad (*mīm:* 40), and ʿAli (*ʿayn:* 70), whose sum total is again
111.[102]

Respect for the *alif* was great in early Muslim thought, and one
understands why Ibn Hanbal condemned the claim of Sari as-Saqati,
his Sufi colleague in Baghdad, who stated that *alif* is the only letter
that did not prostrate itself at the time of the Covenant and is there-
fore the letter of Iblis, Satan.[103] (In fact, one of the strange aspects
of *alif*, for some Sufis, is that it is the initial letter of Allah, Adam,
and Iblis, thus containing a whole mythology in itself.)

But *alif* is also the first letter of *Aḥmad,* the "heavenly" name of
the Prophet Muhammad. Jami elaborates this idea in the first eulogy
for the Prophet in his epic *Tuḥfat al-aḥrār,* alluding to the fact that
the *alif* emerges from the dot, and that letters are measured by cir-
cles. He says:

96

The beginning of the foreword of this alphabet
Is the first letter which is in *Aḥmad:*
When the dot of Unity showed its stature,
And became an *alif* for Ahmad's sake,
The diameter of this upright *alif*
Cut the invisible circle of [divine] Ipseity into halves:
One half is the primordial world,
And the other half is the contingent world which looks toward non-
 existence.

That means, Ahmad = Muhammad stands at the meeting-place of the eternal and the contingent world, for he is the Perfect Man in whom both are reflected.

Speculations about *alif* and other letters were so commonly known in Islam that they could even be applied to religiopolitical facts. During Jahangir's time, Ahmad Sirhindi (d. 1624) in India claimed that by the end of the first millennium after the Hegira, which had just ended, the Prophet's name had changed, its first *mīm* being replaced by an *alif;* Muhammad (*mḥmd*) had become Ahmad (*aḥmd*). This shows that the practical, sociopolitical side of the Prophet's teachings had been replaced by an all too otherworldly interpretation of Islam, so that some religious leader must bring back the *mīm* and restore the faith to its pristine dynamism.[104]

The letter *mīm* has always been connected with the Prophet. The two *mīm*s of his name point, as ᶜAttar says, to the fact that "both worlds" are from him, for ᶜālam (the world) has only one *mīm* in its name.[105] Even more important in this connection is the name *Aḥmad,* by which the Prophet was called in reference to his quality of *perikleitos* (the most praiseworthy) in Sura 61/5. At least from the days of ᶜAttar a *ḥadīth qudsī* became prominent in the eastern Islamic world according to which God said, *Anā Aḥmad bilā mīm* ("I am Ahmad without the *m*, that is, *Aḥad,* One").[106] The mystics and the majority of the poets in the eastern tradition understood this to mean that it is only the letter *mīm,* the "shawl of humanity" as a Panjabi Sufi calls it,[107] that separates Ahmad/Muhammad from God, the One. Since the numerical value of *mīm* is 40, later Sufis took this *ḥadīth qudsī* to point to the 40 degrees of descent and ascent that man has to pass on his way back to his origin in God. Some medieval

authors have interpreted the *mīm,* in accordance with its round shape, as the *khātam an-nubuwwa* (seal of Prophethood),[108] and "everyone who wears a collar from this *mīm* walks like the ringdove constantly in the faith," as Amir Khusrau says.[109] Therefore, Baqli sees the *mīm*s as "belonging to the waterwheels of the oceans of Love, which have been from pre-eternity in the mystery of actions."[110] It is small wonder that the *mīm* has inspired a modern calligrapher-painter from Pakistan, Anwar Shemza, to create a meditative picture.

The letters *alif* and *mīm* are connected with God and His Prophet, respectively. This idea has recently been repeated in a mystical interpretation according to which *mīm* is "the bell," as the medieval

mīm in "bell shape"

authority on magic, al-Buni, found out. Its full shape indeed somewhat resembles a bell. The letter is therefore connected with the sound of the bell the Prophet heard at times when the revelation overcame him and thus appears as the letter of prophetic receptivity. It is, as Jean Canteins says, *la chute vers l'abîme* and is connected with the *laylat al-qadr,* the night of the first revelation of the Koran; the *alif,* in the words of this contemporary French writer, is *la chute vers le ciel* and thus corresponds to Muhammad's heavenly journey that led him into the immediate presence of God.[111] Again, in proto-Ismailism, the connection between the imam ᶜAli, the "adopted child" Salman al-Farisi, and the Prophet was expressed in speculations about the letters *ᶜayn, sīn,* and *mīm.*[112]

Alif and *mīm* occur throughout the whole mystical and poetical tradition, whereas the second letter of the alphabet, *bā,* is not so frequently mentioned. Sometimes it is contrasted as a modest letter with the proud *alif;* content with only one dot, it represents the unassuming, broken heart.[113] But in general it is the letter by which creation begins. It can be connected with the letters to its left so that words can grow out of it, and in the Shia tradition ᶜAli is seen as the dot beneath the *bā,* that is, the first manifestation of creation.[114] That fits well with its interpretation as "intellect" in the Shia and

philosophical tradition, the First Intellect being understood as the energy that, emanating from the Divine Essence, set things in motion—as the dot in calligraphy is the starting point for the pen's movement.

This act of creation has been expressed by the mystics with the symbol of the Divine Order *kun* (Be!) repeatedly mentioned in the Koran. Its two letters, *kāf* and *nūn,* could be seen as a two-colored rope, as Rumi says—a noose that deceives man so that he does not perceive the colorless unity that lies behind the multitude of created things.[115] A completely different interpretation of this creative Divine Word is found in the work of the Pakistani artist Sadiqain, who represents the letters *kāf* and *nūn* as a grand spiral nebula out of which the world emerges in stars and galaxies.

In the mystical tradition, the letter *he* plays a particularly important role. It is the last letter of the word *Allāh,* hence the letter of *huwiyya,* the Divine He-ness or Ipseity. In the Sufi *dhikr,* especially in

ة

hā', the letter of Divine Ipseity

the *dhikr* of the *shahāda,* the name Allah is finally dissolved until only the *h* remains, which is also the sound of human breathing.[116] Very typically, Ibn ᶜArabi saw the Divine Essence in the shape of a luminous *he,* carrying between its two arms the word *huwa* (He) on a radiant red background.[117] Many centuries later, the Naqshbandi mystic Nasir Muhammad ᶜAndalib in Delhi described the spiritual way man has to go in his meditations as a journey through the word *Allāh,* beginning with the *alif:*

> He sees the blessed figure of the word *Allāh* in the color of light written on the tablet of his heart and the mirror of his imagination. . . . Then he will understand himself as opposite to this form or beneath it or at its right or left side, and he should strive to bring himself toward this light. . . . And whenever he finds himself in the middle of the rank of *alif* and *lām,* he must proceed and take his place between the two *lām*s and then walk away from there and bring himself between the *lām* and the *h;*

99

and with high ambition he leaves this place too and sees himself in the middle of the ringlet of the *h*. At the beginning he will find his head in this ringlet, but eventually he will find that his whole self has found repose in this house and will rest there free from all afflictions and perilous calamities.[118]

Rumi may have thought of a similar experience when he sings:

> I have emptied my side from both worlds,
> I am sitting like an *h* beside the *lām* of *Allāh*.[119]

While the mystical content of the *he* was undisputed through the centuries, the letter *wāw* was less frequently discussed, although Najmuddin Kubra called it "the letter of connection between man and God,"[120] taking up the normal grammatical designation of *wāw* as *ḥarf al-ʿatf*. There is also a remark that it is "the ear of the Prophet."[121] For reasons not yet completely clear, the Turks developed a great love for the *wāw* and used it from about 1700 onward for decorative purposes. They may have been inspired by the numerous *wāw*s in the longer profession of faith, which was calli-

The longer Profession of Faith: "I believe in God AND in His angels AND in His books AND in His messengers, AND in the Day of Judgment, AND in the predestination that good AND evil comes both from God, and in the resurrection. I witness that there is no deity save God and that Muhammad is His servant and his messenger." Written as a sequence of *wāw* by a Turkish calligrapher in the early twentieth century

graphically often represented as a boat of salvation, with the *wāws* serving as its oars (*Amentü gemisi*). The first calligrapher mentioned as having drawn an enormous *wāw* in the mosque of Eyüp and in the Eski Cami in Edirne was the somewhat eccentric ᶜAbdallah Vafa'i (d. 1141/1728).[122] The Turkish *wāw*, as found on the walls of mosques but also as independent little calligraphic paintings, are sometimes filled with flowers; look at the observer with big eyes; or, written in mirror style, embrace each other. It has been speculated that, since the numerical value of *wāw* is 6, the double *wāw* may point to the twelve Shia imams; or, if one writes 6 6, they result in 66, the numerical value of the word *Allāh*.[123] If one could surmise that the speculations expressed in the cosmology of the Indian Sufis (see Appendix A) were known in Turkey, the solution would be easy, for there *wāw*, the last letter in their particular alphabet, corresponds to the *ḥaqīqa muḥammadiyya*, the "archetypal Muhammad."[124] Such interpretations, however, are mere musings, the correctness of which cannot be proved.

A particularly important letter in the mystical tradition is the *lām-alif*, originally a ligature but often considered to be a single letter—so much so that a tradition from the Prophet is quoted that a person who does not accept *lām-alif* as a single letter has nothing to do with him and will not come out of hellfire in all eternity.[125] While in early times *lām-alif* was frequently used in profane poetry to point to the quick succession of events or, more often, to tight embrace, speculations about its mystical value developed in the ninth century. Their first known expression is Abu'l-Hasan ad-Daylami's book ᶜ*Atf al-alif al-ma'lūf ilā'l-lām al-maᶜṭūf* ("The Inclination of the Tame *alif* toward the Inclined *lām*").[126] In this book the author, who flourished around the year 1000, discusses problems of mystical love, using a considerable amount of letter mysticism. Ibn ᶜArabi continued this tradition.[127]

At the same time, *lām-alif*, when interpreted according to its semantic content, means *lā* (no), which is most importantly the beginning of the profession of faith—*lā ilāha illā Allāh*—which was interpreted by some writers as the Greatest Name of God. Had not the Prophet seen these words written "in letters of flame on the forehead of the Archangel, on the diadem of his hair"?[128] Owing to its graphic form, the *lā* was interpreted by mystical writers as a broom

that cleans from the heart all worldly concerns[129] or as a sword that cuts the neck of mundane desire.[130] From here, the relation with ʿAli's famous double-edged sword *Dhū'l-fiqār* could easily be established. Thus, popular painting often shows the *lā* as a sword (but even the tail of the *yā* in ʿAli's name was sometimes formed as a double-edged sword).[131] Some mystics compared the *lā* to scissors, cutting off all relationships save with God; and Jami saw it as a crocodile that swallows everything that seems to exist besides God.[132]

The fact that by the simple addition of an *alif* this *lā* could be transformed into *illā*—the positive beginning of the second half of the *shahāda*—supplied the Sufis with innumerable possibilities for further interpretations, and they tried to instruct disciples how to "polish the sword of *lā* with the *alif-i ṣayqal*," that is, to give it a specific luster by transforming the negation of everything besides God into the affirmation of God's Unity and Uniqueness.[133]

Even in the daily routine of the Sufis *lām-alif* played a certain role. The dervish who assumed a special attitude when standing before his master for the *gulbāng* would look like a *lā*.[134] And the interpretation of the *shahāda* that, as Jami stated, is basically nothing but a threefold repetition of the word *ilāh* (God), leads into another, endless field of mystical thought and practice.[135]

Here one may also mention the special prayers that are formed by the repetition of various forms of one Arabic root, such as the *ḥā'iyya* prayer: *Yā muḥawwil al-ḥawl wa'l-aḥwāl ḥawwil ḥālana ilā aḥsan al-ḥāl* ("O you who changest the power and the states, change our state into the best state"), which has been used for decorative purposes in Turkey.[136]

The *ḥā' duaš,* written in Turkey in the nineteenth century

Thinking of all these possible interpretations, Sana'i discovered that the Koran begins with *b* (the *bā* of the *basmala*) and ends with *s*

102

(the *sīn* of *an-nās* in Sura 114), which two letters, taken together, form the Persian word *bas* (enough), proving that the Koran is enough once and forever.[137]

One special art that developed in early mystical Islam was the *ishtiqāq kabīr*, the interpretation of words according to the meaning or numerical value of their single components. Does not *namāz* (ritual prayer) consist of *n*, meaning *nuṣrat* (victory), *m* from *mulkat* (kingdom), *alif* from *ulfat* (intimacy), and *z* from *ziyādat* (increase)? Thus said Abu'l-Qasim in Samarqand in the tenth century,[138] and many centuries later the Persian Ismaili poet Khaki Khorasani interpreted the word *āmīn* (amen) as containing Adam, Muhammad, ᶜAli (through the final *i*) and *nūr* (all light).[139] The interpreters were, as this example shows, not very consistent in their choice of explanations and would even explain the same letter in a word according to different concepts so that they would agree with their ideas. That happens, for instance, in Turkish mystical texts.

It is understandable that the mystics applied their interpretative art particularly to the word *Allāh*. The Ismaili thinker Sijistani combined the four letters of the sacred name with the four elements: *alif* stands for fire; the first *lām* for air and the second one for water; and the round *h* represents the earth.[140] Hallaj has expressed his very personal interpretation of the name Allah in a short poem, in which he speaks of

> an *alif* by whose work the creatures are connected,
> and a *lām* that goes to *malāma*, [blame]
> then another *lām*, increasing in meanings,
> then a *he* by which I become enamored.[141]

His verses have been imitated by Ahmad Ghazzali, and the Egyptian Sufi Shushtari in the thirteenth century developed his ideas about the letters of *Allāh* in a charming popular *muwashshaḥ*. In the Ibn ᶜArabi tradition, Hallaj's verse was interpreted as meaning that *alif* points to Adam as the first human being, the first *lām* to ᶜAzazil, Satan, because he was the first to be blamed and became the model of the *malāmatiyya* who will perform outwardly blameworthy actions rather than pretend conformity with the external law and order to hide their high spiritual status. The second *lām* turns the negation

103

into a positive statement, and the *h* is understood as the Divine *lāhūt* and the human *materia, hayūlā,* from the union of which man gains his perfect nature. But we add with the author, "And God knows best."[142] There are even poetical riddles about the Divine Names that have been commented on time and again.[143]

These interpretations are continued even in our day by modern Western followers of Ibn ᶜArabi such as Léo Schaya. According to him, *alif* is "the only Real," the first *lām,* "the Pure Knowledge of Himself"; the second *lām,* "His knowledge of Himself through His all-embracing power"; and the *h* is, as almost everywhere, the Essence that rests in its Ipseity and is absolutely nonmanifest. Schaya adds to these basic statements further elucidations of the combination of the different letters of the word *Allāh,* the role of the vowel in the *iᶜrāb,* and so forth, all of them heavily charged with mystical meaning.[144]

Ruzbihan Baqli's speculations about Allah take the same direction but are always connected with Love, the central topic of his work. Thus, the *alif* of *Allāh* is the absolute uncreated Unicity that points to inseparable union, and *lām* is the beloved turned into a lover through its own love in its own love[145]—thoughts that hark back, in a certain way, to Daylami's *Kitāb ᶜatf al-alif,* which belongs to the same chain of Shirazi Sufism as Ruzbihan's work.

As the word *Allāh* has been interpreted in various ways, so has *Adam,* but here the general feeling is that the letters of his name represent the three movements of prayer, as the name of Muhammad is also often regarded as a representation of a person prostrating himself in prayer.[146] Even more important is the fact that the very name Muhammad and its derivatives Ahmad, Mahmud, and Hāmid, as well as the second half of the profession of faith (like the first half!), consist exclusively of undotted letters and thus furnished the mystics with a proof that the Prophet was all light, pure, and not stained by any trace of black dots.[147] Perhaps this was one of the reasons why people composed whole works in undotted letters, such as Fayzi's commentary on the Koran or a selection of forty *ḥadīth* with commentary.[148]

One may also mention here the importance of the vision of letters during the education of a Sufi. Thus, the Kubrawi mystic Isfara'ini

104

gave extensive answers to the questions of a disciple who had seen the *basmala* written in black or gold or blessings upon the Prophet in various styles of writing such as *muḥaqqaq, thuluth,* and Kufi.[149]

One understands that pious Muslims would like to make the utmost use of the *baraka* of the Koranic letters. Therefore, it is not surprising to find at the end of copies of the Koran prayers or pious sayings in which the meaning of the letters is explored. Sometimes it is an alphabet that contains exclusively allusions to Koranic sentences. *Th* would be *thiyābun sundus* (brocade garments; Sura 76/21), *kh, khālidīn* (eternally remaining [in Paradise]; Sura 3/15 and many others), and so on. Or, the calligrapher might write some general advice such as, "From *alif* the goal is that you be one with Allah; from *bā,* that you take blessing from the *basmala,*" and the like, as is said in a Turkish Golden Alphabet.[150]

Such Golden Alphabets seem to have been popular all over the Muslim world—the tenth-century Sufi alphabet that Arberry discussed contains twenty-nine definitions of Sufism in alphabetic order,[151] and Mustaqimzade was only one of the numerous pious calligraphers who would compose a *ṣalāt al-ḥurūf,* a letter-prayer, in thirty paragraphs.[152] In the regional languages of Pakistan, such as Pashto, Sindhi, and particularly Panjabi, so-called *Sīharfī* (thirty-letter poems) are an important genre in folk literature;[153] they are found (as *Alifnāma*) in popular Sufi treatises in Malayalam[154] as they are used by speakers of Swahili[155] and by early Turkish poets.[156] These poems are partly used to instruct the generally illiterate listeners in the secrets of the Arabic alphabet and to teach them that *alif* means Allah, *mīm* Muhammad, and *ʿayn* ʿAli (thus the beginning of one of Bullhe Shah's mystical songs). Thus, *kh* is the blameworthy quality of *khudī* (selfishness), while *fā* may tell of *fanā* (mystical annihilation) or *faqr* (poverty). The interpretations again vary greatly, and in Panjabi *Sīharfī* even Panjabi words are utilized for the alphabet, not just the religious Arabic or, less frequently, Persian expressions.

One has also to mention in passing the Sufis' attempts to create special codes, such as the mystical *balabaylān* language, in order to conceal the secrets of Sufi thought from the uninitiated.[157] Ibn Wahshiya's *Kitāb shauq al-mustahām,* which was first discussed by Jo-

105

seph von Hammer in 1806, contains a number of strange alphabets, from "antediluvian" to astrological, which must have been in use at least for purposes of magic.[158]

The early speculations about the meaning of letters were brought to their climax in the system of the Hurufis.[159] Is not the letter "a black cloud pregnant with knowledge"? And the pious were supposed to disentangle the meaning of these letters in which God had manifested Himself to man.

Fadlullah of Astarabad developed a doctrine in which everything was seen and explained under the aspect of letters (*ḥurūf*) after he discovered that the central letter of his name Fadl, *ḍād*, had the numerical value of 800/1397, the year in which he began to expand his ideas. Word is the supreme manifestation of God, and "the whole total of letters and of their numerical values, according to the *abjad*, is the total of all the emanating and creative possibilities of God and is God Himself made manifest."[160] Man was regarded as a copy of this Divine writing:

> The tablet whose quality is "well preserved"—
> this form is the face in the expressed speech.

Is it not amazing that the word *wajh* (face) has the numerical value of 14 and so has the word *yad* (hand)? And there are 14 lines on the face and 14 phalanges of the hand! And 14 is the number of the disconnected letters in the Koran and half of the traditional Arabic letters.

> The four eyelids and the two eyebrows and hair of the head—
> these are seven lines, O just God![161]

Those who have insight and have been granted *ʿilm ul-kitāb* (the knowledge of the book) can understand the secret written in the human face.[162] The *alif* is the equator that divides the face and is represented by the nose; the *bā* corresponds to the 14 innocent martyrs of Shia Islam and is located beside the nose—and thus the book of the face is interpreted one by one. The *sabʿ mathānī* (the seven double verses) that are mentioned in the Koran (Sura 15/87) are likewise connected with the face in its sevenfold and fourteenfold

106

manifestations. It was not difficult for Fadlullah and his followers to find enough Koranic statements that could be meaningfully interpreted according to his system. Thus, the eschatological description, "on the day that the sky brings evident smoke" (Sura 44/10), is understood as meaning "the appearance of the letters and the science of the letters, and the comparison of letters with smoke comes from the fact that the letters and the science of the letters become evident from the black line [or, script]."[163]

Even though the basic ideas of Fadlullah's Hurufi theories were common among the Sufis, he was executed for heresy in 1398. The arrogation of a quasi-prophetic rank for himself, reflected in his claim that the 4 special letters of the Persian language (*p, zh, ch,* and *g*) were specially granted to him to complete the alphabet of 28 letters given to the Prophet Muhammad, was certainly counted against him.

The subtle relations between man and letters had been well known to the mystics. Man was considered to be a manuscript, the external letters of which agree with this world while their inner meaning is related to the Divinity.[164] And long before Fadlullah's days the poets had compared the face of a beautiful beloved to a superbly written copy of the Koran, for both are equally flawless. Such imagery then becomes more common after 1400; thus, the Turkish Hurufi poet Nesimi calls out:

O you, whose eyebrow, eyelashes and musk colored hair is the *umm
 ul-kitāb:*
The Imam and spiritual guide for the true monotheists becomes
 the Koran [i.e., the face of the beloved].[165]

But ᶜAttar had already played with the term *khaṭṭ,* the "script" or "down," when he spoke of the *khaṭṭ* of the Koran copy of beauty, by which he intended the down on the face of the young beloved.[166] This remained a standard topos, to develop which the poets invented ever more eccentric comparisons.[167] ᶜImad-i Hurufi is only one of the numerous poets who wrote verses like:

The *khaṭṭ* ("script/down") which was sent down upon your cheek
is a *lām* which points [*dāll;* also the letter *dāl*] to the verse of mercy.[168]

107

Another poet goes even further when he describes the beloved in perfect Hurufi style:

Between the two eyes (*ᶜayn*) of the friend from the *nūn* of the
 eyebrows to the *mīm* [of the mouth]
The nose has drawn an *alif* on the face of silver.
No, no, I am wrong: by a perfect miracle
The finger of the Prophet has split the moon in two halves.[169]

For the face of the beloved is radiant as the moon, and Muhammad's miracle of "splitting the moon" (Sura 54/1) was very often quoted as one of the proofs of his spiritual power. Even in remote provinces of the eastern Muslim world Hurufi imagery was used at least to the eighteenth century, for a poet in Sind states:

Your face is like a Koran copy without correction and mistake,
Which the Pen of Fate has written exclusively from musk.
Your eyes and your mouth are verses and the dot for stopping,
 your eyebrows the *madda*,
The eyelashes the sign of declension, the mole and the down the
 letters and the dots.[170]

One of the most famous poets to write in this strain, and for whom this imagery was probably more than a mere poetical convention, is the founder of the Safavid kingdom in Iran, Shah Ismaᶜil Khata'i, regarded by the Bektashis in Turkey as one of their great poets. In his Turkish verses, which were meant to attract the Turkish tribes in the border zone between Iran and Anatolia, we find lines like:

O you, whose sign [*āyat;* also, "Koranic verse"] is the title page of
 the primordial *dīvān*,
the *ṭughrā* of your eyebrows is the *bismillāhi' r-raḥmāni'r-raḥīm*.[171]

The expression that the eyebrows or eyes are the *ṭughrā* for the book of the face remained common among mystics and poets. Even an eighteenth-century Naqshbandi mystic like Mir Dard of Delhi, who certainly had no Hurufi connections in the technical sense of the word, described man as the seal of creation: "The *alif* of his stature

108

points to God's unity, and the *ṭughrā* of his composition, that is, the absolute comprehensive picture of his eye, is a *he* with two eyes which indicates the Divine Ipseity."[172]

The Turkish poet Fuzuli, whose verse is almost a compendium of religiously tinged imagery in use in the sixteenth century, skillfully expands the comparison of the face to the Koran by alluding to the art of *tafāʾul* (prognostication):

> My intention (*niyya*) is to give up my soul when I see your face:
> opening the Koran copy of your face, let my omen be blessed![173]

That means that, when the beloved unveils her radiant beauty, the lover will fulfill his intention to die before her from happiness.

Mystically minded poets have always delighted in inventing cross-relations with Sura 12, the story of Yusuf, called in the Koran itself "the most beautiful tale." Thus, the love story that the heart reads from the beloved's eyebrows resembles Sura Yusuf written in the vault of a *miḥrāb*[174] (which the arched eyebrow resembles, the face of the beloved being the direction to which the lover turns for his prayers). Amir Khusrau, who composed this elegant verse, also claims that he constantly talks about the eyebrows and eyelashes of his beloved, "like children who learn the sura *Nūn waʾl-qalam* in school."[175] For the friend's eyebrows resemble an inverted *nūn,* and her eyelashes are sharp and black like pens. He also compares the "page of the face" to a Koranic verse or sign (*āya*) of mercy that induces man to exclaim "Praised be God!"[176]

In mystical tradition, the sura *Waʾḍ-ḍuḥā,* "By the Morning Light!" (Sura 93), is also compared to the radiant face[177] but almost exclusively to the face of the Prophet, as done so ingeniously by Sana'i in his poetical commentary on this sura.[178]

Such rather stereotyped images could become more colorful in the hand of a great master, even though they sometimes seemed to border on blasphemy. Long before the Hurufi movement started, Khaqani said:

> Since it is fitting to write the book of God with red and gold,
> it is without doubt fitting that you wear red and yellow![179]

But when a seventeenth-century Indian poet declared,

Your stature is in uprightness [*rāstī;* also "correctness"] all the word
 of the Prophet,
Your *khaṭṭ* ["down/script"] is esteemed valid, like the Divine word,

his biographer cannot help exclaiming, "He said this because he was
misguided—may God forgive him!"[180]

The tendency to equate human figures to letters developed logi-
cally out of the art of calligraphy. One has to remember that some
technical terms in calligraphy point to the similarity between human
beings and letters. *Tahdīq* (making eyeballs) is used for producing
the correct openings of some rounded letters,[181] and the arrange-
ment of lines of letters should be organized "until it looks as if they
smiled and showed front teeth that are wide apart from one
another"[182] (a traditional mark of beauty). A modern Turkish au-
thor, Ismayil Hakki Baltacıoğlu, has elaborated such comparisons in
his book, *Türklerde yazı sanatı,* and has tried to show not only that
some letters can be drawn in human shapes but that letters, too, like
humans, seem to have empathies and antipathies, so that one should
never try to combine the "inimical" letters when working at a perfect
calligraphic representation.[183]

From here it is not far to the "talking letters" that one sometimes
encounters on metalwork, predominantly from the eleventh and
twelfth centuries.[184] A contemporary of Husayn Bayqara and Babur
in Herat invented letters that looked like animals and human
beings.[185] In the Hurufi tradition as it was continued in the Turkish

Human face, made up from the words *Allāh, Muhammad, ʿAlī, Ḥasan,*
and *Ḥusayn.* From a Bektashi convent in Turkey. After Kühnel, *Is-
lamische Schriftkunst*

Bektashi order, the pictorial representations of the name of ʿAli be-
long to this tradition; but even a strictly Sunni mystic like Nasir Mu-
hammad ʿAndalib in Delhi claimed that "ʿAli is written twice in the
face."[186] Faces composed from the names of Allah, Muhammad, and
the first three imams (ʿAli, Hasan, and Husayn) belong here as much

"ᶜAli is written twice in the face." Bektashi picture, Turkey nineteenth century. After Arseven, *Les Arts Décoratifs Turcs*

as the figures made up of sacred words as they were common in Turkish folk tradition.[187] The Hurufi idea that man is a microcosm that could be represented by letters certainly played a role in the development of this art.

Oriental calligraphers—and here the Turks seem to have been most inventive—created ingenious pictures of living beings built up from pious ejaculations and sacred formulas. Pigeons composed of the *basmala* remind us that in the mystical tradition the pigeon is one of the numerous soul-birds and constantly says *kū kū* (Where, Where?)[188] or attests, in the Turkish tradition, *hū hū* (He, He!) like a true dervish. Sana'i had invented the Litany of the Birds (*Tasbīḥ aṭ-ṭuyūr*) in which the sounds of each bird are interpreted religiously;[189] and from this time, around 1100, these ideas permeate mystical thought and poetry, culminating in ᶜAttar's *Manṭiq uṭ-ṭayr*. The stork with his *lak lak lak* repeats the attestation *al-mulk lak, al-ᶜizz lak, al-ḥamd lak* ("Thine is the kingdom, the power, and the glory"),[190] and therefore the pious bird was a fitting calligraphic symbol. It seems that Mustafa Raqim, Ottoman *qāḍiᶜaskar* and master calligrapher, drew his famous stork first in 1223/1808.[191] The

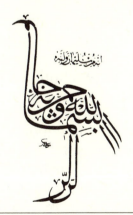

Basmala in the shape of a stork. Turkey, nineteenth century

111

rooster too has been used for calligraphic pictures, for he is not only an important religious bird in the indigenous Iranian tradition but also an angelic animal that calls Muslims to their morning prayers.[192] A contemporary *basmala* of a swan, used by a leading Ceylonese Sufi master, reminds the reader that he should be, like a swan, diving for pearls in the ocean of Divinity.[193] And ᶜAli, with

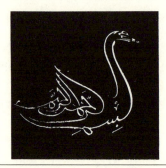

Basmala in the form of a swan, invented by H. H. Bawa Mohaiyuddin, Sri Lanka, ca. 1978

the surnames Haydar or Ghażanfar (the lion of God) appears in numerous pictures that represent a lion made from either the *basmala* or the *Nādi ᶜAliyan*. One of the first known *Nādi ᶜAliyan* lions was drawn by no less a master than Mahmud Nishapuri, Shah Tahmasp's favorite calligrapher.[194]

Flowers also served calligraphers to represent pious words, and sometimes one finds the *gul-i muḥammadī,* which contains the Prophet's family tree or his ninety-nine names or is made up from the words Allah, Muhammad, and ᶜAli.[195]

Lamps were created from letters to remind Muslims that God is the light of the heavens and the earth; and pictures of sacred buildings, especially mosques, were often constructed from the profession of faith and perhaps some additional formulas, in square Kufic. In dervish circles, the *tāj,* the headgear of the dervish, was frequently created from the name of the founder of the order. The Mevlevi *sikke,* containing the invocation of Maulana Rumi, has become a much-sought-after souvenir in Konya.

Circular formulas served for meditative purposes, and the roses formed by the final *sīn*s of the last sura, or the mandalalike repetitions of the formula *lā ilāha illā huwa* in modern Persian calligraphic

112

drawings, serve as much to draw the mind toward the Divine mysteries as do the mirrored, sometimes even fourfold reflected tablets with the invocations of Divine Names or of the *sūrat al-ikhlāṣ,* as they are frequently found in Ottoman mosques.

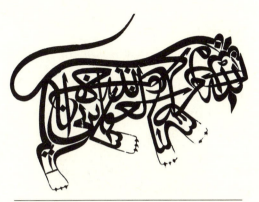

Lion, made of Shiite invocations

One of the finest expressions of these mystical dimensions of calligraphy is a Persian piece that looks almost magical. The letters are filled with tiny flowers and leaves in delicate colors, and the lines contain two verses of the Koran that are at the heart of mystical Islam: *Allāhu, lā ilāha illā huwa, kullu shay'in hālikun illā wajhuhū* ("God, there is no deity but He; everything is perishing save His face"; Sura 28/88). For the Sufis, who delved so deeply into the secrets of the letters and invented ever new explanations of each letter, reached the point where they understood that letters are, as Niffari said as early as in the tenth century, "pure otherness, which symbolize everything as far as it is 'Other,' *siwā,* in connection to God,"[196] and they found that the letter is "radically incompatible with the quest for the Absolute." The blind who touched the elephant described this animal (in Sana'i's and Rumi's tales a symbol of God) "sometimes as an *alif,* sometimes as a *dāl,*"[197] but nobody knew what the whole elephant looked like. The Sufi knew that a rose, *gul,* cannot be plucked from the letters *g* and *l* and that *ᶜishq* (love) is more than the combination of the letters *ᶜayn, shīn,* and *qāf,*[198] even though they might strive to explain each of these letters in hundreds of different ways. But finally they would wash off all their learned pages once the beloved appeared to them; as Nizami said:

113

I studied a hundred learned manuscripts—
When I found Thee, I washed off the pages.[199]

For the mystics' goal, as expressed by Yunus Emre, is:

> to drown in the ocean
> to be neither an *alif* nor a *mīm* nor a *dāl*,[200]

for all the letters, written so beautifully and interpreted so meaning-fully, are in the end nothing but thorn hedges that hide the Eternal Rose[201] and, as Rumi exclaims:

> Every pen is bound to break
> once it reaches the word Love.[202]

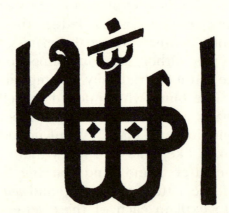

Allāh, from the mausoleum of Shah Daulat, Maner (India), early seventeenth century

<div style="text-align: right;">

IV

</div>

<div style="text-align: center;">

Calligraphy
and Poetry

</div>

How beautifully appeared from this tress and cheek and lovely face
firstly ink, secondly a dot, and thirdly a writing.[1]

Thus says Amir Khusrau around 1300, using a kind of imagery that
had been a favorite with Oriental poets ever since script became a
central issue in Islamic culture. Even though more than one orien-
talist expressed his utter dislike for these "silly games" in which the
poets used metaphors from the sphere of writing,[2] they form part
and parcel of Islamic poetry, and many a poet may have sighed, like
Ghalib:

O Lord, why does Fate obliterate me?
I am not a letter that can be repeated on the tablet of time![3]

From early days onward the literati observed the scribe and were
well aware that his pen was able to perform strange miracles. By the

115

گوز

کور

سنور

سبور

omission of one dot he can "blind the eye" (as in Turkish, by writing *kŏr* instead of *gŏz*, which are discerned only by one dot),[4] and already in the tenth century Hamza al-Isfahani quotes even more terrible events that took place because of a misplaced dot, not to mention the misreadings of important texts such as Prophetic *ḥadīth*[5]—by the movement of a single dot the tradition would permit a person to perform his prayer "while he has a cat (*sinnaur*) in his sleeve," whereas the correct reading should be "a small wooden slate (*sibbūr*)."[6] And while such misreadings and wrong punctuations were a source of great concern for the scholars—and may have helped create the popular saying, *kullu khaṭṭāṭin jahūl* ("every calligrapher is ignorant")—literati and poets enjoyed playing with them in order to create a glittering net of ambiguities or to produce riddles and conundrums, the solving of which seems almost impossible to the modern reader but that even the greatest poets of Iran, such as Jami, indulged in with great zest.

Besides these wordplays, which form an integral part of the rhetorical art of *tajnīs* (paronomasia), poets utilized everything connected with writing for their comparisons, either by inventing clever similes for pen, paper, or ink, or by interpreting different facets of life with images taken from this sphere.

It appears that both Arabic and Persian poets were particularly fond of comparisons with the pen, that mysterious instrument that is "one of the two tongues" (namely "the tongue of the hand")[7] and that had also, as has been seen, an important religious connotation. Sometimes the images are powerful, as when a great poet like Kalim complains in a fine antithetical verse about his old age, which makes him

Like a child just learning to write, whose pen the teacher takes [in his hand],
Thus I drag my cane on the ground with the help of others.[8]

But such striking, melancholy verses are rare; the pen is more frequently imagined as someone who rides (on the fingers). An Andalusian poet describes the pen as a hero riding in a coat of mail of ink,[9] while his colleague combines somewhat contradictory images when he claims that such a riding pen, as lean and tearful as he

116

himself, resembles a salesman who sells one necklace of pearls after the other (in writing accurate lines with harmonious letters).[10] He could therefore flatter a generous master by stating:

If your script is pearls, it is not unusual,
For your hand is an ocean, and the ocean casts pearls [on the
 shore].[11]

One could easily assemble a whole anthology of verse in which the poets praise their pen for the miracles it wrought. Sa'ib claims with a strange combination of images:

 In the work of love I strive like Farhad—
 I practice madness with the steel pen![12]

The steel pen here corresponds to Farhad's ax by which he dug up the rocks to produce a canal for the milk of Shirin's herds.
 The Sufi idea of the obedient pen is common among nonmystical writers, who borrowed it for more worldly purposes. Thus Salman-i Savaji describes the faithful lover:

 We, like the pen, do not want to turn away from the friend–
 One sign from the friend, and we run on our head![13]

This is commonplace; but two centuries earlier, Mas'ud ibn Sa'd-i Salman in Lahore gave the image of the pen a different twist, which may be attributable to his Indian background:

[The pen] bound the infidels' girdle and became a worshipper of
 pictures:
For this reason the master cut its neck.[14]

It seems that the connection of the pen with the "country of the infidelity" was known as early as in 'Abbasid Baghdad. Someone who sent some pens to the vizier 'Ali ibn 'Isa, "which long to visit your finger tips," described them poetically as "being of the color of negroes and coming from the land of infidelity, but intent on guiding the people aright."[15] Is it not strange that this mute one talks

clearly and, when it speaks secretly in Mecca, its talk is known in Syria?[16] And the qualities of the pen as a proper Muslim were stressed more than once in early Arabic poetry. The pen in a master's hand is

> . . . a virtuous one, who performs genuflexion and prostration;
> A useful one, whose tears are flowing,
> who performs the five [prayers] at the right time,
> and exerts itself in the service of the Creator.[17]

Very often the pen and the sword are related; after all, the perfect prince is the *ṣāḥib as-sayf wa'l-qalam* (the lord of sword and pen), as many inscriptions attest (even though some of the Mamluk rulers who bore this title were completely illiterate). Bada'uni quotes a line by an otherwise unknown poet who praises a hero:

> [His sword] cleaves the helmet as the pen divides the columns on the page,
> and with the red blood, draws a ruled column on the page of the battlefield.[18]

Much earlier, Anvari had eulogized a patron with the daring image:

> From the letters of your sword appear the signs (*āya*) of victory;
> the composition of the verse (*āya*) is from dotted letters.[19]

That is, the drops of blood shed by the prince in battle look like the letters in the Koranic verse *innā fataḥnā* (Sura 48/1), most of which have diacritical marks.

The martial imagery continues with numerous comparisons of the pen with a lance (*rumḥ*),

> with which "conquest" is written, and whose pages are the enemies . . .
> and which writes lines with the fresh blood of the enemies . . .[20]

Such expressions are found even in the most famous eulogy for the Prophet, Busiri's *Burda*.[21]

118

As the shape of pen and lance resemble each other, comparisons with arrows likewise offered themselves easily, all the more since the slender long *alif*s and *lām*s the pen produced, particularly in the *muḥaqqaq* and *rīḥānī* styles, enhanced such analogies.[22] That is why Kushajim in tenth-century Aleppo boasted that his right hand "shoots broadside at books,"[23] which includes an allusion to the early, broad shape of codices that was still common for Korans in his time.

When Nizami sees the ten fingers of his heroine, Shirin, as ten pens with which the order to kill is metaphorically written (for each movement of her finger causes the death of a longing lover),[24] he surpasses the more practical comparisons of the Arab poets by far, and the image seems even more farfetched than Fuzuli's idea that every eyelash of his is a pen when it comes to writing the commentary of (the book of) his grief.[25] Comparisons among pens, arrows, and eyelashes are not rare in later verse, but Fuzuli is particularly found of such complicated images. The basis for this imagery may be found in the remark of al-Ma'mun's secretary: "Tears on the cheeks of chaste young women are not more beautiful than the tears of a reed pen on a page."[26]

It was certainly logical to compare the pen to a goldsmith and its product to jewelry,[27] or to see the pen as lean and emaciated like a true lover, growing thinner (as the poet thinks) because its beloved, the Inner Meaning, recedes from it[28]—a skillful way of expressing the position of every author who feels that no words can fully convey the spirit and true meaning of his thought.

Yet the pen is, as the Turkish poet Na'ili says, "without tongue, but in the vat of the inkwell it is a Plato."[29] (The Oriental tradition replaces Diogenes in the vat by Plato who, in Turkish folklore, appears as the master magician.) Even more, the pen is, according to Nizami, a strange dragon that produces jewels, whereas the dragon usually sits on the treasure and rather hides the jewels.[30] Related is the idea that the pen is a serpent, able to produce poison and antidote;[31] or it resembles a lion in the dark forest of the inkwell.

From here, it is not difficult for the Persian poet to reach other sets of images. Khaqani speaks of the *nayistān* (reed thicket) of the inkwell; and the pen recedes, like a lion, into its native reed thicket.[32] Furthermore, the pen being indeed made from reed, its combination with sugarcane came naturally to the poets, and again Khaqani

claimed that the inkwell is filled with sugar so that the lions are completely indebted to the cane sugar that emerges from the pen.[33] A century later, Amir Khusrau sees it differently. The reed becomes so sweet in describing the patron that the pen turns into sugarcane, which the poet then happily chews.[34]

A much more common image is the combination of the reedpen with the reed flute, and everyone who has studied at least the introductory verses of Rumi's *Mathnawī* remembers the praise of the reed flute that reveals the secret of love and longing and casts the fire of love into the human soul. The reedpen could do the same; like the flute, it is separated from the reed bed, and like the flute it is hollow ("with an empty stomach") and is filled with sweetness when conveying the words of love. Both tell the secrets that are in man's mind: the pen puts them on paper in undulating lines, and the flute expresses them in undulating strains of notes, as even a modern European writer, Louis Aragon, has stated: "From the reed the musical line and the written line have emerged, the flute and the pen."[35] This maxim was rightly placed at the beginning of one of the finest recent works on Arabic calligraphy—Hasan Massoudy's *Calligraphie Arabe vivante.*

Good calligraphy certainly has a musical quality, whether the stiff letters of an early *ṭirāz* inscription as described by Arthur Upham Pope ("The verticals in this tall type are marshalled in a processional rhythm")[36] or the lines of *nastaʿlīq* that seem to dance to the inner rhythm of a Persian poem.

The whole education of calligraphers and musicians is very similar, a fact to which Tauhidi had already alluded:[37] the formation of *silsilas* or *gharānas*, lineages of artists, often in the same family; the meticulous observance of the technical details in the preparation of the utensils; and the strict canon of the alphabet and the musical scale, out of which the true master could develop the lines of script and melody, respectively.[38] It is not surprising that many calligraphers are known as musicians, and Mir-ʿAli of Herat was well aware of this connection when he sighed:

From a lifetime of calligraphic exercises my stature became bent
 like a harp
For the script of me, the dervish, to become so perfect [lit., "reach
 this canon"].[39]

Does not the pen sing and divulge secrets like the flute?

> Woe to the hand of the pitch-daubed pen,
> which revealed my heart's secret to friend and foe!
> I said: "I'll cut its tongue so that it be mute!"
> I did it—and now it's become even more eloquent! [40]

The allusion to the *ifshā' as-sirr* (divulgence of the secret of Divine Love and Unity), for which Hallaj had to suffer, is clear in this verse. The martyr-mystic also became more eloquent, and his voice was heard better after his head was cut off.

For the poets, however, these simple and often touching comparisons were not enough. Not only did they hear the melancholy song of the reed flute from their reedpens, but even the sound of the trumpet of Israfil seemed to rise from the scratching of their pens:

> The blowing of the trumpet is the sound of his pen,
> a blowing of the trumpet which is not in the Koran.
> For that [Koranic] blowing gives resurrection to him whose body
> is a sacrifice in the lane of death;
> But this one gives life to the one whose heart
> is killed by the events of [our] time. [41]

To return to more earthly images, many poets have spoken of the pen as producing a veritable garden by its tears:

> As though it were a flourishing garden where the morning drops
> fall in rains,
> a garden, smiling, about which the clouds weep, with camomile
> laughing like a beautiful mouth. [42]

It goes without saying that such similes are frequently used when a specific calligrapher's work was praised for its beauty. [43] An early master, quoted by Tauhidi, had claimed that handwriting without dots and diacritical points is like barren soil, while with these signs it is like a garden in bloom. [44] Thus, an Andalusian poet saw the whole earth in spring covered with vegetabilian writing among which the flowers looked like the dots that make the difficult text understandable—a very fitting comparison, since the vowels and marks were

written in color.[45] The comparisons of garden and page become even more meaningful when the illumination became more elaborate, so that Rumi's little ant (whose story was related in Chapter 3) was certainly justified when she took the page for a garden. The very name of the *rīhānī* script, which inevitably reminded poets of sweet basil (*raihān*), made the image even more convenient. Of course, it was elaborated and twisted by later Persian and Indian poets so that Munir Lahori in the mid-seventeenth century could say, quite elegantly:

The spring cloud makes its ruler from the threads of rain,
When the air writes the description of the rose on "cloud paper"
 [i.e., marbleized paper].[46]

The poets, who described the miraculous work of their pens,[47] were of course also interested in the quality of their ink and inkwells. The inkwell not only appeared to them as the native reed thicket to whose humid depth the pens would recede time and again, but sometimes it became personified—it is a black woman making love with her sons (i.e., the pens) or a king on his throne;[48] the ink, then, was either its milk or its saliva, or else a mixture of honey and poison, because sweet and bitter words could be written with it.[49] Persian poets loved to compare the inkwell to the fountain containing the Water of Life: Did not the ink with which they wrote their poems make them immortal? And since the Water of Life is found in deepest darkness, the image is correct, for the ink contained in the *dawāt* was certainly black.[50]

In describing the various qualities of their ink, Persian poets, particularly those of the *sabk-i hindī* in late Moghul days, invented the most outré images. Making their ink from the pupil of their eye,[51] they would send the letter through the hands of tears toward its destination, or they would burn their bones to produce ink in order to write correctly about the fire of love.[52] Ghalib claimed that only ink made from the shadow of the Huma bird was fitting for the description of his unhappy state.[53] As is well known, the Huma's shade transforms the person touched by it into a king. But it is interesting to note that Kushajim, who was of Sindhi origin, once remarked in a poem that his ink reminded him of his dark-skinned Indian grandfather.[54]

122

Writing material also is often alluded to in poetry. Not all poets speak of "the pages of the day which are sealed by dew drops,"[55] as a seventeenth-century Turkish poet did, but "the pages of the sky" are quite frequently mentioned. Nor did all of them follow the example of Abu Nuwas, who praised the paper because it can carry love letters and has been touched by the fingers of the beloved.[56] Writing material occurs in the earliest-known Arabic poems. Qays ibn al-Khatim alludes to "traces like the lines of gilded parchment";[57] and parchment inspired more than one ancient Arabic poet to compare it to the *aṭlāl,* the deserted dwelling places of friends.[58] The wrinkles on very thin leather are certainly reminiscent of a desert scene. Likewise, pieces of leather or cloth with writing on them are mentioned in pre-Islamic Arabic verse.[59] When Minuchihri in Iran takes over this image in the late tenth century, he cleverly connects it again with *aṭlāl,* which for him, however, look like the *tauqīᶜ* (chancellery script) of the Sahib (Ibn ᶜAbbad) on top of a document, while the garden reminds him of "lines of the scribe on paper."[60] Leaving the desolate campsites to the Bedouin poets and their imitators, Ibn al-Muᶜtazz turned to comparisons closer at hand for a prince in Baghdad, namely to a drinking scene, and saw the wine mixed with water as producing "lines with unknown words."[61]

As the poets in the Persianate world would describe their wondrous pen and ink, they also praised their paper so that the continuous rhyme *kāghidh* (paper) is found in quite a few *dīvāns* of medieval and, especially, postmedieval poets. Only rarely is a negative remark found, such as the curse quoted by (the usually pessimistic) Mustaqimzade:

> When someone has—like paper and pen—
> Two tongues and two sides of speech;
> Blacken his face like that of paper;
> Cut his head as if he were a pen![62]

An interesting remark about writing on colored paper is found as early as in Biruni's *Kitāb fī'l-Hind:*

One would think that the author of the following verses meant the Hindus:

123

> How many a writer uses paper as black as charcoal,
> while his pen writes on it with white color. . . .[63]

We have already mentioned some of Khaqani's witty allusions to paper that always prove the imaginative strength of this writer. One of his finest comparisons is of the rainbow in the evening "producing a *ṭughrā* in seven colors on Syrian paper"[64] (note the pun *shāmī*, "Syrian," and also "related to the evening"). Four centuries later, Fuzuli complains in Turkish that his red tears write his state on the canvas of his eyes, not realizing that one cannot read something that is written with blood on a red page; his eyes are already so red from weeping that the tears remain invisible.[65]

In Shahjahan's time, Kalim speaks of the *kāghidh-i bād,* the extremely fine paper used for pigeon post,[66] but he seems also to be the first, and certainly the most eloquent, Indo-Persian poet to use the term *abrī* (cloud paper) in his verse. He must have been acquainted with the marbleized paper that was so highly prized in Moghul and Deccani art from the early seventeenth century onward. There is even a poetical description of a papermill in Kashmir from that period.[67]

"Cloud paper" could easily be connected with the poet's weeping eyes, which resemble clouds, as Umid addresses his beloved:

I shall write from now on my letters on cloud paper
so that you may become acquainted with the state of my weeping
eye![68]

Kalim, more matter of fact, sees the rivers as a scroll of *abrī* paper,[69] and on a cold winter day in Kashmir the ducks looked to him like designs of cloud paper on the white paper "ice"[70]—a good observation, for there are enough examples of pictures of marbleized paper worked into the white ground.

For Bedil, cloud paper becomes a symbol of imitation and lifelessness (as the "picture in the bath house" or the "lion on the wall" had been symbols of lifeless beings in earlier centuries):

The problem of the stingy person is the imitation of the generous
one:
Where is the cloud paper, when the cloud has water?[71]

124

The comparison of generosity to water or life-bestowing rain is a traditional image. Compared with true generosity, what can a miser offer but soulless words? In a related image, Bedil says:

What can greed hunt from the hiding place of opportunity, O Lord! since the kindled paper does not become a leopard! [72]

The *kāghidh-i ātashzada* (kindled paper) is a favorite term in Indo-Persian poetry from around 1680 onward, because it seemed to be a symbol of transitoriness, of dying in a moment of rapture:

Like kindled paper we are only guests of *baqā* [duration, eternal life].
We are the wing-spreading peacock of the garden of *fanā* [annihilation]. [73]

The kindled paper may sparkle for a short moment like a fierce leopard or a proud peacock, but soon it will be reduced to ashes. In Ghalib's poetry, this term is repeated over and over, and the poet's burning heart seems to manifest itself in the burning spots on the paper. [74] The beginning of this imagery may be traced back to Rumi, who once wrote:

If [the lover] would stitch a piece of paper to a bird's wing, the bird's wing would burn from the heat of that piece of paper. [75]

The idea—not the wording, which is found only in Indo-Persian poetry—seems to go back even further. [76] Poets all over the Muslim world have claimed that, when they wanted to write a love letter, either the fire of their heart or the heat of the pen would burn the paper, while the stream of their tears would dissolve it—words repeated dozens of times from Andalusia to India. The paper may become wet from tears because the poet is jealous of the pen that writes the name of the beloved; [77] the poet may have wrapped burning coal—that is, his heart—into the paper so that the letter carrier may weep about his state. [78] Salman-i Savaji is more modest when he claims:

In separation from him I write a letter with my own hand.
The pen weeps blood, and the writing puts dust on its head.[79]

But more frequently the poets—from ninth-century Sufis in Iraq to nineteenth-century scholars in India—used to write their love letters with red tears on the parchmentlike cheeks "so that someone who cannot read well can read them";[80] and at times the combination of a fiery heart and a weeping eye may even prove useful:

If there were not this fire, my tears would wash off the writing,
and if there were not the water, the letter would burn.[81]

Since such letters would "burn the wings of the pigeon that carries them,"[82] the last poets of the Indian style would not even need a pigeon but would bind their letters to a peacock's tail, which resembles kindled paper.[83]

Ghalib, as usual, reaches the height of hyperbole when he states that his pen runs over the paper with such a heat that fire flares out of it so that he can make his own ink from the smoke and the soot that rise from his paper—certainly a most practical method![84]

It is relaxing to return from these convoluted ideas to the simple statement of Qadi Qadan, the Sindhi mystic (d. 1551), who expressed the secret of loving union with the line:

As paper and writing on it have no distance between them,
So are my beloved and myself![85]

Every calligrapher knew that ink can be washed off (as mentioned in previous chapters). Not only mystical poets alluded to this fact. Abu Nuwas around 800 addressed his young boyfriend:

O you, whom I have kissed and who wiped off the kiss—
Are you afraid that one could read the letters of its alphabet?[86]

A century later, Kushajim went even further when he looked at a charming boy who licked off the wrong letters from his practicing sheet: O that he himself were the paper and the boy would make many, many mistakes![87] Later, the poets would rather "wash off the

126

alphabet of speech from the tablet of life," as Khaqani says to explain his silence;[88] or they felt like a child who has to wash off the slate again and again because he forgets everything he has seen.[89]

As much as the *masṭar,* the ruler made of silk thread, was in use from early days, it appears rather late in poetical language and is particularly prominent in the *sabk-i hindī.* Again, Kalim seems to be especially skillful in the use of this image:

> My bed has acted as a ruler for my side—
> I have drawn the line of oblivion over the story of obesity.[90]

That is, he had become so thin that his ribs look like lines produced by the *masṭar* while he, ailing, was confined to bed. To cross a word out with a simple line is still common. Kalim also uses the image to highlight the importance of content over form:

> Be right inwardly, and be not decorated outwardly.
> The meaning of the Koran copy does not become crooked when it
> is [written] without a ruler.[91]

It is thanks to the *masṭar* that the script can become *kursī-nishīn,* that is, properly placed,[92] and,

> Everyone who has to write a copy of the "Etiquette of Poverty"
> uses the stripes of the reed mat as a *masṭar* for the page "body."[93]

The reed mat as used by the Sufis is the true dwelling place for the man who hopes to achieve spiritual poverty, the fundamentals of which he writes, as it were, by applying them to his own body.

As allusions to the implements of writing are found in every Islamic land, images taken from other aspects of writing are also frequently used. Muslim writers were well aware that the script of their Christian neighbors went from left to right, that is, *tars,* the wrong direction. Therefore, allusions to the *khaṭṭ-i tarsā,* the backward Christian writing, are found in Khaqani's verse (who in general had a thorough knowledge of Christian customs).[94] Naziri in India used them likewise,[95] while the Turkish writer Sami in the eighteenth century sees the tablet of the spheres containing a writing like the

127

khaṭṭ-i tarsā, a pun that is meaningfully used in a poem about the infidels of Balyor.[96]

Much more popular than these rather exotic images are allusions to the names of the master calligraphers Ibn Muqla, Ibn al-Bawwab, and Yaqut, who became as standardized as the figures from the Koran or the *Shāhnāma* in the repertoire of Persianate writers. Luckily for the poets, Ibn Muqla could be interpreted as "son of the eyeball"; Ibn al-Bawwab is the "doorkeeper's son" but is often called by his second name, Ibn Hilal, *hilāl* being the crescent; while Yaqut means "dark red ruby." These particular points were combined with the general puns on *khaṭṭ,* which is both "script" and "down."

In the Arabic tradition, Qalqashandi quotes verses that were echoed in Iran and Turkey as well:

My tear makes beautiful lines on the page of the cheek,
and how should it not do so, since it is Ibn Muqla [= the son of
 the eyeball]?[97]

About the same time Khwaju Kirmani said in Iran:

The lines which the "men of my eye" [i.e., the pupils] have written
 like water;
It is certain (*muḥaqqaq*) that this is a second Ibn Muqla![98]

This development is not unexpected, for even before the days of the calligrapher-vizier lovers would complain in Arabic verse:

The lids of my eyeballs (*muqla*) weep on [the paper]
as many [times] as the number of letters, and the pen too weeps.[99]

In later days, the name of the great calligrapher became synonymous with "good writing"; ath-Thaᶜalibi wishes someone the best of luck and days

as beautiful as the cheek of the beloved and the heart of a
 littérateur,
and the poetry of al-Walid in the handwriting of Ibn Muqla![100]

128

And a calligrapher—allegedly Yaqut—said:

> If the scripts of people were an eye (*ᶜayn*)
> Then my script is the eyeball (*muqla*) in the eyes of script.[101]

The "eloquence of Sahban, the script of Ibn Muqla, the wisdom of Luqman and the asceticism of Ibrahim ibn Adham" formed the highest combination of virtues one could think of.[102]

Even Maulana Rumi does not refrain from alluding to the *riqāᶜ* script of Ibn al-Bawwab. Instead of imitating this style, one should rather read a piece of paper (*ruqᶜa*) speaking of the love of the friend, who would then show him the actual gatekeeper, *bawwāb*.[103]

Once in a while a calligrapher would be praised with verses like:

> Those who saw the writing of Yaqut,
> bought one line of it for a ruby (*yāqūt*).
> If Yaqut had seen this writing,
> he would buy a single letter of it for a ruby![104]

And one of the finest poems of this kind is quoted by Daulatshah:[105] ᶜIsmatullah Bukhari, singing in praise of a royal calligrapher, has inserted not only the traditionally used names of the old masters but also that of Yaqut's foremost disciple, as-Sayrafi, "the money changer," who alone would be able to distinguish the jewels in each letter.

Typical of the fossilization of images is the fact that even in later centuries only in exceptional cases are other names introduced into the imagery, as when a Turkish writer compares the face of his friend to an album page by Mir (ᶜAli) and ᶜImad.[106] The crescent-shaped eyebrows, which are often likened to an inverted *nūn*, inspired them to assure their readers time and again that even Ibn Muqla and Ibn Hilal were not able to write anything similar[107]—the connection of the "eyebrow" with the *muqla* (eyeball) as well as with the *hilāl* (crescent moon) is certainly a clever pun.

On the whole, poets used to play on the double meaning of *khaṭṭ* ("script/down"); and since the red mouth was usually compared to a ruby, the pun on Yaqut became a favorite with Persian and Turkish authors:

The script of Yaqut became abolished (*naskh*), for all the elegant
 ones
in the schools now take instruction in *khaṭṭ* from your *yāqūt*
 ["Yaqut" and "ruby mouth"].[108]

Thus says Jami with a threefold pun, playing also on the double
meaning of *naskh* ("abolition" and *naskhi* style); while a somewhat
later poet sings:

The Calligrapher of creation has written with Chinese musk in
 Yaqut's style
on your ruby lip "Yaqut" [or, "a ruby"].[109]

 The Western reader is soon bored by the constantly recurring
puns on *khaṭṭ* that permeate Persian poetry from its very beginning
to the nineteenth century and were eagerly taken up by the Turks.
It seems that the image developed out of verses like the Arabic one
quoted by Hamza al-Isfahani:

> There came a script (*khaṭṭ*), as if it were hairs
> in the midst of a cheek,
> or like a drawing of henna on the hand of a virgin
> who lifts for a moment her veil.[110]

Some poets have added to the rather insipid comparisons some new
turns and twists. They liked to combine the black *khaṭṭ* of the be-
loved with the book of their actions, which would be blackened by
their interest in this very *khaṭṭ;* as Amir Khusrau says:

> Abolish (*naskh*) the *khaṭṭ* of the beloved for our sake, O angel,
> For I am blackening my book![111]

In another line he complains:

> Your *khaṭṭ* has blackened a hundred books of the pure![112]

 Centuries later, another Indian poet adds to the *khaṭṭ* also the *khāl*,
the mole on a friend's face that, always a model of blackness, also
adds to the blackness of his book of actions.[113]

130

The image of *khaṭṭ* is central in Amir Khusrau's poetry:

As long as I read the Koranic verse of love from the musk-colored
 khaṭṭ of the friend,
I have completely forgotten the traditions of the religious details
 (*furūᶜ*) without foundation.[114]

He also saw the friend's *khaṭṭ* issuing "the *fatwā* for blood and
wealth,"[115] that is, that it is licit to confiscate the lover's wealth and
shed his blood. In a more romantic strain, he acknowledges that the
radiant face of the beloved is the sun on Doomsday, while the black
khaṭṭ is his book of actions.[116]

Even Sufi poets liked this pun (although Rumi rarely uses it), and
ᶜAttar apparently invented an image that prefigures hundreds of
Persian lines:

Everyone who saw the freshness of your *khaṭṭ*
runs like a pen, with his head on the script of the *firmān*.[117]

But Bu ᶜAli Qalandar read ever so many thousands of subtle points
of *tauḥīd* (assertion of God's Unity) from the *khaṭṭ*, which appear to
explain (the friend's) beauty.[118]

Among classical poets, Jami seems to be fondest of puns on *khaṭṭ*
because in them he could best display his breathtaking skill in word-
play. Did he not try to wash off the Book of Love according to the
order of Intellect? But then the *khaṭṭ* of the beloved made him study
the alphabet again.[119]

Any picture which Jami did not paint with the passion [*saudā*,
 "blackness"] of your *khaṭṭ*
His wet eye washed it off with tears of repentance.[120]

And the lovers who remember the *khaṭṭ* of the friend,

make ink from the *suwaidā* [the little black spot] of their hearts.[121]

For a seventeenth-century Indian poet, the "musk-colored *khaṭṭ* is
the binding (*shirāza*) of the clean copy of beauty,"[122] an idea taken
over by ᶜAbdul-Jalil Bilgrami whose "folios of patience and endur-

ance were falling apart" until he realized that "the wave of the *khaṭṭ* was the binding for the book of beauty."[123]

The major classical Turkish poet, Fuzuli, invented an elegant image when he claimed that the sun illuminates the moon of the beloved's face in order to perform the gilding of the paper for the beautiful *khaṭṭ*,[124] meaning that the radiant white face of the beloved resembles gold-flecked paper on which the "script/down" can unfold its real beauty. One of his compatriots even saw the tongue of the pen split when he tried to describe the *khaṭṭ* of the beloved's lip.[125]

The *khaṭṭ* was sometimes considered to be a magic formula drawn around the mouth to preserve its sweetness or to protect its treasure of rubies,[126] or as an amulet against fire and fever in the poet's heart.[127]

But the poets also knew that the appearance of the first down on the face of the fourteen-year-old beloved marks the end of the period of love:

Perhaps the pen of destiny has written on the page of the cheek of
 this child, who still reads the alphabet,
With great letters [or: with visible down]: "Finished! (*tammat*).[128]

And the Sindhi poet Mirza Qalich Beg thinks in the same strain that as long as the face was clear of the *khaṭṭ* an answer to his love letters (*khaṭṭ*) would clearly not come, but now, since a letter (*khaṭṭ*) has come from the friend, it shows that his down (*khaṭṭ*) is sprouting (and he gives up his coquetry).[129] The young beau himself is not happy with the growing of his down that marks the end of his role as a beloved and, as an Indo-Persian poet says:

With such aversion does he see the reflection of his *khaṭṭ* in the
 mirror
That one would think a Christian were looking at a copy of the
 Koran![130]

Sometimes a poet connected the *khaṭṭ* with something positive. While usually the book of actions may be blackened by the thought of the *khaṭṭ*, his own book of actions—thus the proud poet—is nothing but his *dīvān* in which *ghazals* are written in memory of the

132

friend's *khaṭṭ*.[131] Ahmad Pasha in fifteenth-century Turkey used this image inversely. The beloved, asked what this *khaṭṭ* of his was, answered:

> I have written Ahmad's words
> with musk on this rose cheek of mine—[132]

certainly a delightful form of self-praise! Fuzuli, however, knows—as many of the poets must have known—that the *khaṭṭ* of the rose-cheeked friend is only a metaphor, by which one can finally reach "the tablet of Reality," that is, in the Sufi tradition, that love of beautiful human beings can lead to the love of the Divine source of all beauty.[133]

But it was not only the *khaṭṭ* in general that inspired the poets. The letters themselves offered them infinite possibilities for puns, comparisons, and witty remarks. Do not the letters look outwardly like rows of ants, while they possess the power of Solomon when it comes to the world of meaning?[134] Letters—thus says an Andalusian poet—are like curls at the temples on the cheek of a gazelle,[135] a fitting comparison, since the writing material was often gazelle skin. And the writers knew well that Time writes not only a lovely black *khaṭṭ* on the face of young friends but also "white lines from the letters of old age" on their own heads.[136]

As the beauty of a page can be impaired by a single ugly letter, thus good company suffers from intruding, uncongenial people:

> Yesterday there was a rival in the friend's party,
> unfitting, like a letter out of place.[137]

In a mysterious way letters are connected with human beings. This feeling works in two ways. On the one hand, man is the great alphabet in which the meaning of creation is expressed; on the other hand, letters resemble human beings, as it was taught by the calligraphers. Letters may therefore reflect the writer's state of mind. In the *Arabian Nights* a love letter is written in a delicate hand because the writer is a tender, slim girl.[138] It was common to describe the work of a fine calligrapher in imagery from this sphere:

133

His oval shapes are equal in rank to the egg of the ʿAnqa bird, and his *ṭughrās* are the royal falcon in flight. Each of his *alifs* is as lofty as the stature of the sweetheart, each flourish a sign pointing to the black tresses of the friend; the teeth of his *sīn* shining like the teeth of the beloved, the eyebrow of the ʿayn [or "eye"] like the radiant brow of the idols.[139]

Almost every letter could be used in this playful way, and even the diacritical marks were used for comparison. Not only is the mole of the beloved often such a mark—or vice versa the diacritical mark appears "like a mole on the white face"[140]—but even the pupil of the eye becomes a dot on the *khaṭṭ*. That may be so because the poet stares uninterruptedly at the friend's "down/script"; or, since poets want to avert the evil eye from the *khaṭṭ* of the beloved,[141] they may use the pupil as *sipand* (wild rue) that is burned against the evil eye.

Since such puns usually sound tasteless in translation, particularly when the symptoms of scabies are described in similes from calligraphy,[142] they have rarely interested the Western scholar; but they are so deeply ingrained in the rhetorical technique of the Islamic peoples that one has to take notice of them. Let us therefore turn to the poets' alphabet, for as Safadi says in his commentary *Al-ghayth al-musajjam,* "As for comparing human limbs with letters, the poets have done that frequently."[143]

The *alif,* as we saw, has deep religious significance, but as it is related to God as expressing His Unity and Unicity, it is also related to man, since it represents the slender stature of the beloved. When an Andalusian poet complains that he could not see how his friend began to weep "because in the embrace he stood like an *alif*" (i.e., looking at his feet),[144] one immediately thinks of the classical and modern calligrapher's explanation of the various styles of an *alif* by representing them as various postures of a standing person in a more or less stiff position, with or without a beard (thus Ismayil Hakkı Baltacıoğlu's examples).[145] For this reason ʿAbdallah Marvarid, Husayn Bayqara's witty secretary, could compare the sultan with his ceremonial parasol to an *alif* with a *madda* over it.[146]

"The stature of the beloved stands straight in the middle of the soul like an *alif*"[147] (*alif* is indeed the central letter of *jān* [soul]), as also the cupbearers stand like *alifs* among the boon companions (who,

134

we may surmise, were no longer so upright).[148] Examples of this kind are frequent from the days of Ibn al-Mu°tazz. The arrow that reaches the eye of the lover from the side of his beloved (either the sharp glance or the eyelashes) is like an *alif* written in blood, as Fuzuli thinks.[149] This idea was apparently common in the sixteenth century, for Bada'uni quotes an almost identical Persian verse.[150] Another poet at Akbar's court claims that he was so wounded by the sword of his beloved that his breast is full of *alifs* like those which are drawn on paper with a ruler.[151] This idea was extended by a slightly later poet who, in complaining of his friend's cruelty, alludes to the process of learning calligraphy by means of dots:

> Like a child who draws the correct line over the dot,
> the blow of his sword draws an *alif* over my scar.[152]

More attractive is a Turkish folk poet's example. Being in love with a girl called Elif, everything that is straight seems to write her name, whether it be the raindrops or the ducks swimming in the pond.[153]

But as the poets would constantly compare the face of their beloved to the moon only to state then that the moon is a black slave before this radiant beauty, even the *alif* is not enough to express the elegance of the friend's stature, for the friend gracefully moves about, while "*alif* cannot accept a movement," that is, it cannot take any of the Arabic vowel signs on it.[154] And the *alif* is an exceptional letter, as Khaqani says in a praise poem:

> This king is a king, as the *alif* is still an *alif*
> Even though it is sometimes mixed with other letters.[155]

The strongest contrast to the straight *alif* was the *dāl*, bent upon itself. While °Attar describes a brave old woman as having a heart like an *alif*, though she was shaped like a *dāl*,[156] his contemporary Khaqani explains his miserable situation in a related image:

> I came to the leader like a Kufic *alif*;
> full of shame, with my head hanging like a *dāl*, I go away.[157]

Fuzuli again thinks that the beloved has caused him to become crooked like a *dāl*:

135

and when I now give up my head, I am excused,
For what an excuse would I find if she should say: "There is no
 dot on the *dāl!*"[158]

The same letter can also be read as *dāll* (pointing to, hinting at)
and was used frequently for additional puns:

> Jami drew the *dāl* of your tress and said:
> This points to (*dāll*) my good fortune (*daulat*).[159]

For *d* is also the first letter of the word *daulat*.

The *bā,* so important in the religious sphere, has not inspired pro-
fane poets very often. They might see it sitting with a bleeding heart,
the dot beneath it being tears (the *alif* appears, in the same line of
poetry, as a tongue that inaudibly tells the story of grief).[160] Or it
may be a little boat with an anchor,[161] while the *thā,* similar in shape,
was sometimes used to symbolize the three stones on which a kettle
is put or, more rarely, a bowl with beggars hurrying to it.

The group *j–ḥ–kh* was fitting to describe the curls of the beloved.
The *jīm* particularly was used for this purpose, for its dot would
represent the mole close to the ear. The tip of the curl, similar to
the round of the *jīm,* is for the loving poet the first letter of *jān*
(soul).[162] But it could also serve as comparison for the crooked beak
of a hawk "written by a left-handed person."[163]

The letter *rā* stands for the crescent moon because of its shape,
but it reminds the poets also of a dagger. The crescent moon of
Ramadan, which announces the fasting, is both a *rā,* the first letter
of Ramadan, and a dagger that cuts off joy and mirth for a month.
It also may be used to kill the lover. In early Arabic, one finds it
sometimes representing the sidelocks.[164]

More prominent is the letter *sīn,* which is generally connected with
teeth. Saʿdi wrote:

> If Ibn Muqla would come once more to this world,
> claiming to perform miracles in clear magic,
> he could not draw with golden ink an *alif* like you
> nor could he write with dissolved silver a *sīn* like your mouth.[165]

136

From the human "teeth" it was easy to reach comparison with the crenellations of a powerful castle that appeared to a poet "like the *sīn* of *sipihr,*" that is, the first letter of *sipihr* (sky).[166] Baqi, however, has compared the *sīn* to split curls, which is not very common.[167]

Ṣād usually represents almond-shaped eyes, so that a poet wrote in a chronogram for the completion of the Red Fort in Delhi:

> Everyone who wants anything but what Shah Jahan wishes;
> The world be as narrow in his eye as the eye of the *ṣād!* [168]

Jami, 150 years before him, had found a solution for his longing to see the beloved:

> I make my name *ᶜāshiq-i ṣādiq,* "sincere lover," so that,
> When you read my letter, I see your face through the eye of the
> *ṣād!* [169]

Similar ideas are still found in Ghalib's verse. Yunus Emre's use of the *ṣād* to point to the eyebrows is untypical.[170]

The letter *ᶜayn* could serve many purposes, since it means both "eye" and "fountain," and one may remember that this letter in certain positions (thus before *alif* or *lām*) was called by the classical calligraphers *fam al-asad* (lion's mouth).[171] This expression is, however, never alluded to in poetry, so far as I know. A typical example of the traditional imagery is a verse by the Sindhi author Mirza Qalich Beg:

> The mole which is over your eye seems to be an error:
> It is some writer's mistake, for there is no dot on the *ᶜayn.*[172]

The "narrow eye" of the *fā* is mentioned once by Sana'i;[173] otherwise, this letter did not inspire poets too much. Like all curved letters, it might serve to describe the sidelocks of the beloved.

The following letter, *qāf,* was also connected from early times with tresses. Ibn al-Muᶜtazz sings of a pretty girl serving wine, whose sidelocks are like two *qāf*s.[174] Since the very name of this letter can also be interpreted as pointing to Mount Qaf, the world-encircling

137

mountain, it was used rather frequently for various puns, all the more as later poets loved to play with the first letter of concepts central to their verse: *qāf-i qurb*, Mount Qaf, or the first letter of "proximity," or the *qāf-i qanāᶜat*, the *qāf* of contentment, are ambiguous expressions that often recur in Persian and Turkish poetry.

Similarly, Ghalib speaks of the *kashish-i kāf-i karam* (the drawing of the *k*, the first letter of *karam*, kindness) when he describes how the long, stretched-out way drew him to someone from whom he expected kindness.[175]

Kufic *kāf*, from a Nishapur bowl, tenth century

In other cases *k* was, in its Kufic form, a symbol for narrowness— "a heart like the *kāf-i kūfī*"[176] or, as Rumi has it, "empty of intelligence like a *kāf-i Kūfī*"[177]—while the Andalusian poets compared it to "the lower part of a hound's mouth, whose upward line is nicely curved"—a very nice picture indeed![178]

kāf stretched form in the cursive hand, similar to a dog's mouth

The letter *lām* generally describes long tresses; and, while *mīm* has its major importance in the religious sphere, it also designates, on the profane level, everything narrow and minute. In classical Arabic poetry, wine, when mixed, writes on the lines a series of *mīm*s without endings;[179] but the general object of comparison is the small mouth of the beloved, for the smaller the mouth was, the more it was praised by the poets. (Pictorial evidence for the Central Asian type of beauty with a very tiny mouth is plentiful.) Now and then, poets invented novel comparisons such as when Abu Nuwas compared the spider that is closely pressed to the ground to a *mīm*.[180]

138

And, in other cases, not only the ringlet of the *mīm* was alluded to, but the whole letter: "to make the *alif* into a *mīm*" means "to hang the head."

The *nūn* represents the beautifully arched eyebrow, even though it is upside down, and the pupil or the mole could then represent the dot inside the *nūn:*

> As for the calligraphers, there comes from their pen
> No *nūn* more beautiful than your eyebrow.[181]

That would be the traditional use of the letter. But the comparison with sidelocks over the ear is also found,[182] and in descriptions of nature *nūn* could be understood as a crescent with a star.[183]

The letter *hā'* (Turkish pronunciation "hē") is called "two-eyed" in its initial and central shape and was therefore interpreted, at least from Sana'i's time onward, as weeping.[184] This image remained cur-

"two-eyed *hā'* ", *hā'* called "cat's face"

rent and is particularly common in the Turkish tradition where the title of one of Asaf Halet Çelebi's books of poetry, *HE,* harks back to this tradition, building up its imagery upon the picture that one sees now and then in small Turkish coffeehouses: the word *Āh*, with an enormous *alif,* beside which a sad-looking *hē* sits and sheds tears profusely, while in minute script is written at some point [*Āh*] *min al-ᶜashq wa ḥālātihī* ("Woe upon love and its states!")—the beginning of a verse by Jami.[185] The contemporary Persian sculptor Tanavoli has very well expressed this sadness of the *h* in his delightful variations on the word *hīch* (nothing), which looks like a cat and, in fact, the initial form of *hā'* as used by the artist is called in Arabic *wajh al-hirr* (cat's face).

Jami turns to another rather gruesome use of the same letters and curses his rival:

Everyone who opens his eye like a *hā'* toward the *mīm* of your mouth:
I'll put a needle into his eye from the *alif* of my *Āh.*[186]

139

The straight *alif* resembles a needle for applying antimony to the eye, and this instrument was frequently used to blind people; the sigh of the poet can work similarly upon those who dare to gaze at the small mouth of his beloved.

Compared with the imaginative use of the *hā'*, the *wāw* was less inspiring for the poets. Early poets in the Arabic tradition saw the water bubbles in the wine glass as *wāws*[187] or compared the curls over the forehead to it.[188] More frequent is a grammatical pun, such as to call something "like the *wāw* in ᶜAmr," that is, silent, for the written *wāw* at the end of the name ᶜAmr is not pronounced. Even a twentieth-century poet like Ahmad Shauqi, the poet laureate of Egypt, thought that the beauty of the whole world compared to the Bosporus is like the *wāw* in ᶜAmr, that is, without value.[189]

Much more common is the *lām-alif*, understood as a single letter, as the *hadīth* quoted earlier shows. Apparently, before it was interpreted as a ligature, poets could compare the trace of feet in the sand to a *lām-alif*.[190] The idea of *lām-alif* as symbol of very close relationship is found as early as in Abu Nuwas, who says:

I saw you in my dream, embracing me as the *lā* of the scribe
 embraces the *alif*,[191]

an expression that points to the *lā al-warrāqiyya,* the *lām-alif* written in one stroke. This imagery, which might lead a poet to "envy the *lām-alif* when he saw it embracing on the lines in the book,"[192] was so common that it appears even in Sindhi folk poetry where Shah ᶜAbdul Latif, taking up a verse ascribed to Qadi Qadan, exlaims:

O scribe, as you have artistically combined the *alif* with the *lām,*
Thus my heart is connected with the Friend.[193]

For Asaf Halet Çelebi, on the other hand, *lām-alif* has lifted its arms and cries for help.[194]

That goes together with the tendency of many poets to play with the meaning *lā* (no) of this combination of letters:

140

The *lām*-shaped cheek and the *alif*-like stature of the beloved
Make definite (*muḥaqqaq*) reply to the question of the lover: *Lā,
 No!*[195]

Or, in an Andalusian description of nature:

> I asked the stars in the night, "Will the darkness end?"
> They wrote an answer through the Pleiades: *"Lā,* No!"[196]

Sometimes, however, the poet had better luck:

The *nūn* of the eyebrow and the *ᶜayn* of the eyelids,
together with the *mīm* of the mouth, give the answer *naᶜam,*
 "Yes."[197]

Such combination games were extremely popular with the poets of
the Persian world:

> Your eye is a *ṣād,* and the tip of your curl a *dāl,*
> And from these two I have got a hundred (*ṣad*) dreams![198]

The poet may see from the *alif* of the stature, the *lām* of the tresses,
and the *mīm* of the mouth, which he carries in his heart's tablet, the
word *alam* (pain)[199]—if he does not prefer to think of the mysteri-
ous letters at the beginning of Sura 2.

Most of these puns sound very silly when translated, but at times
pleasant little jokes can be detected, such as Ghalib's play with the
mīm and the *lām* of mouth and curl, which are enough provision for
him; taken together, these two letters read *mul* (wine).[200]

A great poet like Sana'i did not refrain from explaining his own
name in similar letter puns: the *sīn* of the teeth, the *alif* of the stat-
ure, the *nūn* of the eyebrow, and the *yā* of *yamīn* (right hand) are
shown in the word *Sanāʾī*.[201] But even he, like Abu Nuwas long be-
fore him, cannot avoid some obscene transformations of letters.[202]

After reading thousands of verses filled with this imagery, one is
easily able to draw the picture of the ideal beloved of Persian poets
as made up from letters.

Human face made up of letters according to the usage of Persian poets

A particular aspect of this imagery are the school scenes that were popular at least since Nizami described how Layla and Majnun went to school together,[203] a scene frequently illustrated; and a very charming description of such a scene has been composed by Shaykh Ghalib Dede in his Turkish epic *Hüsn u aşk,* which retells the story of unlucky lovers who had grown up together only to be separated later:

> When he read *alif* he thought of the friend's stature,
> and raised cries up to the Throne.
> When he read *jīm,* it was pointing (*dāl*) to the curl:
> from one dot he understood the situation.
> He was afraid of the dagger-sharp *rā*
> and could not keep the *mīm* on his lips:
> the teeth of the saw-shaped *sīn*
> cut off the branch of his life.[204]

And one should also not forget the admonition Jami gave to his young son not to follow a bad companion, for when the straight *alif* comes into the embrace of the crooked *lām,* it becomes crooked itself. Further, the boy should not show his teeth like a *sīn* smiling at the one and the other, but rather be like a *mīm* whose mouth is too narrow for speech.[205]

142

Besides allusions to, and comparisons with, single letters, the different styles of writing are also used for poetical purposes. The double meaning of *khaṭṭ* as well as of *naskh* offered unending possibilities for puns to which the *muḥaqqaq* with its primary meaning "certain" was added skillfully. Even serious theologians like the indefatigable Egyptian professor Jalaluddin as-Suyuti (d. 1505) indulged in such games, not to mention the numerous minor poets whose verses are quoted extensively by Turkish historians.[206] Yet, the great mystic ᶜAttar had already said:

> . . . from that *khaṭṭ* it is ascertained (*muḥaqqaq*)
> that your coquetry became abrogated (*naskh*).[207]

The favorite script of the poets was no doubt *rīḥānī,* whose very name evokes the fragrance of sweet basil, *raiḥān.* From among the great number of these images we shall single out Hafiz's lovely wish for happiness:

> as long as in spring the breeze on the page of the garden
> writes a thousand signs in *rīḥānī* script.[208]

And we feel with the author who praised a calligrapher by claiming:

> His *rīḥānī* script is, so to speak, a flower
> which every angel wants to smell.[209]

Poets might compare their *dīvāns* to metaphorical rose gardens that will be envied by real gardens when the *raiḥān* twig "lifts its head from the *basmala*"[210] or see spring arranging "a royal document in basil script on which he has put the dew as a seal."[211] However, the seventeenth-century Indian writer certainly goes too far when he praises his beloved in religious terminology:

His life-bestowing lip is Jesus, the *rīḥān* of his *khaṭṭ* a copy of the
 Koran.
Religion became doubled, because this face gave a Koran to
 Jesus![212]

Another type of script often mentioned is *ghubār,* the dust script. Thus, the poet says, wondering why the down on his young friend's cheeks suddenly had become so visible:

The *ghubār* of your *khaṭṭ* on the lip became, I am afraid, abolished
 (*naskh*),
for suddenly this *naskh* became *thuluth* and *tauqīᶜ* [i.e., grew into
 large types of calligraphy].[213]

Hafiz is more poetical than the just-mentioned hack poet when he says in a multiple *murāᶜāt an-naẓīr:*

My beloved, if it should happen that I reach the dust of your feet,
I shall put on the tablet of my eyes *ghubār* script.[214]

That is, "I shall rub the dust of your feet on my eyes." And Kalim invented an absurd but fitting comparison when he described the famine in the Deccan by claiming that the inkwell has become so dry in this dry season that every pen can write only "dust script."[215] Bedil takes over the inherited images and gives them, as usual, a more pessimistic bent:

Our dust writes letters toward the friends,
 but with *ghubār* script.[216]

Somewhat later, when *shikasta* was introduced, Fani compared the friend's *khaṭṭ* with *shikasta,* which breaks (*shikast*) the value of *ghubār* script.[217] Allusions to *shikasta* are frequent during the later seventeenth century and the eighteenth century when the concept of "breaking" (*shikast*) became a key word in Indo-Persian poetry. Slightly earlier, the Turks had introduced for the chancelleries the *qirma* (*kïrma*) script, a name that means "broken." Therefore, Baqi wants to write about the teeth of an enemy with *qïrma* and to fill the air with dust (*ghubār*) from the copy of his body;[218] that is, he wants to perform magic and break his teeth by describing them in "broken" script and pulverize his body by using "dust script" when mentioning him.

While allusions to other types of writing are rarely used,[219] the *ṭughrā,* originally the sultan's handsign, attracted poets because in its

harmonious shape it was a fitting metaphor for the eyebrows, when the whole face was, as we saw, interpreted as a Koran copy. It seems that this imagery was used predominantly during the sixteenth century when Shah Ismaᶜil the Safavid was one of its representatives.[220] But while he and other poets of his time admired the *ṭughrā* of the eyebrows as drawn by the primordial Calligrapher, a minor poet from Sind did not hesitate to compare the *qashqā,* the caste mark, of a pretty Hindu to "the *ṭughrā* of the book of beauty."[221] In religious poetry, again (particularly in descriptions of Muhammad's *miᶜrāj*) the night, the stars, and the moon can function as dark script, sand, and *ṭughrā* of the heavenly decree.[222]

The Islamic poets could interpret everything as a book and see writing everywhere. In a dirge for a great calligrapher it is natural to write that "cruel Death stretched out his hand to the inkwell and drew with his wrathful hand the pen over the page of his practice."[223] But much more than this. The leaves appeared to Muslim calligraphers as letters,[224] and their beloved was a book full of beauty, which to describe one would need as paper perhaps the rose, and as script the narcissus.

Lovers invented ever new images to tell of their longing in calligraphic images. When an early Arab poet called out, "If it were possible, I would take the skin of my cheek as paper, one of my fingers as pen, and the pupil of my eye as ink!"[225] then Ahmad Pasha in fifteenth-century Turkey composed one of the most delightful love letters:

> a treatise of longing on the page of the heart,
> writing the complaint of the nightingale in the rose garden
> with the hand of the morning breeze. . . .[226]

They would see the hand of the wind write letters on the pond that could be read and sung by the birds,[227] and even the soft skin of a snake appeared to early poets of Baghdad as a "book with lines on it."[228] In short, the whole world was a book, as Sana'i says:

The form of the world is like a book
in which there is a fetter (*band*) and a piece of advice (*pand*)
 together.

Its outward form is a fetter for the body of the accursed one;
its inner meaning is a piece of advice in the heart of the wise.[229]

Many poets were aware that nothing in this world is stable. Is not ᶜālam (world) composed from the words alam (pain) plus the letter ᶜayn, with which ᶜadam (nonexistence) begins?[230] And even though the happiness of the lucky few may draw the line of extinction, naskh, over the thought of paradise, yet suddenly the pen may also cross out the word daulat (fortune).[231]

Akbar's court poet Fayzi very daringly claimed to have seen the book of existence and space chapter by chapter,[232] and a somewhat later Kashmiri poet sings in a rare optimistic mood:

Everyone who has seen the book of the days from beginning to the
 end
has seen the day between the lines of nights![233]

But Sarmad, the eccentric Judeo-Persian mystical poet in Dara Shikoh's entourage, cried out in a moment of despair that everything in the manuscript of the dīvān of his life was wrong (ghalaṭ)[234]—the script was wrong, the meaning was wrong, the orthography was wrong, and the composition was wrong. His contemporary Fani, however, continued the more positive evaluation of the world as a book:

The world is like a book, full of knowledge and justice.
The bookbinder Fate has put its two volumes in two covers
The binding is the sharīᶜa, and the religions are the pages,
Tonight we all are pupils, and the Prophet is the master.[235]

He is not too far from a statement by Frithjof Schuon who once remarked that God has created the world like a book, and His revelation has descended into the world under the form of a book. But man must hear the Divine Word in this creation and must return to God by means of the Word. "God has become Book for man, and man must become Word for God."[236]

Stars and flowers, man and angel are parts of this great book in which innumerable secrets have been written, which the eyes of the

146

heart have to be trained to decipher. Khaqani knew that the alphabet he had written with red tears on his cheeks could finally be discarded, and,

> I forgot that enigma, whose title was Existence,[237]

an expression that may have inspired Ghalib's verse:

> Death is a letter whose title is Living.[238]

The *rīhān* script on the dust (*ghubār*), the *ṭughrā* of the new moon on the page of the sky, the perfect beauty of a face that is as flawless as a copy of the Koran: they all are parts of this great book of creation. The poets caught a glance of this book and tried to tell of it in images taken from the noblest of arts, calligraphy. And yet, in the end they would probably agree with Kalim, who reminds us of our imperfect knowledge of the book of the world and what is in it:

> We are not aware of the beginning and the end of this world—
> the first and the last page of this old book have fallen off![239]

"Everything is perishing except the Face of God" (Sura 28/88) in mirror script. Egypt, sixteenth century

Appendix A

A mystical alphabet according to the order of letters in Sanskrit, elaborated in the Dhauqi branch of the Chishtiyya Sabiriyya, and published in Hz. Shah Sayyid Muhammad Shauqi, *Sirr-i dilbarān*.

The list of the Lords (*rabb*) and those who are ruled by them (*marbūb*), that is, the Divine Names and the names on the plane of creation, the pronounced letters, and the lunar mansions.

Divine Name	Name of the plane of creation	Letter
1. *badīᶜ*, Originator	*ᶜaql-i kull* Universal Intellect	*alif*

This attribute is special to God Most High and is the origin of the capacity to create from nothing, which is directed to the Universal Intellect, which is also called the Pen and is the locus of manifestation for *ibdāᶜ*, creating from nothing, because from the Pen the word *kun,* "Be!" comes into existence without the previous existence of matter, time, and likeness. The name *badīᶜ* is also directed toward the letter *alif*, out of which all letters proceed, and is likewise directed toward the mansion of *sharaṭayn*, the first of all lunar mansions.

2. *bāᶜith*, Invoking	*nafs-i kull* Universal Soul	*hā'*

Bāᶜith points to the evoking capacity by which the Universal Intellect works on the bodies by mediation of the soul. From the Uni-

149

versal Intellect the Divine Order, that is, "Be!" has come into existence. The Universal Soul is also called the Well-Preserved Tablet; that is the first thing created, which was existentialized through the Universal Intellect.

ع

3. *bāṭin,* The Inner *ṭabīʿat-i kull* *ʿayn*
Universal Nature
[*physis*]

It is the origin of the natural capacities, in which the things are hidden. They appear through the *nafas-i raḥmānī,* "the breath of the Merciful."

ح

4. *ākhir,* The Last *habā* *ḥā'*
Primordial matter

The essence of the primordial matter (*hayūlā*) is the last step in the existence of bodies. Existence in this rank is of extreme beauty because it descends from utter fineness (*laṭāfat*) into utter density (*kathāfat*). The forms of the created bodies in the world of composed things appear in it.

غ

5. *ẓāhir,* The Outward *shakl-i kull* *ghayn*
Universal Form

The appearance of the primordial matter depends upon the Universal Form. Without form and shape, the primoridal matter cannot become visible. . . . The Universal Form comprises all forms and figures like the *falak-i aṭlas,* which comprises everything that is in the spheres, the stars, and the mansions.

خ

6. *ḥakīm,* The Wise *jism-i kull* *khā'*
Universal Body

The combination of the various natures comes to pass through wisdom. The Universal Body is the first form of nature in which the various natures manifest their order, as the Universal Body accepts heat and cold, humidity and dryness. God Almighty has made manifest in it the different dispositions of the various forms.

ق

7. *muḥīṭ,* The All-Embracing The Throne *qāf*
The Divine Throne embraces all bodies. Since the Greatest Throne is embracing and encircling, it belongs to the bodies.

ك

8. *shakūr,* The Grateful The Footstool *kāf*
This is the beginning of the legal prescriptions and prohibitions and animates words that cause thanks.

150

9. *ghanī*, The Rich, *falak-i aṭlas* *jīm* ج
 The Independent *falak-i burūj*
 The highest sphere

Ghanī is also called *ghanī ud-dahr,* the one who is independent of Time, for from this name, Time [and fate] seeks and receives help. Near the *falak-i aṭlas* is the sphere of the zodiacal signs. The *falak-i aṭlas* has no need for stars.

10. *muqtadir,* The Powerful The sphere of *shīn* ش
 mansions

In the world of elements these mansions are the causes of good and evil. This is the ceiling of hell and the floor of paradise.

11. *rabb,* The Lord Sphere of Saturn *yā'* ى

The first sphere is that of Saturn, connected with Saturday. It is the ascendant of princes and great men. It is the station of the *bayt al-maᶜmūr* and the *Sidrat al-muntahā,* the "Lotos tree of the utmost border." Abraham is located there. The *bayt al-maᶜmūr* is located exactly opposite the earthly Kaᶜba. It has two gates, one in the east, the other one in the West. The eastern one is called Gate of the Appearance of Lights, through which every day 18,000 angels enter. The western gate is the Gate of the Occultation of Lights through which these angels disappear, not to return till the day of resurrection. The *Sidrat al-muntahā* is also in this sphere; it is in symbolical language a tree whose leaves are like an elephant's ear and whose fruits are like earthen vessels. The blessed eat its fruits by which dishonesty disappears from their breasts. On its leaves is written *Subbūḥ quddūs rabb al-malā'ik,* "Most Glorified, Most Holy, the Lord of the angels." The works of mankind end here; that is why it is called the tree of the outmost limit. Beneath this tree is Gabriel's abode. On this tree is written: "What no eye has seen and no ear has heard, and what did not come to any human being's mind."

12. *ᶜalīm,* The Knowing Sphere of Jupiter *ḍād* ض

With this sphere, Thursday is connected. Divine inspiration and making alive the hearts of scholars with knowledge, kindness, and good ethical qualities is connected with this name and this sphere. To obtain one's livelihood and to heal the sick are also connected with this place. Moses is located in it, and its overseer is Michael.

151

ل

13. qāhir, The Overpowering Sphere of Mars *lām*
Its day is Tuesday. Aaron and John the Baptist are located there. This sphere is the locus of manifestation of Divine grandeur and revenge. The worship of the angels of this sphere is to bring distant things near, to make the invisible visible, to entrench faith in the heart, to defend the world of mysteries against the infidels, and [they are further occupied with] revenge, blaming, and pressing the souls. Its spirituality is that power that helps and strengthens those who wield the sword and take revenge.

ن

14. nūr, The Light Sphere of the Sun *nūn*
From its light the whole world becomes illuminated. This is the axis of all spheres and of the world [being the fourteenth among the twenty-eight stations]. God Most High has proclaimed it to be the *makān-i ᶜulyā*, "the highest place." Jesus, Solomon, David, and Jirjis [St. George], and most of the prophets are located there. It is also one station among the "Muhammadan stations." Its day is Sunday, and its governor Israfil [the angel that blows the trumpet for resurrection]. It is a place where the Divine lights and mysteries descend. Lowliness and height, pressing and relief, and all the affairs beneath the *sidrat al-muntahā* to what is under the earth are under the disposal of the angels of this sphere.

ر

15. muṣawwir, The Former, Shaper Sphere of Venus *rā'*
Its day is Friday. It is the place of the *ᶜālam al-mithāl* [the world of spiritual similitudes] and Joseph's place. Its governor is Sura'il, who responds to the calling angels. He forms the picture of the child in the wombs of the mothers. The angels of this sphere are ordered to inspire and teach and instruct children, to console sad hearts and show mildness and kindness and love, and to kindle the fire of love in the hearts of the lovers and to preserve the figure of the beloved ones in their hearts, and also to bring messages and to carry out the orders of those with authority (*ahl-i tamkīn*).

ط

16. muḥṣī, The Counting Sphere of Mercury *ṭā'*
Mercury is the scribe of heaven; his day is Wednesday. It is Noah's dwelling place. The governor there is Nuᶜahil. Reckoning and writing, sending down of knowledge, guidance toward the Divine lights, and making spiritual forms pass over into bodily shapes are connected with this sphere.

17. *mubīn*, The Clear, Clearing Sphere of the Moon *dāl* د

Its day is Monday. Adam resides there. Ismaʿil is the governor. The relation between the earth and this sphere is like that of the body and the spirit. It is entrusted with the arrangement of the earth. Insight concerning the fates of times can be attained through it.

18. *qābiḍ*, The Pressing, Grasping The ethereal sphere *ṭā'* ت

The ethereal globe and what is in it; it is the one with which dryness is connected.

19. *ḥayy*, The Living The sphere of air *zā'* ز

It is the area in which clouds and wind and vapor are. This area [contains] the provision for the continuation of life. The angel of thunder is created by means of the air.

20. *muḥyī*, The Life-Bestowing The sphere of water *sīn* س

God Almighty has made everything appear from water, as it is said in the Koran: "And We made everything alive from water" [Sura 21/30].

21. *mumīt*, The Death-Bestowing The terrestrial globe *ṣād* ص

The globe of dust, which is the place where the dead return and most living beings have no life (ʿaysh) in it.

22. *ʿazīz*, The Precious, Powerful Minerals *ẓā'* ظ

Those things which have great value for the normal people are found there.

23. *razzāq*, The Nourisher Plants *thā'* ث

In the plants is nourishment for most animals. Through the name of The Nourisher all kinds of nourishment have been arranged and, through nourishment, everything that pertains to the upbringing of all species. All plants are the manifestations of this very name. Of necessity, every kind of nourishment, be it sensual or spiritual, sensuous or intelligible, can be obtained from the plants—as God has also placed great power in medicinal herbs.

24. *mudhill*, The Lowering Animals *dhāl* ذ

God has lowered the animals by placing them at man's disposal. Predatory animals are also among them, and these are under the spell of the name The Lowering.

25. *qawī*, The Powerful, Strong Angels *fā'* ف

God has made the angels powerful.

ب
م
و

26. *laṭīf*, The Subtle Djinns *bā'*

The djinns are subtle bodies that are invisible.

27. *jāmi^c*, The Combining Man *mīm*

Man is the one that unites the mysteries of the Divine Names and the realities of the created world, and is the spirit of the world.

28. *rafī^c ad-darajāt*, High of Rank The all-embracing *wāw*
 rank

By "being all-embracing" it is pointed to the *ḥaqīqa muḥammadiyya*, which is higher and more elevated than the human reality.

In this chart in Urdu, which combines philosophical, gnostic, and mystical ideas, the traditional Sanskrit order of letters, beginning with the hard aspirants and ending with the labials, gives some amazing results, which fit well into the general scheme of letter mysticism. The *alif* stands, as in traditional Sufi thought and in calligraphy, for the originator; *qāf*, generally connected with the world-encircling mountain Qaf, corresponds here to the Divine Throne as described in Sura 2/256; *yā'*, the last letter of the Arabic alphabet, stands for the sphere of Saturn, which is the last sphere that human thought can reach and that is, astrologically, connected with the number eleven, which rank it occupies in this system. *Mīm*, usually connected with the Prophet, appears here as the letter of humanity, which corresponds to the general notion of the *mīm* in *Aḥmad*, being the letter of contingency or, as a Panjabi mystic says, "the shawl of humanity" that separates Aḥmad/Muhammad from *Aḥad*, the One God. The letter *wāw*, with its grammatical role as the conjunction "and," well expresses the position of the *ḥaqīqa muḥammadiyya* as forming the link between the Divine and created beings.

154

Appendix B

Idraki Beglari

In Praise of a Calligrapher

Well done, O scribe, who with a flowing pen
 draws letters, beautiful as Mani's art!
A skilled calligrapher, whose radiant eye
 has scattered musk upon a camphor-sheet!
He showed an *alif* first, so straight and tall,
 its shape was like a graceful cypress tree.
The *alif* is well honored in the world,
 and everywhere it takes the highest seat,
And it clasps nothing closely to its breast—
 its crown is therefore higher than the sky.

ا

A lump of ambergris beneath the *bā'*—
 he cast an anchor from the musky boat!

ب

I saw his *tā'*; my soul became refreshed,
 as Noah's ark came swimming in the sea.

ت

There were some dots connected with the *thā'*;
 some beggars hastened to the amber plate!

ث

155

ج

A hundred roses opened from each *jīm*,
　　and curly hyacinths from jasmine leaves!

چ

Jasmine appeared here from the loop of *chīm;*
　　with dots it furnishes some silver coins.

ح

The *ḥā'* was bashful, modest, full of shame,
　　and thus refrained from wearing any dots.
The benefactor put some dots on it;
　　it looked like magic stones in serpents' heads.

خ

He drew a *khā'* on slates of ivory,
　　he placed a crown upon the hoopoe's head.

د ذ

He drew a *dāl* and *dhāl* on paper, like
　　the mole and down upon a lovely face.

ر ز

From *rā'* and *zā'* he made the eyebrows black
　　and drew a bow of musk upon the moon.

س

The teeth of *sīn* will saw the heathen's head
　　when he becomes confused in ignorance;
The *s* of Islam turns into a saw
　　to punish him for infidelity!

ش

He brandishes the *shīn* of sword (*shamshīr*) now high;
　　he wants to lower yonder blackish hosts.

ص ض

He rubbed collyrium in *ṣād*'s small eye,
　　he put a beauty spot on *ḍād*'s white cheek.
For when the artist draws the shape of *ṣād*,—
　　its blackness makes you think of lovely eyes.

156

The value of the *ṭā'* is only "nine,"
 But add one dot: "nine hundred" is the *ẓā'*! ظ ط

Into eyeliners turned he now his pen
 to fill *ᶜayn*'s eye with blue collyrium;
He then placed on the *ᶜayn*'s face one more dot
 as beautiful as moles (*ghayn*) on moonlike cheeks. غ ع

He drew a *fā'* then on a pure white slate:
 a darling with its head on pillars soft! ف

Since *qāf* is the beginning of "Qur'ān"
 God granted it the rank of "hundred" here. ق

Like salty earth appears the empty page—
 the *kāf* becomes the saltspoon on this field! ل

A *lām* like tresses of the lovely ones—
 he showed a serpent in the garden too! ل

The head of *mīm* is like the friend's small mouth;
 the tress, beware! is like a serpent's tail. م

He drew a *nūn* then with his nimble pen,
 as if it were the ear of moon-faced friends,
And put a dot into the ring of *nūn*,
 as well shaped as a pierced ear can be. ن

The scribe made run the steed, that is, his pen:
 as ball and mallet came the *he* and *wāw*!
And when he twisted the *lām-alif*: this
 was called the tress and stature of the friend. ه و / لا

Abbreviations in Notes and Bibliography

Bayani	Mehdi Bayani, *Tadhkira-i khushnivīsān: nastaᶜlīq-nivīsān,* a comprehensive work about the masters of *nastaᶜliq* in Iran, in Turkey and India
BSO(A)S	*Bulletin of the School of Oriental (and African) Studies*
BEO	*Bulletin des Etudes Orientales*
EI	*Encyclopedia of Islam,* second edition
GAL	Brockelmann, *Geschichte der arabischen Literatur,* with *S,* supplement volumes
GMS	Gibb Memorial Series
Habib	Habib, *Khaṭṭ ū khaṭṭāṭān (Hatt u hattatan),* a useful survey of calligraphers to the late nineteenth century
Huart	Huart, *Les calligraphistes et les miniaturistes,* the first European survey of the history of calligraphy, based on Persian and Turkish sources, and still valuable
JA	*Journal Asiatique*
JAOS	*Journal of the American Oriental Society*
JRAS	*Journal of the Royal Asiatic Society*
MH	ᶜAli Efendi, *Manāqib-i hünarvarān (Menakib-i hünerveran),* based on a Persian biographical work, this Turkish book from the late seventeenth century gives some interesting insights into the life of a scribe and his approach to the art and the artists
QA	Minorsky, *Calligraphers and Painters,* the important translation of Qadi Ahmad's work which is particularly valuable for Timurid and even more Safavid Iran
REI	*Revue des études islamiques*

159

S	Supplement
SH	Inal, *Son Hattatlar,* a continuation of earlier biographical dictionaries of Turkish calligraphers, very important particularly for the late nineteenth and early twentieth centuries
TH	Mustaqimzade, *Tuḥfat al-khaṭṭāṭīn (Tuhfet el-hattatin)*, a voluminous book by an eighteenth-century Naqshbandi, upon whose work *Habib* relies heavily

Notes

CHAPTER ONE

1. Mayil, ed. Majnun, *Risāla*, p. 1.

2. Qalqashandi, *Ṣubḥ al-aᶜshā*, vol. III, p. 35.

3. See Erdmann, *Arabische Schriftzeichen als Ornamente,* and Sellheim, "Die Madonna mit der *šahāda.*"

4. For this development see Fück, *Die arabischen Studien in Europa.*

5. Grohmann, *Arabische Paläographie,* is the most scholarly work on the development of the Arabic script in the first centuries. The articles in the new *EI, Khaṭṭ, Kitāb, Kitābat, Kātib,* deal extensively with the development of calligraphy, epigraphy, and secretarial skills. In addition, a number of more general works have been published in the last two decades, after Kühnel, *Islamische Schriftkunst* (published during World War II), had given the first introduction to our subject, which was both scholarly and delightfully written. For the history of Arabic writing in general, not especially calligraphy, Moritz, *Arabic Paleography,* is still indispensable. Schimmel, *Islamic Calligraphy,* was written for the historian of religions, while Safadi, *Islamic Calligraphy,* gives a good, reliable survey of the development and has plentiful illustrations. Martin Lings, in *The Quranic Art of Calligraphy and Illumination,* offers superb examples of calligraphy as used for Korans, and is a fine guide in this field. Lately, Hasan Massoudy, *Calligraphie Arabe vivante,* has produced a book on calligraphy that is written, and partly illustrated, by one of the leading modern calligraphers. A vast survey of material, unfortunately not very well arranged, is Zaynuddin's *Muṣawwar al-khaṭṭ al-ᶜarabī,* in which the reader finds thousands of examples of the different styles. On the other hand, the beautifully produced book by Khatibi and Sijelmasi, *Splendour of Islamic Calligraphy,* suffers from an inadequate and partly incorrect, rather badly translated text. Among the catalogues of special exhibitions held in the last years, A. Welch, *Calligraphy and the Arts of the Muslim World,* is a good and instructive introduction to the various

applications of calligraphy; A. Raeuber, *Islamische Schönschrift,* has a special chapter on modern calligraphy. Every work on Islamic art deals with calligraphy; particularly rich is Pope, *Survey of Persian Art;* a number of smaller Turkish studies have been devoted to the topic as well. Every issue of the Arabic magazine *Fikrun wa Fann* since 1964 contains examples of classical and modern calligraphy.

6. Abbott, *The Rise of the North Arabic Script* and "Arabic Paleography."

7. Thus *QA,* p. 53, and in Sultan-ᶜAli's *Risāla, QA,* p. 107; this tradition was apparently generally accepted, for even Akbar's chronicler, Abu'l-Fazl, *A'in-i Akbarī,* vol. I, 105 (transl.), mentions it.

8. Rosenthal, *Four Essays,* p. 24.

9. Examples in Moritz, *Arabic Palaeography,* pls. 1, 44; Safadi, *Islamic Calligraphy,* p. 8. Early writing often has a tendency toward slanting, as the examples in Moritz show.

10. *QA,* p. 11.

11. Rosenthal, *Four Essays,* p. 59.

12. Lings, *The Quranic Art of Calligraphy,* chap. 1.

13. Mez, *Renaissance des Islams,* p. 327.

14. *EI,* vol. IV, p. 207, *kitāb.*

15. Abu'l-Aswad ad-Du'ali, the *qāḍī* of Basra (d. 69/688–89), is credited with inventing the diacritical marks; according to another tradition, it was Abu Sulayman Yahya al-Laythi who "was inspired to put diacritical marks while copying the Koran," *TH,* p. 583.

16. Hoenerbach, *Die dichterischen Vergleiche,* p. 151.

17. Pages from this Koran in the Fogg Art Museum, Harvard University, in the Metropolitan Museum New York, and in private collections; see Schimmel, *Islamic Calligraphy,* pl. V a; A. Welch, *Calligraphy,* no. 3.

18. Massignon, *La Passion . . . d'al Hoseyn ibn Mansour al Hallaj,* vol. 1, p. 168.

19. *TH,* p. 370, mentions Madi ibn Muhammad al-Ghafiqi (d. 183/799) and p. 112, Ishaq ibn Murad ash-Shaybani (d. 206/821–22, more than a hundred years old). That would place the beginning of Kufic calligraphy in the mid-eighth century.

20. Lings, *The Quranic Art of Calligraphy,* pl. 10.

21. Al-Muᶜizz ibn Badis, who tried to free Tunisia from Fatimid rule, is mentioned as the author of a treatise on calligraphy that is called either *ᶜUmdat al-kuttāb wa ᶜiddat dhawī' l-albāb* or *ᶜUmdat al-kuttāb fī ṣifati'l-ḥibr wa'l-aqlām wa'l-khaṭṭ;* see *GAL S,* I, 473.

22. Schroeder, "What Was the *badīᶜ* Script?"

23. Pages from the Koran have often been reproduced: Kühnel, *Islamische Schriftkunst,* fig. 12; Schimmel, *Islamic Calligraphy,* pl. VIII a; Lings, *The Quranic Art of Calligraphy,* pl. 17; A. Welch, *Calligraphy,* no. 13. A qualifying paper in the Fine Arts Department, Harvard University, by Beatrice St. Laurent, 1982, deals with this Koran; the author was able to find a group of 55 hitherto unknown pages of this Koran in Istanbul, which show that the Koran was bound not as a whole but in codices containing one *juz'* each (one *juz'* constitutes one thirtieth of

the full text). The date should be around 1100 or slightly later; Lings, *The Quranic Art of Calligraphy,* pl. 16, has a Koran in similar, though less elaborate eastern Kufi, signed by one ᶜAli, and dated 485/1092. Likewise Ḥabibi, *A Short History of Calligraphy,* offers very similar examples written by masters from Ghazni and dated in the second half of the eleventh and mid-twelfth centuries, pp. 178, 182.

24. Kühnel, *Islamische Schriftkunst,* p. 8.

25. See A. Welch, *Calligraphy,* fig. 7.

26. A good introduction to the problems of inscriptions on early ceramics is Lisa Volov, "Plaited Kufic on Samanid Epigraphic Pottery."

27. The dissertation of Bassem Zaki deals with this development, Harvard University, 1976.

28. For Spain see Ocaña Jimenez, *El cúfica hispano,* pp. 47–48.

29. Bivar, "Seljuqid Ziārets of Sar-i Pul."

30. See the figures in Schimmel, *Islamic Calligraphy,* pl. I (Saragossa), and p. 12, fig. *n* (Sar-i Pul).

31. The best survey of a group of plaited inscriptions is Flury, *Islamische Schriftbänder: Amida-Diyarbekir.*

32. Ettinghausen, "Arabic Epigraphy" and Aanavi, "Devotional Writing: 'Pseudo-Inscriptions' in Islamic Art."

33. Bombaci, *The Kufic Inscription in Persian Verses in the Court of the Royal Palace of Masᶜūd III at Ghazni.*

34. A particularly beautiful example of a *shaṭranjī* ᶜAlī from a Turkish manuscript of the later fifteenth century in Ettinghausen, "Die Islamische Zeit," in *Die Türkei und ihre Kunstschätze.* A fine square *Muḥammad* on a Turkish linen kerchief is in A. Welch, *Calligraphy,* no. 36.

35. See Grohmann, *Arabische Paläographie* and Dietrich, *Arabische Briefe.*

36. The best-known handbooks are as-Suli, *Adab al-kuttāb,* and Ibn Durustawayh, *Kitāb al-kuttāb;* see also Sourdel, "Le Livre des Secrétaires."

37. An autograph of Qalqashandi's *Ṣubḥ al-aᶜshā* in the Library of al-Azhar, dated 799/1397, in Moritz, *Arabic Palaeography,* pl. 171. For an analysis of this important work see Björkman, *Beiträge zur Geschichte der Staatskanzlei.*

38. Ibn Wahb, *Al-burhān,* p. 344, gives a good introduction; he himself belongs to an old secretarial family.

39. Rosenthal, *Four Essays,* p. 32.

40. Ibn Wahb, *Al-burhān,* p. 344.

41. A nice poetical description of a scribe working on a scroll that he unfolds on his lap, by Abu Nuwas, quoted in Wagner, *Abū Nuwās,* p. 381.

42. Mez, *Renaissance des Islams,* p. 168, according to Subki, *Ṭabaqāt ash-shāfiᶜiyya,* vol. II, p. 230.

43. *Habib,* p. 76; cf. *Huart,* pp. 93–94; Badruddin, master in all styles, was the son-in-law of Mir-ᶜAli Tabrizi, the first calligrapher of *nastaᶜlīq.*

44. Ibn Khaldun, *Muqaddima,* trans. Rosenthal, Vol. II, p. 390.

45. Hafiz, *Dīvān,* ed. Ahmad-Na'ini, no. 203; ed. Brockhaus no. 247; a good example of *musalsal* in *EI,* vol. V, pl. XXXVI 6.

46. Khaqani, *Dīvān,* p. 411; cf. ibid., p. 424: "the blind *mīm* of the scribes."

47. Ayverdi, *Fatih devri hattatları*, fig. 32; Kühnel, "Die osmanische Tughra."

48. The 687th night: "Asmaᶜi and the Three Girls from Basra."

49. Abu Nuwas, in Suli, *Adab al-kuttāb*, quoted by Wagner, *Abū Nuwās*, p. 324. Moritz's examples in *Arabic Palaeography* show that many profane manuscripts up to the eleventh century were very sparsely, if at all, marked.

50. Rosenthal, *Four Essays*, p. 45. Hamza al-Isfahani, *At-tanbīh* shows the dangers inherent in leaving out or mixing up the diacritical marks; see Chapter 4, note 5, below.

51. Hoenerbach, *Die dichterischen Vergleiche*, p. 99.

52. Hamza al-Isfahani, *At-tanbīh*, p. 94.

53. The story of the first *qalandar*.

54. Ibn ar-Rawandi, *Rāḥat aṣ-ṣudūr*, pp. 437–38, gives the ratios. For an analysis see Ahmad Moustafa, "The Scientific Construction of the Arabic Alphabet," mentioned in Soucek, "The Arts of Calligraphy," p. 21.

55. Rosenthal, *Four Essays*, p. 33.

56. Ünver-Athari, *Ibn al-Bawwāb*, p. 65. A panegyric poem by the scribe-poet Kushajim of Aleppo, in Kushajim, *Dīwān*, pp. 398 ff.

57. Ünver-Athari, *Ibn al-Bawwāb*, p. 66. A fine pun is quoted by Zamakhshari: In his *khaṭṭ* ("script/down") is the good luck, *ḥaẓẓ*, for every eyeball, as if it were the script of Ibn Muqla.

58. *GAL S*, III, 35.

59. *QA*, p. 56.

60. Mez, *Renaissance des Islams*, p. 168.

61. Cf. Ünver-Athari, *Ibn al-Bawwāb*, p. 17, based on Yaqut's *Muᶜjam al-udabā'*: someone admired the calligrapher "because you are singular in things which nobody in Baghdad shares with you: among them is the beautiful handwriting, and that I have never seen in my life a calligrapher except you, the distance between whose turban and his beard is two and a half cubits." Long beards were apparently not too common for calligraphers, as *TH*, p. 81, tells about Ahmad al-Hama'ili (d. 737/1337) in Mecca: "While he was writing the drafts of his correspondence, he would constantly pluck out and corrode his long beard with the hand of negligence."

62. *TH*, p. 27. Ibn al-Bawwab's unique Koran manuscript in the Chester Beatty Library has been studied by D. S. Rice.

63. Ünver-Athari, *Ibn al-Bawwāb*, p. 7.

64. Ibid., p. 26, according to Ibn Khallikan, *Wafayāt al-aᶜyān*, vol. I, p. 246.

65. Sana'i, *Ḥadīqat*, p. 667.

66. Ibn ar-Rawandi, *Rāḥat aṣ-ṣudūr*, pp. 42–44.

67. *Habib*, p. 22, sums up the styles and their proper applications: *rīḥānī* for Koran copies and prayers; *thuluth* for instruction and practicing calligraphy; *riqāᶜ* for correspondence; *naskh* for commentaries of the Koran and *ḥadīth*; *tauqīᶜ* for documents and royal orders; *muḥaqqaq* for poetry of sorts. This typology was, however, not strictly enforced. For the calligraphers in Yaqut's line see *Huart*, pp. 86 ff., who gives a slightly different tradition.

68. Ibn an-Nadim, *Fihrist,* trans. Dodge, chap. I, pp. 6–21. Thus, *naskh* in its later technical sense as copyists' script is missing, and *muḥaqqaq* is mentioned only among the derived scripts.

69. Ibn Wahb, *Al-burhān,* p. 345.

70. Fine examples from Ilkhan and Mamluk times in Lings, *The Quranic Art,* chap. 5.

71. *QA,* p. 64; *Huart,* p. 95; cf. Zaynuddin, *Muṣawwar al-khaṭṭ al-ᶜarabī,* no. 265.

72. Rosenthal, *Four Essays,* p. 59.

73. Ibid., p. 28.

74. According to *QA,* p. 16, it has one and a half circular strokes and four and a half straight strokes.

75. *SH,* pp. 647–767.

76. Murad Kamil "Die *qirma*-Schrift in Ägypten." The scribes knew of course various tricks to conceal or deform their letters so that a secret document could not be read by the uninitiated; one method was to write with milk instead of ink; when the recipient put hot ashes on the paper, the letters became visible; *TH,* p. 628.

77. See Arberry, *The Koran Illuminated,* no. 177, and Lings, *The Quranic Art of Calligraphy,* p. 32.

78. Examples in *TH,* p. 129 (d. 788/1386), *TH,* p. 367 (d. 1035/1626), *TH,* p. 461 (d. 1081/1670–71); Bada'uni, *Muntakhab,* vol. III, p. 429 (transl.), III, p. 310 (text), speaks of the extraordinary achievements of Sharif Farisi, the son of Akbar's famous painter ᶜAbdus-Samad, who made whole drawings and writings on a grain of rice; see also *Huart,* p. 132, for Sayyid Qasim Ghubari in Istanbul. I was given a grain of rice with the *basmala* and one with Sura 112 in Hyderabad/Deccan in 1979 and 1981; my full name in Roman letters was written on another grain.

79. *QA,* p. 64; *Huart,* p. 252.

80. Mez, *Renaissance des Islams,* p. 167.

81. A sumptuous copy of Muhammad-Quli Qutbshah's *Dīvān* is in the Salar Jung Museum, Hyderabad; all the magnificent copies of Ibrahim ᶜAdilshah's *Kitāb-i Nauras* seem to be dispersed.

82. *QA,* p. 24; cf. chapter 2, note 256, below.

83. Al-Washsha,' *Kitab al-muwashshā,* pp. 157 ff.

84. Rosenthal, *Four Essays,* pp. 50–56.

85. Nath, *Calligraphic Art,* fig. VII: correction of inscriptional illusion.

86. Fraad-Ettinghausen, "Sultanate Painting in Persian Style," p. 62. An unusually impressive example is a black stone slab from a Bengali mosque, built by prince Danyal, son of the great patron of arts, Husayn Shah, in 1500, now in the Metropolitan Museum; for a related slab see Faris and Miles, "An Inscription of Barbak Shah of Bengal"; cf. A. Welch, *Calligraphy,* fig. 1.

87. Ibn Khaldun, *Al-Muqaddima,* trans. Rosenthal, vol. II, pp. 378, 386.

88. Mustaqimzade mentions the following masters in the Maghrib who wrote in "classical" style: Ibn ᶜAbdun (d. 300/912–13), *TH,* p. 295; Abu ᶜOmar Yusuf

ibn Muhammad (Cordova, d. 334/945–46), *TH*, p. 591; Ahmad ibn Ibban al-An-dalusi, who studied with Ibn Muqla (d. 381/991–92), *TH*, p. 58; Halaf ibn Sulay-man ᶜAmrun as-Sanhaji (d. 398/1007–8 in Cordova), *TH*, p. 193; Abu ᶜAbdallah Muhammad ibn Shaqq al-layl (d. 454/1062 in Toledo), who had studied with Ibn al-Bawwab, *TH*, p. 373; Muhammad ibn Ahmad al-Maghribi (d. 540/1145–46), *TH*, p. 379; Abu'l-Hasan Muhammad at-Tabib (d. 560/1165), *TH*, p. 417; Abu Bakr ᶜAbdur-Rahman al-Miknasi (d. 592/1196 in Marrakesh), *TH*, p. 250; Hayyan ibn ᶜAbdallah al-Andalusi (d. 609/1212–13), *TH*, p. 189; Abu Jaᶜfar Ahmad ibn Ibrahim (d. 707/1307–8 in Granada), learned from Yaqut, *TH*, p. 58; Abu Mu-hammad ᶜAbdallah ibn ᶜAli ash-Sharishi (d. 717/1317 in Sevilla), *TH*, p. 276; Abu Jaᶜfar Hassan al-Habibi al-Andalusi (d. 742/1341–42), *TH*, p. 145; he further mentions *TH*, pp. 69 and 81, other masters who wrote in the style of Ibn al-Bawwab.

89. Khatibi and Sijelmasi, *Splendour,* pls. 24, 104, 107, 145, 156, 214.

90. Cf. Bivar, "The Arabic Calligraphy of West Africa."

91. *QA*, chap. 2, is devoted to the masters of *taᶜlīq*.

92. *Bayani*, no. 631.

93. *Huart*, pp. 257 ff.: "Les Déformateurs"; *QA*, p. 100, is less aggressive; *TH*, pp. 674–77, is also less critical than Huart; he mentions that "the unlucky callig-rapher" who sometimes signed with "Giraffe" and sometimes with "Shah" became somewhat mentally deranged.

94. *Bayani*, p. 442.

95. Qatiᶜi, *Majmaᶜ al-shuᶜarā*, p. 226 n.

96. *Bayani*, p. 821.

97. *MH*, p. 44.

98. *Bayani*, no. 709; *Huart*, pp. 98, 235; *QA*, p. 167.

99. Aslah, *Shuᶜarā-yi Kashmīr*, S, I, p. 397.

100. *QA*, p. 147; *Huart*, p. 220; the copy, dated 945/1538, is now in the Top-kapu Seray, HS 25, see Lings, *The Quranic Art of Calligraphy*, pl. 91; Zaynuddin, *Muṣawwar al-khaṭṭ al-ᶜarabī*, no. 225. According to *QA*, p. 145, Maulana Malik be-gan a Koran in *Nastaᶜlīq* but did not finish it; in 1111/1699, Dervish ᶜAli wrote a *nastaᶜlīq* Koran; see Ghafur, *Calligraphers of Thatta*, p. 62. A copy of a Koran in *nastaᶜlīq*, dated 1060/1650, is in the National Museum Karachi. To our day, pray-ers in Arabic are frequently written in *nastaᶜlīq*, especially in Iran and Indo-Paki-stan.

101. *QA*, p. 77; *Huart*, p. 244.

102. *Huart*, p. 107; he wrote even a *Fātiḥa* in *shikasta*.

103. Thus Qaniᶜ, *Maqālāt ash-shuᶜarā*, p. 746.

104. Bedil, *Kulliyāt*, vol. I, p. 112.

105. A. Welch, *Calligraphy*, no. 75, color plate p. 14; it is written in Gwalior, 801/1398–99.

106. See Schimmel, *Islamic Calligraphy*, pl. XLV, for a beautiful *Sūrat an-Nās* (Sura 114) from the Deccan; also the same in A. Welch, *Calligraphy*, no. 86.

107. *QA*, p. 133; *Bayani*, no. 826.

108. Avcĭ, "Türk sanatĭnda aynalĭ yazĭlar."

109. Minorsky, in various places in *QA,* translates it with "written with the finger," but it has to be "with the fingernail," as *Huart,* p. 253, correctly says. I received some specimens in 1981 from the Pakistani artist Agha Abdul-Wase Saqib, Lahore.

110. For the development in Pakistan see Halem, ed., *Calligraphy and Modern Art,* the proceedings of a seminar held in Karachi in 1974. Among the modern artists, one can mention the names of Issam as-Saᶜid, and of Wasmaa Chorbachi, whose calligraphies on silk and ceramics were recently widely acclaimed in Saudi Arabia; Massoudy, the author of *Calligraphie Arabe vivante,* has invented powerful calligrams. There are interesting experiments with angular Kufi in both Morocco and Pakistan, and the tradition of "speaking letters" was used in Iran by Adharbod. The work of the Persian sculptor Tanavoli is likewise influenced by calligraphic concepts, as is modern art in Egypt and the Sudan, in Lebanon and Syria.

111. *QA,* p. 52.

CHAPTER TWO

1. Ibn ar-Rawandi, *Rāḥat aṣ-ṣudūr,* p. 40. *TH,* p. 688, quotes the Persian verse:

> The pen said: "I am the emperor of the world—
> In the end, I bring fortune to the writer!"

2. *SH,* p. 442, a calligraphy representing this saying.

3. Rosenthal, *Four Essays,* p. 61.

4. Bivar, "The Arabic Calligraphy of West Africa."

5. Aksel, *Türklerde dini resimler,* p. 41.

6. *SH,* p. 143.

7. *QA,* p. 71, tells that the prince Ibrahim Mirza once, as a joke, signed an inscription with *kuntuhu* ("It was me") instead of *katabahu* by simply changing the position of the dots.

8. *Albumblätter, Indische,* no. 58: ᶜ*Abdallah taqlīd-i Mīr-ᶜImād.* The Fogg Art Museum, Harvard University, has an album (1958–78) in which a page is signed: *Faqīr ᶜAlī al-kātib nāqiluhu Muḥammad Ḥusayn at-Tabrīzī.* As much as the imitation of the masters was admired and encouraged, yet, slavish copying of their works was not sufficient for a calligrapher: *TH,* p. 419, speaks somewhat regretfully of Şekercizade (d. 1166/1753), who wrote first a Koran "in imitation" and then kept on imitating traditional models without adding a personal touch to his writing.

9. *TH,* p. 576; *Habib,* pp. 51–52.

10. Rosenthal, *Four Essays,* p. 28.

11. *QA,* p. 122.

12. *Bayani,* p. 253. The manuscript, which had been endowed to the shrine in Ardabil by Shah ᶜAbbas, was taken away by the Russians in 1828 and brought to St. Petersburg; a facsimile was published by Galina Kostinova, Leningrad, 1957.

13. *QA*, p. 122; cf. ibid., p. 51, Sultan-ᶜAli's remark:

> The aim of Murtaza ᶜAli in writing
> was [to reproduce] not merely speech, letters, and dots,
> but fundamentals, purity and virtue;
> for this reason he deigned to point to good writing.

14. Hafiz Osman gave lessons on Sunday for the poor, on Wednesday for the wealthy, *TH*, p. 303, *Habib*, p. 123.

15. For a full translation see *Ibn Khaldūn: The Muqaddima*, Rosenthal, transl., vol. II, pp. 388–89.

16. *QA*, p. 125.

17. Çığ, *Hafiz Osman*, p. 8. The noted Syrian historian Kamaladdin ibn al-ᶜAdim (d. 666/1267–68) wrote even in the camel litter while traveling, *TH*, p. 344.

18. *TH*, p. 285.

19. *Habib*, p. 197. Cf. the often repeated story of the king and the vizier's clever son, first told by Daulatshah, *Tadhkirat*, pp. 294–95: "Which child writes best?" "He who trims his pen best," etc.

20. Muhammad Hafiz Khan (d. 1194/1780), in *Bayani*, p. 710, no. 1012. It is fitting that an Ottoman Turkish box with the implements of calligraphy bears the inscription *wa ṣabrun jamīlun*, "And good patience" (Sura 12/18); see Arseven, *Les Arts Décoratifs Turcs*, fig. 687.

21. That becomes evident from a story found in almost all Turkish sources (*TH*, p. 129; *Habib*, p. 103; *Huart*, p. 138): the calligrapher Sayyid Ismaᶜil (d. 1090/1679) wrote a wonderful hand, and there would not have been any difference between his writing and that of Shaykh Hamdullah, had he not had such a big belly that he could not place the paper correctly on his knees.

22. Rückert-Pertsch, *Grammatik, Poetik und Rhetorik*, p. 100.

23. Rosenthal, *Four Essays*, pp. 27–28. That is called *taᶜrīq*.

24. See for similar comparisons Sahl ibn Harun, in Hamza al-Isfahani, *At-tanbīh*, p. 92; Ibn al-Muᶜtazz, *Dīwān*, vol. III, no. 169, p. 109; Nuwayri, quoted in Khalidiyan, *Kitāb at-tuhaf*, p. 250.

25. *QA*, p. 25.

26. *Bayani*, p. 503. See Ibn Abi ᶜAwn, *Kitāb at-tashbīhāt*, p. 305; he speaks of:

> Ink like the covert of a raven's wing,
> pens like sharpened lances,
> paper like the glittering of clouds,
> and words like the days of youth.

See also the description in *TH*, p. 602.

27. Ibn az-Zayyat (d. 233/847), in Rosenthal, *Four Essays*, p. 35.

28. Tauhidi, in Rosenthal, *Four Essays*, p. 42; cf. ibid., p. 25.

29. *QA*, p. 112.

30. *QA*, p. 49.

31. Khalidiyan, *Kitāb at-tuhaf*, p. 217. One could also send a slave of good handwriting as a present, praising his skill with appropriate verses:

. . . I saw in his script a beauty by which he captures the intellect,
like delicately embroidered gowns which the singing girls trail behind them . . .

Similarly al-Washsha', *Kitāb al-muwashshā,* pp. 192–93. For instance:

When he enters the *dīwān* [the office] the eyes become amazed
and the hearts of the spectators almost fly away . . .

32. Quoted in Khalidiyan, *Kitāb at-tuḥaf,* p. 250. Many poems of this kind in Hamza al-Isfahani, *At-tanbīh,* pp. 105–10. Amusing is Mustaqimzade's enumeration of the forty items that are needed for calligraphy; he dwells happily on the fact that the names of all of them begin with an *mīm* (the numerical value of which is 40) (*TH,* pp. 603–6). But this is not surprising at all, since all the words that he enumerates are Arabic *nomina instrumenti* in the form *mifˁal* or *mafˁāl.*

33. Qadi ar-Rashid, *Kitāb adh-dhakhā'ir,* p. 254, para. 381; Khalidiyan, *Kitāb at-tuḥaf,* pp. 38, 192, 208, 217, 241, 250; inkstands, ibid., pp. 26, 42, 218, 245.

34. *TH,* p. 580.

35. *TH,* pp. 218–19; *Habib,* p. 11; for the calligrapher Sulayman Ahenīnqalam, "Iron-Pen" (d. 1119/1707) see also *Huart,* p. 152. Writing with a quill is mentioned in *Habib,* p. 110; the calligrapher who practiced this died in 1132/1720.

36. Some fragments of a Koran, of Central Asian or Indian origin, preserved in the Fogg Art Museum and other collections, seem to be written with a brush, and so are a number of early Indian manuscripts. For Islamic writing in China, the use of the brush is attested; but the Chinese Muslims did not follow the classical style as developed in the Middle East. The whole problem still has to be studied carefully.

37. Hamza al-Isfahani, *At-tanbīh,* pp. 109–10.

38. Giese, *Kušāǧim,* p. 205.

39. See the descriptions by Samiha Ayverdi, *Ibrahim Efendi'nin Konaǧi,* quoted in Schimmel, "Eine Istanbuler Schriftstellerin," p. 583; examples of ivory cutting boards in Arseven, *Les Arts Décoratifs Turcs,* pl. 13, figs. 530 and 531.

40. Reckendorf, *Muhammad und die Seinen,* p. 217, states that pious people used water from the well Zamzam in Mecca to prepare their ink. *Habib,* p. 111, based on *TH,* p. 202, tells about a calligrapher (d. 957/1550 at the age of more than a hundred years) that he began late in life to take lessons from Shaykh Hamdullah and, walking a long distance from Galatasaray to Istanbul proper, used to fasten small ink bottles around his legs so that the ink might "mature," i.e., become well mixed.

41. According to Mustaqimzade, *TH,* p. 569, the great jurist of early Islam, Abu Hanifa Nuˁman (d. 150/767), received his surname "father of H." because he always carried an inkwell with him so that he could write down important things, "and in the Iraqian language, *ḥanīfa* means *miḥbara,* that is, inkwell." We need not believe this fanciful explanation.

42. Qadi ar-Rashīd, *Kitāb adh-dhakhā'ir,* p. 254, para. 381. Cf. Giese, *Kušāǧim,* pp. 138, 271, 273.

43. Khalidiyan, *Kitāb at-tuḥaf,* p. 218, quoting as-Suli, *Adab al-kuttāb;* very similar the verse, ibid., p. 26.

44. *Habib,* p. 109, based on *TH,* p. 180. Another inscription quoted by *Habib* in this connection:

> The friend said: "What is in the box with the three ink wells?"
> I said to him: "O my sweet (*shīrīn*) prince Khusrau with sugar lips:
> Your black tresses, your ruby lips, and your blue eyes!"

Cf. also ibid., p. 241, further a verse for a porcelain inkstand, p. 247. Persian verses are found on medieval bronze cases as they adorn later boxes in lacquerwork. Inkwells have been studied more than comparable objects by art historians; see Wiet, "Objets en cuivre," nos. 3331 (with a *répertoire des écritoires*), 4048, and 4461, pls. III–V; Herzfeld, "A Bronze Pen-Case (607/1210)": L. T. Ginzalian, "The Bronze Qalamdān . . . from the Hermitage Collection"; Eva Baer, "An Islamic Inkwell." Good pictures in Safadi, *Islamic Calligraphy,* pls. 94–97; several examples in Sarre, *Erzeugnisse islamischer Kunst,* with inscriptions; A. Welch, *Calligraphy,* pl. 40, inkwell; pl. 48, pen-box; a fine lacquer *qalamdān* from the Victoria and Albert Museum in Losty, *Art of the Book,* p. 17. Most museums possess nice specimens of inkwells.

45. Giese, *Kušāğim,* p. 104, where also other writing utensils are mentioned.

46. Ibid., p. 175; cf. ibid., p. 138, about "writing utensils decorated with gold and silver." For examples see Kühnel, *Islamische Schriftkunst,* pp. 80–84. Several times the *sibbūr* occurs, that is, a slate of ebony used as a notebook; one wonders how legible the letters were on the dark wood.

47. Ghalib, *Kulliyāt-i fārsī,* vol. IV, no. 292.

48. Aslah, *Shuᶜarā-yi Kashmīr, S,* I, p. 509.

49. Safadi, *Das Biographische Lexikon,* vol. XII, p. 127, no. 104. This calligrapher, al-Hasan ibn ᶜAli ibn al-Luᶜaybiya al-Juwayni, was much in demand, and "nobody after ᶜAli ibn Hilal [Ibn al-Bawwab] wrote better than he." He wrote 163 *muṣḥaf,* i.e., parts and full copies of the Koran. He died in 587/1191. *SH,* p. 405, mentions an excellent nineteenth-century calligrapher and seal cutter who used to write while drinking raki!

50. ᶜAufi, *Lubāb al-albāb,* vol. II, pp. 124, 246; also quoted in *TH,* p. 425.

51. Sourdel, "Le Livre des Secrétaires," p. 130/Arabic text 16. *TH,* p. 602, quotes an Arabic verse:

> One quarter of writing is in the blackness of the ink,
> one quarter in the good technique of the writer,
> one quarter from the pen, correctly trimmed,
> and the last quarter depends upon the paper.

52. See Mez, *Renaissance des Islams,* p. 440; Busse, *Chalif und Grosskönig,* p. 305: the best quality is from Khorasan, then Samarqand, Damaskus, Tiberias, and Trablus. According to Khalidiyan, *Kitāb at-tuḥaf,* p. 287, para. 59, the Tulunid ruler Khumarawayh sent loads of papyrus, *qarāṭīs,* from Egypt to the caliph in Baghdad.

53. *MH,* p. 11, mentions Damascus paper as the worst quality; for the translation of the whole paragraph see *Huart,* p. 11.

170

54. See L. Vidal and R. Bouvier, "Le papier de Khānbaligh." N. Abbott, "An Arabic-Persian Wooden Ḳur'ānic Manuscript," describes a Koran from eighteenth-century Iran that consists of twenty-nine wooden folios.

55. Khaqani, *Dīvān, qaṣīda,* p. 47.

56. Recipes for *āhar* by Hafiz Osman in Çığ, *Hafiz Osman,* p. 13. See also Schimmel, "Eine Istanbuler Schriftstellerin," p. 583.

57. Kalim, *Dīvān,* ed. Thackston, p. 15, no. 64.

58. *TH,* p. 641, mentions someone who, without using a *masṭar,* did not deviate from the straight line, and counts this as an outstanding achievement.

59. *Habib,* pp. 46, 145: the mirror models of Muhammad Rasim. *TH,* p. 467; cf. ibid., pp. 580–81: Yahya ibn Osman (d. 1169/1755–56) wrote *jalī* script, and his small house could not accommodate the large models he drew for inscriptions; when his patron became vizier, he provided him with a larger house to facilitate his work.

60. Fani, *Dīvān,* p. 82.

61. *TH,* p. 84, mentions someone who received the degree of *sawwadahu* after filling 1,000 sheets of paper with exercises. See also ibid., pp. 230, 242, and 560 (twice). Yazïr, *Kalam Güzeli,* p. 131, explains *ḥarrarahu* as "writing a vocalized text" (for most texts in Arabic letters do not bear the vowel marks); *sawwadahu* as "practicing," *mashaqahu* means "copying," while *raqamahu* is often used as a sign of modesty.

62. Rosenthal, *Four Essays,* pp. 29–30.

63. *Huart,* pp. 109 ff. Perhaps he was regarded as the perfect embodiment of the Prophet's saying, "Teach your son writing, swimming, and arrow-shooting," which is quoted by Mustaqimzade among the forty *ḥadīth* pertaining to writing, *TH,* p. 15.

64. Pope, *Survey of Persian Art,* p. 1726, n. 1.

65. *TH,* p. 624. It should, however, not be used in calligraphy. Weisweiler, *Arabische Märchen,* vol. II, p. 243, no. 98, has riddles about the sandbox "which never smiles."

66. Ünver, *Türklerde hatt sanatï,* pp. 11, 12.

67. *TH,* p. 557.

68. *SH,* p. 581; *TH,* p. 572: "He succeeded in receiving his *katabahu.*" The *katabahu* was granted, in this case, after the disciple had worked for forty months with Hafiz Osman; "forty" may be taken, as so often, as a round number meaning a long time, even though the dates given for this calligrapher's studies span some three years and a few months. A medieval master, Qadi Hasan ibn al-Marzuban as-Sirafi (d. 368/978–79) allegedly wrote ten pages every day until he became a perfect calligrapher, *TH,* p. 158. For him see note 113.

69. *SH,* p. 619, for a calligrapher who died in 1906. But it was an old custom, for *QA,* p. 74, tells that every child who took a lesson from the fifteenth-century master Simi attained a high rank.

70. *SH,* p. 587.

71. The unpublished Harvard Ph.D. dissertation by Bassem Zaki contains im-

portant material about the signatures on Egyptian tombstones in the first three centuries of the Hegira, particularly master Mubarak al-Makki. See also Ghafur, *Calligraphers of Thatta,* p. 46. Examples of signatures in Safadi, *Islamic Calligraphy,* pp. 92–93.

72. *TH,* p. 239.

73. *Bayani,* no. 1313, p. 877:

> Good and bad, whatever he writes,
> he does it all in the name of this lowly one.

Habib, p. 226, does not quote Shihabi's impudent answer. See for the event also *Huart,* p. 229, and Ziauddin, *Moslem Calligraphy,* p. 44. *Habib,* pp. 108–9, tells about one of Hamdullah's favorite students, that the master sometimes signed his pages because he liked him; but people claimed that the disciple put his writing in such a way before the master that he unwittingly wrote his own *katabahu* on them.

74. *Bayani,* p. 529. See also *Habib,* p. 185. This Mirza Abu Turab wrote a fine elegy on Mir-ᶜImad's assassination. One may mention in this connection Mustaqimzade's aphorism no. 24 that to kiss a master's hand is equal to a prostration, *TH,* p. 626.

75. *QA,* p. 48; Çığ, *Hafız Osman,* p. 13; *Habib,* p. 150; *TH,* p. 484, tells the story more extensively and in a slightly different way.

76. *TH,* p. 656, and *Habib,* p. 194: he permitted Mir Chalama to sign with his, the master's, name, but the disciple retorted: "Who are you that I should sign with your name?" Thereupon he was cursed.

77. *TH,* p. 559, 602, and others.

78. *TH,* p. 580. *Leblebi* are roasted chickpeas, slightly coated with sugar; they are a favorite with Turkish children. Hence, "iron *leblebi*" is something that is difficult to chew and to digest.

79. Safadi, *Das biographische Lexikon,* vol. XII, no. 271, p. 297, about Abu ᶜAli al-Hasan ibn Wahb al-Harithi, born 186/802. The family was originally Christian. Ibn Wahb al-Katib, who "turned to the practicing-house of Paradise" in 427/1036, composed an interesting book, *Al-burhān fī wujūh al-bayān,* in which he often alludes to writing and the terminology of scribes.

80. Sourdel, "Livre des Secrétaires," p. 119. He quotes Baladhuri (*Futūḥ al-buldān,* ed. de Goeje, p. 472) for women in the time of the Prophet who could write, including one of Muhammad's wives. Suli, *Adab al-kuttāb,* pp. 50, 97, states that some authorities do not approve of women as scribes. *TH,* p. 20, quotes as the last of the forty traditions connected with writing: "Do not allow them to come down to the [public] sitting rooms, and do not teach them writing!" He also mentions with apparent approval an alleged saying by Socrates, "not to add evil to evil" by teaching women how to write, *TH,* p. 627. I have met elderly Turkish ladies who knew how to read (so that they could read the Koran) but were not allowed to learn writing, "lest we write love letters," as one of them told me in 1955 in Killis.

172

81. Hamza al-Isfahani, *At-tanbīh,* p. 98: "As if her writing were the shape of her figure, and her ink the blackness of her hair, and as if her paper were the skin of her face, and as if her pen were one of her fingers, and as if her style were the magic of her eyeball, and as if her knife were the flirtation of her glance, and as if her cutting board were the heart of her lover." In eighteenth-century Turkey, poets delighted in describing "a darling scribe with eyebrows like a reed-pen and ink [black] hair" with whom they would like to spend some time in the charming environments of Kâghidhane (lit., "paper house") on the Bosporus because the picture of union (*waṣlī;* also, "album page") with him or her cannot be wiped out from the page of thoughts.

82. *Bayani,* no. 380, p. 267. Interestingly, this lady, who studied with Dost-Muhammad, signed with the masculine form *katabahu* instead of the grammatically correct *katabathu.* That shows that the formula had become stereotyped by that time.

83. Ibid., no. 349. Zebunnisa wrote *shikasta, naskh,* and *nastaᶜlīq.* Her court calligrapher, Muhammad Saᶜid Ashraf, who prepared an anthology from Rumi's *Mathnawī* for her, is praised in a fine quatrain with double rhyme that also highlights his talent as a painter:

> As much as you have no peer in calligraphy—
> in the style of painting you resemble Mani (*bi-Mānī mānī*).

Bayani, p. 744.

84. Arberry, *The Koran Illuminated,* no. 236. The piece is usually thought to be from Lucknow, eighteenth century, which may be correct; but its possible connection with the accomplished queen of Bijapur is too tempting to go unmentioned.

85. *TH,* p. 190; *Habib,* p. 110; and *SH,* p. 174.

86. *SH,* pp. 802–3.

87. *SH,* p. 773. A certain Esma Ibret Hanīm completed a *ḥilya* at the age of fifteen in 1209/1794, *SH,* p. 85.

88. *QA,* p. 62.

89. *TH,* p. 265:

> ᶜAbdul-Karim has delightful lines
> which he writes with skill and elegance;
> he decorates his paper with scripts
> as the clouds decorate the valley slopes with greenery.

It is interesting that this very Sufi wrote also mystical works on the *asrār al-ḥurūf* (mysteries of the letters).

90. *TH,* p. 186.

91. It is natural that many Mevlevis are mentioned in the section on *nastaᶜlīq* in *TH,* for their favorite occupation was to copy Rumi's *Mathnawī* with its ca. 26,000 verses, which must have taken a skilled, fast-writing calligrapher about two years. Ibrahim Cevri (d. 1065/1655) copied this work eighteen times, eighteen being the sacred number of the Mevlevis (*TH,* p. 639). One of Maulana Rumi's

khalīfas, Nizamuddin Dede, learned calligraphy from Yaqut himself, *TH*, p. 548. Among the great number of Mevlevis mentioned by *Habib* and *SH*, two are outstanding: Sarï Abdullah (d. 1070/1659–60), the commentator of the *Mathnawī* and translator of the *Gulshan-i rāz* into Turkish, was as noted as a fine calligrapher (*TH*, p. 280), as was Nahifi (d. 1152/1739), to whom Turkey owes the best metrical translation of the *Mathnawī*. See also *Huart*, pp. 104, 271–72.

92. *Huart*, pp. 20, 313. Mustaqimzade himself is a fine example of a Naqshbandi who studied calligraphy and applied his vast knowledge of Islamic subjects to the history of calligraphy. *Huart*, pp. 282–91, gives a good survey of calligraphers in various Sufi orders. It should be added that the historian Tashköprüzade (d. 968/1560–61) is mentioned in *TH*, p. 89, as a calligrapher and member of the Khalvatiyya order. One may also mention that Riza ᶜAli Shah, the author of the book *Miftāḥ al-khuṭūṭ*, which was written ca. 1800 for Nawwab ᶜAzim Jah Bahadur of Carnatic, was a member of the Qadiriyya order, and that all artists mentioned in his book are Qadiris, *Huart*, p. 5. Riza ᶜAli Shah's book is one of his sources.

93. Mehmed Zaynuddin, a disciple of Hamdullah, was the son of Hamdi, the author of the fine Turkish epos *Yūsuf Zulaykhā*, and grandson of Mehmet the Conqueror's spiritual adviser, Aq Shamsuddin. It is he who wrote the Light-verse (Sura 24/35) around the dome of the Aya Sofya, *TH*, p. 442; *Huart*, p. 119.

94. *SH*, pp. 68 ff. Most of his Korans were written for high-ranking personalities, such as King Amanullah of Afghanistan, and the mother of the Khediv ᶜAbbas Hilmi. His calligraphy of Busiri's *Burda* was printed in Egypt in 1352/1933. ᶜAziz Efendi also wrote three large *ḥilyas;* a photograph of one of them in *SH*, p. 69.

95. This seems to be the case particularly in the Persianate tradition, where many poets are mentioned as calligraphers; for the Arabic world, the information is not so easily available.

96. The calligrapher Muhammad ibn Musa ibn al-Basis wrote a commentary on Ibn al-Bawwab's *Rā'iyya*, *TH*, p. 462.

97. Sultan-ᶜAli's poem in *QA*, pp. 122 ff. According to Qalqashandi, *Ṣubḥ al-aᶜshā*, vol. III, p. 14, Zaynuddin Shaᶜban al-Athari wrote an *alfiyya fī ṣanᶜati'l-khaṭṭ*.

98. Mir-ᶜAli's poems are mentioned in *QA*, p. 125; *Bayani* p. 503, and have often been repeated. He wrote a considerable number of nice verses on album pages.

99. Majnun Haravi was a disciple of Tabbakh; his *Risālas* have been printed in Kabul. A prayer of his, playing with allusions to writing, is quoted by *Habib*, p. 219:

> O God, have mercy upon the soul of Majnun;
> draw the pen over Majnun's script of rebellion!
> Abolish (*naskh*) the dust (*ghubār*) of sin and rebellion
> from the registration (*tauqīᶜ*) of my paper pieces (*riqāᶜ*).

Habib, p. 189, also quotes from a rhymed treatise on calligraphy by Baba Shah of Isfahan, allegedly a disciple of Mir-ᶜAli and teacher of Mir-ᶜImad (d. 1012/1603).

But since this calligrapher was still very young in 995/1587, and "would have become equal to Mir-ᶜAli and Sultan-ᶜAli if he had lived longer," he cannot be a direct disciple of Mir-ᶜAli, who died in 1556, even though he had begun writing at the age of eight—unless the age of thirty-nine is considered "very young" for a calligrapher. See also *Huart,* p. 238.

100. *Bayani,* p. 637, no. 866.

101. *TH,* p. 101.

102. It is signed by Muhammad Salik, 1082/1672.

103. *MH,* p. 27.

104. Giese, *Kušāǧim,* p. 23, in Kushajim's *Dīwān,* no. 336.

105. *TH,* p. 113, and *Habib,* p. 83. He died in 933/1526–27 and was the teacher of Ahmad Qarahisari.

106. *Bayani,* no. 709, p. 524. There, Mir-ᶜImad's full biography is given.

107. *Habib,* p. 157. One may think here also of a verse by a haughty Turkish calligrapher in the eighteenth century who claimed:

A scribe in the midst of illiterate people
is like a copy of the Koran in the house of a *dhimmī* [i.e., a Christian, Jew, or Sabian].

Mustaqimzade, *TH,* p. 514, cannot find enough deprecative expressions for this arrogant person.

108. *Bayani,* no. 514.

109. Information kindly supplied by Professor Carter Findley, who will publish an article on this rare document.

110. *SH,* p. 169. He went to Egypt toward the end of his life and died there in 1941. But a very similar formula is used in *TH,* p. 356, for a calligrapher who died in 970/1562–63. Nowadays in Pakistan, many lower-class calligraphers turn to the decoration of trucks, as George Rich has shown ("Bedford Painting in Pakistan"). They also decorate the motor rikshas with nicely calligraphed Urdu verses, usually quotations from Iqbal's poetry.

111. Among the numerous high-ranking figures we single out the noted poet Shaykh ul-Islam Yahya (d. 1053/1643) and his father, who held the same office. Qadiᶜaskers of the nineteenth century are mentioned in *SH,* pp. 527, 603, 611, 614, 639, and often; particularly famous is Mustafa ᶜIzzet Efendi Yesarizade (d. 1265/1849), son of the famous left-handed calligrapher Esᶜad Yesari (his portrait in *SH,* p. 568). Members of the Köprülü family were as much known for their good hands as were the grand viziers Shehla Ahmed Pasha (d. 1167/1753–54); *TH,* p. 63; *Huart,* p. 167; and Raghib Pasha (d. 1176/1762–63), *TH,* pp. 449–50.

112. Raqim Efendi produced some of the finest *thuluth jalī* plates; see Ünver, *Türkīyazy çeşitleri,* p. 16. After attaining the rank of Qadiᶜasker of Istanbul he became Qadiᶜasker of Anadolu in 1822 (*SH,* pp. 272 ff.). His elder brother Hafiz Ismaᶜil Zühdü Efendi was an established teacher of calligraphy in the imperial household.

113. *TH,* p. 414. The poor man lived in the Choban (shepherd) Chavush Medrese in Istanbul; hence the animal imagery. Cf. also *TH,* p. 367, about a

calligrapher (d. 870/1465–66) who wrote for money, and ibid., p. 440, about one Muhammad Shamsuddin in Egypt, who allegedly charged one dirham for writing one line of the *Alfiyya*—but this remark can be dismissed, since the *Alfiyya* was composed long after his death. See also Mez, *Renaissance des Islams*, p. 212, and *Huart*, p. 77, about Qadi Hasan ibn ʿAbdallah as-Sirafi (d. 978), who lived from selling his famous calligraphies and copies because he did not accept money from the government. Mustaqimzade holds that "to teach writing for a honorarium is permissible" (*TH*, p. 625), and he knows how miserable the life of many of these scribes was: the expression *khubz al-kuttāb* (bread of the scribes) is used for hodge-podge, "since the food of a teacher of writing comes from different houses it is all different," *TH*, p. 623.

114. A charming description by Sultan-ʿAli of a garden party in which all court musicians and singers took part, in *Bayani*, p. 247.

115. *QA*, p. 31.

116. *MH*, p. 34, and *Bayani*, p. 245.

117. For titles in India see *Huart*, pp. 256–57.

118. Mir-ʿAli's biography in *Bayani*, no. 703. The number of his works, or works signed with his name, is by far too great to be listed here; every museum has at least one or two of his calligraphic pages. Since he used various styles of signing his calligraphies, *al-faqīr Mīr-ʿAlī* being apparently the most frequently occurring formula, the identification is not easy. A list of his disciples is given in *Bayani*, p. 505.

شيبك
يشبك

119. *TH*, p. 585, calls the Uzbek ruler Shaybak, with a change of dots, Yashbek, and claims that "he wrote a Yaqutian script and painted Mani-like pictures," a remark that certainly developed out of the story of his attempt to correct the works of Sultan-ʿAli and Bihzad after his conquest of Herat in order to impress his Uzbek officers. For a good description of this scene see Qatiʿi, *Majmaʿ al-shuʿarā*, pp. 55–56.

120. *Bayani*, no. 84, p. 47; he died in 986/1578 in Mashhad.

121. Qatiʿi, *Majmaʿ al-shuʿarā*, p. 226, n.

122. *Bayani*, no. 379.

123. Ibid., no. 111; *QA*, pp. 6–9. Azhari was first employed by Baysunghur, then by Abu Saʿid. Among his works are a copy of the *Haft Paykar* in the Metropolitan Museum, a *Khusrau u Shīrīn* in the John Rylands Library, and Nizami's *Khamsa* in the Punjab University Library. He traveled much and died, as it is said, in 880/1475 in Jerusalem.

124. *QA*, p. 168.

125. *Bayani*, no. 508.

126. *TH*, p. 288.

127. *Habib*, p. 66. His *qaṣīda* is in form of a riddle about the pen in which the contrasting qualities of the pen are elegantly alluded to:

What is that bird that never rests from shrieking,
whose body is decorated with gold while its head is besmeared with pitch? . . .

176

128. *SH,* p. 329.

129. *SH,* pp. 54–57. He states at the end that Filibeli Bakkal was a proof for the saying that "one of God's mysteries lies in the calligraphers' hand," for how else could one explain that he wrote such a fine, strong hand while his hands were torn and worn out from his daily chore as a greengrocer? Mustaqimzade gives numerous examples of calligraphers from a working-class background. Most of them were later employed in offices and had no independent artistic career. One calligrapher's father was a *leblebici,* vendor of roasted chickpeas *(TH,* p. 259), another a ropemaker *(TH,* p. 263); we find a *Sepetizade* (son of a basket maker) and a *Berberzade* (barber's son) *(TH,* p. 280). A father who served in the imperial kitchen *(TH,* p. 245) could give his son a better entrée in the circles of good calligraphers. A detailed study of the data provided by *TH, Habib, MH,* and *SH* would yield interesting results for the sociology of Turkish calligraphers.

130. *Habib,* p. 242; *TH,* p. 51: Ibrahim bī-zabān (d. 1154/1741).

131. *TH,* p. 708; *Habib,* p. 210. Qasim Shadhishah insulted him by claiming that:

> for this reason his writing has no foundation
> because his ear has never *heard* anyone's instruction.

132. *Huart,* p. 265; *TH,* p. 681.

133. *SH,* pp. 531 ff.; *TH,* p. 717, has only a brief note about him.

134. *SH,* p. 582; *Huart,* p. 156, based on *TH,* p. 292; and *Habib,* p. 121, tells about the imperial scribe ᶜAbdallah Vafa'i (d. 1141/1728) that he began to write with his foot and his left hand and added unusual flourishes to his letters, behaving contrary to the customs of calligraphers so that he finally went (as Mustaqimzade says, "for a change of air") to Bursa where he died in exile. Other sources, such as *QA,* p. 52, speak with admiration of someone who could keep the pen in his foot or his mouth.

135. Mustaqimzade, always fond of strange stories, not only mentions that the famous traditionist Bukhari wrote "a good hand, sometimes with the right and sometimes with the left hand" *(TH,* p. 393), but also praises his own contemporary, ᶜAbdul-Muᶜti Altĭ Parmaq who, having six fingers on the right hand, "wrote the six styles with six fingers perfectly" *(TH,* p. 294). Another calligrapher, after losing his right hand on the battlefield, continued to write with his left hand and was admired by the sultan; he died in 1172/1758–59, *TH,* p. 170.

136. For Ahmad ibn Yusuf az-Zuᶜayfari see *TH,* p. 93. A friend consoled him with the verse:

> Verily your right hand has lost its [capacity of writing] calligraphy,
> but don't worry and don't think of difficulties,
> rather be happy with the good tidings of constant happiness and joy,
> for God Almighty has facilitated *(yassara)* for you the left hand *(yusrā)*

TH, pp. 250–51, mentions a Syrian calligrapher of the seventeenth century "whose both hands were right hands when he wrote." The *qāḍī* of Sevilla, a good callig-

rapher (d. 612/1215), was also left-handed, *TH,* p. 273. That even a woman without hands, who appeared in Cairo in 576/1180–81, was a perfect calligrapher is duly mentioned by Mustaqimzade, *TH,* p. 144.

137. Ibrahim Tattawi, *Takmila,* pp. 548–50. He died ca. 1226/1811; the Koran is now in the Talpur Library in Hyderabad/Sind.

138. *Waṣlī* is a cardboard made up from layers of paper that are glued together in a special process; *waṣṣālī* is the preparation of these papers and not, as Minorsky seems to think, "repair."

139. *MH,* p. 76.

140. *MH,* pp. 45–46.

141. *Bayani,* no. 1466, p. 947, mentions "Ottoman Turkish verses in medium size *nastaᶜlīq* of white paper pasted on green" in the Istanbul University Library. The Metropolitan Museum has a volume of fine cutout poems, mainly by Shahi, and some other excellent cutout pages. For the whole art see Çığ, *Türk oymacılarî.*

142. *Huart,* p. 325, after *Habib,* p. 261.

143. Dost-Muhammad is mentioned among the specialists in cutting out verses, and the author of the *Majmaᶜ al-shuᶜarā-yi Jahāngīrshāhī,* Qatiᶜi, received his surname from this art, which he learned in Herat.

144. *Bayani,* pp. 494–95, in the *Muraqqaᶜ* (album) of Shah Tahmasp, written in 943/1536–37 in Bukhara. Another copy is in Boston, Museum of Fine Arts, and yet another piece cut out by ᶜAli Sangi is in the Metropolitan Museum (67.266.76)

145. See also *MH,* p. 63.

146. Safadi, *Das biographische Lexikon,* vol. XII, pp. 431 ff., no. 387. Tughra'i was killed in 513/1119 or 514/1120. For him see *GAL,* I, 247–48; *S,* I, 439–40.

147. Abu'l-Fazl, *Ā'īn-i Akbarī,* transl. I, p. 54.

148. *Huart,* p. 107; *QA,* p. 132. *MH,* p. 70, quotes a verse in which *khaṭṭ-i chap* is equivalent to "illegible." Ibid., p. 60, ᶜAbdallah Marvarid (d. 921/1516) is called a master of *khaṭṭ-i chap.* All the masters of this style mentioned in the sources were *munshīs,* members of the royal bureaus.

149. Qaniᶜ, *Maqālāt ash-shuᶜarā,* p. 776: a man in Sind.

150. See *SH,* pp. 293–97 for Rasim Efendi (d. 1885), the *ser-sikke-ken muᶜavini.*

151. *SH,* p. 435.

152. Vahdeti, who had composed the *ṭughrā* for Sultan ᶜAbdul-ᶜAziz in 1862 (for which achievement he received 500 Turkish pounds), later worked on bank notes, stamps, etc.; see *SH,* pp. 435 ff. Cf. also *Bayani,* no. 248, about Hasan and Husayn-i Hakkak and their activities. The Egyptian bank notes were designed by Sultan ᶜAbdul-Majid's scribe Zühdü Efendi (d. 1879); see *SH,* p. 1, "but he wrote only one Koran."

153. Rice, *Ibn al-Bawwāb,* pp. 7–8, after Yaqut, *Muᶜjam al-udabā',* vol. XV, p. 122.

154. Qatiᶜi, *Majmaᶜ al-shuᶜarā,* p. 103. *Habib,* p. 233, tells a similar anecdote about Anisi and ᶜAbdul-Karim, in which the good, acceptable page was not damaged by the water. A nice story about the imitation of a calligraphic page of Hafiz Osman in 1150/1737, in which the paper was made to look old, is told by the

eyewitness, Mustaqimzade, in *TH,* p. 203; relating another case of forgery, he tells how to use ironing and coloring with coffeeground to give the paper an antique look, *TH,* p. 528.

155. Mez, *Renaissance des Islams,* p. 176.

156. *Bayani,* no. 1085, pp. 749 f. However, even this successful master complained of loneliness when traveling abroad, using, of course, the imagery of writing:

> Since nobody has sent me a letter,
> I have a broken back and am pressed together like a book!

Habib, p. 68.

157. *QA,* p. 65; *Habib,* p. 227.

158. Qati^ci, *Majma^c al-shu^carā,* p. 83. See also Soucek, "The Arts of Calligraphy," p. 28, n. 74: the normal rate was 80 verses *mathnavī* and 50 verses of *ghazal* a day; Sultan-^cAli of Mashhad wrote usually 50 verses a day, ibid., p. 30, n. 76. That amounts to some 18,000 verses a year, and since he wrote for about sixty years, the enormous number of pieces by him that have survived can be easily explained. Apparently, some calligraphers liked to brag about their writing, for Mustaqimzade, in his aphorisms on writing (*TH,* p. 627), says that one should not tell a lie when mentioning how many pages one has written on a certain day, "and if one has filled a hundred practice sheets one may say 'I wrote twenty or thirty,' but not vice versa."

159. *QA,* p. 49.

160. A facsimile edition of this Koran, preserved in the Chester Beatty Library, is in preparation.

161. *Huart,* p. 92, based on *Habib,* p. 57.

162. Safadi, *Das biographische Lexikon,* vol. XII, p. 440, no. 388: Ibn al-Khazin (d. 502/1108–9) wrote "fifty *mushaf,* both quarters and full Korans"; he further copied the voluminous *Kitāb al-aghānī* three times and, as *Habib,* p. 48, states, was particularly fond of writing the *Maqāmāt al-Harīrī.* Copies of the Koran, either bound by *juz'* so that the whole Koran consists of thirty volumes, or by groups of four to five *juz',* were probably common when large letters were used. In such cases, the beginning and the end of each fascicule were lavishly decorated.

163. *Huart,* p. 131; see also ibid., p. 125, and *TH,* p. 324, who mentions an extremely beautiful copy in his hand of Ibn al-Farid's *Dīwān.* A copy of a Koran written by ^cAli al-Qari in 1000/1591–92 is reproduced in Moritz, *Arabic Palaeography,* pl. 94. For the literary achievements of this author see *GAL,* II, 394–98; *S,* II, 539–43.

164. *Huart,* p. 139.

165. *Ibid.,* p. 160, based on *TH,* p. 388, and *Habib,* p. 133. He was a Naqshbandi. The remark in *TH,* p. 72, that Ahmad ibn ^cAbdul-Wahhab an-Nuwayri (d. 733/1332–33) wrote three *juz'* of the Koran every day—which amounts to the completion of a whole Koran in ten days—sounds exaggerated, and even more the story that Abu ^cAbdur-Razzaq ibn al-Fuwati as-Sabuni (d. 728/1328 at the age

of eighty) wrote four *juz'* every day (*TH*, p. 257). To write minute Korans, with one *juz'* on each page, was a special art; see *TH*, p. 176, for a fifteenth-century calligrapher from Transoxania.

166. *SH*, p. 428.

167. Thus the famous Hanbalite scholar ʿAbdur-Rahman Abu'l-Faraj ibn al-Jauzi (d. 597/1200), who wrote in the style of Ibn al-Bawwab (*Huart*, p. 83, based on *Habib*, p. 49, and *TH*, pp. 247–48). The latter claims that it was the leftovers of the pens with which he had written *ḥadīth*, and "after the water was heated there were still wood chops left."

168. *SH*, p. 454.

169. One Turkish calligrapher, who died in 1760, copied it 25 times. Cf. also *SH*, pp. 30, 218.

170. Rasim, who was regarded as the final master in the school of Hafiz Osman wrote *Sūrat al-anʿām* 1,000 times, as well as sixty Korans; he also copied Suyuti's *Unmūdhaj al-labīb* for the sake of blessing, *TH*, pp. 465–70, *Habib*, p. 146.

171. Ünver, *Hilya-i saadet, Hattat Mehmet Şevki*, written in 1881. The Metropolitan Museum owns a *hilya* by "Mustafa called al- . . . [doubtlessly Raqim] written for the sake of blessing for his son and disciple ʿIzzet."

172. *Habib*, p. 90; cf. ibid., pp. 93, 97. Mehmet ibn Ahmad Nargisizade (d. 1044/1634–35), a fertile author who could even write very fast while walking, wrote a copy of Baydawi's commentary on the Koran in forty days; ibid., p. 241, and *TH*, pp. 383–84 and 702.

173. See Atil, *Art of the Mamluks*, no. 9: a *Burda* for Sultan Qaytbay (Berlin Ms. or. fol. 1623); Chester Beatty Arabic MS 4168; Chester Beatty has also a *Burda* written for Yashbek ad-Dawadar, one of the most influential officers in the last days of the Mamluk Empire; also, a *Burda* with a Persian paraphrase—doubtlessly Jami's famous rendering—written by Sultan-ʿAli Mashhadi in 881/1477 (no. 154 Persian). Other fine copies of the *Burda* are in Cairo, Istanbul, London, and Vienna. A Turkish calligrapher in the late eighteenth century wrote a *Burda* for fifty pieces of gold, *TH*, p. 110. Interestingly, the author of the *Burda*, the Shadhili Sufi al-Busiri (d. 698/1298), was a noted calligrapher (*TH*, pp. 411–12); *TH*, pp. 239, 323, and 459 mentions the names of some of his disciples, among them one Muhammad Fakhruddin al-Halabi in Divrigi (d. 713/1313), a place in eastern Anatolia that was then under Mamluk rule.

174. See the useful list at the end of *Bayani*, vol. III.

175. *Bayani*, no. 124.

176. *Ibid.*, no. 84, p. 48, a copy by Sayyid Ahmad Mashhadi in Tehran, Imperial Library. Daulatshah, *Tadhkirat*, pp. 480–92, praises Shahi as a good painter. An incomplete cutout *Dīvān* of Shahi is in the Metropolitan Museum, and fragments of a fine manuscript of his *Dīvān* are pasted around Moghul album pages. Exquisite copies of his *Dīvān* are found in all major libraries and museums; they date from the mid-fifteenth century to the early seventeenth century. See *GA*, p. 68–69. For his poetical achievements see Rypka, *History of Iranian Literature*, p. 284.

177. *Habib*, p. 243, mentions the *Kulliyāt-i Ṣā'ib*, written by Mehmet Eflatun (d. 1168/1754–55), "which deserves to be visited," i.e., is worth seeing. See also *TH*, p. 732, and another *Dīvān* of Sa'ib, ibid., p. 716.

178. *Bayani*, no. 104.

179. *Ibid.*, p. 251. The manuscript was in the Imperial Library in Tehran. There are a considerable number of manuscripts by Sultan-ᶜAli written after this *Dīvān*, all of which show that his artistic strength did not weaken for a long time; we mention the *Khamsa* by Mir-ᶜAli Shir Nava'i, written in 897/1492 (during the author's lifetime), which came via Bukhara to Jahangir's library, and is now in the Royal Library in Windsor Castle (see Losty, *Art of the Book*, no. 177). Some years later, Sultan-ᶜAli copied the versification by Jami of the *Forty ḥadīth*, 903/1498 (now in the Salar Jung Museum, Hyderabad). The copy of Sultan Husayn Bayqara's Turki *dīvān*, dated 906/1501, which is now in the Metropolitan Museum, is still admirably beautiful; he had already copied the same royal book once in 897/1492 (now in the Topkapu Saray, Hazine HE 1639; see Togan, "Miniatures," p. 37).

180. *Huart*, pp. 109 ff.

181. *Bayani*, p. 870. The calligrapher died in 1270/1853.

182. *TH*, p. 105, *Huart*, p. 157: a calligrapher devoted himself to writing Jazuli's *Dalā'il al-Khayrāt* until he died because the Prophet had inspired him in a dream to do so.

183. *QA*, p. 30.

184. *SH*, p. 495, mentions as an exception that a master (d. 1242/1826) wrote even small characters without eyeglasses.

185. *Bayani*, no. 410. Togan, "Miniatures," p. 7, mentions Jami's use of the term *chashm-i firang* (European eyes) for spectacles, but I have not found the reference.

186. Ünver, *Türk yazĭ çeẓitleri*, p. 28; it is Istanbul, Topkapĭ, Hazine KN 2158, verso 18.

187. *TH*, p. 177; the image occurs several times in Kalim's *Dīvān*.

188. *TH*, pp. 504–5, but he confuses this Sultan Mahmud with Mahmud of Ghazna, telling about his chaste love for his Turkish slave Ayaz!

189. *TH*, p. 123. Abu'l-Fida was allegedly "the unique pearl of his time in the Yaqutian style;" *TH*, p. 123.

190. An autograph of Sultan Hasan, dated 755/1354 (reproduced in Moritz, *Arabic Palaeography*, p. 150 A), shows indeed little elegance. But see for the training of young Mamluks in writing, Flemming, "Literary Activities in Mamluk Halls and Barracks." Salahuddin al-Munajjid has edited the work of Hasan at-Tibi, who composed an introduction to the styles of Ibn al-Bawwab for the last Mamluk sultan, Qansauh al-Ghuri; and another manuscript about various styles of writing, copied by a Mamluk, Kasbay min Tanam, for the same ruler, is reproduced in Fehérvári-Safadi, *1400 years of Islamic Art*, no. 14. See also the numerous *Burdas* copied in Mamluk times; cf. note 173, above.

191. *Habib*, p. 36; cf. also *TH*, p. 561.

192. *TH,* p. 519.

193. *TH,* pp. 357–58; a century later the Buwayhid Jalaluddaula ibn Baha'uddaula (d. 452/1060) is mentioned as a good calligrapher, ibid., p. 358.

194. *TH,* p. 364.

195. A friend of the just-mentioned Sahib Ibn ᶜAbbad took up this saying in his Arabic verse:

> He sows in the soil of paper pearls with his script,
> and spreads over them the wings of peacocks.

TH, p. 309; see also Daulatshah, *Tadhkirat,* p. 515, for ᶜAbdallah Marvarid.

196. *TH,* pp. 69, 356–57.

197. *TH,* p. 274.

198. *TH,* p. 520, Masᶜud; ibid., p. 41, Ibrahim.

199. Ibn ar-Rawandi, *Rāḥat aṣ-ṣudūr,* p. 40. This author himself claims to have known "seventy styles of writing" and offers a good introduction into calligraphy before Yaqut at the end of his book.

200. *TH,* p. 225. The Ilkhan ruler Abu Saᶜid ibn Khudabanda was, if we believe *TH,* p. 413, a disciple of Yaqut's disciple as-Sayrafi.

201. *Huart,* p. 96; *TH,* p. 62.

202. *Bayani,* p. 248. He wrote a fine *shikasta taᶜlīq.*

203. *Habib,* p. 58. For Sharafuddin Yazdi (d. 858/1454), the author of the *Ẓafarnāma,* see also Rypka, *History of Iranian Literature,* pp. 434, 444.

204. Daulatshah, *Tadhkirat,* p. 380; *QA,* p. 28.

205. Lings, *The Quranic Art of Calligraphy,* pls. 82–83.

206. His handwriting in this particular Koran seems almost to foreshadow the style that became so typical of Ottoman *naskh* calligraphy; it is very elegant and well proportioned.

207. *Habib,* p. 182; their names are listed in *Bayani,* p. 117.

208. Dost-Muhammad, *Ḥālāt-i hunarvarān,* p. 13.

209. Lings, *The Quranic Art of Calligraphy,* pl. 51; A. Welch, *Calligraphy,* no. 49.

210. *Huart,* p. 99. Rypka, *History of Iranian Literature,* pp. 284–85. Fattahi's *Shabistān-i khayāl* was imitated in Turkish by another calligrapher, Qadi Khwaja ᶜAbdur-Rahman Ghubari in Istanbul (d. 974/1566–67), a master of dust script, *TH,* pp. 246–47.

211. *TH,* p. 659; *Huart,* p. 217.

212. His poems were often calligraphed, and one of his official letters, ordering the assembling of a calligraphic album, is preserved in Roemer, *Staatsschreiben der Timuridenzeit,* no. 74.

213. *Bayani,* no. 164; Schimmel, "Poetry and Calligraphy," p. 85. Prince Sam Mirza, an accomplished author, calligrapher, poet, and sometime governor of Herat, was taught calligraphy by Muhammad Mu'min ibn ᶜAbdallah Marvarid, *Habib,* p. 77.

214. Cf. Dickson-Welch, *The Houghton Shahname,* vol. I, p. 240, for the refutation of the story of Chaldiran.

182

215. *Bayani,* no. 463.

216. Dickson-Welch, *The Houghton Shahname,* gives the best introduction into the artistic and intellectual climate of the early Safavid time. At Tahmasp's court, Amir Ghayb Bek collected a fine album with a foreword by Sayyid Ahmad of Mashhad in 973/1565–66; it is now in Istanbul, Topkapı, Hazine 2161. See *Bayani,* pp. 50–54, for the text of the introduction.

217. *Bayani,* no. 317, p. 201. Dost-Muhammad's introduction was edited by Dr. Abdallah Chaghatay. See also Dickson-Welch, *The Houghton Shahname,* pp. 118–28.

218. *Bayani,* p. 201.

219. *QA,* p. 155.

220. *Bayani,* no. 653.

221. *TH,* pp. 695–97.

222. *Bayani,* no. 471.

223. A. Welch, *Calligraphy,* no. 67.

224. *QA,* p. 165, about Mir Mucizzuddin Muhammad. A specimen by him dated 978/1570–71, in *Albumblätter,* no. 12. See also note 237, below.

225. *QA,* pp. 128–29.

226. Bada'uni, *Muntakhab,* vol. III, p. 378 (transl.), III, p. 273 (text); see also Qatici, *Majmac al-shucarā,* pp. 290–91.

227. *Habib,* p. 202. Cf. *Huart,* p. 319. Another master, who excelled as philosopher and calligrapher, was Mir Baqir Dhu'l-kamalayn, whose albums were highly prized, and who died in India at the age of eighty-seven (*Huart,* pp. 226–27). The sources claim that he was Mir-cAli Haravi's father.

228. Abu'l-Fazl, *Ā'īn-i Akbarī,* transl., I, 109. Conflicting statements about his life span make a proper assessment difficult. *QA* studied with him from 1557 on, when the master was already seventy (*QA,* pp. 135–39). Some sources claim that he died in 972/1564; others, ca. 990/1582 at the age of eighty-eight. *TH,* p. 736, gives the date of 952/1545, which is certainly too early. Shah-Mahmud may have joined Akbar's court just for a brief span of time, as Dost-Muhammad did. Calligraphies by Shah-Mahmud in *Albumblätter,* nos. 6 and 8; Rypka, *History of Iranian Literature,* fig. 20; Atil, *Brush of the Masters,* no. 15; Safadi, *Islamic Calligraphy,* pp. 28, 87, no. 91.

229. Bada'uni, *Muntakhab,* vol. III, p. 316 (transl.), III, p. 227 (text); Abu'l-Fazl, *Ā'īn-i Akbarī,* transl. p. 103.

230. Qatici, *Majmac al-shucarā,* p. 50: "His *thuluth* was like that of Tabbakh, his *rīḥānī* better than Yaqut's." Ashraf Khan was, like Qatici, a disciple of Dost-Salman, a name that may be read as Dost-i Salman or Dost-i Sulayman. That would then point to Dost-Muhammad, whose father's name was Sulayman. See Dickson-Welch, *The Houghton Shahname,* vol. I, p. 118. Qatici, ibid., pp. 53–54, speaks also about Mir Kalang who, along with Ashraf Khan and Khawaja Mahmud Ishaq, worked in Akbar's library (which would be impossible if he had died, as note on p. 255 has it, based on Mir cAla'addaula Qazvini, in 953/1546). Mir Kalang, according to Qatici's statement, worked together with Mir Dauri and Hafiz Muham-

mad Amin to "write the story of Hamza which I [Qaṭiᶜi] had made and finished and brought into bound volumes, and they displayed their fine writing." If this remark is correct, the authorship of the *Hamza-nāma* would be ascertained, in spite of Mir ᶜAla'addaula Qazvini's statement in the *Nafā'is al-ma'āthir,* that Khawaja ᶜAta'ullah, the *munshī* from Qazvin, composed the work (quoted by Pramod Chandra, *The Cleveland Tutiname,* appendix 2). The conflicting Herati and Qazvini traditions will have to be carefully studied to ascertain the truth of Qaṭiᶜi's remarks. Even though he was very advanced in age when he composed the *Majmaᶜ al-shuᶜarā,* and may have mixed up the names of some artists, yet it is rather unlikely that he should have claimed authorship for such a voluminous work as the *Hamza-nāma* if he had not had at least some share in it.

231. *TH,* p. 654. Bada'uni, *Muntakhab,* vol. III, p. 227 (transl.). Dauri was a disciple of Molla Qasim Shadhi and studied together with Sultan-Mahmud of Turbat, another well-known calligrapher. He wrote, among other works, a copy of Amir Khusrau's *Duval Rānī Khizr Khān* for Akbar's library. On the return from the pilgrimage he and a friend of his "became food for crocodiles and fishes" at the Gujarat coast.

232. See Bada'uni, *Muntakhab,* vol. III, pp. 150, 253, 467, 518 (transl.). The most outstanding master was Muhammad Husayn Zarrinqalam, mentioned ibid., p. 378 (transl.), p. 273 (text); see *Huart,* p. 230; *QA,* p. 99; Abu'l-Fazl, *Ā'īn-i Akbarī,* p. 109, transl.; *Bayani* pp. 702–4; *Albumblätter,* no. 4; A. Welch, *Calligraphy,* no. 76; A. Welch, *Art of the Precious Book,* M 146 verso. Among the manuscripts that he wrote for Akbar, we mention the *Khamsa* of Amir Khusrau in the Metropolitan Museum, written in 1006/1597–98; the *Akbarnāma* in the British Library (see Losty, *Art of the Book,* nos. 70–71); a *Gulistān,* written in 1581 in Fathpur Sikri, in the Royal Asiatic Society (see Losty, ibid., no. 58); a *Bahāristān* written in 1004/1595, in the Bodleian Library (see Losty, ibid., no. 64).

233. Khalifa Shaykh Ghulam Muhammad, *Haft Iqlīm-i Akbarshāhī,* British Museum Or. 1861.

234. Mir Maᶜsum Nami was one of the most important historians of Sind; his *Tārīkh-i Maᶜṣūmī* contains valuable information about the history of his home province, the Lower Indus Valley; see Schimmel, "Islamic Literatures of India," p. 45; Storey, *Persian Literature,* pp. 651–52. Ab'l-Fazl, *Ā'īn-i Akbarī,* transl., I, pp. 514–15, and Bada'uni, *Muntakhab,* vol. III, p. 500 (transl.), II, p. 366 (text), give information about him; and Nath, *Calligraphic Art,* has photographs of some of his inscriptions. The date of Jahangir's accession as given in Agra Fort was composed and calligraphed by him.

235. *QA,* p. 153: Maulana Muhammad Amin, who also worked on the *Hamza-nāma;* see note 230, above.

236. *Islamic Culture,* vol. IV, 1931, p. 627.

237. The *Ma'āthir-i rahīmī* tells that one of the Khankhanan's admirers composed a *mathnavī* in praise of him; the Khankhanan sent it to Kashan to have it calligraphed by Mir Muᶜizzuddin, and the master, after fulfilling his wish, and returning the poem to India, received 10,000 rupees. Muᶜizzuddin (see note 224,

184

above) was indeed considered to equal Sultan-ᶜAli and Mir-ᶜAli (*Bayani*, p. 819). *TH*, p. 726, claims that he was a Sunnite and therefore praises him. He died in 981/1573–74. The Khankhanan corresponded also with Mir-ᶜImad (*Bayani*, pp. 531–32).

238. *Bayani*, no. 536; *Albumblätter*, no. 22, dated 1021/1612. In A. Welch, *Art of the Precious Book*, a manuscript of the *Akhlāq-i Nāṣirī* is ascribed to ᶜAmbarinqalam. The miniature at the end of the manuscript is published in S. C. Welch, *Imperial Mughal Painting*, pl. 19, and as dustcover for Losty, *The Art of the Book*, where it appears also on pl. XXI, no. 65. A considerable number of miniatures, predominantly Moghul, but also Ottoman, show calligraphers at work; it would be a rewarding task to compare them, including the fine border drawings in imperial Moghul albums. For examples see A. Welch, *Calligraphy*, no. 76 (in color plate 12); Kühnel, *Islamische Schriftkunst*, fig. 87; Safadi, *Islamic Calligraphy*, nos. 93, 99, and 102. Schimmel, *Islam in India and Pakistan* (Iconography), pl. XXVI b.

239. *Bayani*, p. 258. That happened in 1017/1608. The book came then as part of Nadir Shah's booty in 1739, from Delhi to Tehran, where it was in the Imperial Library. Jahangir himself tells how he bestowed a Koran in Yaqut's handwriting to Sayyid Muhammad, a descendant of Shah ᶜAlam, the great fifteenth-century saint of Gujarat, and asked him to translate the text into plain Persian, *Tuzuk-i Jahāngīrī*, vol. II, transl., pp. 34–35.

240. *Tuzuk-i Jahāngīrī*, vol. I, transl., p. 168. The Khankhanan brought him Jami's *Yūsuf Zulaykhā* in Mir-ᶜAli's hand in 1610; this manuscript was valued at 1,000 gold mohurs.

241. For Ibrahim ibn Mir-ᶜImad see *Huart*, p. 245.

242. *Bayani*, no. 514; on p. 541 a letter from him, imploring Shahjahan for help.

243. Ziauddin, *Moslem Calligraphy*, p. 40. According to *Habib*, p. 197, he died in Kashmir in 1048/1638, but that is less likely.

244. *Bayani*, no. 402, p. 288; a fragment by him in A. Welch, *Calligraphy*, no. 78, dated 1031/1620. See S. A. Shere, "A *waṣlī* of Prince Khurram," dated 1025/1616–17. About the calligrapher who was responsible for the decoration of the Taj Mahal see Wayne Begley, "Amānat and the Calligraphy of the Taj Mahal." Among the numerous precious books in Shahjahan's library was a copy of Sana'i's *Ḥadīqat al-ḥaqīqa*, written by Sultan-ᶜAli in 882/1478; it is now in the Salar Jung Museum, Hyderabad.

245. *Bayani*, no. 310, mentions only fragments from Dara's hand in Delhi, in the Bodleian Library, and one piece in Berlin, previously described by Kühnel. But see the *Albumblätter*, nos. 32, 42, 35, where the signature is partly rubbed off, apparently after Dara's execution; further, the fine piece in the Fogg Art Museum (published in A. Welch, *Calligraphy*, no. 81), dated 1631.

246. Information kindly supplied by Wasmaa Chorbachi, who saw this Koran in Baghdad in January 1982.

247. *Bayani*, no. 199.

248. Ibid., no. 1081, p. 748.

249. Ibid. mentions him twice, no. 1253 and no. 1402.

250. Ibid., no. 633. He became a *hazārī*, commander of thousand, after Aurangzeb had ascended the throne. See *Albumblätter*, nos. 44 and 50.

251. *Albumblätter*, no. 28, a praise poem for the Prophet (wrongly identified in the explanation). Korans by Aurangzeb are in the Museum of Bijapur, the Salar Jung Museum, and the Hyderabad Museum, and probably in many other places.

252. *Bayani*, no. 303.

253. Ibid., no. 1088.

254. Ibid., no. 159. Examples are found in the Museums of Lahore and Delhi, one example in Schimmel, *Islam in India and Pakistan* (Iconography), fig. 16.

255. Khwaja M. Ahmad, "Calligraphy," in Sherwani-Joshi, *History of Medieval Deccan*.

256. Azad Bilgrami, *Khizāna-i ʿāmira*, pp. 21–22.

257. *Huart*, p. 96. The poem is quoted in full in *Habib*, p. 66 (see note 127, above).

258. See Mahmud Gawan, *Rauḍ al-inshā'*, p. 63:

> If the ocean would become ink for me
> and the Tigris and the Euphrates and every valley,
> and the earth would sprout altogether pens
> with which one could write till the Day of Judgment—
> even then I could not count the amount
> of longing which is troubling my heart!

259. *Habib*, p. 125. Ayverdi, *Fatih devri hattatları*, fig. 5, shows some of his mirrored *thuluth* inscriptions. He is buried in the *Hattatlar makberi*, the calligraphers' cemetery, in Istanbul; see also *TH*, p. 582.

260. *Bayani*, no. 1021; *TH*, pp. 690 f., confuses him, understandably, with the other ʿAlis of Herat and Mashhad. Besides, Mustaqimzade's strongly anti-Shia attitude prevents him from fully acknowledging the masterpieces written by Persian Shiite calligraphers.

261. *Habib*, pp. 185–86, Sayyid Ahmad of Mashhad.

262. *Bayani*, no. 297; cf. also *Habib*, pp. 195–96. *The Indian Heritage*, no. 43, a page from this manuscript, now in the Benkaim collection.

263. For the whole field see B. D. Varma, "ʿAdil Shahi Epigraphy."

264. A page that is most probably by him with a *Nādi ʿAliyyan* in *Albumblätter*, no. 30. The high standard of calligraphy in the Deccan ca. 1600 is also evident from the *qaṣīda* of the Bijapuri poet Nusrati in honor of ʿAbdallah Qutbshah (Brit. Library, Or. 13533), with alternating *thuluth* and *naskh* lines; see Losty, *The Art of the Book*, no. 103. A considerable number of manuscripts from the royal libraries of Bijapur and Golconda, including a deluxe copy of Muhammad-Quli Qutbshah's poetry, are now in the Salar Jung Museum.

265. Ghafur, *Calligraphers of Thatta*; Ibrahim Tattawi, *Takmila*, p. 551. Cf. also Burton, *Sindh and the Races That Inhabit the Valley of the Indus*, p. 396.

266. *Habib*, p. 153: Murad II.

186

267. His teacher was Hasan ibn ᶜAbdus-Samad as-Samsuni; see also *Huart,* p. 119.

268. Ayverdi, *Fatih devri hattatları,* fig. 5; see note 259, above.

269. *SH,* pp. 27 ff., p. 45: His maternal uncle Jalal Amasi and his two sons Jamal and Muhyi'ddin. *MH,* p. 25, says about him:

> When the writing of Hamdi, the Shaykh's son, appeared,
> it was certain (*muhaqqaq*) in the world that the script
> of Yaqut was abolished (*naskh*)

See Malik Celâl, *Şeyh Hamdullah.*

270. Saghani's *Mashāriq al-anwār,* Baghawi's *Maṣābīḥ as-sunna,* but also Hunayn ibn Ishaq's work on medicine are mentioned among the books Hamdullah copied. A beautiful album with Prophetic traditions is now in the Metropolitan Museum.

271. Ünver, *Türk yazı çeşitleri,* p. 7. Cf. *TH,* p. 453. Both of Hamdullah's sons, Mehmet Dede and Mustafa Dede, excelled in their father's profession; his daughter married Shukrullah, Hamdullah's former servant and apprentice, who was to become his true successor. A poem on the lineage is quoted *TH,* pp. 628–29, and *Habib,* p. 87:

> Shaykh Hamdullah, and his noble son-in-law Shukrullah,
> the third his son Mehmet, then Usküdari Hasan;
> Erzerumlu Khalid became the fifth among the calligraphers,
> the sixth one Dervish ᶜAli, the seventh Suyolcuzade of pure art;
> Hafiz Osman obtains the eighth rank,
> Sayyid ᶜAbdallah is the *imām* of his class in penmanship.
> Hoca Rasim with two wings was it with whom "the pen dried up":
> He was in the six styles unique like an *alif,* of perfect shape.
> Such is this line, which is complete with ten—
> May God Most Gracious make the souls of all of them happy!

Calligraphies of Hamdullah and his family are found rather frequently; a good number of album pages are in the Museum of Fine Arts, Boston. See also Arberry, *The Koran Illuminated,* nos. 189, 190, 193, 201. A. Welch, *Calligraphy,* no. 92; A. Welch, *The Art of the Precious Book,* M 47, perhaps written for Sultan Bayezid II, the artist's patron.

272. So much so that *shehri* (from the city) in Mustaqimzade's diction means simply from (the *polis*) Istanbul.

273. *TH,* p. 663.

274. Yahya as-Sufi should not be confused with the elder Sufi, who wrote many inscriptions in Shiraz and Najaf and was one of Yaqut's direct disciples; one of his Korans, dated 745/1344–45, in Lings, *The Quranic Art of Calligraphy,* pl. 50.

275. *Habib,* p. 86; see also MH, p. 25: "Qarahisari [i.e., 'he from the black castle'] is it who makes the paper's face shine white," that is, honors it.

276. Zaynuddin, *Muṣawwar al-khaṭṭ,* no. 222.

277. Hasan Çelebi wrote a Koran for Selim II in 977/1570; see Arberry, *The*

Koran Illuminated, no. 195. Other disciples of Qarahisari were Farhad Pasha (d. 984/1576) and Dervish Mehmet (d. 1000/1591).

278. *TH*, p. 94; the formula is used for another calligrapher but is too charming to be left out. About Qarahisari's death, *TH*, p. 100.

279. *TH*, p. 516; *Habib*, p. 152.

280. *Huart*, p. 235. The text (77 pages) was edited by the best authority on Ottoman calligraphy, Mahmud Ibnül Emin, with an interesting introduction of 135 pages. Some examples of ᶜAli Efendi's *naskh* were still found sixty years ago (introduction, p. 101). ᶜAli Efendi died in 1008/1599 at the age of sixty after having worked in Istanbul, Cairo, Syria, Iran, and other countries where he accompanied his masters during numerous campaigns, as he describes them in more or less elegant verses. *Habib*, p. 216, is extremely critical of his work.

281. ᶜAbdallah Qirimi (d. 999/1590–91) wanted to invent a new style of *naskh*, "with long teeth of the *sīn*" and other changes. See *TH*, p. 289.

282. *Huart*, p. 124; the work is by Mehmet Cencerecizade, written in 980/1572.

283. *Bayani*, no. 132, p. 82; see *Huart*, p. 234. *TH*, p. 641, and *Habib*, p. 184, refrain from this remark.

284. *Huart*, p. 263. *Habib*, p. 245, quotes Nargisizade as saying:

> His Majesty Sultan Murad the Great,
> a ruler the like of whom the world has never seen:
> virtuous, caring for scholars, eloquent,
> brave, a poet and a calligrapher, and a versifier.

TH, pp. 738–39.

285. Çığ, *Hafız Osman; Habib*, pp. 121–23; *TH*, p. 171.

286. The chronogram is, "Longing for the eternal kingdom, Osman Efendi said *Hū*" (He) = 1110/1698. He is buried in Kocamustafapaşa. A little human touch: according to *TH*, p. 172, he loved to watch wrestling matches.

287. *TH*, p. 539. For Süleyman II (r. 1687–90), a disciple of Toqadizade, see *TH*, p. 209.

288. *Habib*, p. 157.

289. *TH*, p. 302.

290. *Habib*, p. 118.

291. *Habib*, pp. 94–95, gives chronograms by Vehbi and Nedim for this event. Nedim's chronogram is *Bu nazïk khaṭṭ-i Sulṭān Aḥmad'a baq da duᶜā eyle*, "Look at this elegant script of Sultan Ahmad and bless him." Other chronograms for this occasion in *Habib*, pp. 140, 144, 147.

292. In *Türk ve Islam Eserleri Müzesi*, Topkapi Env. 272, 4; cf. Cavit Avcï, "Türk sanatïnda aynalï yazïlar."

293. *Habib*, p. 95. He sent one Koran to Medina, *TH*, pp. 76–79. One of his Korans is in the *tekke* of Kocamustafapaşa; he wrote also the proverb "Fear of God is the beginning of wisdom" in the Aya Sofya.

294. *Habib*, p. 122; *TH*, p. 384, for Mehmet III (d. 1170/1756).

295. Avcï, "Türk sanatïnda aynalï yazïlar."

296. *SH*, pp. 35–38.

297. *Habib*, p. 44; Ünver-Athari, *Ibn al-Bawwāb*, p. 22. The two verses are quoted in all major Arabic historical works, from Ibn Khallikan to Qalqashandi.

298. Thus Tahir ibn Hasan (d. 1051/1641), the author of the *Tārīkh-i Ṭāhirī*, quoted in Ghafur, *Calligraphers of Thatta*, p. 59.

CHAPTER THREE

1. *MH*, p. 41.

2. Aslah, *Shuᶜarā-yi Kashmīr, S*, I, p. 135.

3. Furuzanfar, *Aḥādīth-i Mathnavī*, no. 97; for Rumi's interpretation in *Mathnawī*, vol. V, ll. 3132 ff., see Schimmel, *Triumphal Sun*, pp. 259–62.

4. *TH*, p. 8.

5. Khushhal Khan Khatak, *Muntakhabāt, rubāᶜī* no. 88.

6. Fuzuli, *Divan*, no. CIII.

7. Ibid., no. XXX, 6.

8. Shah ᶜAbdul Latif, *Risālō*, Sur Ḥusaynī, VIII, 8.

9. Ruzbihan Baqli, *ᶜAbhar al-ᶜāshiqīn*, para. 120.

10. Ghalib, *Urdū Dīvān, nūn* no. 6. But cf. Kalim, *Dīvān, ghazal* no. 134:

> There is not such a difference in the writing of one scribe
> the *sarnivisht* of everyone is from the pen of Fate!

11. Ghalib, *Urdū Dīvān, wāw* no. 2; cf. Schimmel, *Dance of Sparks*, p. 113. See also ᶜUrfi's remark that he, a child, studies the first lesson of love, "but the intended letter does not drip from the pen, because the pen of my fortune has a narrow split" (*Kulliyāt, ghazal*, p. 283).

12. *TH*, p. 7.

13. Ibn ᶜArabī, *Journey to the Lord of Power*, p. 113 n.

14. See *TH*, p. 7, in the forty *ḥadīth* about writing.

15. S. H. Nasr, "Cosmography in Pre-Islamic and Islamic Persia," p. 51.

16. Marquet, *Ikhvân aṣ-ṣafâ*, p. 67.

17. Quoted in *Habib*, p. 222.

18. Thus Suras 10/62; 18/47; 34/3; 83/7–12; 17/14; 69/19 and 25.

19. Ibn al-Bawwab, "Rā'iyya," transl. Ibn Khaldun, *The Muqaddima*, transl. Rosenthal, vol. II, pp. 278–82. Also in Arberry, *The Koran Illuminated*, Introduction.

20. Talib, in Aslah, *Shuᶜarā-yi Kashmīr, S*, II, p. 691.

21. Rumi, *Mathnawī*, vol. II, l. 3382; cf. ibid., vol. V, l. 1961: man's mind is the paper on which the master can write. A similar comparison is also found in Guru Nanak's work: "Our body is paper with our destiny written on it" (Mohan Singh, in *Guru Nanak Memorial Volume*, p. 9).

22. Quoted in every Muslim work on calligraphy or writing, and included in the Forty *ḥadīth* on writing collected by Mustaqimzade, *TH*, p. 10, and *QA*, p. 50. For different styles of the *basmala* see the drawings in Qalqashandi, *Ṣubḥ al-aᶜshā*,

vol. III, pp. 129 ff.; Schimmel, *Islamic Calligraphy,* pp. 17–19; Safadi, *Islamic Calligraphy,* pp. 31–39.

23. *TH,* p. 343. The calligrapher was ᶜImaduddin ibn ᶜAfif (d. 736/1336).

24. Aksel, *Türklerde dini resimler,* p. 18.

25. *TH,* p. 45, in connection with Ibn Hilal as-Sabi.

26. *TH,* p. 624.

27. Nwyia, *Exégèse coranique et langage mystique,* p. 165.

28. Ritter, *Meer der Seele,* pp. 270, 295. A Bengali colleague told us that people in the rural areas of Bengal still pick up anything on which Arabic letters are written, even though it may be an empty cigarette box. A very interesting study about the spread of the Arabic alphabet over the world from Somali to Mongolian and Japanese is Hegyi, "Minority and Restricted Uses of the Arabic Alphabet."

29. Lings, *The Quranic Art of Calligraphy,* p. 17.

30. This happened to me in Ankara in 1955; the *ḥāfiz* was a highly educated civil servant who taught the recitation of the Koran at the Ilâhiyat Fakültesi (Faculty of Islamic Theology) in Ankara.

31. About the technique of these arrangements see Samiha Ayverdi, in Schimmel, "Eine Istanbuler Schriftstellerin," p. 581.

32. Vehbi Efendi (d. 1261/1845), quoted in *SH,* p. 454. Mustaqimzade, *TH,* p. 9, connects the three fingers with which one holds the pen, with Muhammad (index), ᶜAli (thumb), and Abu Bakr (middle finger).

33. *QA,* p. 55.

34. *TH,* p. 187.

35. *TH,* p. 470.

36. In Indo-Pakistan the boy is called *bismillāh kā dūlhā* (the bridegroom of *bismillāh*) and is dressed up like a bridegroom.

37. *TH,* p. 6.

38. Bertholet, *Die Macht der Schrift,* p. 37.

39. Bada'uni, *Muntakhab,* vol. II, p. 408 (transl.), II, p. 394 (text). That happened in 1002/1593–94; *TH,* p. 561.

40. For pictures of a fine Indian bowl with inscription see A. Welch, *Calligraphy,* no. 80; Schimmel, *Islam in India and Pakistan* (Iconography), pl. XLIV b.

41. A. Welch, *Calligraphy,* no. 57; the mystical meaning of barely legible inscriptions on metalwork has been highlighted by A. S. Melikian Shirvani in his publications. See also Aanavi, "Devotional Writing: 'Pseudo-Inscriptions' in Islamic Art."

42. "Talismanic undershirt," in Fehérvári-Safadi, *1400 Years of Islamic Art,* p. 164. Several examples are in the Salar Jung Museum, Hyderabad; see Schimmel, *Islam in India and Pakistan* (Iconography), pl. XLIV a; a related coat of chain mail with Shia inscriptions in A. Welch, *Calligraphy,* no. 37.

43. Verse by Khan-i Arzu, quoted in Azad Bilgrami, *Khizāna-yi ᶜāmira,* p. 120.

44. A. Welch, *Calligraphy,* no. 30.

45. Ibid., no. 24; a silk tombcloth, ibid., no. 62, contains the *Nādi ᶜAliyyan* and Sura 61/13. See also Schimmel, *Islamic Calligraphy,* pl. XXXI b, c.

46. Grabar, "The Umayyad Dome of the Rock," pp. 53–55.

47. For the importance of the *Burda* see Schimmel, *As Through a Veil,* pp. 185–87. See also Chapter 2, note 173, above.

48. *TH,* p. 606, speaks at length about the blessings involved in writing the *ḥilya.* See also Chapter 2, note 171, above.

49. The ten companions of the Prophet to whom he promised paradise are: Abu Bakr, ᶜOmar, ᶜOthman, ᶜAli, Talha, Zubayr, Saᶜd ibn Abi 'l-Waqqas, Saᶜid, ᶜAbdallah, and ᶜAbdur-Rahman ibn ᶜAuf.

50. The Greek names of the Seven Sleepers are used as an amulet; if written in circular form, they contain in the center the name of the faithful dog, Qitmir. For a specimen written in 1318/1910, see Schimmel, *Islamic Calligraphy,* pl. XLIII a.

51. One of these apotropaic inscriptions, which are usually interpreted as a *miḥrāb,* but look almost like an arrow, is in the Fogg Art Museum, another one in a private collection; they seem to come from the Deccan. See S. C. Welch, *Indian Drawings,* no. 38; A. Welch, *Calligraphy,* pl. 88; Schimmel, *Islam in India and Pakistan* (Iconography), pl. XL.

52. A good example is the *Dīvān-i Ḥāfiz* in the Bankipore Khudabakhsh Library, in which the Moghul emperors Humayun, Jahangir, and Shahjahan noted down their comments about the outcome of certain prognostications; see Schimmel, *Islam in India and Pakistan* (Iconography), pl. XXI. Cf. also Jahangir's remark in *Tuzuk-i Jahāngīrī* (transl.), p. 38.

53. The term "paper shirt" occurs from early times onward and is also attested in historical works. Some examples: Pa'izi, in ᶜAufi, *Lubāb al-albāb,* vol. II, p. 345; Khaqani, *Dīvān,* pp. 258, 500, 541, 557; ᶜAttar, *Dīvān, ghazal* no. 490; Rumi, *Dīvān,* no. 2134; Amir Khusrau, *Dīvān,* nos. 296, 902, 1152, 1712; Hafiz, *Dīvān,* ed. Injuvi, p. 122, where also a related verse by Auhadi is quoted; Fighani, *Dīvān,* no. 310; and Ghalib also in his Persian *qaṣīda* no. 9.

54. Amir Khusrau, *Dīvān,* no. 1080.

55. Furuzanfar, *Aḥādīth-i Mathnawī,* no. 13.

56. Rumi, *Dīvān,* no. 2350; see also *Mathnawī,* vol. III, ll. 2777–78.

57. Rumi, *Dīvān,* no. 1521; cf. also ibid., nos. 1664, 1915, 2530, and the chapter "Divine Calligraphy," in Schimmel, *Triumphal Sun.*

58. Rumi, *rubāᶜī,* Ms. Esᶜat Efendi, fol. 336 a 1.

59. "I have never seen someone shed tears, and at the same time smile, more beautifully than the *qalam*" is an often quoted saying by Jaᶜfar ibn Yahya (Rosenthal, *Four Essays,* p. 39); *MH,* p. 9, wrongly attributes it to Imam Jaᶜfar as-Sadiq.

60. ᶜAttar, *Dīvān, ghazal* no. 508; cf. Sana'i, *Ḥadīqa,* chap. VIII, p. 625.

61. Ibid., *ghazal* no. 602.

62. Rumi, *Dīvān,* no. 1948.

63. Rumi, *Mathnawī,* vol. IV, ll. 3722 ff.

64. Ghazzali, *Iḥyā' ᶜulūm ad-dīn,* "*Bāb at-tawakkul,*" German translation in Hans Wehr, *Al-Ghazalis Buch vom Gottvertrauen.*

65. Izutsu, "The Basic Structure of Metaphysical Thinking," p. 66.

66. Johns, "*Daḳā'iḳ al-ḥurūf,*" pp. 68–69.

67. Ibid., p. 72.

68. Rumi, *Dīvān,* no. 2251.

69. *TH,* p. 602.

70. Massignon; "La Philosophie Orientale d'Ibn Sînâ," p. 2.

71. Rumi, *Mathnawī,* vol. V, l. 1316.

72. Massignon, "La Philosophie Orientale," p. 9.

73. Canteins, *La Voie des Lettres,* chap. III, "Sigles et thématiques coraniques." The "sectarian interpretation" is by Khaki Khorasani.

74. Ibid., chap. V, "ṬâHâ."

75. Massignon, "La Philosophie Orientale," p. 11. *Yāsīn* was often interpreted as *Yā insān,* "Oh human being!"

76. Ibid., p. 9; Ritter, *Picatrix,* Arabic text, pp. 171–75, also about astrological connections between the secret names of the Koranic suras and the stars.

77. Marquet, *Ikhvân aṣ-ṣafâ,* p. 321.

78. *EI,* s.v. *djafr;* Massignon, *La Passion de . . . Hallaj,* vol. I, pp. 246–47, and vol. III, pp. 103–10.

79. One example: Hartmann, *Eine islamische Apokalypse der Kreuzzugszeit.*

80. *TH,* p. 599.

81. *EI,* s.v. ḥisāb al-djummal. See also Ibn Khaldun, *The Muqaddima,* trans. Rosenthal, vol. III, pp. 171–226, "The Science of the Secrets of the Letters"; Fahd, *La Divination Arabe;* Horten, *Die religiösen Vorstellungen des Volkes im Islam;* Dornseiff, *Das Alphabet in Mystik und Magie.* As early as the tenth century, Hamza al-Isfahani, *At-tanbīh,* p. 108, writes that the astrologers claim that the word *al-qalam* (pen) according to the *ḥisāb al-jummal* is equivalent to *naffāᶜ* (most useful), since both have the numerical value of 201.

82. Corbin, "Le Livre du Glorieux de Jâbir Ibn Ḥayyân."

83. Massignon, "La Philosophie Orientale," pp. 4–5.

84. Dhauqi, *Sirr-i dilbarān,* pp. 358–65.

85. Massignon, "La Philosophie Orientale," p. 10. Similar ideas are also found in the medieval Jewish tradition.

86. Sana'i, *Dīvān,* p. 667; cf. also ibid., p. 333.

87. Yunus Emre, *Divan,* p. 524.

88. Sahl at-Tustari, in Sarrāj, *Kitāb al-lumaᶜ,* p. 89.

89. Quoted in Nwyia, *Exégèse coranique et langage mystique,* p. 166. For a twentieth-century interpretation of the letters see Lings, *A Sufi Saint of the Twentieth Century,* chap. VI, "The Symbolism of the Alphabet," esp. pp. 154–55.

90. ᶜAttar, *Ushturnāma,* p. 95.

91. Rumi, *Dīvān,* no. 2356.

92. Sana'i, *Ḥadīqa,* chap. II, p. 187; Sana'i, *"Sayr al-ᶜibād,"* in *Mathnavīhā,* l. 700; Rumi, *Mathnawī,* vol. VI, ll. 2239–45.

93. Isfara'ini, *Kāshif al-asrār,* p. 77.

94. Sana'i, *Ḥadīqa,* p. 110.

95. Yunus Emre, *Divan,* p. 308, no. LIX.

96. Huart, *Houroufis,* p. 364.

97. Hafiz, *Dīvān*, ed. Ahmad-Na'ini, p. 363, no. 315, *mīm* no. 9.

98. Shah ʿAbdul Latif, *Risālō*, Yaman Kalyan, V, 21; see also *Sur Ramakali*, V, 3, about the Yogis as prototypes of the "spiritual man": "The *adesis* (= homeless ones) have, at the beginning, placed the *alif* in their mind." Bullhe Shah, in *Qānūn-i ʿishq*, no. 75, cf. nos. 77, 78; Sultan Bahu, in Ramakrishna, *Panjabi Sufi Poets*, p. 52; Abdal Musa, in Ergun, *Bektaşi şairleri*, p. 21, and many more examples.

99. *Qāḍī Qādan jō kalām*, no. 99.

100. Rumi, *Dīvān*, no. 2. Rumi has a very strange letter poem in his *tarkībband* no. 12, ll. 35117–20.

101. *Ishtiqāq kabīr* is the explanation of each letter according to its pronunciation; thus, the letter *wāw* would be $w = 6$, *alif* $= 1 + w = 6 = 13$. Thus, every word can be taken apart and interpreted and then sometimes exchanged for another word or letter with the same numerical value.

102. These speculations are still very much alive in mystical circles; see, e.g., in Sindhi, *Makhzan Shāh ʿAbdul Laṭīf Bhiṭā'ī*, p. 62.

103. Massignon, "La Philosophie Orientale," p. 14. Rumi too speaks once of the proud, stubborn *alif* and admonishes his listeners not to be like it, nor like the *bā'*, but rather like a *jīm*, *Dīvān*, no. 1744.

104. Friedmann, *Ahmad Sirhindi*, p. 15, has dealt in detail with these speculations. There is also the idea that *Adam*—"man"—consists in reality of the letters of Muhammad: his head is a *mīm*, his hand a *ḥā'*, his middle part another *mīm*, and the rest a *dāl*, thus the human figure came into existence; quoted in Jurji, *Illumination in Islamic Mysticism*, p. 84.

105. ʿAttar, *Muṣībatnāma*, introduction, p. 20.

106. Shabistari, *Gulshan-i rāz*, says:

> From *Aḥmad* to *Aḥad* there is only one *m* difference—
> the world is submersed in this one *m!*

Practically all poets in the eastern Islamic tradition from ca. 1200 onward use this *ḥadīth qudsī*, with the exception of the Naqshbandis; it was particularly frequently quoted in folksongs such as in Sindhi, Panjabi, Gujarati, Kashmiri, Uzbek, etc. The Bektashis in Turkey had a special *mīm duasï*, a prayer centering on the letter *m*. Ghalib, in his praise of the Prophet, goes even further in his explanation of the mysteries of *Aḥmad*: Alif is the letter of Divinity; *mīm*, that of Muhammad; and the remaining two letters, *ḥā'* and *dāl*, have the numerical value of 8 and 4, respectively which makes 12, and points to the twelve imams of Shia Islam. See Schimmel, "Ghalib's *qaṣīda* in Honor of the Prophet," and Schimmel, *Dance of Sparks*, p. 129.

107. Ramakrishna, *Panjabi Sufi Poets*, p. 99, with allusions to the *alif*.

108. Amir Khusrau, *Dīvān*, no. 596.

109. Ibid., no. 601.

110. Ruzbihan Baqli, *Sharḥ-i shaṭhiyāt*, para. 13.

111. Canteins, *La Voie des Lettres*, pp. 35 ff., according to Buni, *Shams al-maʿārif al-kubrā*, vol. I, p. 43.

112. Corbin, "Epiphany," p. 135.

113. *TH,* p. 5.

114. As a mystical tradition says, "I never saw anything but the *bā'* was written on it," quoted in Daudpota, *Kalām-i Girhōrī,* p. 55, where more examples are found. See also Nicholson, *Studies in Islamic Mysticism,* p. 209, n. 94.

115. Rumi, *Dīvān,* no. 1520. A riddle by the founder of the Shadhiliyya order, Abu'l-Hasan ash-Shadhili, playing on the letters *nūn* and *ᶜayn,* which are supposed to point to *Sūrat ar-Raḥmān* (Sura 55), cited in *TH,* p. 633.

116. Meier, *Vom Wesen der islamischen Mystik,* p. 30, quotes Najmuddin Kubra: "If you are afflicted do not say Okh, for that is the name of Satan, but say Ah, for that is God's name—the *h* in *Allāh* is this very *h.*"

117. Ibn ᶜArabi, *Al-futūḥāt al-makkiyya,* quoted by Corbin, *Creative Imagination,* p. 171. Ibn ᶜArabi has a number of books and treatises about the mystical meaning of the letters and numerals to his credit, see *GAL,* II, pp. 574, 578. Another mystic in his succession, who worked in this field, is ᶜAbdul-Karim al-Jili, *Ḥaqīqat al-ḥaqā'iq,* see *GAL,* II, p. 265, and *S,* II, p. 284.

118. ᶜAndalib, *Nāla-i ᶜAndalīb,* vol. I, p. 270.

119. Rumi, *Dīvān,* no. 1728.

120. Teufel, *ᶜAlī-i Hamadānī,* p. 87, n. 2.

121. Canteins, *La Voie des Lettres,* p. 41.

122. *TH,* p. 292; cf. *Habib,* p. 121.

123. Aksel, *Türklerde dini resimler,* figs. 11–16, offers numerous pictures of different types of *wāw.*

124. The Sufis also liked to play with the letters *ᶜayn* ﻉ and ﻍ *ghayn,* since *ᶜayn* also means "essence, eye, fountain." Thus, the Deccani mystical poet Qadi Mahmud Bahri sings in the late seventeenth century:

> In this world which is like the letters of the alphabet,
> thou alone art *ᶜayn* (the true essence) and the rest is *ghayn* ("absent," from *ghaybat*)

"Dīvān-i Qāḍī Maḥmūd Baḥrī," no. 40, verse 4.

125. Goldziher, "Aus der Literatur der muhammadanischen Mystik," p. 782. But even a sober historian like Qalqashandi mentions this *ḥadīth* in *Ṣubḥ al-aᶜshā,* vol. III, p. 7.

126. Ed. by J. C. Vadet, who also translated it. A new edition of the complicated text would be welcome.

127. Ibn ᶜArabi, *Al-futūḥāt al-makkiyya,* pp. 75 ff., 177. Cf. also Massignon, *La Passion de . . . Hallāj,* vol. III, pp. 103–40, about the relation between the *lā* and the *al* of the definite article and similar topics.

128. Corbin, "Epiphany," p. 99. The beginning of an interesting *qaṣīda* about the meaning of the *basmala* is contained in a page in the Metropolitan Museum, see here color pl. no. 4. Its author, the noted poet Jami, claims that *bismillāh* is the Greatest Name of God, and that the 18,000 worlds have found blessings from its 18 letters.

129. Schimmel, *Dance of Sparks,* p. 129.

194

130. Ruzbihan Baqli, *Sharḥ-i shaṭhiyāt,* p. 196, speaks of the *lā* as scissors.

131. Aksel, *Türklerde dini resimler,* cover picture.

132. Jami, *Silsilat adh-dhahab,* in *Haft Aurang,* p. 18.

133. Schimmel, *Dance of Sparks,* pp. 127–28.

134. Gramlich, *Schiitische Derwischorden,* vol. III, p. 19.

135. Jami, *Silsilat adh-dhahab,* in *Haft Aurang,* pp. 21 f; to also Canteins, "La specchio della Shahāda."

136. *TH,* p. 630. There is also a *duᶜā-yi qâf,* consisting of four Koranic verses with ten *qâf* each, *TH,* p. 634.

137. Sana'i, *Dīvān,* p. 309. Pseudo-Majriti derives another interesting conclusion from the first and last letters of the *Fātiḥa* (without the *basmala*): the *alif* with which the sura begins points to the beginning of the world of Divine Order, *amr,* and the *nūn* of the last word, *aḍ-ḍāllīn,* points to the end, *nihāya,* of the created world; Ritter, *Picatrix,* Arabic text, p. 171.

138. Khanqahi, *Guzīda dar taṣawwuf,* p. 47; cf. ibid., p. 69, for a similar interpretation of *ḥikmat* (wisdom).

139. Khaki Khorasani, *Dīvān,* p. 107. Even Nizami, in *Laylā u Majnūn,* p. 454, plays with the numerical value of his name: *Niẓāmī*'s numerical value is 1,001, while his given name, Ilyas, by a subtractional trick, comes to 99.

140. Sijistani, *Kitāb al-yanābīᶜ,* paras. 147–48.

141. Hallaj, *Dīwān,* ed. Shaybi, no. 38, pp. 214–16, with the poems by Ahmad Ghazzali, Shushtari, and others. For *Allāh* as the Greatest Name that always gives a meaning, even if divided, see Nicholson, *Studies in Islamic Mysticism,* p. 209, n. 96, for Jili's argumentation; the same idea is found in Sarraj, *Kitāb al-lumaᶜ,* p. 89: when one takes the *alif* from *Allāh,* الله there remains *lillāh,* "for God" لله, when the first *lām* is taken away, *lahu,* "for him" له , remains and finally the *h* is the pronoun of third person singular masculine,

142. Hallaj, *Dīwān,* ed. Shaybi, p. 215.

143. *TH,* p. 45; the author wrote a Turkish commentary on this riddle.

144. Schaya, *La doctrine soufique de l'unité,* p. 83; for his interpretation of the Divine Name *ar-raḥmān* see p. 47; it contains the seven essential qualities of God: *alif* (life), *lām* (knowledge), *rā'* (power), *ḥā'* (will), *mīm* (hearing), the vertical *alif* (seeing), and *nūn* (speaking).

145. Ruzbihan Baqli, *Sharḥ-i shaṭhiyāt,* paras. 11–16.

146. Cf. Khaqani, *Dīvān, qaṣīda,* p. 301.

147. *TH,* pp. 614–15.

148. *TH,* p. 629.

149. Isfara'ini, *Kāshif al-Asrār,* pp. 72–79.

150. Vizeli Alaettin, quoted in Gölpïnarlï, *Melâmiler ve melâmilik,* p. 208.

151. See Arberry, "A Sūfī Alphabet."

152. Mustaqimzade has composed a prayer of letters, and a Sufi profession of faith according to the letters of the *basmala, TH,* Introduction, p. 51. See also ᶜAli ibn Ibrahim al-Mirghani (d. 1792), *Al-ḥikam ᶜalā ḥurūf al-muᶜjam, GAL S,* II, p. 258, and again from the eighteenth century, ᶜAbdur Rahman ibn Muhammad al-

Bistami, *Kitāb fī'l-kalām ᶜalā ḥurūf ismi Muḥammad,* Ms. Princeton, Yehuda Coll. No. 4522, fols. 42b–52b. In popular Sufism, particularly in the dervish orders, such books and treatises were very common, and are found from Morocco to Indonesia. We find the same motif also in a short treatise by the great calligrapher ᶜAbdallah as-Sayrafi (Berlin Ms. or. oct. 48), who praises God's creative work with skillfull allusions to each letter in alphabetical sequence, beginning with the *alif* of *aḥbabtu,* "I loved." (That points to the favorite mystical *ḥadīth qudsī* according to which God said: "I was a hidden treasure, and I wanted [*aḥbabtu*] to be known, therefore I created the world.")

153. There are numerous collections of Panjabi *sīharfīs;* R. Siraj ud-Din and Walter, "An Indian Sufi Hymn"; for Sindhi see Baloch, ed., *Ṭīh akharyūñ;* a fine Persian Golden Alphabet in honor of ᶜAli by the sixteenth-century poet Qasim-i Kahi, in Hadi Hasan, "Qāsim-i Kāhī," pp. 186–89; for the whole genre see Schimmel, *As Through a Veil,* p. 147, and pp. 263–64, n. 56. For Pashto see Raverty, *Selections from the Poetry of the Afghans,* pp. 61 ff.; Blumhardt-MacKenzie, *Catalogue of Pashto Manuscripts,* nos. 22, 39.

154. For Malayalam see K. A. Paniker, "Mystical Strain in Medieval Malayalam Poetry," about the *Ruby Alif* by Qadi Muhammad of Calicut, written in 1607.

155. For Swahili see Knappert, *Swahili Religious Poetry;* Werner, "An Alphabetic Acrostic in a Northern Dialect of Swahili."

156. For medieval Turkish see Zajączkovsky, *ᶜĀšïq Paša.*

157. Bertholet, *Die Macht der Schrift,* p. 35, for the problem of "steganography." The best example in the Islamic tradition is in Goldziher, "Linguistisches aus der Literatur der muhammedanischen Mystik," about the *balaybalan* language and based on this, Bausani, "About a Curious Mystical Language."

158. Hammer, *Ancient Alphabets.* A modern translation in Sylvain Matton, *La magie Arabe traditionelle,* pp. 130–241; see also Casanova, "Alphabets Magiques Arabes"; H. A. Winkler, *Siegel und Charaktere in der muhammedanischen Zauberei.*

159. *EI,* s.v. *ḥurūfiyya,* vol. III, pp. 600–601; Huart, *Les Houroufi;* Ritter, "Die Anfänge der Ḥurūfī-Sekte"; Birge, *The Bektashi Order of Dervishes,* pp. 148 ff.; Gibb, *History of Ottoman Poetry,* vol. I (texts in vol. VI), concerning Nesimi.

160. *EI,* vol. III, p. 600.

161. Huart, *Houroufis,* mainly pp. 11, 63, 64, 284 ff.

162. Gibb, *History of Ottoman Poetry,* vol. VI, p. 41.

163. Huart, *Houroufis,* the end of Fadlullah's *Hidāyatnāma.* Bada'uni, *Muntakhab,* vol. III, p. 285 (transl. III), p. 205 (text), tells that one Tashbihi of Kashan dedicated to Abu'l-Fazl a treatise "after the manner of the Nuqtavi sect and their manner of writing the letters." According to the *EI,* s.v. *ḥurūfī,* the *nuqtaviyya* are the Hurufis; but Bada'uni's description does not square with other information about this sect. It may have been a later development of the Hurufi tradition.

164. Nyberg, *Kleinere Schriften des Ibn al-ᶜArabi,* p. 99.

165. Gibb, *History of Ottoman Poetry,* vol. VI, p. 38.

166. ᶜAttar, *Dīvān, ghazal* no. 686:

196

No one has seen sent down (*tanzīl*) from the *muṣḥaf* [Koran copy] of beauty
a wondrous sign (*āya*, also verse of the Koran) fresher than your *khaṭṭ* ("script/down")

167. Cf. Fuzuli, *Divan*, nos. CCXCI, CXLV.

168. Rami, *Anîs el-ochchâq*, p. 44.

169. Ibid., p. 41; *TH,* p. 175.

170. Qaniᶜ, *Maqālāt ash-shuᶜarā*, p. 44.

171. Quoted in Fakhri Haravi, *Rauḍat as-salāṭīn*, p. 85. Cf. Gandjei, *Il Canzoniere de Šāh Ismāᶜīl*.

172. Dard, ᶜ*Ilm ul-kitāb*, p. 561; see Schimmel, *Pain and Grace*, p. 77.

173. Fuzuli, *Divan*, no. CCLXV.

174. Amir Khusrau, *Dīvān*, no. 587; cf. no. 1083.

175. Ibid., no. 69; cf. ᶜAbdallah Marvarid in Qatiᶜi, *Majmaᶜ al-shuᶜarā*, p. 55.

176. Amir Khusrau, *Dīvān*, no. 1407; cf. Safadi, *Al-ghayth al-musajjam*, p. 78:

> The *yāsīn* of her tresses and the *ṣād* of her eyes:
> verily I seek refuge in Sura Ṭāhā!

Both *Yāsīn* and *Ṣād* are beginnings of Koranic sura; i.e., 36 and 38, respectively. A calligraphy of Sultan-Muhammad Nur in the Metropolitan Museum contains related images:

> Everyone who saw the *Sūrat al-fātiḥa* of your face,
> Recited "Say: God is One!" [(Sura 112)] and blew with
>> sincerity [i.e., blowing for warding off evil
>> and for magical purposes; sincerity, *ikhlāṣ*,
>> is the name of Sura 112]
> "God made sprout a beautiful plant", [(Sura 3/37)] thus recited Khidr
>> and went away
> the moment that he saw the greenery (i.e., the down) around
>> your face.
> How could one say: "May God increase your beauty!"
> for there is no possibility of adding to your joy-increasing beauty.

177. Amir Khusrau, *Dīvān*, no. 317.

178. Sana'i, *Dīvān*, p. 34; Schimmel, *As Through a Veil*, pp. 190–92.

179. Khaqani, *Dīvān*, *qaṣīda*, p. 326.

180. Azad Bilgrami, *Khizāna-i ᶜāmira*, p. 278.

181. Rosenthal, *Four Essays*, p. 27.

182. Ibid., p. 28.

183. Baltacïoǧlu, *Türklerde yazï sanatï*, especially *Bölüm* V, and figures pp. 91–92.

184. Grohmann, "Anthropomorphic and Zoomorphic Letters"; Grohmann, "Die Bronzeschale M 388–1911"; Ettinghausen, "The Wade Cup." Examples in Schimmel, *Islamic Calligraphy*, pl. XVIII a–c; Safadi, *Islamic Calligraphy*, pls. 154–57.

197

185. *QA,* p. 133, *Bayani,* no. 826. Babur, in the *Bāburnāme,* mentions this invention as well.

186. ᶜAndalīb, *Nāla-i ᶜAndalīb,* vol. II, p. 344.

187. Aksel, *Türklerde dini resimler,* p. 111; cf. also the remarks of W. Born, "Ivory Powder Flasks," p. 102, about "*ṭughrās* as amulets." Horovitz, in the *Epigraphica Indo-Moslemica,* vol. II, p. 35, mentions that illiterate people, especially in Bengal, regard stones with Arabic inscriptions, particularly in *ṭughrā* style, as sacred, and pour oil and milk over them.

188. For such an interpretation see Schimmel, *Mystical Dimensions,* pp. 307–9.

189. Sana'i, *Dīvān,* pp. 39 ff.

190. Schimmel, *Triumphal Sun,* "Imagery of Animals," pp. 119–22.

191. *SH,* p. 16. The most famous stork made of the *basmala* was written by the Mevlevi Dervish Leylek Dede, "Grandfather Stork." See Aksel, *Türklerde Dini Resimler,* pp. 76–77.

192. A beautiful example of a rooster, written by a Bahai calligrapher, in the Fogg Art Museum; see Schimmel, *Islamic Calligraphy,* pl. XLVI; A. Welch, *Calligraphy,* no. 71.

193. The swan—philologically, it should rather be the goose, *hāns*—is found on the publications of the Bawa Muhayiuddin group. This bird plays a great role in Indian traditions, in the Islamic literatures particularly in Sindhi mystical folk poetry.

194. Khatibi and Sijelmasi, *Splendour,* pp. 132–33. Numerous other examples can be found. An interesting lion from a Bektashi convent, created from a verse by ᶜAttar (*Dīvān,* p. 23, *qaṣīda* no. 8) in 1210/1795, in the Staatliches Museum für Völkerkunde, Munich; see Schimmel, *Islamic Calligraphy,* pl. LXVII a.

195. A beautiful "Muhammadan Rose," containing the ninety-nine Most beautiful names of God and the ninety-nine noble names of the Prophet, in the Staatsbibliothek, Berlin; published in Schimmel, *Und Muhammad ist Sein Prophet,* pl. 1.

196. Nwyia, *Exégèse coranique et language mystique,* pp. 363–67.

197. Rumi, *Mathnawī,* vol. III, l. 1267.

198. Ibid., Often thus and similarly in Sana'i, see *Dīvān,* pp. 94, 337, and *Ḥadīqa,* p. 333; see also Rūzbihān Baqli, *Sharḥ-i Shaṭḥiyāt,* para. 48.—Rumi has explained the meaning of the letters of ᶜishq (love): ᶜayn is ᶜābid (worshiper), shīn is shākir (grateful), and qāf qāniᶜ (content), *Dīvān,* rubāᶜī no 1047; Rumi, *Dīvān,* no. 1187; cf. Schimmel, *Dance of Sparks,* p. 135, n. 30.

199. Nizami, quoted in Jami, *Nafaḥāt al-uns,* p. 608.

200. Yunus Emre, *Divan,* p. 204. Cf. also ᶜAttār, *Muṣībatnāma,* p. 13: Throw away the *h* and discard the *w* [of *hū,* "He"], become a servant and remember Him without *h* and *w*.

201. Cf. Rumi, *Mathnawī,* vol. VI, l. 2972.

202. Ibid., vol. I, l. 114.

1. Amir Khusrau, *Dīvān*, no. 100.

2. See, for instance, Hammer, *Bericht über den Kommentar des Mesnewi*, p. 89.

3. Ghalib, *Urdū Dīvān, nūn* no. 23.

4. This joke is found already in Fuzuli's verse, and quoted again in *TH*, p. 616.

5. Hamza al-Isfahani, *At-tanbīh*, pp. 33–47. He tells the story of the Omayyad caliph Sulayman ıbn ᶜAbdul-Malik's order to the governor ot Medına: "*Aḥṣi'l-mukhannathīn* ("count the passive pederasts!"). But a drop of ink fell on the *ḥ*, changing it into *kh*, so that the governor read: *Ikhṣi'l-mukhannathīn* ("*Castrate the pederasts*"). Hearing that, some ran away while others underwent the operation without complaint. Mustaqimzade, *TH*, p. 615, mentions an even odder instance by claiming that the whole Christian faith relies upon a misreading: instead of the Divine Word, "This is My prophet," (*nabiyyi*), نبيِّ, the Christians read "My son" (*bunayyi*) بنيِّ, and thus, by the mere exchange of two dots, the erroneous doctrine of Christ being God's son was developed.

6. Hamza al-Isfahani, *At-tanbīh*, p. 34.

7. Qalqashandi, *Ṣubḥ al-aᶜshā*, vol. III, p. 18.

8. Kalim, *Dīvān, muqaṭṭaᶜa* no. 72.

9. Hoenerbach, *Die dichterischen Vergleiche*, p. 199.

10. Ibid., p. 204. The comparison of lines of writing to necklaces seems to be common in medieval Andalusia, see ibid., 201. Compare also *TH*, p. 590:

> When he takes the paper you imagine his right hand
> to shed light or string pearls.

11. *TH*, p. 651. The pun is on *kaff*, which means both "hand, palm" and "foam"—hence the common connection of the generous hand with the ocean.

12. Azad, *Khizāna-i ᶜāmira*, p. 288.

13. Ibid., p. 216.

14. Ibid., p. 19.

15. Thus Abu'l-Husayn ibn Abi'l-Baghl al-Katib in Khalidiyan, *Kitāb at-tuḥaf*, p. 38.

16. Qalqashandi, *Ṣubḥ al-aᶜshā*, vol. III, p. 37; cf. Giese, *Kušāǧim*, pp. 109–10, the descriptions of pens; further Khalidiyan, *Kitāb at-tuḥaf*, p. 241: "A mute one that speaks in the country."

17. Ibn al-Muᶜtazz, *Dīwān*, no. 118, p. 89.

18. Bada'uni, *Muntakhab*, III, p. 439 (transl.).

19. Anvari, *Dīvān, qaṣīda*, p. 199. Cf. also Giese, *Kušāǧim*, p. 109: "But while real swords are saturated with blood only at certain times, the swords of the writers never dry up." Ibn ar-Rumi, quoted in Ibn Abi ᶜAwn, *Kitāb at-tashbīhāt*, pp. 305–6, also claimed that the pen is to be more feared than the sword.

20. Hoenerbach, *Die dichterischen Vergleiche*, p. 178.

21. Busiri, *Al-burda*, l. 140.

22. Amir Khusrau, *Dīvān*, no. 283; Shah ᶜAbdul Latif, *Risālō,* Sur Yaman Kalyan, V, 28.

23. Giese, *Kušā ğim,* pp. 223–24; there are also more comparisons with writing utensils. Cf. Ibn Abi ᶜAwn, *Kitāb at-tashbīhāt,* pp. 303–6, chap. 87.

24. Ritter, *Über die Bildersprache Niẓāmīs,* p. 37.

25. Fuzuli, *Divan,* no. LXXIV.

26. Rosenthal, *Four Essays,* p. 36.

27. Ibn al-Muᶜtazz, quoted in Schwertfeger, *Kitāb az-zahr al-maqṭūf,* p. 105.

28. Hoenerbach, *Die dichterischen Vergleiche,* p. 200.

29. Na'ili, in Gibb, *History of Ottoman Poetry,* vol. VI, pp. 213 f.

30. Nizami, *Iskandarnāma,* in Khamsa, p. 1012.

31. Giese, *Kušā ğim,* p. 67.

32. Khaqani, *Dīvān, qaṣīda,* p. 299, *qaṣīda,* p. 233.

33. Ibid., *Dīvān,* p. 758.

34. Amir Khusrau, *Dīvān,* no. 1546.

35. Massoudy, *Calligraphie Arabe vivante,* p. 14, quoted from Aragon, "Le Fou d'Elsa."

36. Pope, *A Survey of Persian Art,* p. 1730.

37. Rosenthal, *Four Essays,* pp. 29–30.

38. *TH* and *Habib* give numerous examples for calligraphers being musicians, based on them, see, e.g., *Huart,* pp. 132, 139, 155, 181, 183, 251, 277, 291, 298; *SH,* pp. 39, 73, 78, 81, 204, 312, 332, 427; *Bayani,* no. 771; and many more. For ᶜAbdul Mu'min al-Isfahani (d. 646/1248), allegedly a disciple of Ibn al-Bawwab, who excelled as calligrapher and musician, see *Huart,* p. 83; *Habib,* p. 50. But there is a gap of 200 years between him and Ibn al-Bawwab.

39. *Bayani,* no. 494, a line from Mir-ᶜAli's most famous complaining poem, written in Bukhara.

40. Daulatshah, *Tadhkirat,* p. 545.

41. Anvari, *Dīvān, qaṣīda,* p. 58. Cf. also Ghalib, who says with an allusion to the beginning of Rumi's *Mathnawī,* the so-called Song of the Reed:

> The sound of my pen burnt the world—
> I am Ghalib, who has cast fire from the Song of the Reed into the reedbed.

42. Hoenerbach, *Die dichterischen Vergleiche,* p. 199, see also p. 200.

43. See Hamza al-Isfahani, *At-tanbīh,* p. 100.

44. Rosenthal, *Four Essays,* pp. 45–46.

45. Hoenerbach, *Die dichterischen Vergleiche,* p. 52; cf. ibid., p. 36: the cloud should water the meadows "until you regard the puddles as the circular signs for denoting every tenth verse in a copy of the Koran, and consider the traces of rain in the fields to be vowel signs or letters." See also ibid, p. 44 n. 171. Kushajim has devoted a whole poem to the sections of the Koran where he finds "greenery in the empty spaces of yellow and red, in the midst of those lines, similarly to what the crawling of diminutive ants leaves on the fresh complexion of tender girls." Giese, *Kušā ğim,* pp. 228–30.

46. Munir Lahori in Aslah, *Shuʿarā-i Kashmīr, S,* III, p. 1466. Cf. also Fani, *Dīvān,* p. 42, for images from the garden for calligraphy.

47. There are many more examples. For riddles about the reedpen see Weisweiler, *Arabische Märchen,* vol. II, no. 98, pp. 243–45; quotations from Ibshihi, *Al-Mustaṭraf,* vol. II, pp. 184–85, and Ibn ʿAbd Rabbihi, *Al-ʿiqd al-farīd,* vol. IV, p. 474.

48. Giese, *Kušāğim,* p. 175.

49. Hoenerbach, *Die dichterischen Vergleiche,* p. 202.

50. For a variant of this widespread image see *TH,* p. 132: the pen is a bird that puts its beak into the darkness and then sprinkles Water of Life upon the page.

51. Aslah, *Shuʿarā-yi Kashmīr, S,* III, p. 1436.

52. Thus also Kabir, quoted in Vaudeville, *Kabīr,* vol. I, p. 8:

> Je brûlerai ce corps pour en faire de l'encre et pour écrire le Nom de Ram,
> de mes os, je ferai la plume pour écrire la lettre que j'enverrai à Ram.

53. Ghalib, *Kulliyāt-i Fārsī,* vol. IV, no. 209.

54. Giese, *Kušāğim,* p. 18.

55. Mesihi, quoted in Köprülü, *Eski şairlerimiz,* p. 116.

56. Suli, *Adab al-kuttāb,* quoted in Wagner, *Abū Nuwās,* p. 326.

57. Krenkow, "The Use of Writing for the Preservation of Ancient Arabic Poetry," p. 265.

58. Ibid., pp. 264–66, for instance, al-Harith ibn Hilliza; Freytag, *Darstellung der arabischen Verskunst,* pp. 207, 251; Daudpota, *The Influence of Arabic Poetry on Persian Poetry,* pp. 40–41; Ibn Abi ʿAwn, *Kitāb at-tashbīhāt,* p. 167: like signs drawn by a pen on leather (al-Muraqqish) or "remnants of Divine inspirations on the text page" (Dhu-r-Rumma).

59. Lichtenstädter, "Das *Nasīb* der altarabischen *qaṣīda,*" p. 31, gives the various comparisons of the deserted camps to writing material.

60. Minuchihri, quoted in Daudpota, *The Influence of Arabic Poetry,* p. 40.

61. Ibn al-Muʿtazz, *Dīwān,* vol. III, p. 118.

62. *TH,* p. 600.

63. Al-Biruni-Sachau, *Alberuni's India,* p. 90.

64. Khaqani, *Dīvān, qaṣīda,* p. 136.

65. Fuzuli, *Divan,* no. CCLV, 5.

66. Kalim, *Dīvān, ghazal,* p. 62.

67. Aslah, *Shuʿarā-yi Kashmīr, S,* III, p. 1327.

68. Ibid., p. 569, cf. ibid., *S,* I, p. 239 (Danish).

69. Kalim, *Mathnavī, Dīvān,* p. 405.

70. Kalim, *Dīvān,* ed. Thackston, *muqaṭṭaʿ,* 24/28. Pictures of this type were very fashionable and seem to have originated in the Deccan; see S. C. Welch, *Indian Drawings,* nos. 34, 35.

71. Bedil, *Dīvān* (Bombay), p. 45.

72. Bedil, *Kulliyāt,* vol. I, p. 605.

73. Bedil, *Dīvān* (Bombay), p. 188.

74. Schimmel, *Dance of Sparks,* pp. 121–22.

75. Rumi, *Mathnawī,* vol. III, l. 4755.

76. For the motif see Fenesch, "Una mañera estraña d'escribir," p. 212 (Abu Jaᶜfar ibn Khatima). Khaqani, *Dīvān,* p. 920:

> The heart is like a pen in fire, and the body like paper in water—
> the fire burnt it, and the water dissolved it.

A few examples: Amir Khusrau, *Dīvān,* nos. 402, 832, 1088; Saᶜdi, *Kulliyāt: Gha-zaliyyāt,* no. 351; Naziri, *Dīvān, ghazal* no. 460; Rumi, *Mathnawī,* vol. VII (commentary), a similar quotation from the *Dīvān* of Ahmad-i Jam; Furughi, *Dīvān,* p. 100; Ibrahim Tattawi, *Takmila,* pp. 10, 129. A Sufi saying by Abu ᶜAli ar-Rudh-bari in Sarraj, *Kitāb al-lumaᶜ,* p. 249.

77. Bada'uni, *Muntakhab,* vol. III, p. 385 (transl.), III, p. 280 (text).

78. Aslah, *Shuᶜarā-yi Kashmīr,* p. 506.

79. Salman-i Savaji, in Azad, *Khizāna-i ᶜāmira,* p. 256.

80. Shibli, quoted in Sarraj, *Kitāb al-lumaᶜ,* p. 50; see also ᶜAttar, *Dīvān, ghazal,* p. 255; Saᶜdi, *Kulliyāt: Ghazaliyyāt,* p. 117:

> The needle of my eyelashes writes the story of my heart with red on the white page of
> my face—there is no need to talk.

This is taken up by Jami, *Dīvān,* p. 205, no. 189; cf. also ibid., p. 429, no. 671.

81. Ibrahim Tattawi, *Takmila,* p. 12.

82. Amir Khusrau, *Dīvān,* no. 183.

83. Schimmel, *Dance of Sparks,* p. 121; for more examples, ibid., pp. 133–34, n. 23.

84. Ibid., p. 120.

85. *Qāḍī Qādan jō kalām,* no. 42.

86. Wagner, *Abū Nuwās,* p. 381.

87. Giese, *Kušāğim,* p. 51 (*Dīwān* of Kushajim no. 45).

88. Khaqani, *Dīvān,* p. 633.

89. Aslah, *Shuᶜarā-yi Kashmīr, S,* IV, p. 1702.

90. Kalim, *Dīvān,* ed. Thackston; cf. also his *ghazal* no. 419. Bedil, *Dīvān* (Bombay), p. 188, uses on the page "a ruler from the wave of the ᶜAnqa's wing," that is, he does something absolutely impossible, for the mythical ᶜAnqa has only a name but not real existence.

91. Kalim, *Dīvān,* ed. Thackston, *qaṣīda* 36/29.

92. Ibid., *tarkībband,* 6/6.

93. Kalim, *Dīvān, ghazal* no. 316.

94. Khaqani, *Dīvān, qaṣīda,* p. 35; quoted also in *TH,* p. 623.

95. Naziri, *Dīvān, ghazal* no. 458.

96. Köprülü, *Eski şairlerimiz,* p. 467.

97. Qalqashandi, *Ṣubḥ al-aᶜshā'*, vol. III, p. 13.

98. Azad, *Khizāna-i ᶜāmira*, p. 216.

99. Al-Washsha', *Kitāb al-muwashshā*, p. 155; pp. 154–59 contain a chapter on poetry written by the elegant people concerning love letters.

100. Thaᶜalibi, quoted in Ünver-Athari, *Ibn al-Bawwāb*, p. 65.

101. *MH*, p. 18.

102. Ünver-Athari, *Ibn al-Bawwāb*, p. 72.

103. Rumi, *Dīvān*, no. 2205.

104. *Bayani*, p. 69. For a verse with a nice double entendre see Rückert-Pertsch, *Grammatik, Poetik und Rhetorik*, p. 284;

> A single letter of your *khaṭṭ* would be worth a hundred mines of ruby,
> whether Ibn Muqla would buy it or Yaqut.

Cf. also Kalim, *Dīvān*, ed. Thackston, *muqaṭṭaᶜ*, p. 71.

105. Daulatshah, *Tadhkirat*, p. 359, trans. Hammer, *Geschichte der schönen Rede-künste*, p. 277 (he could not understand the pun on *Ṣayrafi* because the history of calligraphy was then still unknown in the West).

106. *Habib*, p. 158.

107. Rami, *Anîs el-ochchâq*, p. 26.

108. Jami, *Dīvān*, p. 138, *ghazal* no. 15.

109. Aslah, *Shuᶜarā-yi Kashmīr*, p. 365.

110. Hamza al-Isfahani, *At-tanbīh*, p. 100.

111. Amir Khusrau, *Dīvān*, no. 1271.

112. Ibid., no. 1509.

113. Aslah, *Shuᶜarā-yi Kashmīr, S*, I, p. 303.

114. Amir Khusrau, *Dīvān*, no. 1104, so also no. 1086 with the continuing rhyme word *khaṭṭ*.

115. Ibid., no. 1474; cf. also ibid., no. 916.

116. Ibid., no. 107.

117. ᶜAttar, *Dīvān, ghazal*, p. 301.

118. Bū ᶜAlī Qalandar, *Dīvān*, fol. 6, quoted in Tafhimi, "The Life and Work of Bū ᶜAlī Qalandar," Ph.D. dissertation, Karachi University, 1975, p. 392.

119. Jami, *Dīvān*, p. 884. But cf. also Amir Khusrau's charming lines, *Dīvān*, no. 642:

> Like a child, the violet reads constantly the alphabet of greenery;
> it has become old, and its heart turns toward youth.

"The alphabet of greenery" points to the *khaṭṭ-i sabz*, the "green" fresh down of the young beloved.

120. Jami, *Dīvān*, no. 147, p. 189.

121. Ibid., no. 637, p. 416.

122. Aslah, *Shuᶜarā-yi Kashmīr, S*, I, p. 113.

123. Quoted in Qaniᶜ, *Maqālāt ash-shuᶜarā*, p. 412.

124. Fuzuli, *Divan*, no. CXLVIII; cf. Amir Khusrau, *Dīvān*, no. 1086:

O Lord, how beautifully has the hand of creation written with the pen of Destiny the
khaṭṭ on the page [of the cheek] of the friend.

125. *TH*, p. 407.

126. Ahmad Pasha, quoted in Gibb, *History of Ottoman Poetry*, vol. VI, p. 56.

127. Amir Khusrau, *Dīvān*, no. 1500.

128. *TH*, p. 300. This awkward verse was apparently admired by Turkish read-
ers, for *Habib*, p. 145, repeats it.

129. Mirza Qalich Beg, quoted in *Mihrān jā mōtī*, p. 72.

130. Aslah, *Shuᶜarā-yi Kashmīr*, p. 610.

131. Gibb, *History of Ottoman Poetry*, vol. VI, p. 102.

132. Köprülü, *Eski şairlerimiz*, p. 97.

133. Fuzuli, *Divan*, no. CCXL.

134. Ibn ar-Rawandi, *Rāḥat aṣ-ṣudūr*, p. 44.

135. Hoenerbach, *Die dichterischen Vergleiche*, p. 199.

136. Ibid., p. 222.

137. Aslah, *Shuᶜarā-yi Kashmīr*, p. 557.

138. In the story of ᶜAziz and ᶜAziza, 113th night.

139. *SH*, p. 360, about Sami Efendi (1837–1912).

140. Hoenerbach, *Die dichterischen Vergleiche*, p. 200.

141. Fuzuli, *Divan*, no. CCLV.

142. Thus *TH*, p. 139, about the fatal illness of the physician Ibn al-Quff (d.
685/1286), who was also a calligrapher. "He became [thin] like a Kufic *alif*" and
decorated all over with reddish and green dots.

143. Safadi, *Al-ghayth al-musajjam*, p. 77.

144. Hoenerbach, *Die dichterischen Vergleiche*, p. 142.

145. Baltacıoğlu, *Türklerde yazı sanatı*, p. 51.

146. Qatiᶜi, *Majmaᶜ al-shuᶜarā*, p. 55.

147. Rami, *Anîs el-ochchâq*, p. 83.

148. Ibn al-Muᶜtazz, *Dīwān*, vol. III, p. 110. One may also think of Necati's
Turkish *qaṣīda* with the recurring word "violet" in which he claims:

> The violet's hand trembles so that it cannot write a straight *alif*–
> perhaps it has been in the street of the wine-sellers?

Köprülü, *Eski şairlerimiz*, p. 273.

149. Fuzuli, *Divan*, no. CCXLI.

150. Bada'uni, *Muntakhab*, vol. III, p. 257 (transl.), III, p. 184 (text).

151. Ibid., III, p. 471 (transl.), III, p. 342 (text).

152. Aslah, *Shuᶜarā-yi Kashmīr*, p. 593.

153. *Karacaoğlan*, ed. Cahit Öztelli, no. 15.

154. Fuzuli, *Divan*, no. XXIX. Cf. also the poem by the Arabic calligrapher Ibn
Khazin, quoted in *MH*, p. 79, and *Habib*, p. 48, where the "purity" of the *alif*
incites the writer to some negative remarks about the crookedness of the time:
someone who remains upright like an *alif* has no luck, just as the *alif* has no share
in the dots, while the crooked *nūn* possesses a dot.

155. Khaqani, *Dīvān*, p. 119. He has also a very fine grammatical pun on *ṭa°n* and *aṭa°nā*, which, however, is meaningful only when one knows Arabic grammar, and thus cannot be properly translated without a long commentary.

156. °Attar, *Ilāhīnāma*, chap. XIV, story 5.

157. Khaqani, *Dīvān*, p. 898.

158. Fuzuli, *Divan*, no. CCLV. A dot on the *dāl* would transform it into a *dhāl*.

159. Jami, *Dīvān*, no. 75, p. 161.

160. Yahya Bey, *Shah u geda*, quoted in Köprülü, *Eski şairlerimiz*, p. 148.

161. Thus, for instance, Idraki Beglari in Sind (see Appendix B).

162. Amir Khusrau, *Dīvān*, no. 1152.

163. Wagner, *Abū Nuwās*, p. 389.

164. Ibn Abi °Awn, *Kitāb at-tashbīhāt*, p. 251.

165. Quoted in Rami, *Anîs el-ochchâq*, p. 65.

166. Kalim, *Dīvān, mathnavī*, p. 339.

167. *Eski şairlerimiz*, p. 296; cf. also Safadi, *Al-ghayth al-musajjam*, p. 77.

168. Rückert-Pertsch, *Grammatik, Poetik und Rhetorik*, p. 241.

169. Jami, *Dīvān*, no. 357, p. 309.

170. Yunus Emre, *Divan*, p. 426.

171. Ibn ar-Rawandi, *Râhat aṣ-ṣudūr*, p. 442.

172. Qalich Beg, in *Mihrān jā mōtī*, p. 66.

173. Sana'i, *Dīvān*, p. 763.

174. Ibn al-Mu°tazz, *Dīwān*, vol. III, p. 61. Cf. Kushajim: a curl like a *qāf* (made) of night on a daylike complexion, in Giese, *Kušāǧim*, p. 85. Also Ibn Abi °Awn, *Kitāb at-tashbīhāt*, p. 250.

175. Schimmel, *Dance of Sparks*, p. 125.

176. Sana'i, *Ḥadīqa*, chap. IX, p. 666, Rumi, *Dīvān*, no. 2752.

177. Rumi, *Mathnawī*, vol. VI, l. 1650.

178. Hoenerbach, *Die dichterischen Vergleiche*, p. 169.

179. Ibn al-Mu°tazz, *Dīwān*, vol. III, p. 85.

180. Wagner, *Abū Nuwās*, pp. 288, 397; he also compared the spider to the dot beneath the initial *jīm*.

181. Rami, *Anîs el-oshchâq*, p. 26, cf. also p. 52.

182. Hoenerbach, *Die dichterischen Vergleiche*, p. 201; Ibn al-Mu°tazz, quoted in Ibn Abi °Awn, *Kitāb at-tashbīhāt*, p. 253, sees the mustache as half a *ṣād* and a *dāl*, and the sidelock as a *nūn*.

183. Cf. Hoenerbach, *Die dichterischen Vergleiche*, p. 10, n. 17; Khaqani, *Dīvān, qaṣīda*, p. 261, gives this image an elegant turn, playing with the beginning of Sura 68:

The [new] moon and the fingertips of the people [pointing to it:] these are like a pen,
 and that one
[ie., the crescent moon] like a *nūn*—
people are happy like children [who have recently learned the sura] *Nūn wal-qalam*,

for when the new moon of Shawwal appears, the month of fasting is over, and everyone rejoices.

205

184. Sana'i, *Ḥadīqa*, p. 524.

185. Aksel, *Türklerde dini resimler*, pp. 135–38.

186. Jami, *Dīvān*, no. 357, p. 307.

187. Ibn al-Muʿtazz, *Dīwān*, vol. III, p. 8.

188. Wagner, *Abū Nuwās*, p. 303.

189. *GAL S*, III, p. 35, where also other examples of letter imagery in classical Arabic are mentioned.

190. Krenkow, "The Use of Writing for the Preservation of Ancient Arabic Poetry," p. 265.

191. Wagner, *Abū Nuwās*, p. 380.

192. *TH*, p. 636.

193. *Qāḍī Qādan jō kalām*, no. 8; Shah ʿAbdul Latif, *Risālo*, Yaman Kalyan, V, 31. Ibn ʿArabi, in the *Tarjumān al-ashwāq*, poem no. LIII, 1, compares the lovers in embrace to a doubled letter, *ḥarfan mushaddadan*.

194. Asaf Halet Çelebi, *Lām-alif*.

195. Rosenthal, *Four Essays*, p. 57.

196. Hoenerbach, *Die dichterischen Vergleiche*, p. 10.

197. Rosenthal, *Four Essays*, p. 57; see also Safadi, *Al-ghayth al-musajjam*, p. 77, for two examples of such a *naʿam*.

198. Jami, *Dīvān*, p. 499, no. 853.

199. Cf. Khaqani, *Dīvān*, p. 260.

200. Schimmel, *Dance of Sparks*, p. 126.

201. Sana'i, *Dīvān*, p. 549; see also pp. 143 and 628.

202. Wagner, *Abū Nuwās*, pp. 380–83, usually obscene changes of meaning. See also the numerous examples in Hamza al-Isfahani, *At-tanbīh*, pp. 252 ff. For the Persian area, Rückert-Pertsch, *Grammatik, Poetik und Rhetorik*, gives many interesting examples. The art of riddles, in which puns by change of letters are most common, was highly appreciated in the fifteenth and the early sixteenth century, so that almost every poet composed a collection of complicated riddles.

203. The school scene from Nizami's *Majnūn u Laylā* forms a major subject for miniature painters in late Timurid and Safavid Iran.

204. Ghalib Dede, *Hüsn u aşk*, ll. 393–97.

205. Jami, *Tuḥfat al-aḥrār*, in *Haft Aurang*, p. 440. The verse was already translated by Hammer, *Geschichte der schönen Redekünste*, p. 322, and is quoted by E. G. Browne, *A Literary History of Persia*, vol. III, p. 533. Similar is Hatifi, translated by Hammer, ibid., p. 358.

206. Suyuti's skillful verse is quoted in *TH*, p. 619, and following it, *Habib*, pp. 25–26; unfortunately, it loses all its charm in a translation that of necessity would have to be heavily annotated. *Habib*, pp. 25–26, quotes more Turkish poems of this kind, as he loves to refer to poetical utterances that use the terminology of calligraphy. See also *TH*, pp. 254–55.

207. ʿAttar, *ghazal* no. 629.

208. Hafiz, *Dīvān*, only in Rosenzweig-Schwannau, vol. III, p. 532.

209. *SH*, p. 267.

210. Aslah, *Shuᶜarā-yi Kashmīr, S,* II, p. 744.

211. Aslah, *Shuᶜarā-yi Kashmīr,* p. 97.

212. Ibid., *S,* II, p. 738.

213. Rami, *Anîs el-ochchâq,* p. 44. Cf. Amir Khusrau, *Dīvān,* no. 108, and similarly the verse quoted by *Habib,* p. 188:

Your *khaṭṭ* is dust, *ghubār,* sitting on that lip—
well, the script of Yaqut [or: the ruby script, "ruby" denoting the red mouth] has to be
 seated

(i.e., given a high place; "seating" in calligraphy means to arrange the script in an artistic way).

214. Hafiz, *Dīvān,* ed. Rosenzweig-Schwannau, vol. II, p. 250, edition Na'ini-Ahmad, p. 344, no. 9.

215. K̲alim, *Dīvān,* ed. Thackston, *mathnavī* 19/28.

216. Bedil, *Kulliyāt,* vol. I, p. 705.

217. Fani, *Dīvān,* p. 62. This is the first example of *shikasta* in poetry known to me.

218. Baqi, quoted in Köprülü, *Eski şairlerimiz,* p. 306.

219. That a good calligraphy is worthy of being suspended (*taᶜlīq*) from the sky is commonplace with later Persian and Turkish poets.

220. Quoted in Fakhri, *Rauḍat as-salāṭīn,* p. 85; see chap. III, n. 171. A similar verse by Mir ᶜAli Shir Nava'i, ibid., p. 110.

221. Qaniᶜ, *Maqālāt ash-shuᶜarā,* p. 19.

222. Thus Ghanizade in his *miᶜrājiyya,* describing the Prophet's ascension to heaven, in Köprülü, *Eski şairlerimiz,* pp. 353, 356.

223. *SH,* p. 266.

224. Baqi, quoted in Köprülü, *Eski şairlerimiz,* p. 273.

225. Thus al-Khwarizmi, quoted in Mez, *Renaissance des Islam,* p. 235.

226. Gibb, *History of Ottoman Poetry,* vol. VI, p. 56.

227. Sami al-Barudi, quoted in *GAL S,* III, p. 17.

228. Ibn Abi ᶜAwn, *Kitāb at-tashbīhāt,* p. 58.

229. Sana'i, *Ḥadīqa,* chap. VII, p. 457.

230. *Bayani,* p. 249, invented by a calligrapher, Muhammad Ibrishimi, a disciple of Sultan-ᶜAli Mashhadi.

231. Daulatshah, *Tadhkirat,* p. 378, concerning Sharafuddin Yazdi.

232. Fayzi, quoted in Ikram, *Armaghān-i Pāk,* p. 193.

233. Aslah, *Shuᶜarā-yi Kashmīr, S,* IV, p. 1736.

234. Sarmad, quoted in Ikram, *Armaghān-i Pāk,* p. 239.

235. Fani, *Dīvān,* p. 144.

236. "Comprendre l'Islam," p. 67, quoted in Canteins, *La Voie des Lettres,* p. 76, n. 21.

237. Khaqani, *Dīvān,* p. 209.

238. Ghalib, *Kulliyāt-i Fārsī,* vol. IV, p. 264.

239. Kalim, *Dīvān,* p. 119, no. 80.

Bibliography

Aanavi, Don. "Devotional Writing: 'Pseudo-Inscriptions' in Islamic Art." *Bulletin Metropolitan Museum of Art,* NS XXVI (1968), pp. 353–58.

Abbott, Nabia. "Arabic Paleography." *Ars Islamica* 8 (1941), pp. 67–104.

———. "An Arabic Persian Wooden Ḳur'anic Manuscript from the Royal Library of Shah Ḥusain Ṣafawī I, 1105–35 H." *Ars Islamica* 5 (1938), pp. 89–94.

———. "The Contribution of Ibn Muḳlah to the North-Arabic Script." *American J. of Semitic Languages and Literatures* 56 (1939), pp. 70–83.

———. *The Rise of the North Arabic Script and Its Ḳur'anic Development.* Chicago: The University of Chicago Oriental Institute Publications 50, 1939.

ᶜAbdul-Laṭīf Bhitā'ī, Shāh. *Risālō,* ed. Kalyan Adwani. Bombay: Hindūstān Kitābghar, 1958.

Abū'l-Fażl. *Ā'īn-i Akbarī,* trans. H. Blochmann, 3 vols. Calcutta: Bibliotheca Indica. Asiatic Society of Bengal, repr. 1939.

Abū Nuᶜaym al-Iṣfahānī. *Ḥilyat al-auliyā' wa ṭabaqāt al-aṣfiyā'.* 10 vols. Cairo, 1930–37; repr. Beirut: Dār al-Maᶜrifa, 1967.

Aflākī, Aḥmad ibn Muḥammad. *Manāqib al-ᶜārifīn,* ed. Tahsin Yazıcı, 2 vols. Ankara: University, 1959–60.

Ahmad, Khwaja Muhammad. "Calligraphy." In H. K. Sherwani and

P. M. Joshi, *History of Medieval Deccan.* Vol. II. Hyderabad: Government of Andhra Pradesh, 1973, pp. 411–22, pls. LXXVII–LXXXVI.

Ahmad, Qeyamuddin. *Corpus of Arabic and Persian Inscriptions of Bihar, AH 640–1200.* Patna: K. P. Jayaswal Research Institute, 1973.

Aksel, Malik. *Türklerde dini resimler—yazı resim.* Istanbul: Elif Yayınları, 1967.

———. "Das Schriftbild in der türkischen Kunst." *Anatolica* I (1967), pp. 111–17.

Albumblätter, Indische: Miniaturen und Kalligraphien aus der Zeit der Moghul-Kaiser. Herausgegeben und kommentiert von Regina Hickmann, mit einem Beitrag von Volkmar Enderlein. Leipzig und Weimar: Gustav Kiepenheuer Verlag, 1979.

Alf Layla wa Layla (Arabian Nights). Used in various versions, along with the German translation: *Die Erzählungen aus den Tausendundein Nächten,* deutsch von Enno Littmann, 6 vols. Wiesbaden: Insel-Verlag, 1953.

ᶜĀlī Efendi. *Manāqib-i hünarvarān,* ed. Ibnülemin Mahmud Kemal. Istanbul: Türk Tarih Encümeni, 1926.

Amīr Khusrau. *Dīvān-i kāmil,* ed. Maḥmūd Darvīsh. Tehran: Intishārāt-i Jāvīdān, 1343sh/1965.

———. *Majnūn Laylā,* ed. T. A. Magerramov, Moscow: Nauk, 1964.

ᶜAndalīb, Nāṣir Muḥammad. *Nāla-i ᶜAndalīb.* 2 vols. Bhopal, 1309h/1890–91.

Anjum, Raḥmānī. *Barr-i ṣaghīr Pāk ū Hind mēñ khaṭṭāṭī.* Lahore: Museum, 1978.

Arberry, Arthur John. *The Koran Illuminated. A Handlist of the Korans in the Chester Beatty Library.* Dublin: Chester Beatty Library, 1967.

———. "A Ṣūfī Alphabet." *J. of the Bombay Branch of the Royal Asiatic Society,* NS 13 (1937), pp. 1–5.

———. E. Blochet, M. Minovi, B. W. Robinson, and J. V. S. Wilkinson. *The Chester Beatty Library: A Catalogue of the Persian Manuscripts and Miniatures.* 3 vols. Dublin: Hodges Figgis, 1959–62.

Arif, Aida S. *Arabic Lapidary Kufic in Africa.* London: Luzac and Co., 1967.

Arseven, Celal Esad. *Les Arts Décoratifs Turcs.* Istanbul, n.d.

ᶜAskarī, Abū Hilāl al-Ḥasan al-. *Kitāb aṣ-ṣināᶜatayn al-kitāba wa'sh-shiᶜr*, ed. ᶜAlī Muḥammad al-Bajāwī and Muḥammad Abū'l-Faḍl Ibrāhīm. Cairo: ᶜĪsā al-Bābī al-Ḥalabī, 1952.

Aṣlaḥ, Muḥammad. *Tadhkirat-i shuᶜarā'-i Kashmīr,* ed. Sayyid Hussamuddin Rashdi. 5 vols. Karachi: Iqbal Academy, 1967–68.

Atïl, Esin. *The Brush of the Masters.* Washington: Smithsonian Institution, 1978.

———. *Renaissance of Islam: Arts of the Mamluks.* Washington: Smithsonian Institution, 1981.

ᶜAṭṭār, Farīduddīn. *Dīvān-i qaṣā'id ū ghazaliyyāt,* ed. Saᶜīd Nafīsī. Tehran: Sanā'ī, 1339sh/1960.

———. *Ilāhīnāma,* ed. Hellmut Ritter. Istanbul-Leipzig: Brockhaus, 1940.

———. *Manṭiq uṭ-ṭayr,* ed. M. Javād Shakūr. Tehran: Kitābfurūsh Tehrān, 1962.

———. *Muṣībatnāma,* ed. N. Viṣāl. Tehran: Zavvār, 1338sh/1959.

———. *Ushturnāma,* ed. Mehdī Muḥaqqiq. Tehran: University, 1339sh/1960.

ᶜAufī, Muḥammad. *Lubāb al-albāb,* ed. Edward G. Browne and Mohammad Qazvini. 2 vols. London: Luzac—Leiden: Brill, 1903, 1906.

Avcï, Cavit. "Türk sanatïnda aynalï yazïlar," *Kültür ve Sanat,* no. 5. Ankara: Kültür Bakanlïğï, Ocak 1977.

Ayverdi, Ekrem Hakkï. *Fatih devri hattatlarï ve hat sanatï.* Istanbul: Fatih Derneği, 1953.

Ayverdi, Samiha. *Ibrahim Efendi'nin konağï.* Istanbul: Fatih Cemiyeti, 1964.

Āzād Bilgrāmī, Ghulām ᶜAlī. *Khizāna-i ᶜāmira.* Lucknow: Naval Kishor, n.d. (ca. 1890).

Aziza, Mohamed. *La Calligraphie Arabe.* Tunis: S. T. D., 1973.

Badā'ūnī, ᶜAbdul-Qādir. *Muntakhab at-tawārīkh.* Vols. 1–3. Ed. William Nassau Lees and Ahmad Ali. Calcutta, 1865–89; trans. George S. A. Ranking, W. H. Lowe, and Wolseley Haig; repr. Patna: Academia Asiatica, 1973.

Bahrami, Mehdi. "Faïences émaillées et lustrées de Gurgan." *Artibus Asiae* 10 (1947), pp. 100–20.

Baer, Eva. "An Islamic Inkwell in the Metropolitan Museum of Art."

In Richard Ettinghausen, ed. *Islamic Art in the Metropolitan Museum of Art.* New York: Metropolitan Museum, 1972, pp. 199–211.

Baloch, Dr. N. A., ed. *Ṭih Akharyūñ.* Hyderabad/Sind: The Sindhi Adabi Board, 1962.

Baltacǐoğlu, Ismayil Hakkǐ. *Türklerde yazǐ sanatǐ.* Ankara: Ilâhiyat Fakültesi, 1958.

Baqlī, Rūzbihān. *ᶜAbhar al-ᶜāshiqīn,* ed. Henry Corbin. Tehran—Paris: Adrien Maisonneuve, 1958.

―――. *Sharḥ-i shaṭḥiyāt, Les Paradoxes des Soufis,* ed. Henry Corbin. Tehran-Paris: Adrien Maisonneuve, 1966.

Barrett, Douglas. *Islamic Metalwork in the British Museum.* London: British Museum, 1949.

Bausani, Alessandro. "About a Curious Mystical Language." *East and West* IV, 4 (1958), pp. 234–48.

Bayānī, Mehdī. *Aḥvāl ū āthār-i Mīr ᶜImād, khushnivīs-i mashhūr-i ᶜahd-i ṣafavī.* Tehran: Anjuman-i dōstdārān-i kitāb, 1331sh/ 1952.

―――. *Kitābshināsī-yi kitābhā-yi khaṭṭī.* Tehran: University, 1971.

―――. *Tadhkira-i khushnivīsān: nastaᶜlīq-nivīsān.* 3 vols. Tehran: University, 1345sh/1966, 1346sh/1967, and 1348sh/1969.

Bēdil, Mirzā ᶜAbdul-Qādir. *Dīvān.* Bombay, 1302h/1885.

―――. *Kulliyāt.* 4 vols. Kabul: Ministry of Education, 1962–65.

Begley, Wayne. "Amānat Khān and the Calligraphy on the Taj Mahal." *Kunst des Orients* XII, 1–2. Wiesbaden: Steiner, 1978–79.

Berchem, Max van. *Matériaux pour un Corpus Inscriptionum Arabicarum. I, 1: Le Caire.* Paris: Leroux, 1894.

Bertholet, Alfred. *Die Macht der Schrift in Glauben und Aberglauben.* Abh. Deutsche Akademie der Wissenschaften, Berlin, Phil.-hist. Kl. 1948. No. 1. Berlin: Akademie-Verlag, 1949.

Bhattachary, A. K. "A Study in Muslim Calligraphy in Relation to Indian Inscriptions." *Indo-Iranica* VI, 2–3 (1950–51), pp. 13–23.

Birge, John Kingsley. *The Bektashi Order of Dervishes.* London: Luzac, 1937; repr. 1965.

Bīrūnī, Abū Rayḥān al-. *Kitāb fī'l-Hind; Alberuni's India.* (an account of the religion, philosophy, literature, chronology, astronomy, customs, laws, and astrology of India about 1030), ed. Eduard Sachau. London, 1887; English trans. Eduard Sachau. London, 1888; 2d. ed., 1910.

Bivar, A. D. H. "The Arabic Calligraphy of West Africa." *African Languages Review* 7 (1968), pp. 3–15.

———. "Seljuqid Ziārets of Sar-i pul (Afghanistan)." *BSOAS* 29 (1966), pp. 57–63, pls. I–XI.

———. "The Tomb at Resget, Its Architecture and Inscriptions." Proceedings, *Sixth International Congress of Iranian Art and Archeology*. Vol. 2. Tehran: University, 1972, pp. 15–23.

Björkman, Walter. *Beiträge zur Geschichte der Staatskanzlei im islamischen Ägypten*. Hamburg: Friedrichsen, de Gruyter, 1928.

Blumhardt, James Fuller, and D. N. Mackenzie. *Catalogue of Pashto Manuscripts in the Libraries of the British Isles*. London: British Museum, 1965.

Bombaci, Alessandro. *The Kufic Inscription in Persian Verses in the Court of the Royal Palace of Mas͑ūd III at Ghazni*. Rome: I.S.M.E.O., 1966.

Born, Wolfgang. "Ivory Powder Flasks." *Ars Islamica* 9 (1962) pp. 100–132.

Brockelmann, Carl. *Geschichte der arabischen Literatur (GAL)*, 2d. ed. Vols. I–II. Supplement I–III. Leiden: Brill, 1937 ff.

Browne, Edward Granville. *A Literary History of Persia*, 4 vols. Cambridge: Cambridge University Press, 1902–21; repr. 1957.

Burton, Richard. *Sindh, and the Races That inhabit the Valley of the Indus*. London, 1981.

Būṣīrī, Abū ͑Abdallāh Muḥammad al-. *Die Burda*, ed. and trans. C. A. Ralfs, with metrical Persian and Turkish translations. Vienna, 1860.

Busse, Heribert. *Chalif und Grosskönig: die Buyiden im Iraq, 945–1055*. Beirut-Wiesbaden: Steiner, 1969.

Calligraphy and the Decorative Arts of Islam. Exhibition Catalogue. London: Bluett and Sons Ltd., 1976.

Canteins, Jean. "Lo spechio della Shahāda." *Conoscenza Religiosa* 4 (1980). Firenze: La Nuova Italia, 1980.

———. *La Voie des Lettres*. Paris: Albin Michel, 1981.

Casanova, M. "Alphabets magiques arabes." *JA* (1921), pp. 37–55 (1922), pp. 250–62.

Celâl, Melek. *Şeyh Hamdullah*. Istanbul: Kenan Matbaası, 1948.

Çelebi, Asaf Halet. *HE*. Istanbul, n.d. (ca. 1952).

———. *Lam-alif*. Istanbul, n.d. (ca. 1951).

Chagatay, Dr. Abdullah. "The Earliest Muslim Inscription in India from Ahmadabad." *Proceedings, Third Indian Historical Congress,* Calcutta, 1940, pp. 647–48.

Chandra, Pramod. *Ṭūṭīnāme.* Complete colour facsimile of the manuscript in possession of the Cleveland Museum of Art. Commentarium. Graz: Akademische Druck- und Verlagsanstalt, 1976.

Çïğ, Kemal. *Hattat Hafiz Osman Efendi* (1642–1692). Istanbul: Uzman Laboratuarï, 1949.

———. *Türk Oymacïlarï (katïğlarï) ve eserleri.* Ankara: Ilâhiyat Fakültesi, 1957.

Corbin, Henry. *Creative Imagination in the Sufism of Ibn ᶜArabi,* trans. Ralph Manheim. Princeton: Princeton University Press, 1969.

———. "Divine Epiphany and Spiritual Birth." In Joseph Campbell, ed., *Man and Transformation,* Princeton: Bollingen Series XXX, 5, 1964, pp. 69–160.

———. "Le Livre du Glorieux de Jâbir Ibn Ḥayyân (Alchimie et Archétype)." *Eranos-Jahrbuch,* XVIII (1950), pp. 47–114.

Cragg, Kenneth. "The Art of Theology: Islamic and Christian Reflections." In Alford T. Welch and Pierre Cachia, eds., *Islam, Past Influence and Present Challenge,* Edinburgh: Edinburgh University Press, 1979, pp. 276–95.

Dard, Khwāja Mīr. *ᶜIlm ul-kitāb.* Delhi, 1310h/1891–2.

Daudpota, Umar M. *The Influence of Arabic Poetry on the Development of Persian Poetry.* Bombay, 1934.

———. *Kalām-i Girhōṛī.* Karachi: Maṭbaᶜ al-ᶜarab, 1956.

Daulatshāh. *Tadhkirat ash-shuᶜarā',* ed. Edward G. Browne. Leiden: Brill, 1900.

Daylamī, Abū'l-Ḥasan ad-. *Kitāb ᶜatf al-alif al-ma'lūf ilā' l-lām al-maᶜṭūf,* ed. Jean-Claude Vadet. Cairo: Institut Français d'Archéologie Orientale, 1962; trans. Jean-Claude Vadet, *Le Traité d'amour mystique d'al-Daylami,* Geneva: Librairie Droz; Paris: Librairie Champion, 1980.

Deladrière, Roger, ed. and trans. *La Profession de la Foi d'Ibnᶜ Arabī.* Paris: Michel Allard, 1978.

Derman, M. Uğur. "Hafiz Osman'ïn muhraclarï." *Sanat Dünyamïz* IX, No. 24, pp. 11–20. Istanbul: Yapï ve Kredi Bankasï, 1982.

———. "The Turks and the Development of Calligraphy." *Turkish Contributions to Islamic Art,* Istanbul: Yapĭ ve Kredi Bankasĭ, 1976, pp. 58–62.

Dhauqī, Ḥażrat Shāh Sayyid Muḥammad. *Sirr-i dilbarān,* 2d ed. Karachi: Maḥfil-i dhauqiyya, 1388h/1968.

Dickson, Martin, and Stuart Cary Welch. *The Houghton Shahname,* 2 vols. Cambridge, Mass.: Harvard University Press, 1981.

Dietrich, Albert. *Arabische Briefe aus der Papyrussammlung der Hamburger Staats- und Universitätsbibliothek,* Hamburg: J. J. Augustin, 1955.

Dornseiff, Franz. *Das Alphabet in Mystik und Magie,* Berlin, 1922.

Dōst-Muḥammad. *Ḥālāt-i hunarvarān.* A treatise on calligraphists and miniaturists. Ed. Abdallah Chaghatay. Lahore: Chābuk Sāvarān, 1936.

Erdmann, Hanna. *Iranische Kunst in deutschen Museen* (unter Verwendung des Nachlasses von Kurt Erdmann). Wiesbaden: Steiner, 1967.

Erdmann, Kurt. *Arabische Schriftzeichen als Ornamente in der abendländischen Kunst des Mittelalters.* Mainz, Akademie der Wissenschaften und der Literatur, Abhandlungen der geisteşwissenschaftlichen und sozialwissenschaftlichen Klasse no. 9. Wiesbaden: Steiner, 1953.

Ergun, Sadettin Nüzhet. *Bektaşi şairleri ve nefesleri.* Istanbul: Maarif Kitabevi, 1944.

Ethé, Hermann. *Catalogue of Persian Manuscripts in the India Office Library.* 1903; repr. London: India Office Library and Records, 1980.

Ettinghausen, Richard. "Arabic Epigraphy: Communication or Symbolic Affirmation?" *Near Eastern Numismatics, Studies in Honor of George C. Miles.* Beirut: AUB, 1974, pp. 297–317.

———. "Die islamische Zeit." In Ekrem Akurgal, Cyril Mango und Richard Ettinghausen, *Die Türkei und ihre Kunstschätze,* Genf: Skira, 1966.

———. "Kufesque in Byzantine Greece, the Latin West, and the Muslim World." *Colloquium in Memory of George C. Miles.* New York: American Numismatic Society, 1976, pp. 28–47.

Fahd, Taufiq. *La Divination Arabe.* Leiden: Brill, 1966.

215

Fakhrī Haravī. *Rauḍat as-salāṭīn,* ed. Sayyid Hussamuddin Rashdi. Hyderabad: The Sindhi Adabi Board, 1968.

Fānī Kashmīrī, Muḥsin. *Dīvān,* ed. G. L. Tikku. Tehran: Indo-Iranian Association, 1964.

Faris, Nabih A., and George C. Miles. "An Inscription of Barbak Shah of Bengal." *Ars Islamica* 7 (1946), pp. 141–46.

Farrukh, Rakzuddīn Humāyūn. *Sahm-i īrāniyān dar paydāyish ū āfrīnish-i khaṭṭ dar jahān.* Tehran: Government publication, 1971.

Fażā'ilī, Ḥabībullāh. *Aṭlas-i khaṭṭ.* Isfahan: Shahriyār, 1971.

Fehérvári, Géza, and Yasin H. Safadi. *1400 Years of Islamic Art: A Descriptive Catalogue.* London: Khalili Gallery, 1981.

Feketé, Ludwig. *Einführung in die persische Paläographie.* 101 persische Dokumente. Aus dem Nachlass des Verfassers herausgegeben von G. Hazai. In Zusammenarbeit mit B. Alavi, M. Lorenz, W. Sundermann, P. Ziemke. Budapest: Akademie, 1977.

———. (Lajos). *Die Siyāqat-Schrift in der türkischen Finanzverwaltung.* 2 vols. Budapest: Bibliotheca Orientalis Hungarica no. 7, 1955.

Fenesch, Soledad G. "Sobra una extraña manera de escribir." *Al-Andalus* 14 (1949), pp. 211–12.

Fighānī, Baba. *Dīvān,* ed. A. S. Khwānsarī. Tehran: ᶜIlmiyya islāmiyya. 2d ed., 1340sh/1961.

Fikrun wa Fann. Zeitschrift für die arabische Welt. Herausgegeben von Albert Theile und Annemarie Schimmel. Vols. 1–35, Hamburg: Übersee-Verlag, 1963–1970; München: Bruckmann, 1970–82.

Flemming, Barbara. "Literary Activities in Mamluk Halls and Barracks." In Myriam Rosen-Ayalon, ed. *Studies in Memory of Gaston Wiet.* Jerusalem: University, 1977, pp. 249–66.

Flury, Samuel. "Le Décor épigraphique des monuments de Ghazna." *Syria* 6 (1925).

———. *Islamische Schriftbänder: Amida-Diyarbekir, XI Jahrhundert.* Basel: Frobenius A.G., 1920.

Fōfalzāi, ᶜAzīzuddīn Wakīlī. *Hunarhā-yi khaṭṭ dar Afghānistān dar dū qarn-i ākhir.* Kabul: Anjuman-i tārīkh-i Afghānistān, 1342sh-q/1963.

Fraad, Irma L., and Richard Ettinghausen. "Sultanate Painting in Persian Style, Primarily from the First Half of the Fifteenth Century." *Chhavi, Golden Jubilee Volume, Bharat Kalan Bhavan.* Benares: Hindu University, 1971, pp. 48–66.

216

Freytag, Georg Wilhelm. *Darstellung der arabischen Verskunst.* Bonn, 1830; repr. Osnabrück: Biblio, 1968.

Friedmann, Yohanan. *Shaykh Aḥmad Sirhindī: An Outline of His Thought and a Study of His Image in the Eyes of Posterity.* London and Montreal: McGill University Press, 1971.

Fück, Johann. *Die arabischen Studien in Europa.* Leipzig: Harrassowitz, 1955.

Furūzānfar, Badī ᶜuzzamān. *Aḥādīth-i Mathnavī.* Tehran: University, 1334sh/1955.

Fużulī. *Dīvān,* ed. Abdulbaki Gölpǐnarlǐ. Istanbul: Inkilâp, 1948.

Gandjei, Turhan. *Il Canzoniere de Šāh Ismāᶜīl Ḥaṭā'ǐ.* Naples: Annali dell'Istituto Orientale, 1959.

Gāwān, Maḥmūd. *Riyāḍ al-inshā',* ed. Dr. Ghulām Yazdānī. Hyderabad (Deccan): State Printing Office, 1948.

Ghafur, M. A. *The Calligraphers of Thatta.* Karachi: Sindhi Adabi Board, 1968.

———. "Fourteen Kufic Inscriptions of Bhambhor." *Pakistan Archeology.* Karachi, 1966.

Ghālib, Mirzā Asadullāh. *Kulliyāt-i Fārsī,* 17 vols., Lahore: University of the Punjab, 1969.

———. *Urdū Dīvān,* ed. Ḥāmid Aḥmad Khān, Lahore: University of the Punjab, 1969.

Ghalib Dede. *Hüsn u aşk,* ed. Abdulbaki Gölpǐnarlǐ. Istanbul: Altǐn Kitablar, 1968.

Ghazzālī, Abū Ḥāmidal. *Iḥyā' ᶜulūm ad-dīn.* Bulaq, 1289h/1872–73.

Gibb, Elias John Wilkinson. *A History of Ottoman Poetry.* 6 vols. London: Luzac, 1900–1909; repr. London, 1958–63.

Giese, Alma. *Waṣf bei Kušāǧim. Eine Studie zur beschreibenden Dichtkunst der Abbasidenzeit.* Berlin: Klaus Schwarz Verlag, 1981.

Ginzalian, L. T. "The Bronze Qalamdān (Pen-Case) of 542/1148 from the Hermitage Collection." *Ars Orientalia* 7 (1968), pp. 95–119.

Goethe, Johann Wolfgang von. *West-Östlicher Divan.* Unter Mitwirkung von Hans Heinrich Schaeder hersg. und erläutert von Ernst Beutler. Leipzig: Dieterich'sche Verlagsbuchhandlung, 1943.

Goldziher, Ignaz. "Linguistisches aus der Literatur der muhammedanischen Mystik." *ZDMG* 26 (1872), pp. 764–85.

Gölpïnarlï, Abdulbaki. *Melâmilik ve Melâmiler*. Istanbul, 1931.

———. *Tasavvuftan dilimize geçen deyimler ve atasözleri*. Istanbul: Inkilâp ve Ata, 1977.

Grabar, Oleg. "The Omayyad Dome of the Rock." *Ars Orientalis* 3 (1959), pp. 33–62.

Gramlich, Richard. *Die schiitischen Derwischorden*. Vol. 3, Wiesbaden: Steiner, 1980.

Grohmann, Adolf. "Anthropomorphic and Zoomorphic Letters in the History of Arabic Writing." *Bulletin de l'Institut d'Égypte* 38 (1955), pp. 117–22.

———. *Arabische Paläographie*. 2 vols. Österreichische Akademie der Wissenschaften, Phil. hist. Kls. Denkschriften Bd. 94, 1, 2. Vienna: Hermann Böhlaus Nachf., 1967, 1971.

———. "Die Bronzeschale M 388–1911 im Victoria and Albert Museum." In R. Ettinghausen, ed., *Aus der Welt der islamischen Kunst, Festschrift für Ernst Kühnel*. Berlin: Gebr. Mann, 1959, pp. 125–38.

———. "The Origin and Early Development of Floriated Kufic," *Ars Orientalis* 2 (1951), pp. 183–213.

Güner, Sami. "Examples of Turkish Calligraphy." *Turkish Contributions to Islamic Art*. Istanbul: Yapï ve Kredi Bankasï, 1976, pp. 65–83.

Ḥabīb, *Hatt u hattatan* (= *Khaṭṭ ū khaṭṭāṭān*). Istanbul, 1305h/1887.

Ḥabībī, ᶜAbdul-Ḥayy. *A Short History of Calligraphy and Epigraphy in Afghanistan*. Kabul: Afghanistan Academy, 135osh/1971.

Hadi Hasan. "Qāsim-i Kāhī. His Life, Time, and Works." *Islamic Culture* 27 (1953), pp. 99–131, 161–94, 199–224.

Ḥāfiẓ, Muhammad Shamsuddīn. *Dīvān-i Ḥāfiẓ*, ed. Nadhīr Aḥmad and S. M. Jalālī Nā'inī. Tehran: Sāzmān-i umūr-i farhangī ū kitābkhānahā, 1971.

———. *Der Diwan des grossen lyrischen Dichters Hafis . . .*, herausgegeben und . . . übersetzt von Vincenz Ritter von Rosenzweig-Schwannau. 3 vols. Vienna, 1858.

———. *Die Lieder des Hafiz*, herausgegeben von Hermann Brockhaus. 3 vols. Leipzig, 1854–60; repr. Osnabrück: Biblio, 1969.

Halem, Hilmann von, ed. *Calligraphy in Modern Art*. Papers read at a symposium organized by the Goethe-Institute Karachi, and the Pakistan-German Forum. Karachi: Goethe-Institute, 1975.

218

Hammer (-Purgstall), Joseph von. (*Ibn al-Waḥshiyya*), *Ancient Alphabets and Hieroglyphic Characters Explained*. London, 1806.

————. *Bericht über den zu Kairo im Jahre 1835 erschienenen türkischen Kommentar des Mesnewi Dschelaleddin Rumi's*. Sitzungsberichte der K.u.K. Österreichischen Akademie der Wissenschaften. Vienna, 1851; repr. in Annemarie Schimmel. *Zwei Abhandlungen zur Mystik und Magie des Islams*. Vienna: Österreichische Akademie der Wissenschaften: Hermann Böhlaus Nachf.; 1974, pp. 19–119.

————. *Geschichte der schönen Redekünste Persiens*. Vienna, 1818.

Ḥamza al-Iṣfahānī. *At-tanbīh ᶜalā ḥudūth at-taṣḥīf*, ed. Ash-Shaykh Muḥammad Ḥasan Āl Yāsīn. Baghdad: Maktaba an-Nahḍa, 1967.

Haravī, Muḥammad ᶜAlī ᶜAṭṭār. *Ganjīnah-i khuṭūṭ dar Afghānistān* (Treasures of Calligraphies in Afghanistan), ed. Māyil Haravī, Kabul: Anjuman-i tārīkh, 1967.

Hartmann, Richard. *Eine islamische Apokalypse aus der Kreuzzugszeit: ein Beitrag zur ǧafr-Literatur*. Berlin: Deutsche Verlagsgesellschaft für Politik und Geschichte, 1924.

Hegyi, Othmar. "Minority and Restricted Uses of the Arabic Alphabet: The Aljamiado Phenomenon." *JAOS* 99, 2 (1979), pp. 262–69.

Herzfeld, Ernst. "A Bronze Pen-Case." *Ars Islamica* 3 (1936), pp. 35–43.

Hill, Derek, and Oleg Grabar. *Islamic Architecture and Its Decoration*, London: Faber and Faber, 1964.

Hīrī, ᶜAbdallāh ibn ᶜAlī, al-. *Al-ᶜumda: risāla fī'l-khatt wa'l-qalam*, ed. Hilāl Nājī. Bagdad: Maṭbaᶜa al-maᶜārif, 1970.

Hoenerbach, Wilhelm. *Die dichterischen Vergleiche der Andalus-Araber*. I und II. Bonn: Orientalisches Seminar, 1973.

Horovitz, Josef. *Epigraphica Indo-Moslemica*. Vol. II, Calcutta: Archeological Survey of India, 1909.

Horten, Max. *Die religiösen Vorstellungen des Volkes im Islam*. Halle: Niemeyer, 1917.

Houdas, O. V. "Essai sur l'écriture maghrebine." *Nouveau mélanges orientaux*. Paris, 1886.

Huart, Clément. *Les calligraphes et les miniaturistes de l'Orient musulman*. Paris, 1908; repr. 1972.

————. *Textes Persans relatifs à la secte des Houroûfîs.* Publiés, traduits et annotés, suivis d'une étude sur la religion des Houroûfîs par le Docteur Rizâ Tevfîq. *GMS,* IX. Leiden: Brill-London: Luzac, 1909.

Hujwīrī, ᶜAlī ibn ᶜUthmān al-Jullābī al-. *Kashf al-maḥjūb,* trans. Reynold Alleyne Nicholson. *GMS,* XVII. London: Luzac-Leiden: Brill, 1911; 3d ed., 1959; many reprints.

Ḥusayni, Ḥasan ibn Murtażā al-. *Tadhkira-i khushnivīsān-i har khaṭṭ.* Tehran: Mu'assasa-i nashr-i kitāb-i akhlāq, 1344sh/1965.

Ibn Abi ᶜAwn. *Kitāb at-tashbīhāt,* ed. M. Muᶜīd Khān. *GMS, NS* 17. London: Luzac-Leiden: Brill, 1950.

Ibn ᶜArabī, Muḥyīddīn. *Al-futūḥāt al-makkiyya.* 4 vols. Bulaq 1213/1876.

————. *Fuṣūṣ al-ḥikam,* ed. Abū'l-ᶜAlāᶜAffīfī. Cairo: Dār iḥyā' al-kutub al-ᶜarabiyya, 1946. Trans. R. J. W. Austin, *Bezels of Wisdom.* New York: Paulist Press, 1980.

————. *Journey to the Lord of Power,* trans. Rabia T. Harris. New York: Inner Traditions International, 1981.

————. *The Tarjumān al-ashwāq: A Collection of Mystical Odes,* ed. and trans. Reynold A. Nicholson. London: Royal Asiatic Society, 1911; repr. with foreword by Martin Lings, London: Theosophical Publishing House, 1978.

Ibn Khaldūn, ᶜAbdur-Raḥmān. *Al-Muqaddima,* ed. M. Quatremère. 3 vols. Paris, 1858. Trans. Franz Rosenthal, *The Muqaddima.* 3 vols. 2d. ed. Princeton: Bollingen, 1967.

Ibn Khallikān. *Wafayāt al- aᶜyān,* ed. McGuckin de Slane. 4 vols. Paris 1838–42.

Ibn al-Muᶜtazz. *Dīwān.* Vol. III, ed. Bernhard Lewin. Istanbul: Maṭbaᶜa al-maᶜārif, 1945.

Ibn an-Nadīm. *The Fihrist,* trans. Bayard Dodge. 2 vols. New York: Columbia University Press, 1970.

Ibn ar-Rāwandī, Muḥammad ibnᶜAli. *Rāhat aṣ-ṣudūr wa āyat as-surūr. Being a History of the Seljukids,* ed. Mohammad Iqbal. Leiden: Brill-London: Luzac, 1921.

Ibn aṣ-Ṣā'igh, ᶜAbdur-Raḥmān. *Tuḥfat ūlī'l-albāb fī ṣināᶜati' l-khaṭṭ wa'l-kitāb,* ed. Hilāl Nājī. Tunis: Dār Bū Salāma 1967.

Ibn Wahb al-Kātib, Isḥāq ibn Ibrāhīm. *Al-burhān fī wujūh al-bayān,*

ed. Dr. Aḥmad Maṭlūb wa Dr. Khadīja al-Ḥadīthī. Baghdad: University, 1967.

Ibn al-Waḥshiyya. "Kitāb shauq al-mustahām fi maᶜrifati rumūz al-aqlām." translation in Sylvain Matton, *La Magie Arabe traditionelle*. Paris: Retz, 1977, pp. 130–241.

Ibrāhīm Tattawī. *Takmila maqālāt ash-shuᶜarā*, ed. Sayyid Hussamuddin Rashdi. Karachi: The Sindhi Adabi Board, 1958.

Ikrām, Shaykh Muḥammad. *Armaghān-i Pāk*. Karachi: Idāra-i maṭbūᶜāt-i Pākistān, 1953.

Inal, Ibnülemin Mahmud Kemal. *Son Hattatlar*. Istanbul: Devlet Matbaasi, 1954.

Īrānī, ᶜAbdul-Muḥammad. *Paydāyish-i khaṭṭ ū khaṭṭāṭān*, with the addition of ᶜAlī Rahjīrī, *Tadhkira-yi khushnivīsān-i muᶜāṣir*. Tehran: Ibn-e Sīnā, 1346sh/1967.

Indian Heritage, The. Court Life and Arts under Mughal Rule. London: Victoria and Albert Museum, 1982.

Iranian Calligraphy. A selection of works from the fifteenth to the twentieth century. The Aydin Aghdashloo collection in Negaristan, April–May 1975. Tehran, 1975.

Isfārayīni, Nūruddīn ᶜAbdur-Raḥmān. *Kāshif al-Asrār*. Texte Persan publié avec deux annexes, une traduction et une introduction par Hermann Landolt. Tehran: Iranian Institute of McGill University and Tehran University, 1980.

Izutsu, Toshihito. "The Basic Structure of Metaphysical Thinking in Islam." In Mehdi Mohaghegh and Hermann Landolt, eds., *Collected Papers on Islamic Philosophy and Mysticism*. Tehran: Iranian Institute of McGill University and Tehran University, 1971.

Jahāngīr, Shāh Salīm. *Tuzuk-i Jahāngīrī*, 2d. rev. ed. by Sayyid Aḥmad Khan, Aligarh, 1864; trans. A. Rogers and H. Beveridge, London, 1909–14; repr. 1978.

Jāmī, ᶜAbdur-Raḥmān. *Dīvān-i kāmil*, ed. Hāshim Riżā. Tehran: Payrūz, 1341sh/1962.

———. *Haft Aurang*, ed. Aqā Murtażā and Mudarris Gīlānī. Tehran: Saᶜdī, 1337sh/1958.

———. *Nafaḥāt al-uns min ḥaḍarāt al-quds*, ed. Mahdī Tauḥīdīpūr. Tehran: Saᶜdī, 1336sh/1957.

221

Jimenez, Manuel Ocaña. *El cúfico hispano y su evolución.* Madrid: Istituto Hispano-arabe di cultura, 1970.

Johns, Anthony H. *"Daḳā'iḳ al-ḥurūf* by ᶜAbd al-Ra'ūf of Singkelt." *JRAS* (1955), pp. 55–73, 139–58.

Jurji, Edward J. *Illumination in Islamic Mysticism.* Princeton: Princeton University Press, 1938.

Kalīm, Abū Ṭālib. *Dīvān,* ed. Partav Bayḍā'ī. Tehran: Khayyām, 1336sh/1957. See also Thackston.

Kamil, Murad. "Die *qirma*-Schrift in Ägypten." In Wilhelm Hoenerbach, ed., *Der Orient in der Forschung, Festschrift für Otto Spies.* Wiesbaden: Harrassowitz, 1967.

Karacaoğlan, *Şiirleri,* ed. Cahit Öztelli. Istanbul: Varlĭk, 1952.

Khakī Khorāsānī. *Dīvān.* Bombay, Matbaᶜ-i Muẓaffarī, 1933.

Khālidīyān, Abū Bakr Muḥammed wa Abū ᶜUthmān al-. *Kitāb at-tuḥaf wa'lᶜhadāyā,* ed. Sāmī ad-Dahhān. Cairo: Dār al-maᶜārif, 1956.

Khānqāhī, Ṭāhir. *Guzīda dar akhlāq u taṣavvuf,* ed. Īraj Afshar. Tehran: University, 1337sh/1958.

Khāqānī, Afẓaluddīn Ibrāhīm. *Dīvān,* ed. Żiā'uddīn Sajjādī, Tehran: Zavvār, n.d.

Khatibi, Abdel Kebir, and Muhammad Sijelmasi. *The Splendour of Islamic Calligraphy.* London: Thames and Hudson, 1976.

Khaṭṭ. In *Encyclopedia of Islam.* 2d ed. IV (1978), pp. 1113–30, by Janine Sourdel-Thomine, Ali Alparslan, M. Abdullah Chaghatay, and Taufiq Fahd.

Khushḥāl Khān Khattak. *Muntakhabāt,* ed. Anwār ul-Ḥaq. Peshawar: Pashto Academy, n.d.

Klimkeit, Hans-Joachim. *Manichean Art and Calligraphy* (Iconography of Religions, XX). Leiden: Brill, 1982.

Knappert, Jan. *Swahili Religious Poetry.* 3 vols. Leiden: Brill, 1971.

Köprülü, Mehmet Fuad. *Eski şairlerimiz: Divan şiiri antolojisi.* Istanbul: Ahmet Halit Kitabevi, 1931.

Kostigova, G. D. *Obrazcui kalligrafii Irana v sredneyi Azii, XV–XIXs.* Specimens of Persian and Central Asian calligraphy from the fifteenth to the nineteenth century from the Leningrad collections. Moscow: Nauk, 1964.

Krachkovskaia, Vera A. "Evolutsia kuficheskovo pisma v srednei Azii." *Epigraphika Vostoka* 3 (1940).

————. "Notice sur les inscriptions de la Mosquée Djouma'a à Veramin." *REI* (1931), pp. 25–58.

———— and Y. Ibanty. "The Earliest Document from Central Asia." *Sogdijskij Sbornik.* Leningrad, 1935.

Krenkow, Fritz. "The Use of Writing for the Preservation of Ancient Arabic Poetry." In ᶜ*Ajabnāma, Studies in Honour of Edward Granville Browne.* Cambridge: Cambridge University Press, 1922, pp. 261–68.

Kriss, Rudolf, and Hubert Kriss-Heinrich. *Volksglaube im Bereich des Islam.* Vol. 2. Wiesbaden: Harrassowitz, 1962.

Kühnel, Ernst. *Islamische Kleinkunst.* 2d. ed. Braunschweig: Klinkhardt und Biermann, 1963.

————. *Islamische Schriftkunst.* Berlin: Heintze und Blankertz, 1942; repr. Graz, 1975.

————. "Die osmanische Tughra." *Kunst des Orients* 2 (1955), pp. 69–82.

Kureshi, B. A. "Calligraphy." In Hamid Jalal et al., eds., *Pakistan, Past and Present,* London: Stacey International, 1976, pp. 233–36.

Lichtenstädter, Ilse. "Das *nasīb* der altarabischen *qaṣīda*." *Islamica* V, 1 (1931), pp. 17–91.

Lings, Martin. *The Quranic Art of Calligraphy and Illumination.* London: World of Islam Festival Trust, 1976.

————. *A Sufi Saint of the Twentieth Century.* London: Allen and Unwin, 1971.

———— and Yasin Hamid Safadi. *The Qur'ān.* Catalogue of an exhibition of Qur'ān manuscripts at the British Library, 3 April–15 August 1976. London: The British Library, 1976.

Losty, Jeremiah P. *The Art of the Book in India.* London: The British Library, 1982.

Marquet, Yves. *La Philosophie des Ihvân al-ṣafâ.* Alger: Service de reproduction des thèses, 1973.

Makhzan Shāh ᶜAbdul-Laṭīf Bhitā'ī, ed. Laṭīf Yādgār Committee, Hyderabad/Sind: Muslim Adabi Printing Press, 1954.

Massignon, Louis. *Essai sur les origines du Lexique Technique de la mystique musulmane.* 2d. ed. Paris: Vrin, 1954.

————. *La Passion de Husayn Ibn Mansur Hallaj.* 4 vols. 2d. ed. Paris: Gallimard, 1975.

————. "La Philosophie Orientale d'Ibn Sînâ et son alphabet philosophique." *Mémorial Avicenna IV.* Cairo: Institut d'archéologie orientale, 1954, pp. 1–18.

Massoudy, Hamid. *Calligraphie Arabe Vivante.* Paris: Flammarion, 1981.

Māyil, Riżā. *Barkhī az katībahā va sang-nivishtahā-yi Harāt.* Kabul: Anjuman-i tārīkh-i Afghānistān, 1950.

————, ed. *Risāla-yi khaṭṭ-i Majnūn-i Rafīqī-yi Haravī.* Kabul: Anjuman-i tārīkh-i Afghānistān, 1355sh-q/1976.

Meier, Fritz. *Vom Wesen der islamischen Mystik.* Basel: Benno Schwabe und Co., 1943.

Mez, Adam. *Die Renaissance des Islams.* Heidelberg: Carl Winter, 1922.

Mihrān jā mōtī (Collection of Sindhi articles). Karachi: The Sindhi Adabi Board, 1959.

Minorsky, Vladimir. *Calligraphers and Painters. A Treatise by Qāḍī Aḥmad son of Mīr-Munshī (ca A.H. 1015/A.D. 1606).* Translated from the Persian with an introduction by B. N. Zakhoder. Washington: Smithsonian Institution, Freer Gallery of Art, 1959.

————. "The Poetry of Shāh Ismāᶜīl I." *BSOAS* 10 (1940–42), pp. 1006a–1053a.

Mīr-ᶜImād-i Qazvīnī. *Adab al-mashq, bā-risāla-i naṣā'iḥ al-mulūk.* Tehran: Kārkhāna-i Mashhadi Khudādād, 1317sh/1938.

Moritz, Bernhard. *Arabic Palaeography. A Collection of Arabic Texts from the First Century of the Hidjra Till the Year 1000.* Cairo: Khedivial Library no. 16. Leipzig: Karl W. Hiersemann, 1906.

Munajjid, Ṣalāḥuddin al-. *Dirāsāt fī ta'rīkh al-khaṭṭ alᶜarabī.* Dār al-kutub al-jadīda, 1972.

————. *Al-kitāb al-ᶜarabī al-makhṭūṭ ilā'l-qarn al-ᶜāshir al-hijrī.* Cairo, 1960.

Mustaqimzade, Süleyman Sadeddin. *Tuhfet al-hattatin (Tuḥfat al-khaṭṭāṭīn),* ed. Ibnülemin Mahmud. Istanbul: Devlet Matbassï, 1928.

Nath, Ram. *Calligraphic Art in Mughal Architecture.* Calcutta: Iran Society, 1979.

Nazir Ahmad. *"Kitāb-ī nauras," Islamic Culture* 28(1954), pp. 333–71.

Naẓīrī Nīshāpūrī, Muḥammad Ḥusayn. *Dīvān,* ed. Maẓāhir Muṣaffā. Tehran: Amīr Kabīr, 1340sh/1961.

Nicholson, Reynold Alleyne. *Studies in Islamic Mysticism.* Cambridge: Cambridge University Press, 1921; repr. 1967.

Niẓāmī, Ilyās. *Kulliyāt,* ed. Vaḥīd Dastgirdī. Tehran, 1313–18sh/1934–39; reprints.

Nwyia, Paul. *Exégèse coranique et langage mystique.* Beirut: Dār al-mashriq, 1970.

Nyberg, Hendrik Samuel. *Kleinere Schriften des Ibn al-ᶜArabi.* Leiden: Brill, 1919.

Paniker, I. Ayyapa. "Mystic Strain in Medieval Malayalam Poetry." *J. of Medieval Indian Literature* IV, 1–2(1980). Chandigarh: Panjab University.

Pope, Arthur Upham, and Phyllis Ackerman. *A Survey of Persian Art.* 6 vols. London, 1938–39; repr. Tokyo, 1969.

Qāḍī Qādan jō kalām, ed. Hiro J. Thakur. Delhi: Puja Publications, 1978.

Qāḍī ar-Rashīd ibn az-Zubayr, al-. *Kitāb adh-dhakhā'ir wa't-tuḥaf.* ed. M. Hamidullah. Kuwait, 1959.

Qalqashandī, Shihābuddīn Aḥmad, *Ṣubḥ-al-aᶜshā fī ṣināᶜat al-inshā,* ed. Muḥammad ᶜAbdur-Rasūl Ibrāhīm. 14 vols. Cairo: Dār al-kutub al-khadīwiyya, 1931–32.

Qāniᶜ, Mīr ᶜAlī Shīr. *Maqālāt ash-shuᶜarā,* ed. Sayyid Hussamuddin Rashdi. Karachi: The Sindhi Adabi Board, 1956.

Qāṭiᶜi-i Haravī. *The Majmaᶜ al-shuᶜarā-i Jahāngīrshāhī,* ed. Muhammad Saleem Akhtar. Karachi: University, 1979.

Qanun-i ᶜishq. Urdu commentary on Bullhē Shāh's kāfīs. Lahore: Allāhwālē kī qaumī dukān, n.d. no. 372.

Raeuber, Alexandra. *Islamische Schönschrift.* Zürich: Museum Rietberg, 1979.

Ramakrishna, Lajwanti. *Panjabi Sufi Poets.* London and Calcutta: Oxford University Press, 1938.

Râmî, Cheref-eddîn. *Anîs el-ᶜochchâq.* Traduit du Persan et annoté par M. Cl. Huart. Paris: F. Vieweg, 1875.

Rashid, Lieut. Col. K. A. "Some Styles of Practice Writing by Great Calligraphists." *Iqbal Review.* April 1966.

Raverty, H. G. *Selections from the Poetry of the Afghans.* London, 1862.

Reckendorf, Hermann. *Mohammed und die Seinen.* Leipzig: Teubner, 1907.

225

Rice, D. S. "Studies in Islamic Metalwork." *BSOAS* XIV, 3 (1952), pp. 564–78, and *BSOAS* XV, 1 (1953), pp. 61–79.

————. *The Unique Ibn al-Bawwāb Manuscript in the Chester Beatty Library.* Dublin: Chester Beatty Library, 1955. Complete facsimile edition with the commentary of D. S. Rice in preparation in the Akademische Druck-und Verlagsanstalt, Graz.

Rich, George W., and Shahid Khan. "Bedford Painting in Pakistan. The Aesthetics and Organization of an Artisan Trade." *J. of American Folklore* (1980), pp. 257–75.

Ritter, Hellmut. "Die Anfänge der Ḥurūfī-Sekte." *Oriens* VII (1954), pp. 1–54.

————. *Das Meer der Seele: Gott, Welt und Mensch in den Geschichten Farīdaddīn ᶜAṭṭārs.* Leiden: Brill, 1955.

————, ed. *Pseudo-Maǧrīṭī, Das Ziel des Weisen (Picatrix),* 1. Arabischer Text. Leipzig-Berlin: Teubner, 1933.

————. *Über die Bildersprache Niẓāmīs.* Berlin: de Gruyter, 1927.

Robertson, E. "Muḥammad ibn ᶜAbd al-Raḥmān on Calligraphy." *Studia Semitica et Orientalia Presented to J. Robertson.* Glasgow, 1920, pp. 57–83.

Roemer, Hans Robert. *Staatsschreiben der Timuridenzeit. Das Šaraf-nāma des ᶜAbdallāh Marwarīd in kritischer Auswertung.* Wiesbaden: Steiner, 1952.

Rosenthal, Franz. *Four Essays on Art and Literature in Islam.* Leiden: Brill, 1971; therein: "Abū Ḥayyān at-Tawḥīdī on Penmanship," pp. 20–49; "Significant Uses of Arabic Writing," pp. 50–62.

Rückert, Friedrich. *Grammatik, Poetik und Rhetorik der Perser,* hersg. von Wilhelm Pertsch. Berlin, 1874; repr. Osnabrück: Zeller-Wiesbaden: Harrassowitz, 1966.

Rūmī, Maulānā Jalāluddīn. *Dīvān-i kabīr ya Kulliyāt-i Shams,* ed. Badīᶜuzzamān Furūzānfar. 10 vols. Tehran: University, 1957 ff.

————. *Mathnawī-yi maᶜnawī,* ed. and trans. Reynold A. Nicholson, 8 vols. *GMS NS,* 4. London: Luzac, 1925–40.

Rypka, Jan. *History of Iranian Literature.* 's Gravenhage: Reidel, 1968.

Sachal Sarmast. *Risālō Sindhī,* ed. ᶜOthmān ᶜAlī Anṣārī. Karachi: The Sindhi Adabi Board, 1958.

Saᶜdī, Muṣliḥuddīn. *Kulliyāt,* from the manuscript of Muḥd. ᶜAli Furūghī. 4 vols. Tehran: Eqbal, 1342h/1963.

Ṣafadī, Ṣalāḥuddīn Khalīl ibn Aibek as-. *Das Biographische Lexikon.*

226

Vol. 12, ed. Ramaḍān ᶜAbd at-Tawwāb. Beirut—Wiesbaden: Steiner, 1979.

———. *Al-ghayth al-musajjam fī sharḥ lāmiyyat al-ᶜajam.* Cairo: Al-maṭbaᶜa al-azhariyya, 1305h/1888.

Safadi, Yasin H. *Islamic Calligraphy.* Boulder: Shambhala, 1978.

Sanā'ī, Majuddīn Abū l-Majd. *Dīvān,* ed. Mudarris Riżavī. Tehran: Ibn-i Sīnā, 1341sh/1962.

———. *Ḥadīqat al-ḥaqīqa wa sharīᶜat aṭ-ṭarīqa,* ed. Mudarris Riżavī. Tehran: Ṭāhūrī, 1329sh/1950.

———. *Mathnavīhā,* ed. Mudarris Riżavī. Tehran: University, 1948sh/1969.

Sarrāj, Abū Naṣr as-. *Kitāb al-lumaᶜ fi't-taṣawwuf,* ed. Reynold A. Nicholson, *GMS XXII.* Leiden: Brill—London: Luzac, 1914; numerous reprints.

Sarre, Friedrich. *Erzeugnisse islamischer Kunst I: Metall.* Mit epigraphischem Beitrag von Eugen Mittwoch. Leipzig: Karl W. Hiersemann, 1906.

Schaya, Léo. *La doctrine soufique de l'unité.* Paris, 1962.

Schimmel, Annemarie. *A Dance of Sparks, Studies in Ghalib's Imagery.* New Delhi: Ghalib Academy, 1979.

———. *As Through a Veil. Mystical Poetry in Islam.* New York: Columbia University Press, 1982.

———. "Ghalib's *qaṣīda* in Honor of the Prophet." In Alford T. Welch and Pierre Cachia, eds., *Islam, Past Influence and Present Challenge.* Edinburgh: Edinburgh University Press, 1979, pp. 188–209.

———. *Islam in India and Pakistan* (Iconography of Religions). Leiden: Brill, 1982.

———. *Islamic Calligraphy* (Iconography of Religions). Leiden: Brill, 1970.

———. *Mystical Dimensions of Islam.* Chapel Hill: The University of North Carolina Press, 1975.

———. *Pain and Grace. A Study of Two Mystical Writers of Eighteenth-Century Muslim India.* Leiden: Brill, 1976.

———. "Poetry and Calligraphy: Thoughts about their Interrelation in Persian Culture." In Ehsan Yar-Shater, ed. *Highlights of Persian Art.* Boulder: Westview Press, 1979, pp. 188–209.

———. "Samiha Ayverdi, eine Istanbuler Schriftstellerin." In Wil-

helm Hoenerbach, ed., *Der Orient in der Forschung, Festschrift für Otto Spies*. Wiesbaden: Harrassowitz, 1967.

———. "Schriftsymbolik im Islam." In Richard Ettinghausen, ed., *Aus der Welt der islamischen Kunst*. Berlin: Gebr. Mann, 1959, pp. 44–53.

———. "Some Cultural Activities of the Uzbek Rulers." *J. Pakistan Historical Society*, 1960, pp. 149–166.

———. *The Triumphal Sun. A Study of the Works of Jalāloddin Rumi*. London–The Hague: East-West Publications, 1978.

———. *Und Muhammad ist Sein Prophet*. Köln: Diederichs, 1981.

Scholem, Gershom. *Major Trends in Jewish Mysticism*. New York: Schocken, 3d. ed. 1954.

Schroeder, Eric. "What was the *badīᶜ*-script?" *Ars Islamica* 4 (1937), pp. 232–48.

Seher-Toss, Sonia P., and Hans C. *Design and Color in Islamic Architecture*. Washington: Smithsonian Institution, 1965.

Selim, George Dimitri. "Arabic Calligraphy in the Library of Congress." *Quarterly J. of the Library of Congress*. (Spring 1979), pp. 140–77.

Sellheim, Rudolf. "Die Madonna mit der *šahāda*." In Erich Gräf, ed., *Festschrift Werner Caskel zum siebzigsten Geburtstag gewidmet*. Leiden: Brill, 1968.

Shaybī, M. Kāmil ash-, ed. *A Commentary on the Dīwān of al-Ḥallāj* (with an edited text and an introduction). Baghdad-Beirut: al-Nahḍa Bookshop, 1973.

Shere, S. A. "A *waṣlī* of Prince Khurram." *J. Bihar and Orissa Research Society*, 29, pt. 1 (1943), pp. 171–74.

Shiloah, Amnon. *The Epistle on Music of the Ikhwān aṣ-Ṣafā*. Tel Aviv: University, 1978.

Sijistānī, Abū Yaᶜqūb as-. *Kitāb al-yanābīᶜ*, ed. Henry Corbin, Tehran-Paris: Adrien Maisonneuve, 1969.

Soucek, Priscilla P. "The Arts of Calligraphy." In Basil Gray, ed., *The Arts of the Books in Central Asia in the fourteenth to the sixteenth century*. Paris:UNESCO, 1979, pp. 1–40.

Sourdel, Dominique, "Le Livre des Secrétaires de ᶜAbdallāh al-Bagdādī." BEO XIV (1952 54), pp. 115–153.

Shabistarī, Maḥmūd. *Gulshan-i rāz: The Rose-Garden of Mysteries*, ed. and trans. Edward Henry Whinfield, London, 1880.

Ṣūlī, Abū Bakr Muḥammad aṣ-. *Adab al-kuttāb*, ed. Muḥammad Bahjatal-Atharī. Cairo, 1341h/1921.

Tanavoli, Parviz. *Fifteen Years of Bronze Sculpture*. New York: New York University, 1977.

Teufel, Johann Carl. *Eine Lebensbeschreibung des Scheichs ᶜAlī-i Hamadānī*. Leiden: Brill, 1962.

Thackston, Wheeler M., Jr. *The Poetry of Abū Ṭālib Kalīm*. Vol. 2 (edition of the *Dīvān*). Harvard Ph.D. diss., 1974.

Ṭībī, Muḥammad ibn Ḥasan aṭ-. *Jāmiᶜ maḥāsin kitābat al-kuttāb* (The kinds of Arabic calligraphy according to the method of Ibn al-Bawwāb), ed. Ṣalāhuddīn al-Munajjid. Beirut: New Book Publishing House, 1962.

Togan, Zeki Velidi. *On the Miniatures in Istanbul Libraries*. Istanbul: Edebiyat Fakültesi yayĭnlarĭndan no. 1034, 1963.

Ünver, Süheyl. *Hilya-i saadet, Hattat Mehmet Şevki*. Istanbul: Yeni Laboratuvar, 1953.

———. *Al-khaṭṭāṭ al-baghdādī ᶜAlī ibn Hilāl al-mashhūr bi-Ibn al-Bawwāb*. Arabic translation with enlargement and annotation by ᶜAzīz Sāmī and Muḥammad Bahjat al-Atharī. Baghdad: Maṭbaᶜa al-majmaᶜ al-ᶜilmī al-ᶜirāqī, 1958.

———. *Türk yazĭ çeşitleri ve faydalĭ bazĭ bilgiler*. Istanbul: Yeni Laboratuvar, 1953.

ᶜUrfī Shīrāzī, Muḥammad. *Kulliyāt,* ed. Ghulāmḥusayn Javāhirī, Tehran, n. p. 1336sh/1957.

Uzluk, Şahabettin. *Mevlevilikte resim—resimde mevleviler*. Ankara: Türk Tarih Kurumu, 1957.

Vajda, Georges. *Album de paléographie arabe*. Paris: Librairie d'Amérique et de l'Orient, 1958.

Varma, B. D., "ᶜAdil Shahi Epigraphy in the Deccan." *J. University of Bombay,* NS, 8 (1939), pp. 13–51.

Vaudeville, Charlotte. *Kabīr*. Vol. I. Oxford: University Press, 1974.

Ventrone, Giovanna. "Iscrizioni inedite su ceramica samanide in collezioni italiane." *Gururajamanjarika, Studi in onore de Giuseppe Tucci*. Naples, 1974, pp. 221–34.

Vidal, L., et R. Bouvier. "Le papier de Khānbaligh et quelques autres anciens papiers asiatiques." *JA, CCVI* (1925), pp. 160–64.

Volov, Lisa. "Plaited Kufic on Samanid Epigraphic Pottery." *Ars Orientalis,* 7 (1966), pp. 10–33.

Wagner, Ewald. *Abu Nuwās.* Wiesbaden: Steiner, 1965.

Washsha', Abū ᶜṭayyib Muḥammad ibn Isḥāq al-. *Kitāb al-muwashshā.* ed. Rudolph Brünnow. Leiden: Brill, 1886.

Weisweiler, Max. *Arabische Märchen.* Vol. II. Köln-Düsseldorf: Diederichs, 1968.

Welch, Anthony. *Calligraphy in the Arts of the Muslim World.* Catalogue of the Asia House Exhibit. Austin: University of Texas Press, 1979.

———— and Stuart Cary Welch. *Arts of the Islamic Book. The Collection of Prince Sadruddin Aga Khan.* Ithaca and London: Cornell University Press, 1982.

Welch, Stuart Cary. *Imperial Mughal Painting.* New York: Braziller, 1978.

————. *Indian Drawings and Painted Sketches.* New York: The Asia Society—Weatherhill, 1976.

Werner, A. "An Alphabetic Acrostic in a Northern Dialect of Swahili." *BSOS* 5 (1928–30), pp. 561–69.

Wiet, Gaston. "Objets en cuivre." *Catalogue général du Musée Arabe du Caire.* Vol. 6. Cairo: Institut Français d'archéologie orientale, 1932.

Winkler, Hans A. *Siegel und Charaktere in der muhammedanischen Zauberei.* Berlin, 1930; repr. 1980.

Woodhead, Christine. "From Scribe to Littérateur: The career of a Sixteenth-Century Ottoman *kātib.*" *Bull. of the British Society for Middle Eastern Studies.* Vol. 9, no. 1 (1982), pp. 55–74.

Yazïr, Mahmud Bedreddin. *Kalem güzeli.* ed. M. Uğur Derman. Ankara: Diyanet Işleri, 1981.

Yūnus Emre. *Dīvān,* ed. Abdulbaki Gölpïnarlï. Istanbul: Ahmet Halit Kitabevi, 1943.

Yusuf, K. M. "Muslim Calligraphy under the Mughals." *Indo-Iranica* X, 1 (1957), pp. 9–13.

Zajączkowski, Ananiasz. *Poezje strofniczne ᶜAšïq Pāšā.* Warsaw: Polskiej Akademie Nauk, 1967.

Zakariya, Mohamed. *The Calligraphy of Islam.* Washington: Georgetown University, 1979.

Zaki, Bassem. "The Development of *mashq, musanam,* and *ḥiliyya* in the Epigraphy of Early Egyptian Tombstones, 31–389 A.

H./652–1000 A.D." Termpaper, offered in the course "Islamic Calligraphy," Harvard University, 1979.

Zaynuddīn, Nājī. *Muṣawwar al-khaṭṭ al-ᶜarabī* (Atlas of Arabic Calligraphy). Baghdad: Maṭbaᶜat al-ḥukūma, 1388h/1968.

Ziauddin, M. *Moslem Calligraphy.* Calcutta: Visva Bharati Studies no. 6, 1936.

Zick, Johanna. "Islamische Keramik in deutschen Museen." *Fikrun wa Fann* VII (1965), pp. 30–36.

Index
of Proper Names

In order to facilitate the identification we have added the dates, as far as they were available. In many cases, conflicting statements are found in different sources.

Irregularities in spelling are due to the different way of transcribing Turkish and Persian words; we ask the readers' indulgence. In Turkish names, Mehmet and Muḥammad are interchangeable.

233

Abū Turāb of Isfahan, Mirza, calligrapher, d. 1661-2, 46, 172n74
Adam, 95, 103, 153; letters of, 96, 104, 193n104
Adharbōd, Persian calligrapher, 167n110
Ādharī of Isfarā'īn, poet, mid-fifteenth century, 69
ᶜAdil, al-Malik al, Maḥmud Ayyūbī, d. 1174, 62, 181n188
ᶜAdilshāhī dynasty of Bijapur, 1506-1686, 70
Adler, J. G. C., eighteenth century, 2
ᶜAḍudaddaula, Buwayhid, r. 949-983, 62
Afghanistan, 7, 9, 10, 11
Africa: North, 8, 27; Western, 27, 29, 36, 85
Agra, 68; Fort 67, 184n234. See also Taj Mahal
Ahenīn-Qalam, Suleymān, Turkish calligrapher, d. 1707, 169n35
Aḥmad, heavenly name of Muḥammad, 96, 97, 104, 154, 193n106
Aḥmad III, Ottoman sultan, r. 1703-1730, 74, 75, 188n291
Aḥmad as-Suhrawardī, disciple of Yāqūt, d. after 1318, 22, 71
Aḥmid-i Jām, Sufi, d. 1141-2, 202n76
Aḥmad ibn Abī Khālid, see Aḥwal
Aḥmad ibn al-Ḥamā'ilī, d. 1337, 164n61
Aḥmad ibn Ibbān al-Andalusī, d. 991, 166n88
Aḥmad ibn Uways Jalā'ir, d. 1410-1, 63
Aḥmad ibn Yāsuf az-Zuᶜayfarī, calligrapher, fl. ca. 1400, 177n136
Aḥmad of Mashhad, see Sayyid-Aḥmad
Aḥmad Pasha, Turkish poet, d. 1496-7, 133, 145, 204n126
Aḥmad Qaraḥiṣārī, Turkish calligrapher, d. 1556, 72, 73, 175n105, 187n275, 188n277, n278
Aḥmad Shāh Walī, Bahmani ruler, r. 1422-1435, 69
Aḥmad Sirhindī, Sufi reformer, d. 1624, 66, 97
Aḥmad Ṭayyib Shāh, calligrapher, early fourteenth century, 22
Aḥwal, Aḥmad ibn Abī Khālid al-, calligrapher, d. 826, 13, 40, 53

Akbar, Moghul emperor, r. 1556-1605, 67, 84, 184n232; his court, 55, 56, 135, 183n228, 183n230; his court poets etc., 146, 162n7, 165n78
Aleppo, 49, 119, 164n56
Alhambra, 19, 27, 86
ᶜAlī, calligrapher of Eastern Kufi, fl. ca. 1092, 163n23
ᶜAlī al-Qārī, Naqshbandi author, d. 1605, 57, 179n163
ᶜAlī aṣ-Ṣūfī, calligrapher, d. 1478-9, 47, 69
ᶜAlī Efendi, Muṣṭafā ibn Aḥmad, Turkish author, d. 1599, 49, 54, 73, 188n280
ᶜAlī ibn Abī Ṭālib, Murtaża, fourth caliph, 656-661 first imam of the Shia, 3, 29, 47, 59, 62, 82, 84, 96, 98, 103, 105, 168n13, 191n49, 196n153; his name, 12, 86, 102, 110, 111, 112, 163n34; connected with the thumb, 190n32
ᶜAlī ibn ᶜIsā "the good vizier," d. 946, 16, 117
ᶜAlī-Riża of Tabriz (Tabrīzī), calligrapher, d. after 1627, 65
ᶜAlī Sangī Badakhshī, découpé master, d. after 1537, 55, 178n144
Amānullāh of Afghanistan, r. 1919-1929, 174n94
Amasya, 71
Amīr Ghayb Bek, Safavi librarian, mid-sixteenth century, 183n216
Amīr Khusrau of Delhi, poet, d. 1325, 87, 98, 109, 115, 120, 130, 131, 184n231, 191n53, 202n76, 203n119
ᶜAmr (with a silent w), 140
Amul, 39
Anadolu, Qāḍīᶜasker of, 51, 175n112
Anatolia, 10, 94, 108, 180n173
ᶜAndalīb, Nāṣir Muḥammad, of Delhi, Sufi, d. 1758, 99, 110
Andalusia, 125, 199n10; Andalusian, 16, 141; script, 27; poets 116, 121, 133, 134, 138
Anīsī, Persian calligrapher, d. 1495, 178n154
Ankara, 190n30
ᶜAnqā bird, 134, 202n90
Anvarī, Auḥaduddīn, Persian poet, d. ca. 1190, 60, 118

235

Delhi, 10, 11, 37, 66, 87, 99, 108, 110,
185n239,n245, 186n254; Quṭb Minār,
25; Quwwat ul-Islam mosque, 25; Red
Fort, 137
Dervish ᶜAbdī Mashhadī Bukhārī, calligra-
pher, d. 1647, 53
Dervish ᶜAli, calligrapher in Thatta, d.
after 1699, 166n100
Dervish ᶜAli, discipline of Erzerumlu,
Turkish calligrapher, d. 1673, 187n271
Dervish Mehmet, Turkish calligrapher, dis-
ciple of Qaraḥiṣārī, d. 1591, 188n277
Dhauqiyya-Chishtiyya order, 149
Dhū'r-riyāsatayn, see al-Faḍl
Dhū'r-Rumma, Arabic poet, d. 735–6,
201n58
Diogenes, 119
Divrigi, 180n173
Dōst-Muḥammad, calligrapher and author,
d. 1565, 30, 65, 67, 173n82, 178n143,
183n217, 228, 230
Dōst-Salmān (Dost-i Salmān?), calligrapher,
sixteenth century, 183n230

Edirne:Eski Cami, 101
Egypt/ian, 9, 12, 19, 24, 29, 33, 39, 41, 45,
48, 54, 140, 147, 167n110, 170n52,
174n94, 175n110, 176n113; pen, 42;
banknotes, 56, 178n152; Sufi, 103; pro-
fessor, 143; tombstone, 72n41. See also
Mamluk
Erzerumlu Khālid, Turkish calligrapher,
seventeenth century, 187n271
Esᶜad Yesārī, Turkish calligrapher, d.
1798, 53, 175n111
Esmā ᶜIbret Hanïm, Turkish calligrapher,
born 1780, 173n87
Ettinghausen, Richard, 10
Euphrates, 186n258
Europe, 2; European, 159; paper, 81;
writer, 120; "eyes," 181n185
Eyüp (Istanbul), 101

Faḍl ibn Sahl, al, Dhū'r-riyasātayn, d. 818,
13
Faḍlullāh of Asterabad, Ḥurūfī, d. 1398,
106, 107, 196n163
Fakhrī of Bursa, découpé master, eighteenth
century (?), 55

Fānī Kashmīrī, Persian poet, d. 1670, 43,
144, 146, 201n46
Faraj, al-Malik an-Nāṣir, Mamluk sultan, r.
1399, 1405, 1405–1412, 15, 54
Farhād the stonecutter, 117
Farhād Pasha, Mehmet II's son-in-law, cal-
ligrapher, d. 1576, 188n277
Fatḥ-ᶜAlī Shāh Qajar, r. 1797–1834, 66
Fathpūr, Sikrī, 67, 184n232
Fāṭima, daughter of the Prophet, d. 632,
92
Fāṭimids in Egypt, 969–1171, 39, 162n21;
ṭirāz, 8
Fattāḥī, see Yaḥyā Sībak
Fayżī, Akbar's court poet, d. 1593, 104,
146, 207n232
Fighānī, Bābā, Persian poet, d. 1519,
191n53
Findley, Carter, 175n109
Filibeli Bakkāl, see ᶜArif
Fogg Art Museum, Cambridge, Massachu-
setts, 162n17, 167n8, 169n36, 185n245,
191n51, 198n192
Fuad, king of Egypt, r. 1922–1936, 48
Furūghī, Persian poet, d. 1857, 202n76
Fużūlī, Turkish poet, d. 1556, 109, 119,
124, 132, 133, 135, 199n4

Gabriel, 151; connected with lām, 91
Galatasaray (Istanbul), 169n40
Gallipoli, 73
Gauharshād, daughter of Mīr-ᶜImād, cal-
ligrapher, d. after 1620, 47
German, 2, 4
Ghālib, Mirzā Asadullāh, of Delhi, poet, d.
1869, 79, 87, 115, 122, 125, 126, 137,
138, 141, 147, 191n53, 193n106, 200n41
Ghālib Dede, Shaykh, Turkish poet, d.
1799, 142
Ghanīzāde, Turkish poet, seventeenth cen-
tury, 207n222
Ghażanfar (surname of ᶜAlī ibn Abī Ṭālib),
112
Ghaznī, 7, 11, 163n23; Ghaznavids, 10, 63,
66
Ghazzālī, Abū Ḥāmid al-, d. 1111, 88
Ghazzālī, Aḥmad, Sufi, d. 1126, 103,
195n141

238

242

Muḥammad the Prophet, 78, 91, 96, 97, 98, 103, 104, 105, 108, 145; his name, 110, 112, 163n34, 193n104; his wives, 172n80; connected with index finger, 190n32. *See also* Prophet

Muḥammad, Sayyid of Gujarat, early seventeenth century, 185n239

Muḥammad, Qāḍī of Calicut, d. after 1607, 196n154

Muḥammad II of Granada, r. 1272-1302, 62

Muḥammad ᶜĀlam ibn Muḥammad Panāh of Thatta, d. ca. 1811, 54

Muḥammad Amīn, Mollā Ḥāfiẓ of Kashan, Persian calligrapher, late sixteenth century, 67, 184n230, 184n235

Muḥammad aṣ-Ṣūfī al-Bukhārī, Pīr, Persian calligrapher, d. after 1445, 57

Muḥammad Bāqir, disciple of Muᶜizzuddīn Kāshānī, fl. ca. 1600, 70

Muḥammad Fakhruddīn al-Ḥalabī, d. 1313, 180n173

Muḥammad Ḥāfiẓ Khān, Indian calligrapher, d. ca. 1780, 168n20

Muḥammad Ḥusayn Zarrīnqalam, Persian calligrapher at the Moghul court, d. after 1597, 184n232

Muḥammad Ḥusayn at-Tabrīzī, Persian calligrapher, 167n8

Muḥammad ibn Aḥmad al-Maghribī, d. 1145, 166n88

Muḥammad ibn Mūsā ibn al-Basīs, eleventh century, 174n96

Muḥammad Ibrīshimī, disciple of Sulṭān-ᶜAlī, d. 1544, 207n230

Muḥammad Mu'min ibn ᶜAbdallāh Marvarīd, sixteenth century, 182n213

Muḥammad Saᶜīd Ashraf, court calligrapher of Zēbunnisā, d. 1704, 173n83

Muḥammad Sālik, d. after 1672, 175n102

Muḥammad Shāh Qājār, r. 1834-1848, 66

Muḥammad Shāh Rangēlā, Moghul emperor, r. 1719-1748, 68

Muḥammad Shamsuddīn, eleventh century, 176n113

Muḥammad Shauqī, Shāh Sayyid, Sufi, 149

Muḥammad Sīmī Nīshāpūrī, Persian calligrapher, d. after 1459, 57, 64, 171n69

Muḥammad Tughluq of Delhi, r. 1325-1351, 37

Muḥammad-Qulī Quṭbshāh of Golconda, r. 1580-1612, 25, 70, 165n81, 186n264

Muḥāsibī, al-Ḥārith al-, Sufi, d. 857, 94

Muḥyī'ddīn ibn Jalāl Amāsī, Turkish calligrapher, d. 1575-6, 187n269

Muᶜizz ibn Bādīs, al-, Zirid ruler, r. 1016-1061, 6, 62, 162n21; his nurse, 6

Muᶜizzuddīn Muḥammad of Kashan, Persian calligrapher, d. 1587, 70, 183n224, 184n237

Mu'min Akbarābādī Mushkīn-Ragam, Indian calligrapher, d. 1680, 68

Munajjid, Ṣalāḥuddīn, 181n190

Munich, Staatliche Museum für Völkerkunde, 198n194

Munīr Lāhōrī, Indo-Persian poet, d. 1645, 122, 201n46

Muqtadir, al-, Abbasid caliph, r. 908-932, 15

Murād II, Ottoman sultan, r. 1421-44, 1446-1451, 71

Murad III, Ottoman sultan, r. 1574-1595, 73

Murad IV, Ottoman sultan, r. 1623-1640, 73, 188n284

Muraqqish, al-, Arabic poet, sixth century, 201n58

Musaylima the Liar, d. 633, 21

Muṣṭafā II, Ottoman sultan, r. 1695-1703, 74

Muṣṭafā III, Ottoman sultan, r. 1757-1774, 53

Muṣṭafā Dede, son of Ḥamdullah, Turkish calligrapher, d. 1539, 187n271

Muṣṭafā ᶜIzzet Yesārīzāde, Turkish calligrapher, d. 1849, 175n111

Muṣṭafā Rāqim, Turkish theologian and calligrapher, d. 1825, 51, 75, 111, 175n112, 180n171

Mustanṣir, al-, Fatimid caliph, r. 1036-1094, 39

Mustaqīmzāde, Suloymān Saᶜduddīn, Turkish historian and Sufi, d. 1789, 46, 48, 63, 66, 81, 82, 105, 123, 165n88, 169n32, 169n41, 171n63, 172n74, 174n92, 175n107, 176n113,

244

246

247

Sharīf Fārisī, son of ʿAbduṣ-Ṣamad, calligrapher at Akbar's court, d. 1612, 165n78
Shauqī, Aḥmad, Egyptian poet, d. 1932, 19, 140
Shaybānī, *see* Ibrāhīm
Shaybānī Khān (Shaybak), Uzbek ruler, r. 1500-1510, 52, 176n119
Shaybanids, 52
Shehlā Aḥmed Pasha, Ottoman grand vizier, d. 1753, 175n111
Shemza, Anwar, Pakistani painter, 98
Shia, 10, 61, 79, 82, 90, 93, 96, 98, 190n42; twelve imams, 101, 193n106; fourteen martyrs, 106; Shiite, 26, 84, 86, 88, 186n260
Shiblī, Abū Bakr ash-, Sufi, d. 945, 202n80
Shihābī, *see* Maḥmūd
Shiraz, 18, 39, 63, 104, 187n274
Shīrīn, 117, 119
Shuhda al-Kātiba, Zaynab Sitt ad-dār, calligrapher, d. 1178, 21, 47
Shukrullah Khalīfa, son-in-law of Ḥamdullah, d. 1543, 72, 187n271
Shukrullāh Qazvīnī, calligrapher, fifteenth century, 69
Shukrullahzāda, *see* Mehmet Dede
Shushtarī, ʿAlī ash-, Egyptian Sufi, d. 1269, 103, 195n141
Shuʿūrī, Mollā Abū'l-Qāsim, calligrapher, fl. last half fifteenth century, 57
Sijistānī, Abū Yaʿqūb as-, Ismāʿīlī thinker, tenth century, 103
Sīmī, *see* Muḥammad
Sinān, Miʿmār, Turk. architect, d. 1578, 3
Sind, 46, 54, 67, 71, 76, 108, 122, 145, 178n149, 184n234, 205n161; Sindhi language and literature, 79, 105, 126, 132, 137, 140, 193n106, 196n153, 198n193
Sīrafī, *see* Ḥasan
Sivas, 10, 11
Socrates, 172n80
Solomon, 84, 133, 152
Somali, 190n28
Sourdel-Thomine, Janine, 2
Spain, 10, 26, 27, 163n28; Spanish silks, 27; text, 28
Sprenger, Aloys, 70
Sri Lanka (Ceylon), 112

St. Laurent, Beatrice, 162n23
Subki, Taqīuddīn as-, historian, d. 1355, 26
Sudan, 167n110
Suhrawardī, *see* Aḥmad
Sulaymān ibn ʿAbdul-Malik, Omayyad caliph, r. 715-717, 199n5
Sulaymān-Shikōh son of Dārā-Shikōh, d. 1660, 68
Suleyman the Magnificent, Ottoman sultan r. 1520-1566, 72, 84
Suleyman II, Ottoman sultan, r. 1687-1690, 188n287
Sulṭān-ʿAlī of Mashhad (Mashhadī), Persian calligrapher, d. 1519, 3, 30, 36, 38, 39, 48, 51, 52, 56, 60, 63, 64, 68, 72, 76, 168n13, 174n97, 175n99, 176n114, 119, 179n158, 180n173, 181n179, 185n237, 207n230
Sulṭān Bāhū, Panjabi Sufi poet, d. 1692, 193n98
Sulṭān-Maḥmūd of Turbat, Pers. calligrapher, fl. after 1500, 184n231
Sulṭān-Muḥammad Nūr son of Sulṭān-ʿAli, Persian calligrapher, d. after 1532, 67, 197n176
Sunbuliyya order, 48, 74
Sunnite, 66, 82, 110, 185n237
Ṣūrā'īl (angel), 153
Suyolcuzade, Muṣṭafā ibn ʿOmar, Turkish calligrapher, d. 1696, 187n271
Suyūṭī, Jalāluddīn as-, Egyptian polymath, d. 1505, 143, 180n170, 206n206
Swahili, 105, 196n155
Syria, 118, 167n11, 188n280; Syrian, 168n17, 177n136; paper, 13, 41; glass, 26
Szigetvár, 72

Ṭabbākh, *see* ʿAbdallāh-i Haravī
Tabriz, 44, 52, 64
Ṭāhir ibn Ḥasan Nisyānī, author in Sind, d. 1641, 189n298
Ṭahmasp, Shāh Ṣafavī, r. 1524-1576, 30, 64, 65, 67, 112, 178n144, 183n216
Taj Mahal, 26, 185n244
Ṭalḥa, companion of the Prophet, d. 656, 191n49

Index
of Technical Terms

A, alif, 9, 15, 16, 19, 22, 83, 102, 113, 119, 204*n*148; Kufic, 3, 5, 94, 135, 204*n*142; two-horned, 3; split-arrowhead, 3; as basic letter in calligraphy, 18; nine points in *muhaqqaq,* 23; seven points in *thuluth,* 23; five points in *naskh* and *riqᶜa,* 23; as stature, standing person, 45, 50, 91, 95, 96, 108, 134, 136, 139, 141, 142; as flag, 72; sign of *wāhidiyya,* 89; angel with beard, 90; upright position, 91; fiery sign, 92, 96, 103; and Divine order, *amr,* 93, 195*n*137; connected with *al-bārī,* 93; letter of Allāh, 94-96, 99, 105, 193*n*98, 193*n*106, 193*n*107; as *ālif,* "connecting," 94; *erenler* as, 94; of *bism,* 95; of Ahmad, 96, 97; of Iblīs, 96; connected with *miᶜrāj,* 98; of *ulfat,* 103; of *Allāh,* 103, 104; as nose and equator of the face, 106, 108; as arrow, 135; as needle, 139, 140; as tongue, 136; connected with *al-badīᶜ,* 149; with Universal Intellect, 149; as originator, 154; as cypress, 155; unique, 187*n*271; proud, 193*n*103; connected with Divine Life, 195*n*144; pure, 204*n*154; *alif-i sayqal* high degree of polishing, 102

a-l-m at the beginning of Sura, 2, 3, 29-32, 91, 141

abjad, Arabic alphabet according to the old Semitic order, 92, 106

abrī, Turkish *ebru,* "cloud paper," marbleized paper, 124

ᶜadam "non-existence," 146

ahad, "One," 97, 154, 193*n*106

ahadiyya, "Absolute Oneness," 89

āhar, starch for paper, 42, 171*n*56

Ahenīn-Qalam "Steel Pen," *see* Sulaymān

ahl al-kitāb, those who own a God-sent book, 77

ākhir, The Last, connected with *hā,* 150

alam "pain," connected with *a-l-m,* 91, 141; connected with *ᶜālam,* 146

ᶜālam "world," mystical explanations of its letters, 97, 146

ᶜālam al-mithāl, the world of imagination, 152

ᶜalīm, The Knowing, connected with *dād,* 151

alīn yazisi (Turkish), "what is written on the forehead," fate, 78

Aljamiado, texts in Spanish and other languages in Arabic letters, 28

Allāh, 9, 62; two *lām* of, 9, 99, 100; numerical value, 66, 92, 101; in *ishtiqāq kabīr,* 103, 104; *h* of, 99, 194*n*116; "Greatest Name of God," divisible, 195*n*141

251

252

hīch, (Persian) "nothing," 139
hilāl, "crescent," 21, 128, 219; numerical
 value, 66, 92
hilliya, space filler in Kufi inscriptions, 9
hilya-i sharīf, description of the Prophet, 45,
 47, 58, 75, 86, 174n94, 180n171, 191n48
hisāb al-jummal, "gematria," 92, 192n81
hū "He," 111
hubā, primordial matter, connected with *hā*,
 150
huffāz, 4; *See also hāfiz*
huwa "He," 99

ibdāᶜ, creation from nothing, 149
ifshā' as-sirr, "divulgence of the secret" of
 love and union, 121
ijāza script, 15
ijāza (Turkish *icazet*) "permission," 36, 44,
 45, 46, 47, 75
illā, "but," beginning of the second half of
 the *shahāda*, 102
ᶜilm ul-kitāb, "knowledge of the book" in
 Hurūfī interpretation, 106
ink, 12, 39; colored, 15, 40; black, 38; solu-
 ble in water, 42, 80, 126, 127; mystical
 interpretation, 79, 89, 90; tresses like,
 115; in poetical language, 122, 126;
 strange ways of making, 131, 145,
 201n52; *See hibr, midād*
inkwell, 40, 41, 169n41, 170n44; mystical
 interpretations, 79; poetical comparison,
 119, 120, 122, 144; *See also dawāt*
iᶜrāb, signs of declension in Arabic, 104
irsāl "swinging of the long ends," 38
ᶜishq, "love" (also *ᶜashq*), letter interpreta-
 tion, 113, 198n198
ishtiqāq kabīr, cabalistic method of interpret-
 ing words, 96, 103, 193n101

j, jīm, 193n103, 205n180; connected with
 nafs, 93; watery letter, 93; poetical com-
 parison, 136; as curl, 136, 142; con-
 nected with *ghanī*, 151; roses, 156
jafr, prognostication from letters, 92
jalī, the large form of calligraphic styles,
 13, 38, 59, 63, 75, 171n59
jāmiᶜ, The Combining, corresponds to *mīm*,
 154
jān, "soul," 134, 136

Jawāhir-Raqam, "Jewel-Letter," 51, 68; *See*
 Sayyid-ᶜAlī
juz', one thirtieth of the Koran, 56, 63;
 amount of *juz'* a calligrapher could write,
 57, 58, 179n165; bound separately,
 162n23, 179n162

k, kāf, 99, 138; Kufic, 5, 7, 33, 138; con-
 nected with *shakūr*, 150; as salt spoon,
 157
k-h-y-ᶜ-ṣ, beginning of Sura, 19, 91
kaff, "Hand," "foam," 199n11
kāghidh, "paper," 123; *kāghidh-i bād*, "wind-
 paper" for pigeon post, 124; *kāghidh-i
 ātashzāda*, "kindled paper," 125
kashish-i kāf-i karam, "the drawing of the
 letter *kāf* of the word *karam*, generosity,"
 138
katabalhu, "he has written," signature of the
 calligrapher, 36, 44, 45, 171n68, 172n73,
 173n82; transformed into *kuntuhu*, 167n7
kātib, "scribe" secretary, 12; numerical
 value of, 92
kathāfat, "density," 150
kh, khā: abreviation for *khālidīn*, 105; for
 khudī, 105; corresponds to Universal
 Body, 150; like a hoopoe, 156
khafī, the small hand of calligraphic styles,
 13, 38
khāl, "mole," beauty spot, 130
khātam an-nubuwwa, "Seal of Prophetship,"
 resembles *mīm*, 98
khatt, "script," 35, 55, 84, 203n114; trans-
 formed into *hazz*, 49, 160n57; double
 meaning as "down on the cheek," 39,
 107, 110, 128-134, 143, 144, 160n57,
 197n166, 203n104, 203n119, 204n124,
 207n213
khatt-i Bāburī, 66
khatt-i chap, from left to right, 178n148
khatt-i maᶜkūs, mirror script, 56
khatt-i nākhun, script engraved with the fin-
 gernail, 32
khatt al-mu'āmarāt, script for correspon-
 dence between amirs, 13
khatt al-qiṣaṣ, script for small pieces of pa-
 per, 13
khatt-i tarsā, "Christian script," which goes
 from left to right, 127, 128

254

mudhill, The Lowering, connected with dhāl, 153

Muḥammad rasūl Allāh, numerical value, 92

muḥaqqaq, 22, 23, 105, 119, 128, 141, 143, 164n67, 165n68, 187n269; Koran in, 64, 65; inscription in, 69

muḥarrir, "clean copyist," 12

muḥīṭ, The All–embracing, connected with qāf, 150

muḥyi, The Life Bestowing, connected with sīn, 153

mukhraj, "taken out," pages taken out by the calligrapher for some defects, 44

mukhṣī, The Counting, connected with ṭā, 152

mul, "wine," 141

mumīt, The Death Bestowing, connected with ṣād, 153

munḥarif, "slanted," 79

munshī, secretary in an office, 178n148, 184n230

muqawwar, "hollowed," round scripts like thuluth, 22

muqla, "eyeball," 19, 129

muqtadir, The Powerful, connected with shīn, 151

murāʿat an-naẓīr: in poetics, to use words of one sphere of meaning in a verse, 144

muraqqaʿ, "album," 65; of Mīr-ʿAlī, 65; of Ṭahmasp, 183n216

musalsal, "chain script," chancellery script, 15, 163n45

musannam, hump-like fillers in Kufi inscriptions, 9

muṣawwir, The Former, connected with rā, 152

muṣḥaf, "book," as contrasted to scroll, copy of the Korans or parts of it, 4, 57, 170n49, 179n162, 197n166

Mushkīn-Raqam, "Musk Letter," 68; See also Muʾmin

muwashshaḥ, strophic poem in post-classical Arabic, 103

n, nūn, 95, 99, 194n115; Kufic, 5, 8; crescent, 21, 139; heart, 55; primordial inkwell, 79; in genuflection, 88; light (from nūr), 103, 152; nuṣrat, 103; eye-brows, 108, 109, 129, 139, 141; ear, 157; nihāya "end," 195n137; Divine speaking, 195n144; crooked, 204n154; as side lock, 205n182

naʿam "yes," from nūn, ʿayn, and mīm, 141, 206n197

nabiyyi "My prophet," 199n5

nādi ʿAliyyan, "Call ʿAli, the locus of manifestation of wonderful things," 84, 186n264, 190n45; as lion, 112

nafas-i raḥmānī, the Divine breath, 150

nafs-i kull, Universal Soul, connected with he, 149

namāz "ritual prayer" in ishtiqāq kabīr, 103

naskh script, 2, 22, 23, 24, 27, 29, 36, 48, 54, 58, 59, 62, 64, 71, 73, 83, 87, 164n67, 165n68, 173n83, 186n264, 188n281; Koran in, 15, 52; Indian, 24, 31; Turkish, 71, 182n206; double meaning with "abolition," 78, 130, 143, 144, 146, 174n99, 187n269

nastaʿlīq, 2, 3, 29, 30, 36, 37, 44, 51, 52, 53, 59, 60, 64, 66-70, 73, 120, 159, 163n43, 166n100, 173n83, 173n91; Koran in, 30, 59, 166n100; Turkish, 53, 178n141; on seals, 55; inscriptions, 71

nāṭiq, "speaker," the Prophet, 91

nayistān, "reed thicket" out of which the reed pen and the reed flute are cut, 119

niṣf, "half": large early chancellery script, 13

niyya, "intention" before every religious act, 109

nūr, "light," 103; connected with nūn, 152

nūrāniyya, the fourteen detached letters at the beginning of certain suras, 90

p: Persian letter revealed to Faḍlullāh Ḥurūfī, 107

pādishāh-i qalam, "emperor of the pen," 70; See also Khalīlullāh

paper, 7, 13, 16, 41, 170n52, 170n53; colored, 6, 13; Samarqandi, 14, 41; Khānbaliq, 15; Daulatābādī, 41; ʿAdilshāhī, 41; Niẓāmshāhī, 41; silk, 42; Syrian, 42, 124; European, 81; in poetry, 123, 124, 125

paper shirt, 87, 191n53

256

papyrus, 4, 16, 170n52
parchment: in poetry, 123
peacock script, 32
Pen, Primordial, of Fate, 1, 77-80, 87, 108, 132, 189n10, 189n11, 204n124; has dried up, 78; equals First Intellect, 79, 149; writing pen, 167n1, 199n16; reed, 38, 39; servant or lover as, 65, 87, 88, 131; split, 78; man's heart as, 87; comparisons in poetry, 116, 117, 201n47-50; steel, 117; and sugar cane, 119, 120; and reed flute, 120, 121, 200n41; like Isrāfīl's trumpet, 121; qaṣīda on, 176n127
pen knife, 39
pigeon: in calligraphy, 111
point, see dot
profession of faith, 9, 10, 24, 101, 104; numerical value of, 92; See also shahāda

q, qāf, 93, 195n136; in Maghribi, 27; tresses, curls, 137, 205n174; corresponds to muḥīṭ and the Divine Throne, 150, 154; numerical value, 93, 157; of ᶜishq, 113; of qāniᶜ, 198n198; qāf-i qurb, 138; qāf-i qanāᶜat, 138
qābiḍ, The Pressing, connected with ṭā, 153
qāhir, The Overpowering, connected with lām, 152
qalam, "pen," 191n59; numerical value of al-qalam, 192n81
qāshqa, caste mark of the Hindus, 145
qāṭiᶜ, découpé master, 55
qawī, The Strong, connected with fā, 153
qiblat al-kuttāb, "direction to which the calligraphers turn," 51
qirma, "broker," chancellery style in Ottoman Turkey, 24, 144
quddūs, The All-Holy, numerical value 199, 92
qudwat al-kuttāb, "model of the calligraphers," 29, 51; See also Mīr-ᶜAlī Tabrīzī
qurrā', pl. of qāri', "reciter of the Koran," 4

r, rā: Kufic, 5; "crooked," 94; crescent, 136; dagger, 142; connected with muṣawwir, 152; eyebrow, 156; Divine power, 190n144

rabb, "lord," Divine Name that works upon created beings, 149, 151
radīf, in Persian poetry the continuing rhyme of several syllables or words, 10
rafīᶜ ad-darajāt, "Of High Ranks," connected with wāw, 154
Raḥīm, ar-, The Merciful, 62
Raḥmān, ar-, The Compassionate, 62, 195n44
raiḥān, "sweet basil," 122, 143
raqamahu, "he wrote it," expression of modesty, 171n61
rāstī "uprightness," "correctness," 110
razzāq, The Nourisher, connected with thā, 153
reed flute, 121, 200n41
rīḥānī, 15, 22, 23, 119, 122, 143, 147, 164n67, 183n230; Koran in, 63
riqāᶜ, bold cursive hand, 15, 22, 87, 129, 164n67; on seals, 55
riqᶜa, small chancellery script, 23, 24
riyāsī, ancient chancellery script, 13
rooster: in calligraphy, 112
rubᶜ, quarter of the Koran, 57
rumḥ, "lance," comparison for pen, 118
ruler, see masṭar
ruqᶜa, piece of paper, 129, 174n99

ṣ, ṣād, in Bihari, 31; eye, 136, 141, 156, 197n176; connected with mumīt, 153; "mustache," 205n182
s, sīn, 15, 16, 83; teeth of, and comparison with teeth, 32, 134, 136, 141, 142, 156, 188n281; of bism, 62, 83, 95; numerical value, 93; of an-nās, 103, 112; cypher for Salmān, 98; of sipihr, 137; connected with muḥyī, 153; saw, 156
sabᶜ mathānī (Sura 15/87), 106
sabk-i Hindī, the Indian style of Persian poetry, 122, 127
safīna, "boat," oblong booklet for poetry, anthology, 30
ṣāḥib as-sayf wa'l-qalam," the lord of sword and pen," title of Muslim princes, 118
ṣalāt al-ḥurūf, prayer in the sequence of the alphabet, 105
sarnivisht, "written on the head," fate, 78, 189n10

257

umm ul-kitāb "Mother of the Book," the heavenly prototype of the Koran, 107

ummī, "unlettered," the Prophet who needs no literacy but was inspired solely by God, 77

unconnected letters of the Koran, 90, 91, 106

Universal Body, *jism-i kull,* corresponds to *khā,* 150

Universal Form, *shakl-i kull,* corresponds to *ghayn,* 150

Universal Intellect, *ʿaql-i kull,* also The Pen, corresponds to *alif,* 149, 150

Universal Nature, *ṭabīʿat-i kull,* corresponds to *ʿayn,* 150

Universal Soul, *nafs-i kull,* also the Well-preserved Tablet, corresponds to *he,* 149, 150

vellum, 4, 5, 6, 27

w, *wāw,* 16, 36, 55, 100, 101, 194n123; Kufic, 5; as body, 93; as ear of the Prophet, 100; as oars, 101; as water bubbles, 140; in *ʿAmr,* 140; conjunction, 140, 154; corresponds to *rafīʿ ad-darajāt,* 154; as mallet, 157; in *ishtiqāq kabīr,* 190n101; of *huwa,* 198n200

wa lā ghāliba illā Allāh, "And there is no victor but God," emblem of the Naṣrid kings of Granada, 86

waḥdat, "unity," 89

wāḥidiyya, "the state of being One," 89

wajh, "face," numerical value fourteen, 106

wajh al-hirr, "cat's face," initial form of *he,* 139

waqf, "pious foundation," 4

warrāq, "copyist," 12, 56

waṣlī, "album page," 54, 56, 173n81, 178n138

waṣṣālī, preparation of cardboard for album pages, 54, 178n138

Water of life, ink, 122, 201n50

wuḍūʾ, ablution after minor impurities, 37

y, *yā:* numerical value, 93; corresponds to *al-mawālīd;* of *ʿAlī* as sword, 102; as *yamīn,* 141; connected with *rabb,* 151; with Saturn, 151, 154

yābis, "dry," sharp edged styles like *muḥaqqaq,* 23

yad, "hand," numerical value fourteen, 106; *yad-i ṭūlā,* "special power," 74

yāsīn (Sura 36/1), 91; as tresses, 197n176

yusrā "left hand," 177n136

z, *zā:* as eyebrow, 156; connected with the spheres, 93; connected with *ḥayy,* 153; *ziyādat,* 103

ẓ,ẓā: connected with *ʿazīz,* 153; numerical value, 157

ẓāhir, The Outward connected with *ghayn,* 150

Zarrīn-qalam, "Golden Pen," 51; *See also* Muḥammad Ḥusayn, Niẓāmuddīn

zh, Persian letter revealed to Faḍlullāh Ḥurūfī, 107

Index of
Koran and Prophetic
Traditions

Koran (qur'ān), 31, 32, 35, 36, 37, 47, 51, 57, 58, 62, 78, 80-84, 86, 94, 102, 103, 106, 132, 143, 157, 161n5, 162n15, 167n8, 169n36, 179n162; in Kufi, 3, 4, 5, 8, 10, 12, 19, 82, 92; pocket, 6, 180n165; in Eastern Kufi, 7, 163n23; Karmathian Kufi, 7, 162n23; in colors, 15; in *naskh*, 15, 24; in *thuluth*, 15, 22; in *naskh* and *thuluth* alternating, 22; in *ghubār* script, 24; in gold, 25; in *nasta'līq*, 30, 59, 166n100; in *muhaqqaq*, 64, 65; in *rīhānī*, 164n67; in Maghribi, 27; on colored paper, 6; on papyrus, 12; on Khanbaliq paper, 15; written by 'Othmān ibn 'Affān, 4; by Ibn al-Bawwāb, 19, 57, 164n62; by Baysonghur Mirzā, 25, 64; by Ibn al-Lu'aybiya, 41, 170n49; by Malika-Jahān, 47; by 'Azīz Rifā'ī, 48, 174n94; by 'Abdallāh Arghūn, 49; by 'Abdallāh-i Haravī, 52; by Muhammad 'Alam "with amputated hands," 54, 178n137; by Ibn Muqla, 56; by Yāqūt, 57, 185n239; by Nasrullāh Qandahārī, 57; by Hājjī Muhammad Banddūz, 57; by Muhammad as-Sūfī 57; by 'Alī al-Qārī, 57, 179n163;

by Mehmet Kaiserili, 58; by Vasfī Efendi, 58; by Shaykh Hamdullāh, 60, 72; by Mas'ūd I of Ghazni, 63; by Ibrāhīm ibn Mas'ūd of Ghazni, 63; by Tughrul III, 63; by Ibrāhīm Mirzā, 63, 182n206; by Bahrām Mirzā ibn Ismā'īl as-Safavi, 65; by Nasīruddīn of Delhi, 66; by Bābur, 66; by Dārā-Shikōh, 68, 185n246; by Aurangzēb, 68, 186n251; by Ahmad Qara-hisārī, 73; by Hāfiz Osman, 74, 92; by Yedikuleli, 74; by Sultan Ahmad III, 74; by Sultan Mehmet III, 75; by Ahmad an-Nuwayrī, 179n165; by Abū 'Abdur-Razzāq as-Sābūnī, 179n167; by Mehmet Rāsim, 180n170; by Hasan Chelebi, 187n279; *Mushaf al-hādina*, 6; copying as expiation for sins, 84; prognostication from, 86; human face, as, 107-110, 145, 197n166, 197n176

Koranic suras:

Sura, 1, *al-Fātiha*, 82, 195n137; in *shikasta*, 166n102; face as, 197n176

Sura 2, 91, 141; verse 151, 11; verse 256, "Throne-verse," 84, 154

Sura, 3, verse 15, 105; verse 37, 197n176

Index
of Book Titles

اموت ويبقى كل ما قد كتبه
فياليت من يقرأ كتابي دعا لي

I'll die, but all that I have
written remains—
I wish that whoever reads
my book may pray
for me.